ONE ARTIST
ONE MATERIAL

Fifty-five makers on their medium

FRAME

CONTENT

INTRODUCTION

Does living in the digital age intensify our relationship with the material world? The success of One Artist, One Material, a regular feature section that has appeared in *Frame* magazine for over a decade, suggests that it does. An interview with a maker about his or her chosen material, it first appeared in *Frame* 65 (May/June 2007) and is still going strong. At time of writing, 58 further editions have appeared. The only issue not to include a One Artist, One Material story was *Frame* 116, which was the 20th anniversary issue.

This book contains 55 of those interviews, most (but not all) of them written by me. I stumbled into the subject almost by accident, as a *Frame* editor, and was quickly captivated. My first interview, early in the section's history, was with tape artist Rebecca Ward; the most recent one, in *Frame* 121 (March/April 2017) is with Emmanuelle Moureaux. Initially, I suspected ideas for stories would eventually dry up. Many interviews later, I'm sure that will never happen. If this series teaches us anything, it's that everything can be used to make art – including traffic surveillance camera images (James Bridle), blood (Jordan Eagles) and plant roots (Diana Scherer), to name just three of the stranger materials in the series.

Within the deceptively simple formula, dramatic, amusing, perplexing and humbling stories unfold. The subjects are enthusiastic about their chosen material to the point of monomania, spending long hours on eBay procuring vintage furniture (Michael Samuels), or behind a microscope arranging diatoms, which are invisible to the human eye (Klaus Kemp), or tracing huge yet transient patterns in sand or snow (Jim Denevan and Simon Beck, respectively). A material's simplicity often bears no relation to the complexity it expresses in the hands of a creator. Magpie feathers are shaped into disturbing

spatial deluges by Kate MccGwire; white balloons are used over and over again by Charles Pétillon to undermine our perceptions of everyday reality.

These two share a spatial approach, along with many more creatives in the series, offering inspiration to *Frame*'s core audience of interior designers. Over One Artist, One Material's lifetime, art and design have been steadily converging, with pop-up shops now often appearing to be art installations (and occasionally vice versa). Pressures on budgets and increasing awareness of sustainability issues have led designers to take a new look at materials, opting for recycling, making, and even growing their own. Handcrafted items have meanwhile found a new popularity and relevance. All of these material trends are prefigured in One Artist, One Material.

Yves Klein fortunately failed to set a precedent when he trademarked his colour-medium back in 1959, but his fierce possessiveness reflects the passion shown by every artist for their chosen material. After all, materials move, motivate, and marshal creativity in ways that we might never have expected. Sensory, tactile, smelly, ugly, worthless, precious, organic, artificial, beautiful, grotesque, microscopic, miraculous, visceral and mundane — materials in all their complexity can change the course of a creative career, and often do. This book is the story of material encounters, and material adventures.

Words JANE SZITA

COLOUR

Almost every artist deals with colour,
by default, but for some it's the main
ingredient of their work. John Sabraw, for
instance, uses poisonous coal mine pollution
to create the most intense, mesmerising colours,
Gabriel Dawe transforms humble polyester
thread into rainbow-like illusions, and
Emmanuelle Moureaux creates art works
with as many as 1,000 different hues.
The artists in this chapter show just how
rich a world full of colour can be.

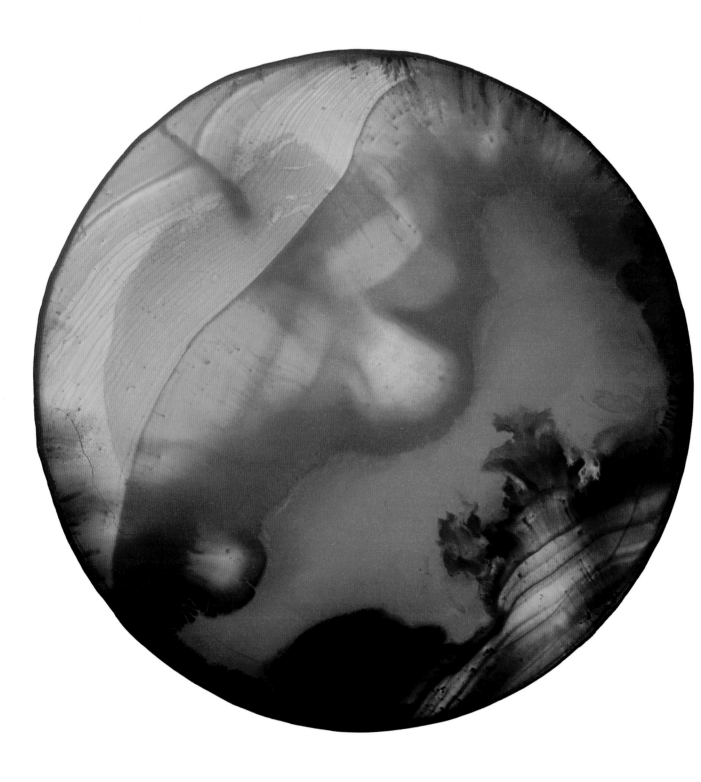

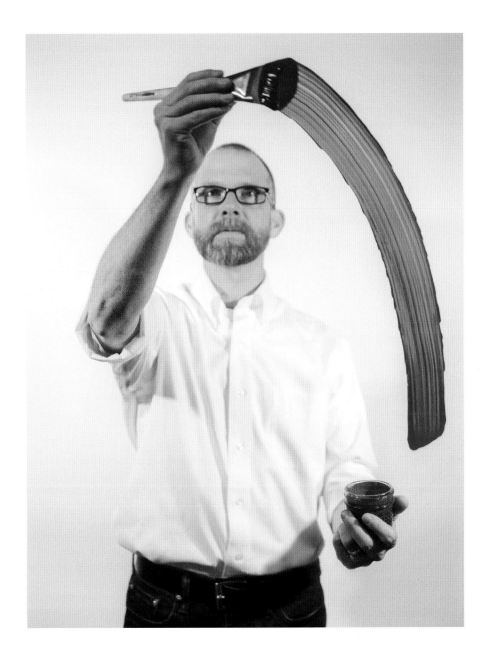

POLLUTION AND THE PAINTER

With paints derived from the toxic run-off that pollutes Ohio's coal-mining country, John Sabraw used a simple technique to achieve the ecological complexity of his *Chroma* series.

Words JANE SZITA **Portrait** LOUISE O'ROURKE

Born in England, artist John Sabraw was still known as a realist painter when he horrified his agent by producing *Chroma*, a series of circular abstract works. Made with pigments derived from the toxic run-off that pollutes the coal-mining region of Ohio (Sabraw is an art professor at Ohio University), the pieces underline the theme of environmental activism in Sabraw's work: he once devised a carbon-offset scheme for artists, which he applied to Leonardo's *Mona Lisa*. Sabraw and chemist Guy Riefler,

Where do you see the *Chroma* project heading? We want the paint-making process to be commercially viable, and we're looking for funding from various sources. The same process could be used for other polluted sites. It's an exportable technology that could clean up an area in a generation.

Are you involving other artists? I'm making a large batch of acrylics and oils from the heavily polluted Ore-

'It's an exportable technology that could clean up an area in a generation'

his paint-making partner at Ohio University, have big plans for pollution-based pigments as a means to clean up industrial sites.

What inspired the idea of making paint from pollution? JOHN SABRAW: Ohio has over 4,000 abandoned mines leaking lifeless but dazzlingly coloured mineral streams. I was struck by the amazing colours and wondered if I could work with them. I quickly discovered that environmental engineer Guy Riefler was already using the run-off to make paint, and he asked me to join him.

Is making the paint a simple process? It's easy — but making a viable, consistent and stable pigment is hard. We start with containers of polluted water, which vary enormously from site to site. We consulted a paint manufacturer in order to achieve a finer grind and the right pH balance to mix with linseed oil or acrylic compounds.

How do you make the *Chroma* works using these pigments? I lay a sheet of aluminium flat, draw a circle and apply lots of water-based pigment to it, creating a large bubble on the surface. Then I wait for it to dry. It takes weeks and weeks. A piece measuring about a metre across has around a gallon [3.79 litres] of water on it, with surface tension holding it in place.

How many of these pieces have you made? There are lots of failures. I've made dozens successful ones, and the process is evolving and becoming crazier. I am now working on a bigger scale, almost 2 m in width, and I'm doing an experimental piece that's over 3 m wide. The larger the scale the less control, and the more an ecology-like complexity emerges.

ton site. Later, I'll send tubes to artists around the world. Their works will form a future exhibition.

They look quite earthlike, but what do your *Chroma* works *really* represent? Actually, the initial idea was to find an organic way of representing tree rings. These days I begin each work with an idea of something like algae.

Is art important in tackling environmental issues? The science is compelling to those who can process it, but art can connect with people on a more basic, emotional level. It raises awareness and involvement.

How can artists and scientists work together effectively? I've worked with astrophysicists before and now with Guy, and I really like collaborating with scientists. These days, everything is so specialized that there is little discussion among disciplines. But artists and scientists communicated closely in the past. Often, they were the same people. There is a commonality.

johnsabraw.com

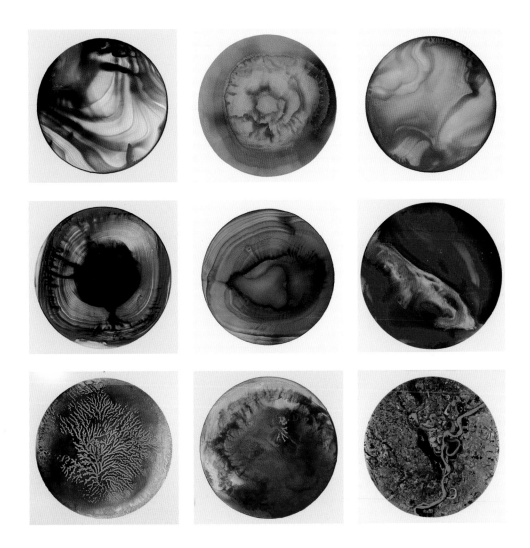

Above from left to right
CHROMA S2 2 (2014), *CHROMA S1 11* (2013),
CHROMA S1 12 (2013), *CHROMA S2 3* (2015),
CHROMA S1 13 (2013), *CHROMA S4 NEBULA* (2017),
CHROMA S4 BLUE RIVER (2016), *CHROMA S3 1*
(2015), *CHROMA S5 ST. FRANCIS* (2017).

Previous spread, left page
CHROMA S1 14 (2013).

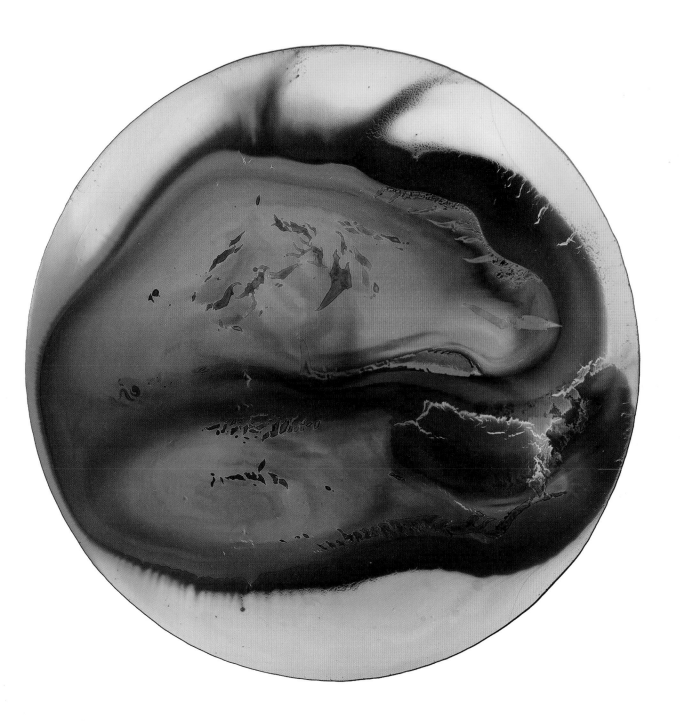

Above
CHROMA S11 (2013).

Opposite page
OHIO HAS OVER 4,000 ABANDONED
MINES LEAKING LIFELESS BUT DAZZLINGLY
COLOURED MINERAL STREAMS.
THIS ONE IS IN CARBONDALE.

THE WATCHER

In the hands of James Bridle, machine-made surveillance images become abstract kaleidoscopic cityscapes of infinite shape-shifting beauty.

Words JANE SZITA **Portrait** ANDY SEWELL **Photos** DOT

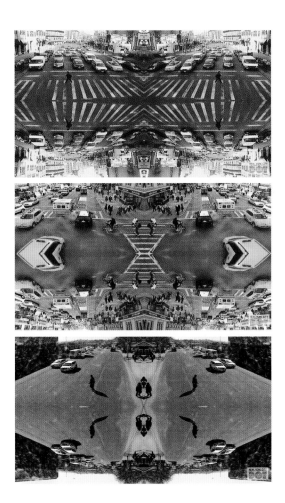

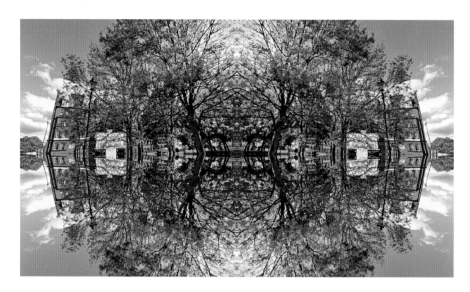

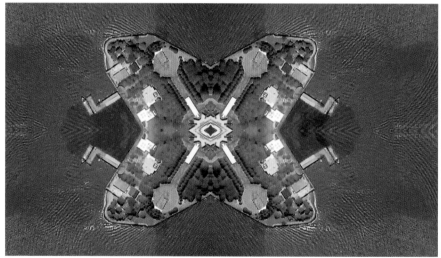

Above
BRIDLE HOPES THAT *RORSCHMAP* (2011),
A KALEIDOSCOPIC SERIES OF ONLINE MAPS,
WILL HELP US TO THINK MORE CAREFULLY
ABOUT THE SYSTEMS WE DESIGN.

Previous spread, right page
RORSCHCAM NYC (2014) IS THE THIRD IN THE
RORSCHMAP SERIES, FOLLOWING *RORSCHMAP*
AND *RORSCHMAP STREET VIEW*.

London-based artist, technologist, writer and publisher James Bridle has a master's degree in computer science and cognitive science — specialist areas: linguistics and artificial intelligence — from University College London. After graduating, he worked in publishing before joining Apt, a design, technology and marketing consultancy. Currently, he is a member of design partnership the Really Interesting Group. As a solo artist, his work is about the often unnoticed ways in which technology influences our world. *Where the F**k Was I?* is a book of maps that detail a year of Bridle's movements as recorded by iPhone. The *Drone Shadow Catcher* places full-scale silhouettes of usually unseen military drones on public streets. While in New York recently, he set up his

itself. You can enjoy the visual beauty of the images, but at the same time I'm pointing a finger at surveillance. Although mine is a benign form of finger-pointing, it's related to others that are not so benign. This is the central issue of what we are making now: we have amazing technology, and we could do wonderful things with it, yet we're using it largely for control. Very disturbing.

Big brother is watching us . . . A cliché, but true. It *is* just like *1984*. And everyone seems to be okay with that.

How can that be? It's a paradox. We declare a philosophical right to privacy, yet we act in the opposite way — from Facebook to email surveillance to police

'We declare a philosophical right to privacy, yet we act in the opposite way'

Rorschmap project, using live traffic-surveillance footage to make intriguing kaleidoscopic cityscapes in real time.

What was the motivation behind this series? JAMES BRIDLE: I did my first street-view piece in London. It was a love letter to the city, a way of rooting myself there. When I found myself working in New York, I decided to do the same thing.

How did you create the *Rorschmap* site? The footage is streamed; the New York Department of Transportation [DoT] has its own site, and you can find all the camera footage there. I wrote my own code to assemble the images in real time — this is simple to do when I can locate the cameras.

Any feedback from the DoT? Yes, they like the work. They wanted their technology to be more visible, and through this piece it is.

Why the fascination with surveillance-camera footage? It's this vast amount of data put together by machines. I love that. It's fantastic material, and the majority of it is unseen by the human eye. You have to go and find it and add meaning to it.

What meaning is your work adding? The fourfold reflection is unlike our expected vision of the world; it removes utility and transforms the image into something we can appreciate aesthetically. As it's abstracted, it's no longer about a particular place but about surveillance

departments that record every car journey made. I see it as a bizarre duality that's a product of technology itself, perhaps because technology works through lines of invisible code that lends itself to invisibility. I am not anti-technology, but I'm not a techno utopian or techno determinist either.

Will you continue to use surveillance footage as material? Yes, if I can find suitable imagery. Actually, I'm interested in doing a system of selfies using CCTV. I've done a few, and I'd like to develop the idea. It's really about making something big enough for people to share and explore.

What do you hope to achieve with your work? I hope my work can contribute to more awareness and, ultimately, to foster more debate. The surveillance mentality affects the design of our world. Expectations of surveillance change our behaviour. We should think much more carefully about the systems we design.

shorttermmemoryloss.com

rorschmap.com

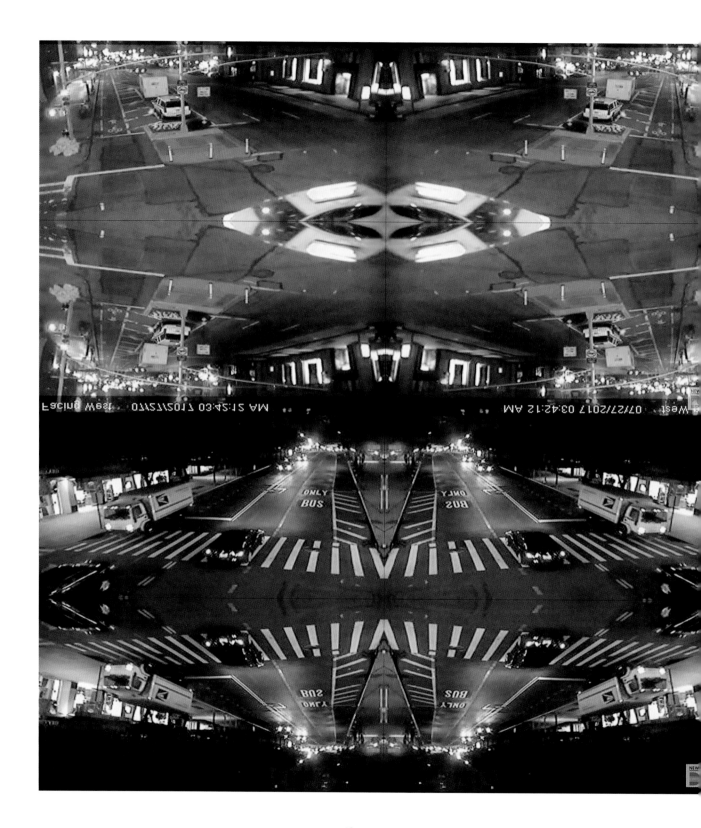

Above
FOR *RORSCHCAM NYC*, THE ARTIST USES
LIVE TRAFFIC-SURVEILLANCE FOOTAGE
FROM NEW YORK TO MAKE INTRIGUING
KALEIDOSCOPIC CITYSCAPES IN REAL TIME.

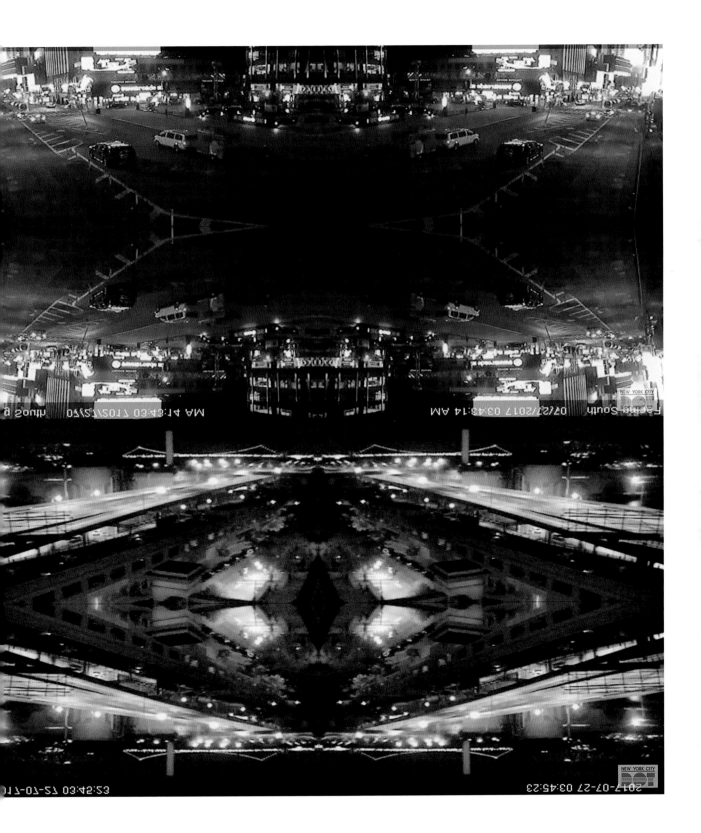

'It is just like *1984*. And everyone seems to be okay with that'

DEUS EX MACHINA

Andreas Nicholas Fischer sees a future in which his works — created with open-source software — are smart enough to make their own choices.

Words JANE SZITA **Portrait** DANIEL HOFER

Born in Munich, Andreas Nicolas Fischer moved to Berlin to attend the UDK (Berlin University of the Arts). Once enrolled, he followed courses given by Jussi Ängeslevä and Joachim Sauter on digital media arts, which he recalls as 'a hybrid of digital media and fine art'. Fischer graduated in 2008, having already decided to become an artist in 2005. His work explores a wide range of media, with a particular focus on the digital. For his *Schwarm* series, he writes software capable of generating intricate and intriguing abstract works.

How did you first get interested in using digital processes to make art? ANDREAS NICOLAS FISCHER: If I had to name one trigger, it would be an exhibition by software artist Casey Reas at Dam Gallery [Berlin]. His natural-looking, computer-generated images really spoke to me.

What fascinates you about code as a material? You design the system and let it loose. It has autonomy, and you can't predict the result. You are the creator as well as your own audience. And there are no physical constraints: you can extend yourself and your abilities through software.

What technology do you use to make the *Schwarm* works? I use an open-source programming language called Processing, which originated at the MIT Media Lab in 2001. It's a wrapper for Java and has lots of functions specific to art, media and design.

Can you describe your working process? It starts with developing a core algorithm. The hardest thing is to pro-

Is there a difference between working digitally and working with 'real' media? Why isn't this real? I like to quote William Gibson, who said, 'One of the things our grandchildren will find quaintest about us is that we distinguish the digital from the real, the virtual from the real.' The more digital skills I acquire, the more the work proceeds as a sort of flow — as would happen in any other media.

What inspires your art? I look at images on the internet in a sort of instant-gratification way — I call it 'aesthetics mining'. It's just viewing other people's images, making connections and categorizing. It can be art, nature, anything. It's about being totally oversaturated and seeing what sticks.

How would you like to develop your *Schwarm* works? By adding an in-built feedback loop that eventually causes the program to evaluate itself and to make choices. That would make it really interesting. I might need some programming help to achieve that, though.

How do people react to your work? I think my work appeals to the parasympathetic system, which is what Brian Eno said about his *Music for Airports*. My pieces may not provoke a direct response, but I think they change the viewer's mood in a positive way.

How has your digital art changed the way you think about technology in general? I've become both more critical and more optimistic. Critical, because of the way technology works. We have to conform to it, to sit in front of a screen all day long. That's so limiting. But I'm

'You are the creator as well as your own audience'

duce output you're happy with. The key word is *iteration*: a multiplication of many small processes that makes the final result more than the sum of its parts. So I just have to run the program and see. For a large image — a print measuring 1.8 × 1.2 m — I need from one to three days, and it pushes the limits of the technology I use. To make prints, I have to optimize the output to get the desired resolution.

What does your work reveal about the relationship between the digital and the natural? It's interesting that what I make seems to be organic rather than computer-generated. It looks like nature, without being a copy.

optimistic too, because technology has the potential to break boundaries and enhance civilization.

How would you like us to look at *Schwarm*? As you look at any other work of art. When you view a painting, you don't think about the paint. It's the same with *Schwarm*. I want you to think about the work, not the technology behind it.

anf.nu

Above
SCHWARM PINK (2015). FOR HIS *SCHWARM*
SERIES, FISCHER WRITES SOFTWARE CAPABLE
OF GENERATING INTRICATE AND INTRIGUING
ABSTRACT WORKS.

Previous spread, left page
SCHWARM ORANGE (2015). THE GERMAN ARTIST
HOPES PEOPLE WILL SEE *SCHWARM* AS THEY
WOULD 'ANY OTHER WORK OF ART. WHEN YOU
VIEW A PAINTING, YOU DON'T THINK ABOUT
THE PAINT.'

Following spread
SCHWARM GREEN (2015). FISCHER
USES AN OPEN-SOURCE PROGRAMMING
LANGUAGE CALLED PROCESSING FOR
THE *SCHWARM* SERIES.

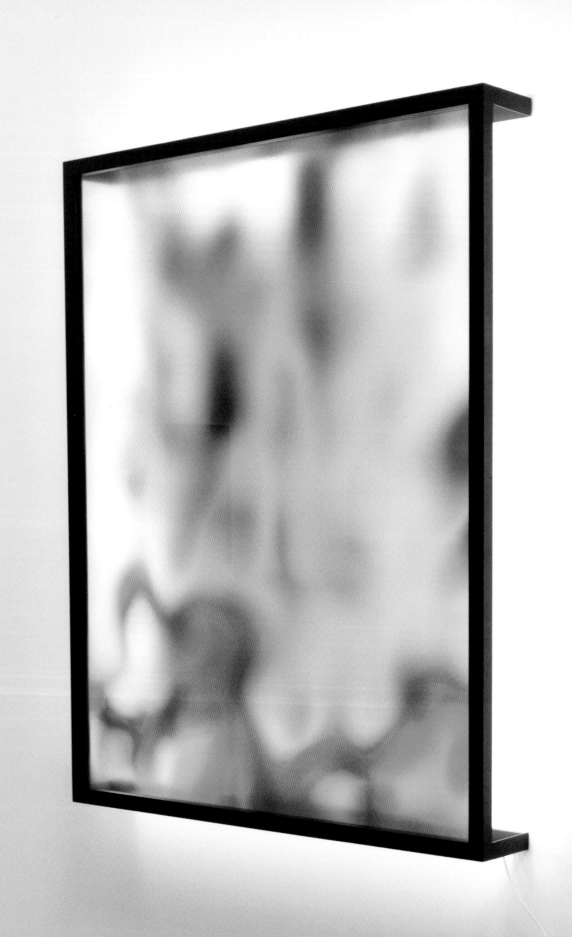

DATA PAINTER

**Jonas Lund adds the digital
to traditional art production.**

Words JONATHAN OPENSHAW **Portrait** ALEX SANTANA

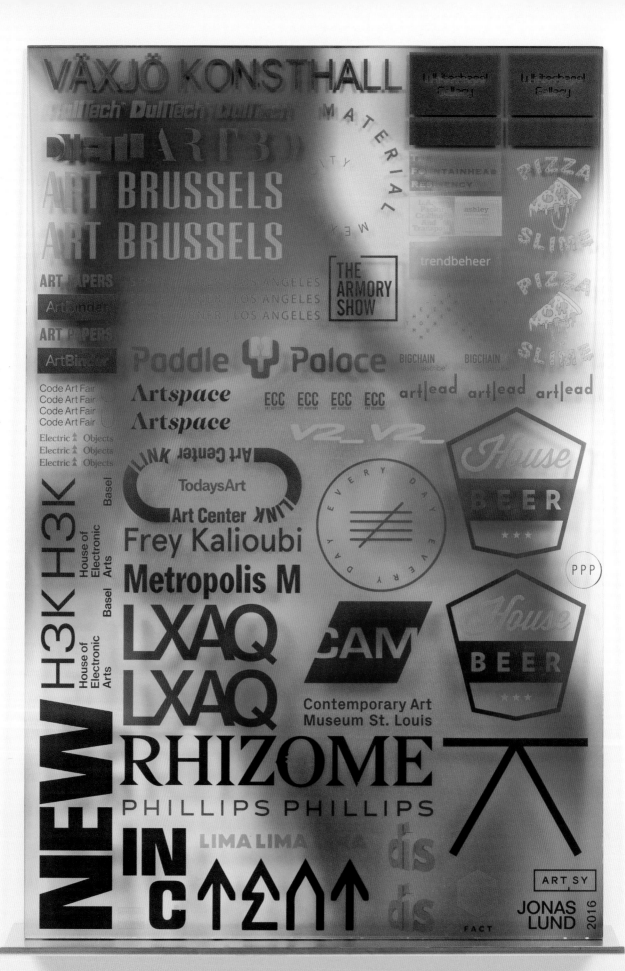

Swedish artist Jonas Lund approaches his work like a *bricoleur*, sampling and mixing any materials that come to hand – from digital screens to ping-pong tables. By seamlessly integrating data into the things he makes, he exposes the ways in which algorithmic logic and artificial intelligence (AI) have come to dominate our lives, and questions whether machines operate in our best interests.

Data plays a big role in your work. Do you relate to the digital and the tactile in the same way? JONAS LUND: I don't really differentiate. I'm more interested in building systems that can enrol a whole load of things, no matter what the medium. I have a box of tools available to me, so just like a painter has a paintbrush or a sculptor has clay, I use whatever I can get my hands on. And part of this is data. So-called virtual activities are no less real than physical ones. The bigger question is: how can you translate a variety of materials into one coherent thing that can be called a piece of art?

Are you trying to make data less abstract and more relatable? The definition of big data is that it's too big for a human to process, so we need machines to assist us. It's these machines and algorithms that I'm interested in, because we assume that they are objective and rational, but they were designed by real people who have very real biases. These biases are becoming unquestioned black boxes that are totally outside any type of policy or control, but that do create a filter that dominates our experience of the world. I want to pick that filter apart and interrogate it.

For your work New Now, you let AI produce the final piece. Can you talk a bit more about the process? I wanted to outsource my creativity to a computer and see what happened. I trained a very simple AI neural network to emulate my visual style by entering all my previous art works and setting the AI to create new works

informed by that *oeuvre*. My input consisted of parameters and rules for the system, but the final work was out of my control.

There are growing concerns about AI's potential to replace us. What's your personal perspective? Right now, AI is really good at doing rather mundane tasks. It's all speculation as to where it could go in the future. If it can move from mechanical tasks to more general abilities and reach an evolutionary tipping point, then I believe we'll either witness the total extinction of humanity, or we'll all live forever. Could AI save the world? For sure, without a doubt. Maybe it's more likely to be bad than good for us. But I choose to be optimistic.

We produce reams of data all the time, which is often monetized without our full knowledge or consent. How do you explore the role that algorithms play in this pursuit of profit? Algorithms want to optimize everything, and today's neoliberal society wants us to accept the outcome as inevitable progress. It isn't inevitable. It's a choice we've made. It's become part of daily life because we have surrendered our privacy. I like the fact that you cannot apply this logic to the art world, however. I *try* to apply it through my work, but my efforts only show that art is too irrational for computers to comprehend.

So the value of art is subjective, and machines struggle with that? For sure. Algorithms favour easy, simple, quick things; they don't favour deep thought or proper consideration. But you can still find a place in the art world to reflect and to escape the hype cycle that has taken over our lives. Although I do think escape is becoming less and less possible, so who knows whether art is immune ultimately?

jonaslund.biz

Opposite page
PART OF LUND'S SOLO EXHIBITION AT LOS ANGELES GALLERY STEVE TURNER WERE PAINTINGS FEATURING LOGOS OF ART-RELATED INSTITUTIONS THAT SPONSORED THE EVENT.

Previous spread, left page
A WORK FROM *NEW NOW* (2016), A SERIES OF 'DIGITAL PAINTINGS' DEVELOPED USING MACHINE LEARNING, EXEMPLIFIES THE WAY IN WHICH A NEURAL NETWORK BECOMES THE ARTIST.

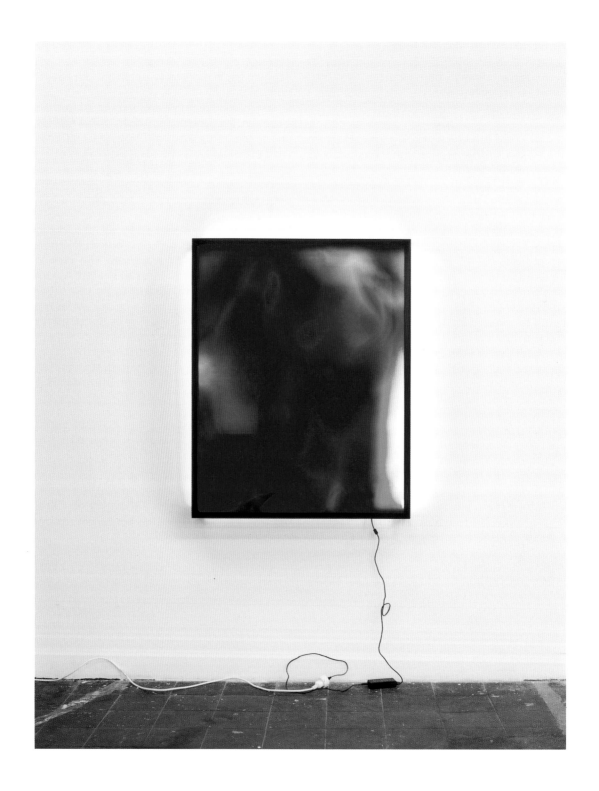

Above and opposite page
PAINTINGS IN THE *NEW NOW* SERIES ARE MADE
OF A UV PRINT ON PLEXIGLASS IN A METAL
FRAME AND A LED STRIP.

ALWAYS ON SCREEN

Playing with the connection between people and technology, artist Rafaël Rozendaal's web works address the issue of ownership.

Words JANE SZITA **Portrait** CINDY BAAR

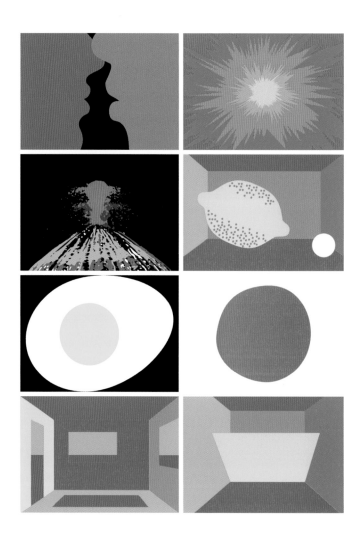

Rafaël Rozendaal was born in the Netherlands to a Dutch father and a Brazilian mother. He studied art in The Hague and Maastricht and completed his first website work in 1999. After graduating, he began travelling while still working on web art, as 'it meant I didn't need to be tied to a studio'. Graphic and deceptively simple, his works seem to ponder our relationship with technology by playing with expectations of interactivity and online functionality. Rozendaal has invented a model in which the collector who buys a website signs a contract to keep it publicly accessible. 'Other artists make websites,' he says, 'but my focus is almost exclusively on websites.' Rozendaal currently lives in New York City.

Which came first for you: art or the internet? RAFAËL ROZENDAAL: Definitely art. My parents were

any scale. In a way, it's an indestructible medium. It exists in multitudes. And it can always be changed. I usually don't alter my works, but I like the idea that they can be manipulated. It feels free and that's unique — this kind of freedom didn't exist before.

The web is important to me as a free space and a public studio. No-one is looking over my shoulder, asking me if I'm sure about what I'm doing — the type of response you'd get from a curator. I wouldn't be comfortable working with someone else's interference.

Why is it so important to make sure that your art stays publicly accessible? At art school I couldn't find any examples of interactive art — it's so marginal. I believe in the value of passing on knowledge. Think about the online presence of David Bowie versus that

'We're used to works of art deteriorating over time, but mine will only get crisper, brighter, sharper'

artists, and as a kid I was constantly drawing. I was always interested in reproducible media — stickers, comic books and that sort of thing — because basically I like things to spread. I'm also drawn to reduction. 'Reproducible' means you have to simplify.

Why did you gravitate towards technology? Mainly because it was a new area, so it was easier to do something fresh. Before that I'd tried all sorts of things. Moving images seemed to work best for me, so I stuck with that. When I did my first website I had to reduce my work even more, and I was struck by a sense of freedom — the freedom of a lack of history, and the freedom of distribution.

How do you make these works? They usually start off as hand drawings. I draw rectangles and sketch out ideas in those frames. I can't sketch on an iPad. It's quicker by hand, and some things are just harder to draw digitally.

When I decide to develop a sketch, I contact my programmer; I've worked with the same one since 2001. It would have taken me three years to learn what he can do in ten minutes. So I make a few frames, maybe a rough animation, and we Skype. He makes a prototype in JavaScript, and I can change the variables to create a different effect. That's the nice thing about programming.

What's the best thing about the website as a medium? Well, the resolution is independent — it's just instructions — which means it can be seen anywhere at

of David Hockney. Visual art is hard to experience online as it's mostly *documentation* of the work, not the work itself. With music, on the other hand, you can listen to the actual songs. I like to see the full story of an artist, but very few get their own museum. I'm building my own lifetime museum together with the collectors. For them it's strange not to own something outright, but there's a joy in sharing.

I've made around 110 websites. Collectively, they get 50 million visitors a year, many more than any private work can achieve. For me, digital media is always about accessibility. Sure, music from an MP3 sounds worse than what's on vinyl, but you can listen to it anywhere. That said, my work is always uncompressed. I make it with the network in mind; it's not the same process as reducing music to an MP3.

What do you explore with your work? I'm against the idea that my work is *about* something. If anything, the internet is about unimportant thoughts. Painters deal with curators, writers with editors. On the internet, there's no-one; it's more a stream of consciousness. I'm interested in certain themes, like interactivity, infinity and composition.

How important is interactivity in what you do? Very. With technology, interactivity is always goal driven. You click to send something, go somewhere, buy something. I'm interested in interactivity for its own sake. I want to make people conscious of clicking.

How has the development of technology affected your work? The web was very limited in the beginning. Up until 2008, it kept getting better and better, more and more sophisticated. When mobile phones emerged, I wanted to reduce my art even more. It became simpler, because of the small screen, but also slower, with even less of a 'point'.

I'm not interested in virtual reality or anything like that. I like technology that's available to everybody.

Is it difficult to exhibit website art in galleries? It's not easy, but the economics involved are the real challenge. With paintings and other works, the big issues are transport and security. For websites you need, say, 50 projectors and 50 computers, equipment that requires a sizable base budget — but the rest is quite simple.

With the rapid advance of technology, could your work become obsolete? It's actually a very practical medium, because with the passage of time you can recode. Displays are getting very cheap, so it's easier every year. My works are just instructions, remember? We're used to works of art deteriorating over time, but mine are the opposite. They will only get crisper, brighter, sharper.

And your work appears everywhere, from phones to giant screens in major cities. Yes. I see it as being similar to a song you might hear at a party and then while alone. All the experiences are complementary, and together they are the work. A website should be like gas — able to adapt to fill any space.

You've branched out into other areas — podcasts and haikus among them. Will you continue to work with websites? Yes, but also with other media. I find I have lots of time left over every day. And I love coming up with things that didn't exist before.

newrafael.com

Previous spread, left page, from left to right
MUCH BETTER THAN THIS (2006), *HYBRID MOMENT* (2009), *HOT DOOM* (2009), *TOSSING TURNING* (2011), *EGG ALONE* (2017), *SAD FOR JAPAN* (2011), *THIS EMPTY ROOM* (2016), *VIOLENT POWER* (2012).

Following spread
RAFAËL ROZENDAAL'S *MUCH BETTER THAN THIS* APPEARED ON ELECTRONIC BILLBOARDS IN NEW YORK'S TIMES SQUARE IN 2015. OTHER WEB WORKS SHOWN HERE ALSO INCORPORATE MOVING IMAGERY.

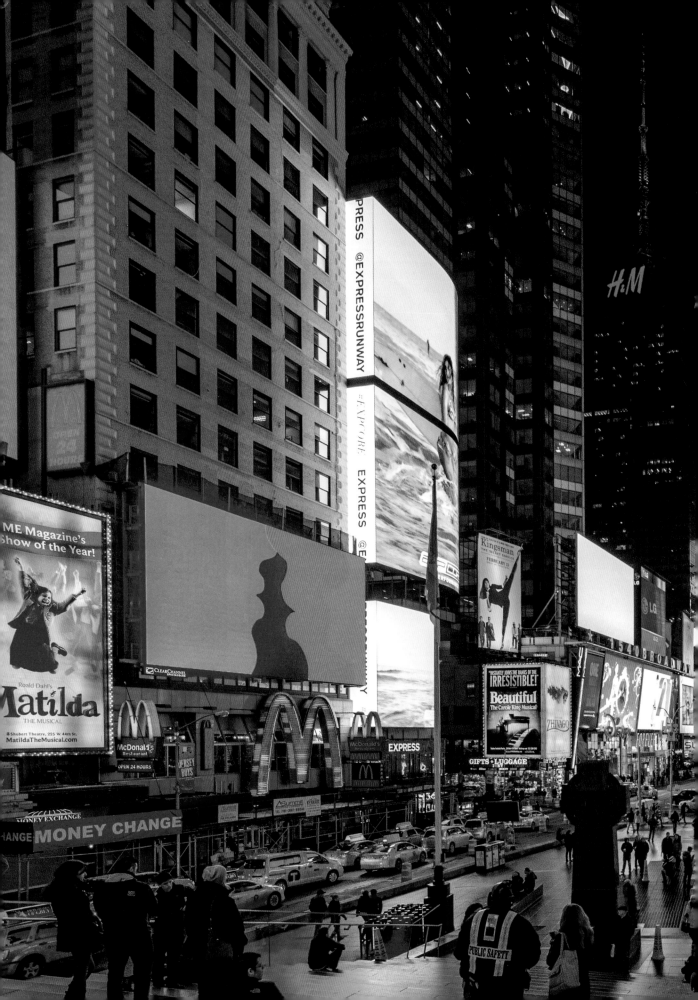

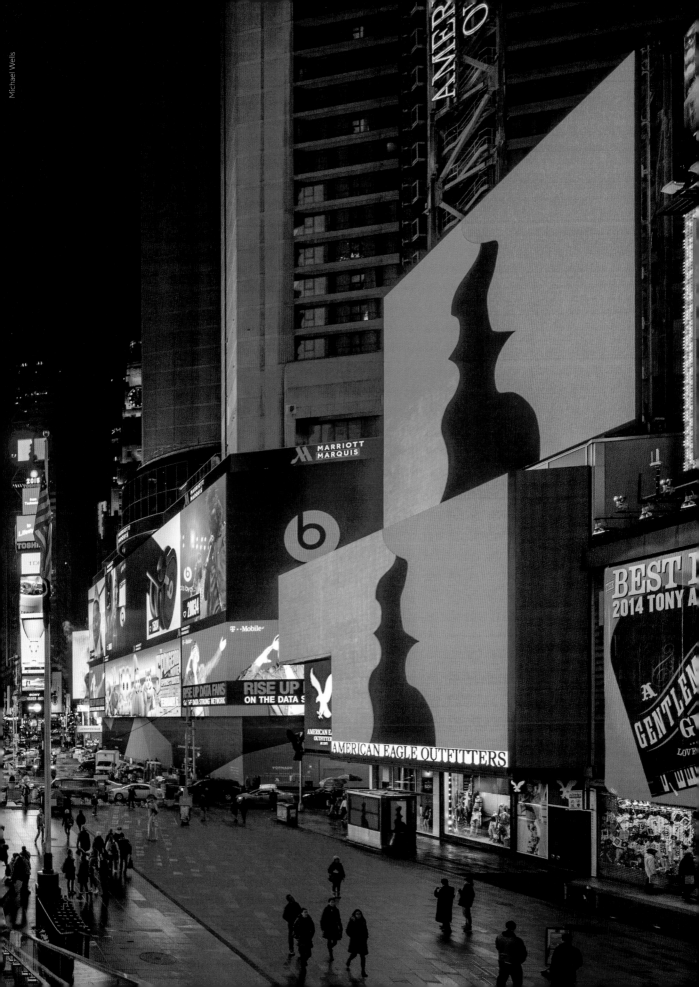

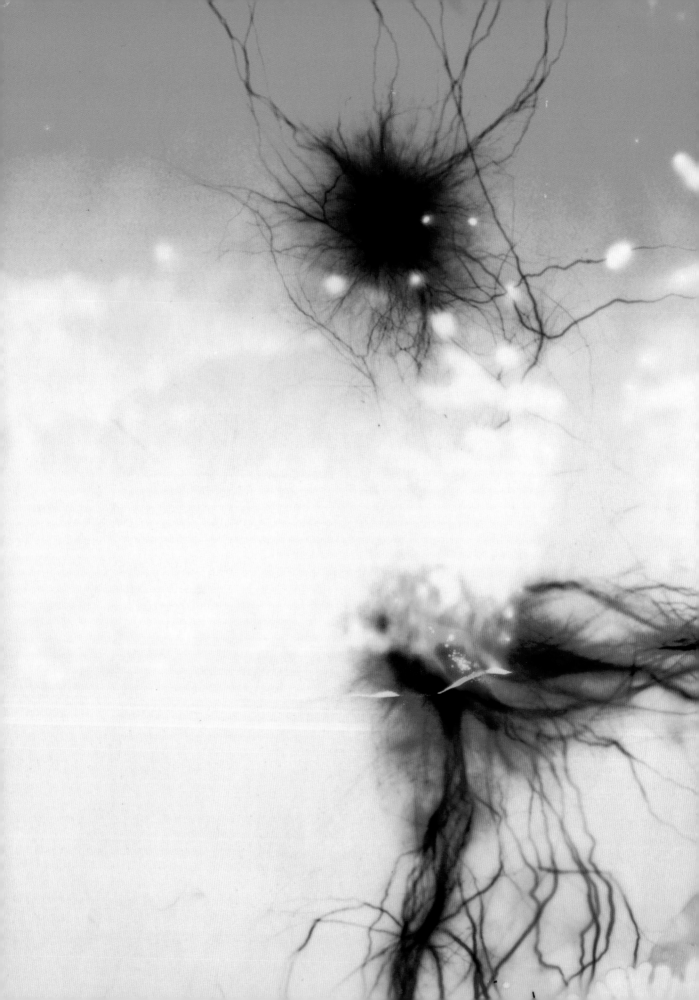

LET THE SPARKS FLY

Dangerously high-voltage electricity meets instant film to become elemental art at the hands of Phillip Stearns.

Words JANE SZITA **Portrait** RUDOLF BEKKER

Born in Austin, Texas, Phillip Stearns studied engineering and physics at the University of Colorado at Denver before switching to music. He completed his MFA in music and integrated media studies at the California Institute of the Arts in 2007, having shaped a series of sound and light installations — often using the knowledge of electronics he'd picked up in his engineering courses. Among many other things, Stearns has produced a sequence of images by exposing instant film to high-voltage electricity, with results that evoke both macrocosms and microcosms — from galaxies to nerve clusters in the body.

When did you first get interested in electricity? PHILLIP STEARNS: It goes back to the first device I ever dismantled, probably a Fisher-Price walkie-talkie, when I was in elementary school.

Describe your technique. It's simple but unpredictable — and dangerous. I remove unexposed instant film from its cartridge and place it between two electrodes. It's then subjected to high-voltage discharges provided by a neon transformer and developed. Sometimes I preexpose the film to different colours of light or apply different household chemicals to its surface.

What voltages are you working with? The neon transformer I'm using — a giant mass of copper wire wound around an iron core — can boost 120 VAC, or mains power, to 15,000 VAC. Neon tubes require high voltages to get the electrons of the atoms inside to shimmy and shake violently. When they do, they give off light.

Your images rely on digital technology, too. It allows me to share the project more widely. I'm also able to magnify the images, to amplify their impact in evoking universal and elemental connections.

Would you call your images photographs? Not quite. While the medium, instant film, is photographic, how I'm using it departs subtly from the larger photographic tradition. The images I create are more like footprints in the sand on a beach. The film is the sand in this analogy, the image is the footprint, and the electricity is the owner of the foot.

What fascinates you about them? They transcend scale on a certain level. My entry point to the project was in questioning our relationships to photography, physical material, electricity, image-making, media — and in probing how these relationships are simultaneously defined by and define society to varying degrees.

What are your ambitions for this medium? There's so much to be explored, and I'd like to approach it more methodically. Now that I have a sense of what's going on, electrically and chemically, I'd like to spend some time discovering the full range of expressivity in the medium, to really find my voice in it.

What are your works about? Ultimately, that's not for me to decide. Hopefully, they're not so boring that only one meaning emerges from them.

Has other electrical art inspired you? In terms of my own use of extreme voltage or fringe electronics, I was inspired by performers like Arthur Elsenaar, Mario de Vega and Arcangel Constantini. Plus those who have worked with photography in alternative ways: Man Ray, Hiroshi Sugimoto, Pierre Cordier, Marco Breuer. Sugimoto is probably my biggest source of inspiration.

Why do these pieces make me think of Frankenstein? Maybe we're on the same psychic frequency? I sometimes refer to cobbled-together technologies as being 'Frankensteined'. This project is definitely an example of that.

phillipstearns.com

All art works
HIGH VOLTAGE IMAGES (2014). STEARNS REMOVES UNEXPOSED INSTANT FILM FROM ITS CARTRIDGE, PLACES IT BETWEEN TWO ELECTRODES, SUBJECTS IT TO HIGH-VOLTAGE DISCHARGES AND DEVELOPS IT. TO CREATE VARIED EFFECTS, HE SOMETIMES PREEXPOSES THE FILM TO DIFFERENT COLOURS OF LIGHT OR APPLIES HOUSEHOLD CHEMICALS TO ITS SURFACE.

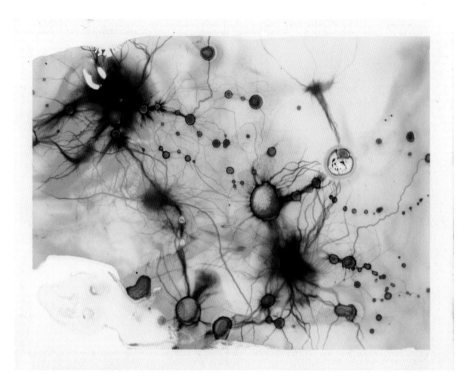

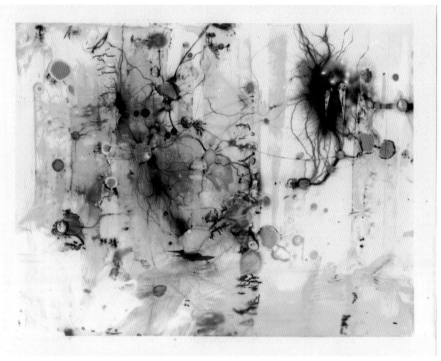

**'My technique is simple but
unpredictable – and dangerous'**

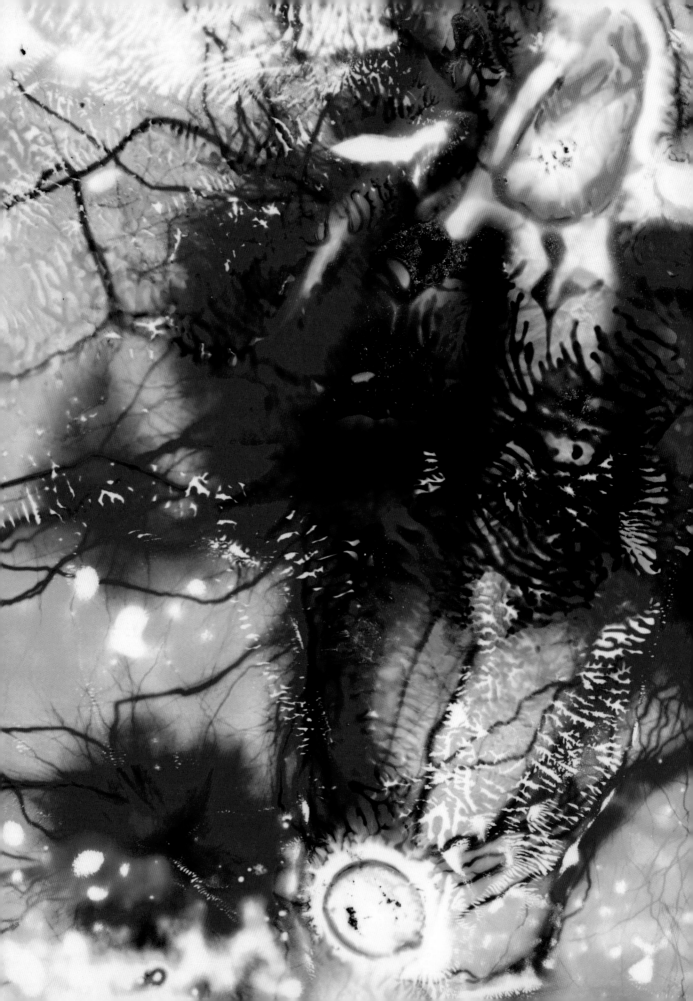

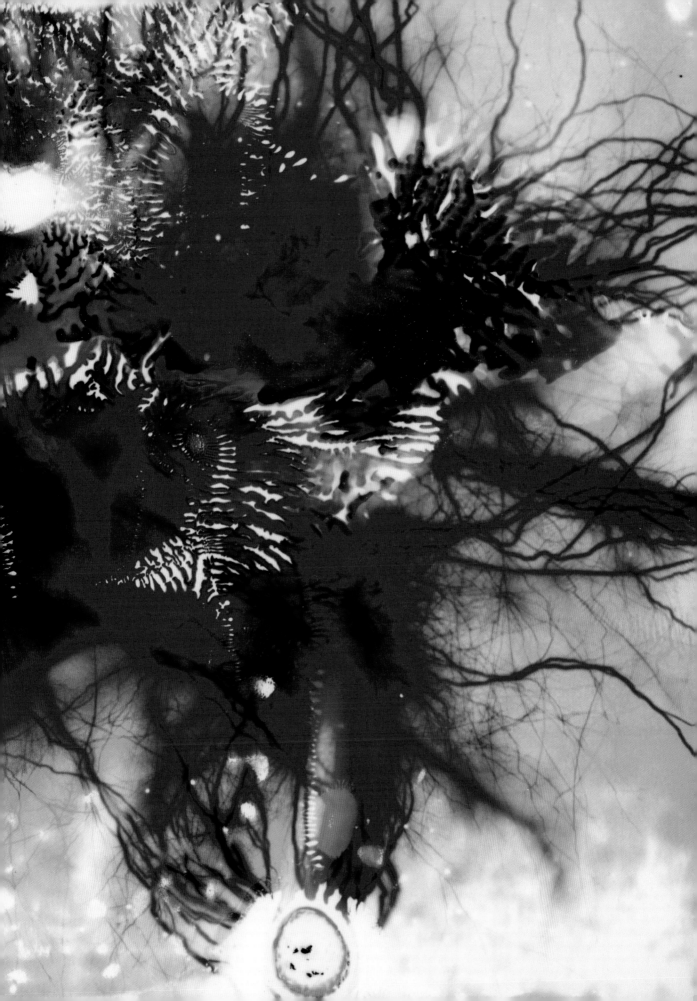

LINES OF VISION

**The sole subject of Ian Davenport's
work is his medium: paint.**

Words LOUISE SCHOUWENBERG, JANE SZITA **Portrait** SUE ARROWSMITH

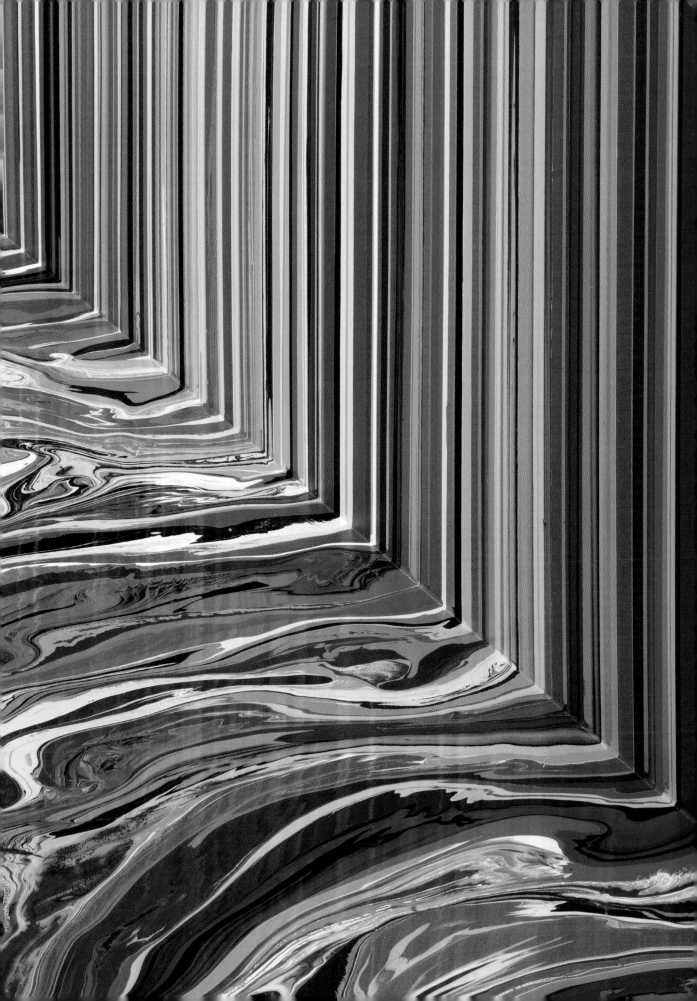

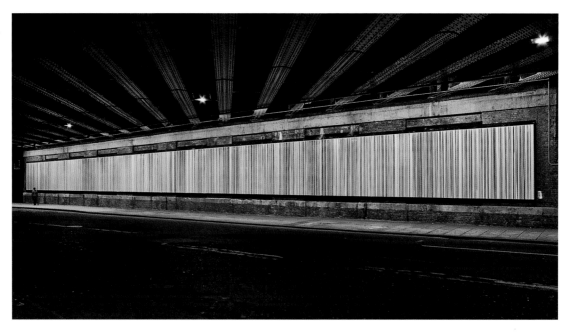

Pia Capelli

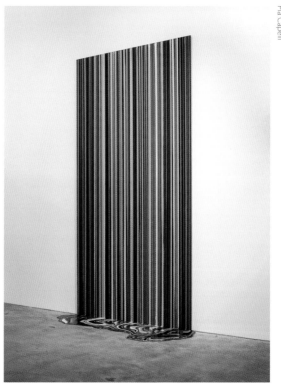

Above
SOUTHWARK BRIDGE: POURED LINES (2006).
VITREOUS ENAMEL ON STEEL INSTALLATION
UNDER SOUTHWARK BRIDGE.

COBALT BLUE WATER (2017).

Previous spread, right page
MIRRORED PLACE, DETAIL (2017).

Following spread
PUDDLE PAINTING: BLACK (WAVE) (2009).

Colour, paint and gravity — these are the main ingredients that English abstract artist Ian Davenport (1966) has been using ever since he was a student at Goldsmiths College of Art in London in the 1980s. His paintings and site-specific interventions on the walls of galleries, museums and public buildings never display a single colour but always a fascinating palette of varying colour combinations. In 1988 he participated in Freeze, a group exhibition curated by Damien Hirst. In 1991 he was nominated for the prestigious Turner Prize. He is represented by Waddington Galleries in London. His paintings have been included in the collections of museums such as Tate Gallery, London; the Weltkunst Collection, Zurich; and the Dallas Museum of Art, Texas.

How did your fascination with paint begin? IAN DAVENPORT: As a young boy, I found I could use paint to college, this was really important. Over the last 20 years I've used lots of different materials. Most recently I've been using acrylic paints, which I buy from both DIY shops and art suppliers.

What drives your experimentation with different methods of application? A different method will mean a different set of results. I find the simplest ideas lead to the best results. I have used wind machines, fans, nails, watering cans and syringes to make paintings.

Some of your pieces are prints — are these also an exploration of the paint medium? I was invited to make prints some years ago. In the beginning, I had no idea how to approach the project. By coincidence I spoke to a friend who explained how I could make an image by working on a clear surface and exposing the

'Gravity is such a powerful force in our lives and one we take for granted'

do things that were quite unexpected. What took a long time was to realize that this could be the subject of my work — that the medium could be the message.

What qualities of paint do you find most intriguing? I am exploring the organic nature of paint and how it is affected by gravity. Gravity is such a powerful force in our lives and one we take for granted. I am still amazed by the notion that the earth is a big ball spinning through space.

I control fluid paints with minimal interference. I set up a system that enables me to focus on one specific area. At the moment, this system involves putting sequences of coloured, dripped lines together. The way the lines are poured is very precise, even though they puddle and pool at the bottom. The lines fuse and break in places, but the overall composition is very rhythmic.

You've sometimes used commercial gloss paint. Why? I wanted to break some rules. At the time, I felt that people seldom questioned how and with what they made paintings. I wanted to examine certain preconceived notions. I thought an interesting way to explore the subject would be to use industrial paints and materials. It led to some very interesting paintings and surfaces, which could not have been made in any other way.

It was also much cheaper to buy large amounts of household paints and lacquers. For an artist just leaving result to a light-sensitive screen. From this screen, I can produce a plate for making prints. The different print processes allow me to explore colour and surface. I find that one medium tends to feed another.

How does an ancient medium like paint retain its relevance in the modern world? Artists will always find a way of exploring and expressing the world around them. If the approach is relevant, the work will be too.

Where to next with this material? I want to play with colour. I'm enjoying composing the coloured stripes in my current series of works. Recently I have been using other artists' paintings to influence the colour selection.

Who has influenced your work? This question follows on very well from the last. Warhol, Matisse, Van Gogh and Fra Angelico have all influenced my work. I am also a big fan of cartoons, like The Simpsons.

iandavenportstudio.com

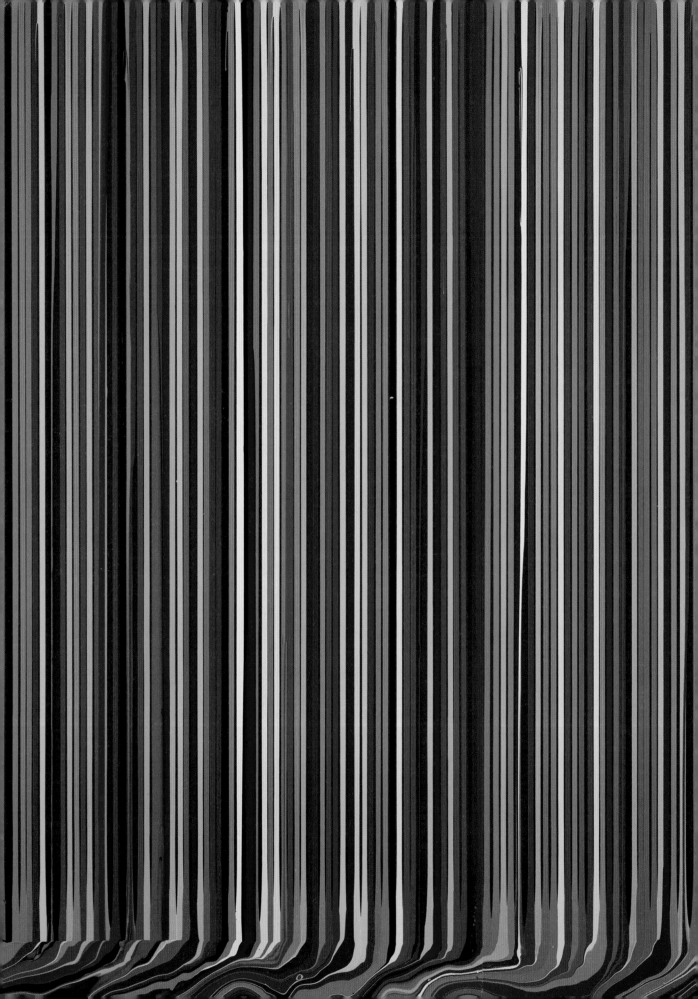

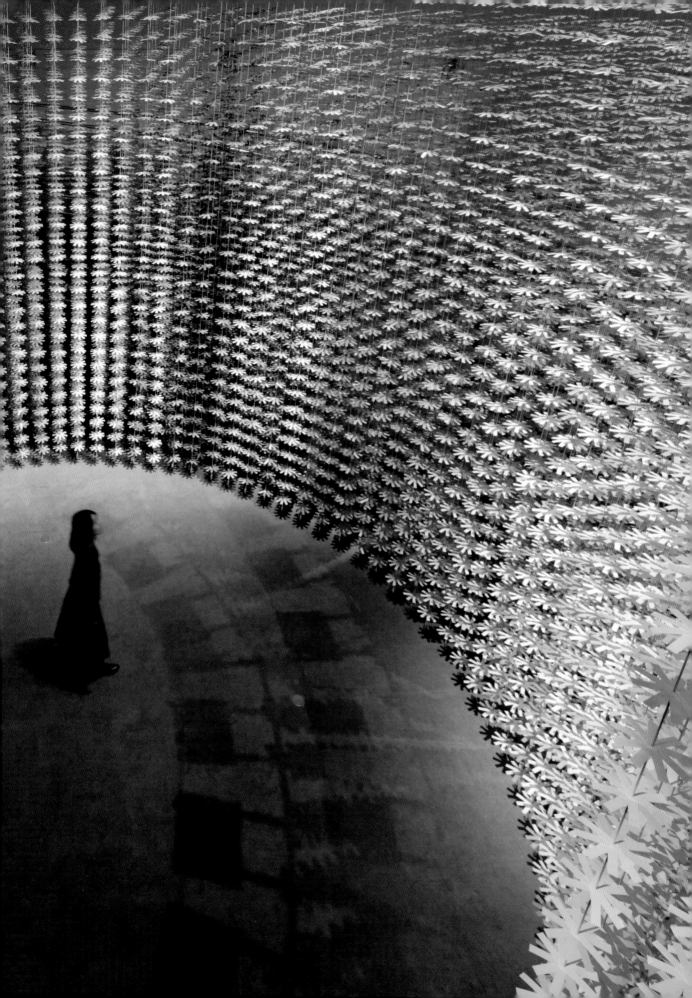

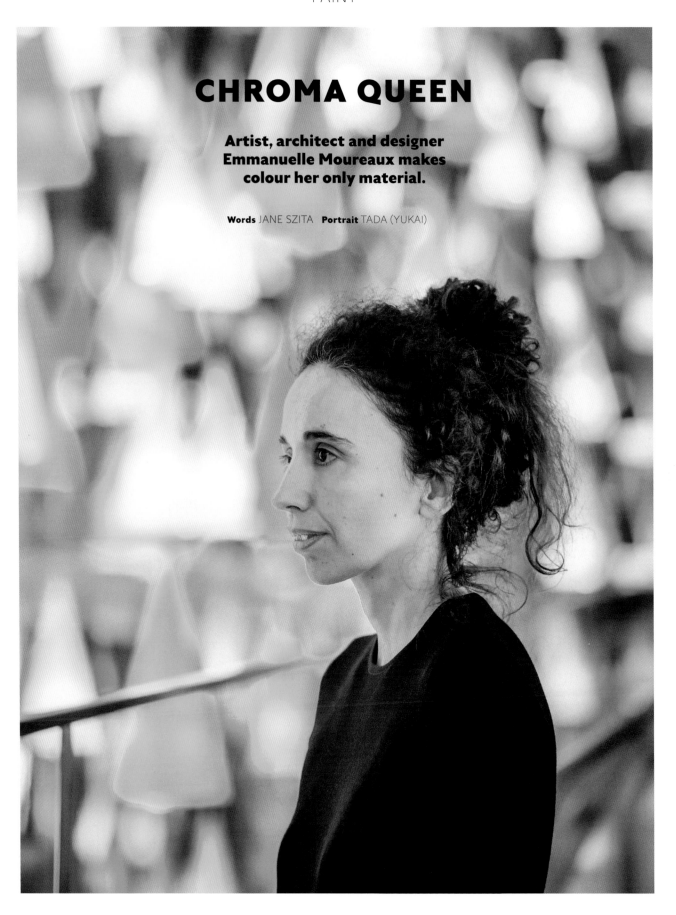

CHROMA QUEEN

Artist, architect and designer Emmanuelle Moureaux makes colour her only material.

Words JANE SZITA **Portrait** TADA (YUKAI)

A visit to Tokyo in the 1990s changed Emmanuelle Moureaux's life forever. Falling in love with the city and its colourscapes, she decided to move there after completing her architecture studies in France. Her dream was to open her own design office in Tokyo, even though the need to learn the language and obtain Japanese qualifications meant starting from scratch. In 2003 she finally opened her studio, from which she has worked on a wide range of projects — including a bank, an entire train line in Taiwan and numerous art installations — ever since. United by their use of colour as a main spatial principle, an approach she calls *shikiri*, her creations use as many as 1,000 different hues, each of which is custom made. Moureaux teaches at Tohoku University of Art and Design.

When did your obsession with colour begin? EMMANUELLE MOUREAUX: When I saw Tokyo for the first time. As a student back home in France, I'd never really been aware of colour, and as soon as I got off the

the traditional Japanese screen. I adapted the characters so that it means 'divide with colours' — that's what I base all my projects on. I use colour in a three-dimensional way, not as a finishing touch.

Art, architecture, design — you work in all three. Is there a difference in the way you approach them? No, it's all the same to me. I don't see architecture, design and art as different disciplines. Instead, I see my work as travelling between different scales. The process is always identical.

Can you describe it? I start with the concept. At the beginning, I decide how many colours I'm going to use — not precisely but roughly, say 20 or 100. Then I work on the name and the concept, in words — both of these are very important to me. When thinking about the concept, I design small spaces based on the idea, so I'm working with words and visuals at the same time. The second step is to develop the design by making models — which

'Pantone has lots of colours, but not enough for me'

train, I saw it with fresh eyes. There's just so much colour here. It's also the way it manifests itself as layers floating in space. That effect is created by the combination of neon signage, overhead cables and different building heights — and it's unique to Tokyo. When I realized how little colour actually features in Japanese design and architecture, which is mostly monochrome, I decided I wanted to establish my own studio to explore it.

What's the appeal of colour for you? The emotions it generates. It makes the heart sing; it fills you with energy. Through my work I want people to feel what I felt on my first visit to Tokyo.

What was your first project?= A small interior for a cosmetics company. I got the commission through one of my students — I'd been teaching French while learning Japanese. I didn't want to work in anyone else's design studio. I just wanted to work for myself. That interior was a tiny space, but I used *lots* of colour. When it was completed, the client said she felt purified by colour. That's when I knew I was on the right track and wanted to continue.

How did you develop your concept of *shikiri*? I was inspired by Tokyo and by the way that colour defines depth in the cityscape. The term shikiri basically refers to

can be small or 1:1 — and lots of drawings. Then I develop the colours, which is the hard part.

Where do your colours come from? I mostly mix them myself. Sometimes I use Pantone colours, but that's an exception. I'm using them for the train line I'm doing in Taiwan, for example, because of the distance involved. Pantone has lots of colours, but not enough for me. Luckily, I find my colours everywhere. It might be a page in a magazine that's a beautiful blue, so I'll give that to the paint or dye factory — which one depends on the material we plan to use. I check colour samples at the factory until they're right. It's a difficult process.

How do different materials affect the colours in your projects? They don't. Materials are absolutely not important to the outcome. Only colours matter. I don't want people to recognize the materials I use, because I want them to focus solely on the colours. If I use wood, people can't tell it's wood. I always hide the texture.

What's the maximum number of colours you've used? I used 1,000 for *1000 Colors Recipe,* the installation I completed last year for Imabari, a city famous in Japan for its dyeing industry. The brief was to showcase the techniques of eight dye factories, so I decided to do something that would be impossible otherwise — hence

the 1,000 colours. It was a big challenge. To select that many colours, you need several thousand to choose from. Because dyeing is like cookery, the installation takes the forms of symbols that refer to the temperature, timing and percentage of 'ingredients'.

Prior to this installation, my colour limit was 100, as demonstrated by my 100 Colors series, which I began in 2013 to celebrate my studio's tenth anniversary. One of my goals was to prove you can see 100 colours in a space. While it's a large figure, it's also a familiar number, and the colours are easy to distinguish. I've made many different versions of 100 Colors in various countries.

Does colour play an equally big role in your home and wardrobe? Not really. My studio is filled with colour, and I spend lots of time there, so generally I wear either black or white. My home is very neutral and simple, but that's partly because you're not allowed to paint rentals in Japan.

Do you think you're more colour-sensitive than other people? Because of my work, I'm always looking for new colours, but I don't think I see more colours than anyone else. I'm just more attuned to them. I believe it's a universal ability and that almost anyone can distinguish millions of colours.

What I find from talking to architects, designers and students — because I also teach — is that people often say it's too difficult to use colour and that they're not brave enough. You need courage, so I teach my students not to be afraid of colour.

Do you have a favourite colour? How can I possibly choose? But if I have to, then it would be white. That's because whenever I use whites, they make the other colours appear even more beautiful. I've used black only once, in *Color of Time,* but that installation was based on a special concept about the colours of one day and night.

Whose work inspires you? Tokyo is my main inspiration, but there's one person, too: Issey Miyake. I love his concepts and the way he treats clothes like architecture or products in such a three-dimensional way. I've worked with him twice on installations, and I loved it.

Where do you want to take your work next? I'd like to continue working on lots of different scales. In particular, I want to do a 100 Colors building.

emmanuellemoureaux.com

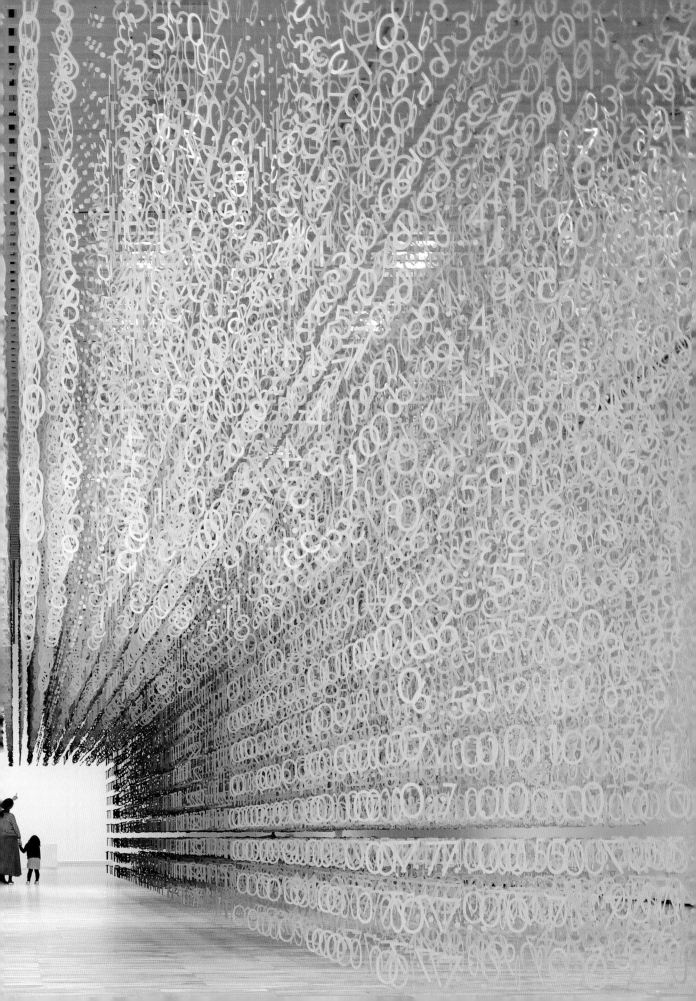

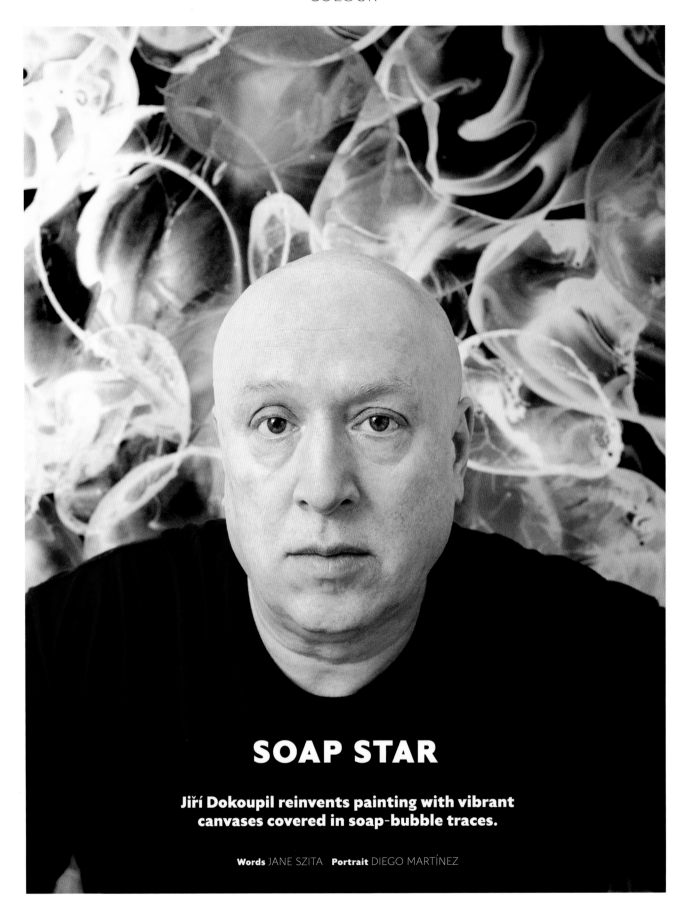

SOAP STAR

**Jiří Dokoupil reinvents painting with vibrant
canvases covered in soap-bubble traces.**

Words JANE SZITA **Portrait** DIEGO MARTÍNEZ

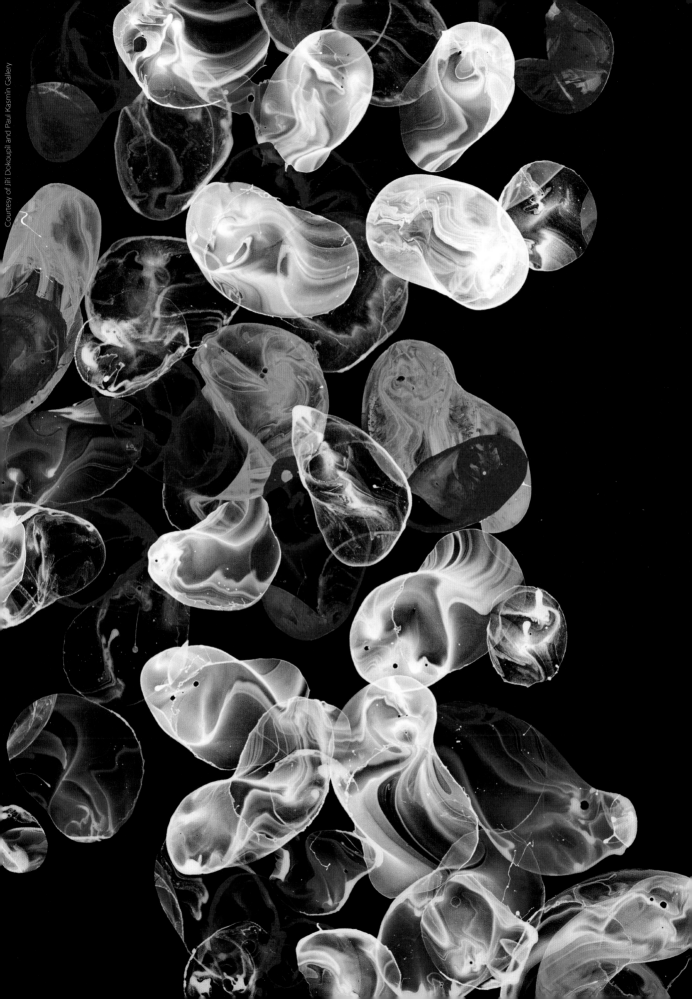

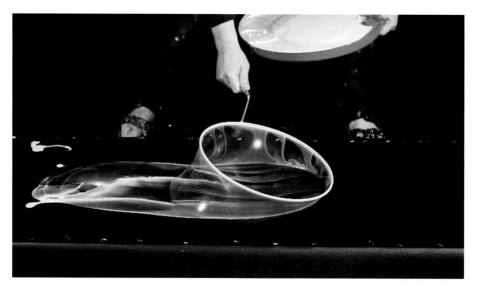

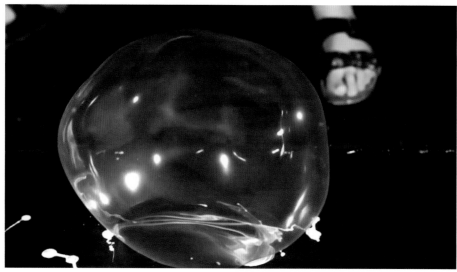

Above
THE ARTIST HAS PRODUCED ABOUT 400
SOAP-BUBBLE PAINTINGS TO DATE.

Previous spread, right page
ONE OF DOKOUPIL'S MORE RECENT WORKS
INCLUDES *FANULIFA* (2014), MADE WITH SOAP
LYE AND PIGMENTS ON CANVAS.

Jiří Georg Dokoupil was 14 in 1968, the year in which he and his family fled Communist Czechoslovakia and settled in West Germany. After studying art in Cologne and New York, he rose to fame with Cologne's influential neo-expressionist Mülheimer Freiheit group in the 1980s. Since then he has produced dozens series of paintings, encompassing a huge variety of experimental techniques. Among his most successful works are his soap-bubble paintings, a constant in his oeuvre for over 20 years, which evolved after he added soap to the liquid he used to clean his brushes.

How do you go about painting with soap bubbles? JIŘÍ DOKOUPIL: I use a metal wand to produce the bubbles, which I then draw over the canvas. The soap mixture contains pigment, so when the bubbles burst, they leave colourful traces. You could say chemistry produces pictures.

You've been making these images for some time. How have they developed? In the very beginning, the concept of painting with soap bubbles completely fascinated me, because I was dealing with the idea of doing something with nothing. Over the years, the concept shifted to something I would call a real painting.

You started off as a conceptual artist, making installations and performance art, but since the 1980s you've devoted yourself to painting. What happened? In the 1970s everyone wanted to be a conceptual artist. But my teachers hated painting so much that I just *had* to become a painter. As a child I loved the

What was the initial inspiration for the soap-bubble paintings? In the late 1980s I became obsessed with the idea of impossible paintings. I'm interested in media that you cannot control — so there is always a fight for something that is not strictly possible.

How many of these works have you done? Three hundred ninety-eight and counting.

What do these works say about the role of the artist? I think they suggest the supremacy of technique. I am convinced that the brothers Jan and Hubert van Eyck were the best oil painters of all time. They invented the technique. To become an outstanding artist, you have to have your own technique, and this is mine.

Are the bubble paintings commenting on the state of the world in some way? I think they are. I think they might be the perfect symbol of the world today — but ultimately future generations will have to decide that.

What other painting techniques have you invented? I put paint on canvas using a whip or car tyres, and I also paint with candle soot. All in all, I've invented around 100 different techniques.

Your father was an inventor, too. Yes, a very successful one. He had his own mechanical-engineering company with 300 employees. My father always dreamed of inventing something like the yo-yo, which would cost very little to develop but which every child in the world would want to own. I am a lot like him in that respect. I

'I'm interested in media that you cannot control'

Impressionists, and I am still in love with Impressionism, so I became some sort of a conceptual impressionist. Producing a painting has to do with the artist's encounter with the material, and this usually refuses to subordinate itself to a concept.

You have said that your paintings reach more people than your conceptual art. Why is that? People go to museums and galleries for a form-colour experience. This remains the essence of art. The painting is an incredible invention. You have a wooden frame with some canvas, you put it on the wall and immediately people begin to look at it. It's great — and it gives you a kind of freedom.

dream of having a monopoly on something that everyone loves and wants to have.

Like the bubble paintings? Yes — I can say that I am the best soap-bubble painter in the world!

Does this series have a message? If so, what is it? We are all bubbles…

Will you continue to produce these images? Yes. I fact, I feel as if I am just beginning. I want to make bigger and better versions.

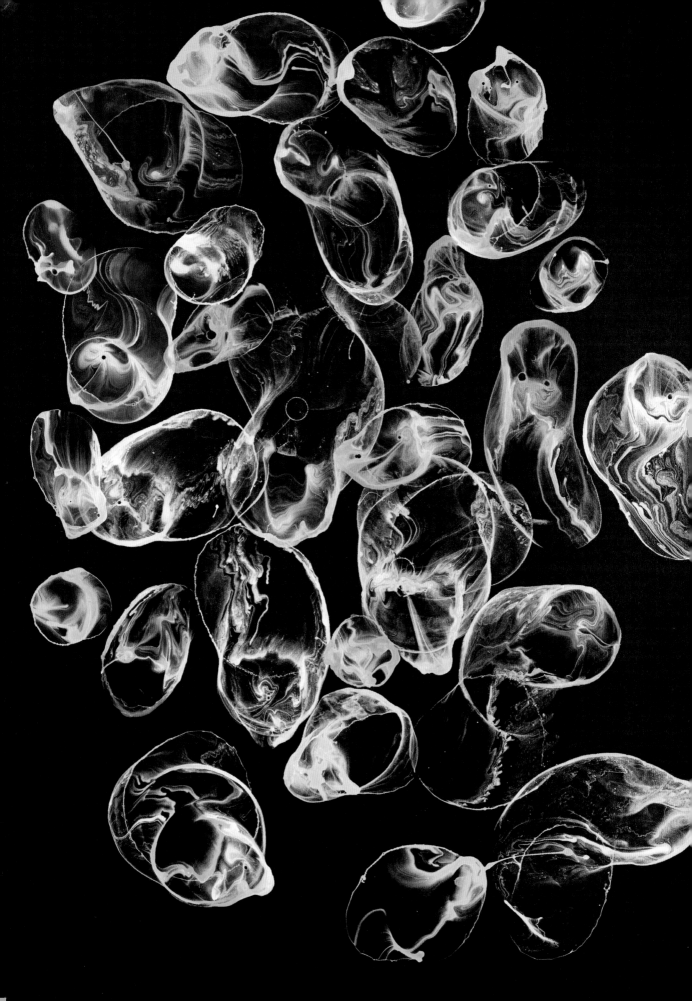

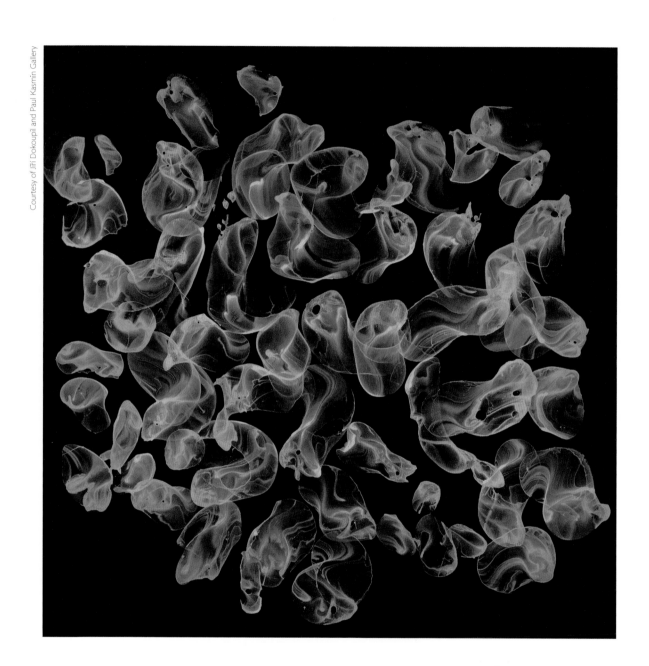

Above
UNTITLED (2014) WAS MADE WITH SOAP
LYE AND PIGMENTS ON CANVAS.
IT MEASURES 300 X 300 CM.

Opposite page
BUMBUMKOKILA (2014) COMBINES ACRYLIC
PAINT AND SOAP ON CANVAS.

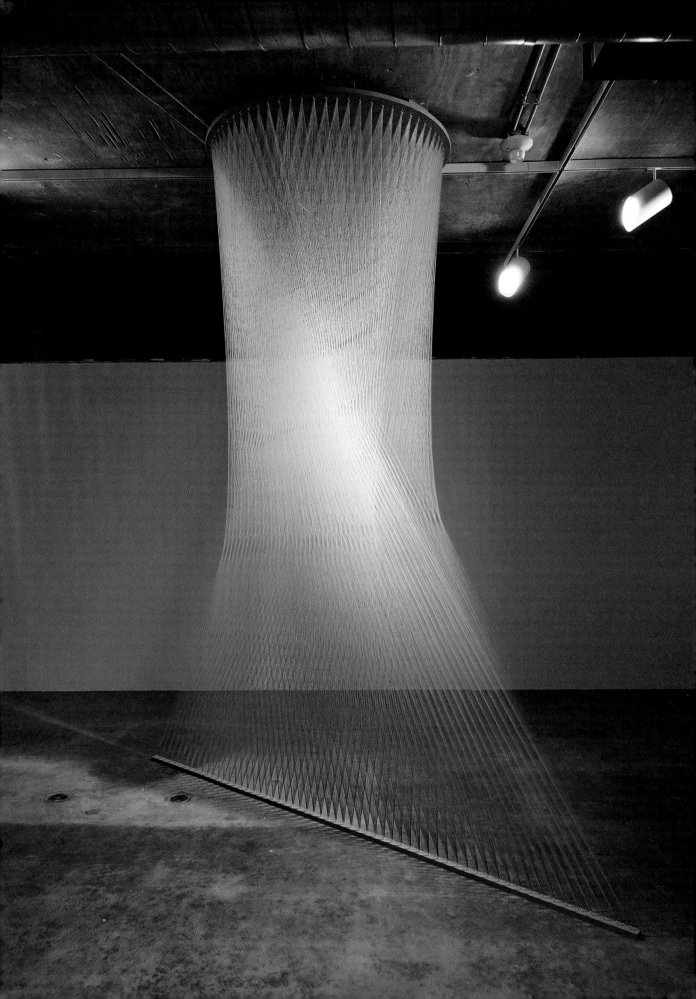

BY A THREAD

**Gabriel Dawe's installations
transform humble polyester thread
into an illusion of light.**

Words JANE SZITA **Portrait** GABRIEL DAWE

Born in Mexico City, Gabriel Dawe grew up surrounded by what he calls 'the intensity and colour of Mexican culture'. After seven years in Montreal, Canada, he studied art and technology at the University of Texas in Dallas. Dawe's large-scale installations are created using little more than thread and form environments that he says 'deal with notions of social constructions and their relation to evolutionary theory and the self-organizing force of nature'. His work has been exhibited in Texas, Missouri, New York, Canada and the UK.

What material do you use for these installations? GABRIEL DAWE: I use regular sewing thread, 100 per cent polyester. The cool thing is that because it's so thin, it basically disappears when used at an architectural scale, leaving only the colour behind. When seen from afar, it evokes the illusion of pure light.

How did you get interested in using it? Before doing the thread installations, I was working with textiles, using pieces of deconstructed clothing to make small-scale works. The opportunity to explore something bigger came when I was asked to collaborate with architect Gary Cunningham on an installation for Transitive Pairings, a group show that explored the overlap between fashion and architecture. I decided to make an architectural structure out of the core material of clothing.

What are the advantages – and disadvantages – of the material? Thread is normally used to sew pieces of fabric together with minute stitches; it's also used in long strands, which crisscross to make the fabric itself. But by stringing it between two points and spanning a long distance within a space, I push the limits of what it normally does. Used in this way, thread offers a new avenue of exploration that is not only visual but also conceptual. The drawback is the delicacy of the material.

How many installations of this type have you done? A few dozen.

Aren't you reaching the limits of this material? So far, every installation has shown me something new, and the work has been evolving. As long as the work keeps surprising me, I will keep doing it.

What are these works about? On the surface, they are visually intriguing and beautiful. Further, both clothing and architecture provide the physical body with protection from the elements. By taking the core material of clothing, which is thread, and using it on an architectural scale, I reverse the proportions in which it is normally used. The result is a sort of alchemical process in which the sheltering qualities transform from the physical level to a higher level, where the installation has a soothing effect on the viewer.

How long does it take to make an installation? Planning can take anywhere from a few hours to a few weeks. The actual execution can take from a few days to several weeks. Up to now, the longest it's taken has been three weeks.

How do you make them? I developed a tool with a painting extension pole that is something like a giant needle. With it, I am able to reach long distances, threading between anchor points, one strand of thread at a time, in a systematic way. It's a very Zen process.

How do you choose the colours? Because the thread tends to disappear, leaving a fog of colour that looks like rays of light, these installations are an attempt to materialize light itself, which is why I use the shades of the colour spectrum.

How do people react to your work? People react with a sense of wonder and often tell me how soothing and calming it is. I'm happy that my work brings a bit of much-needed joy into the world.

gabrieldawe.com

Oppostie page
PLEXUS A1 (2015) AT THE RENWICK GALLERY OF THE SMITHSONIAN AMERICAN ART MUSEUM, WASHINGTON, DC, USA.

Previous spread, left page
PLEXUS 24 (2013) AT THE CONTEMPORARY ART MUSEUM, HOUSTON, TEXAS, USA.

Following spread
PLEXUS 19 (2012) AT THE VILLA OLMO, COMO, ITALY, FOR MINIARTEXTIL.

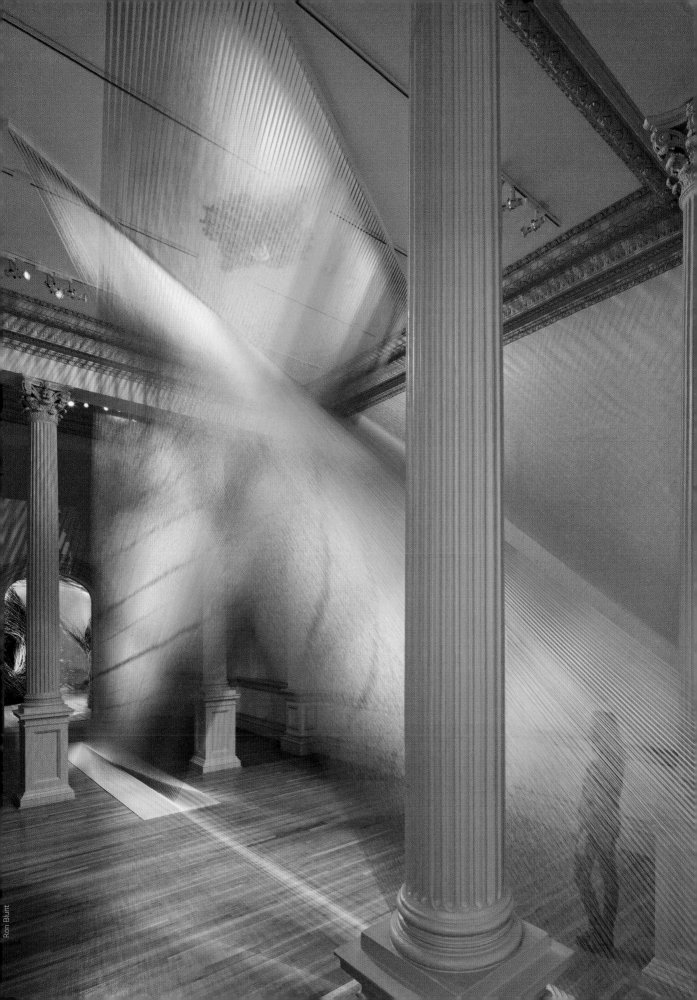

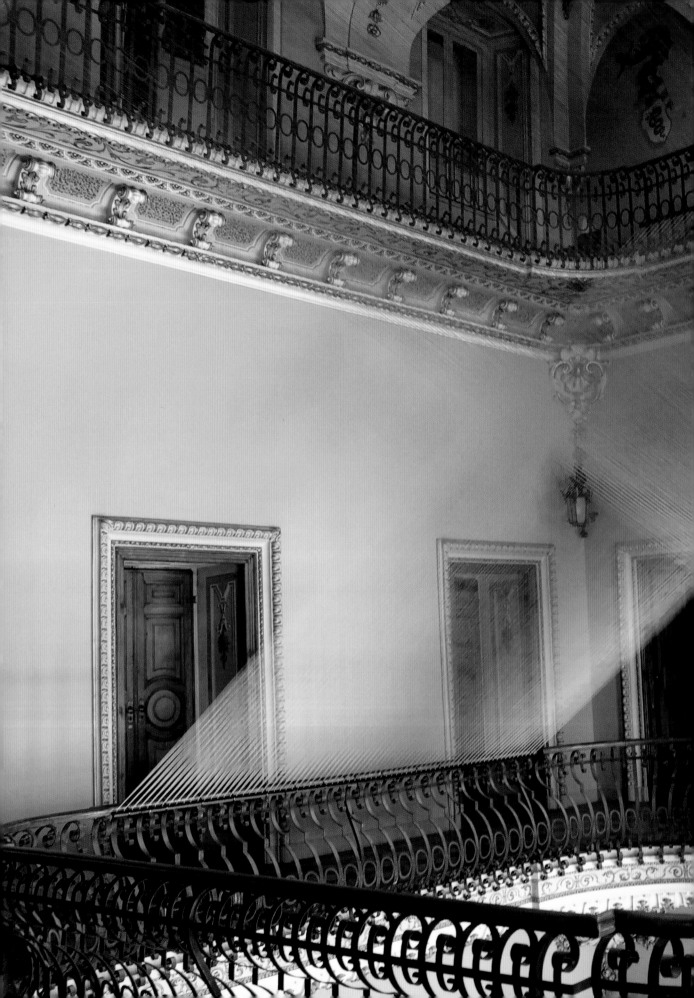

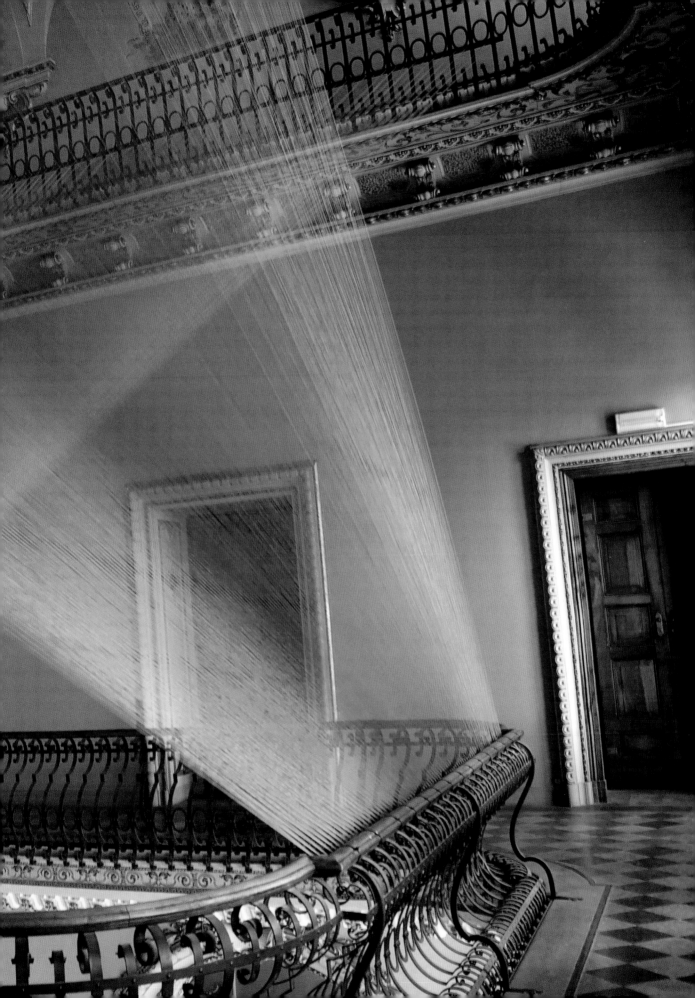

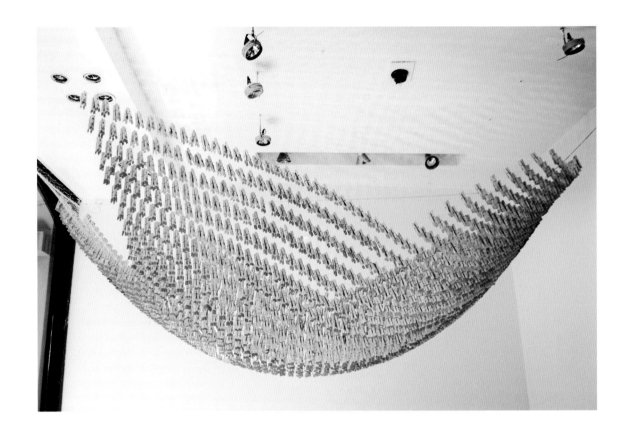

A TENDER TOUCH

Created from nothing other than wooden clothes pegs, Martin Huberman's fluid structures sweep gracefully through interiors.

Words TRACEY INGRAM **Portrait** CRISTOBAL PALMA

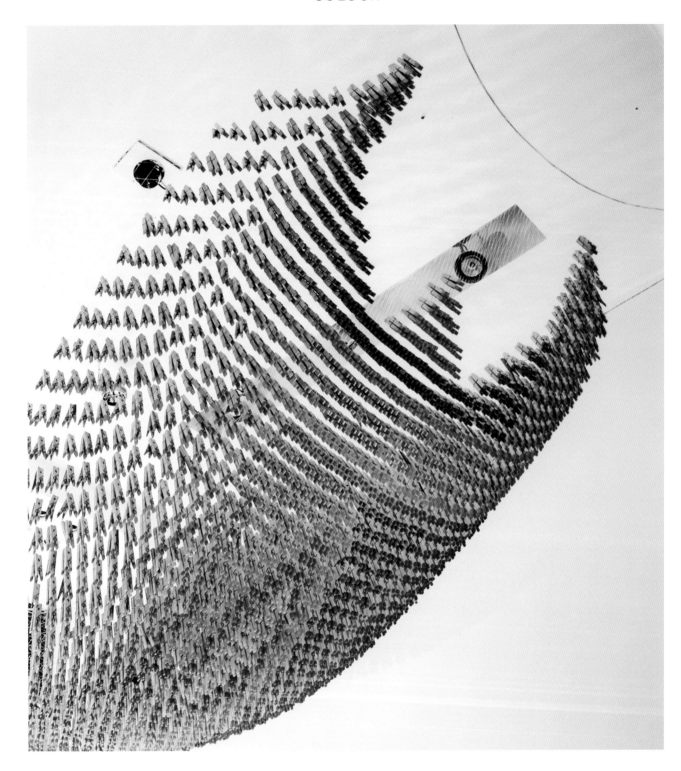

Above and previous spread, left page
LOVE ME TENDER 1 (2009). A SERIES OF THREE
INSTALLATIONS FOR TRAMANDO, A FASHION
LABEL BY MARTIN CHURBA. THIS FULL-COLOUR
ONE IS IN THE WINDOW DISPLAY OF THE
TRAMANDO STORE CASA MATRIZ IN BUENOS
AIRES, ARGENTINA.

Previous spread, right page
LOVE ME TENDER 2 (2009).

At what moment did you see artistic potential in the humble clothes peg? MARTIN HUBERMAN: A friend of mine, who was doing a gallery presentation, invited several creative friends to work on pieces for the event. Although I had no restrictions, I also had no budget. Eager to work with repetition, I remembered a student project in which I'd used clothes pegs. It was a very different piece, but it taught me that pegs are self-supporting, have a distinctive structure and are cheap to work with. The gallery project — Tender — evolved from there. Here in Argentina, tender means 'clothesline', and the word has become a common thread in my work. I was inspired by the tenders in historical neighbourhoods, such as those in Barcelona, where clothes-filled lines can be seen as colourful urban landscapes.

Is that why you introduced colour? Tramando, a local haute couture brand, asked me to come up with something for its stores, but it had to be different. Opting to

We control the rope tension by hand, and the amount of sagging depends on the length of the ropes: some installations are over 6 m long, but each one is experimental. We were working on one installation when it dropped completely. When that happened, we saw how the installation would look vertically — something we hadn't considered earlier. We stopped to document the 'happy accident' before continuing with our initial design. But it's moments like this that can suggest new approaches to the work.

What other surprises have you had? The whole project has been one surprise after another. While building the Tender on my terrace, I saw it at sunset and at sunrise: the difference was amazing. The shadows it generated offered so much potential. Some of the Tenders can be touched. Everyone thinks they are just pieces of untouchable art, but I see them as pieces of accessible design. I encourage people to run their hands along the

'Pegs are self-supporting, have a distinctive structure and are cheap to work with'

work with colour, I designed a system featuring pegs dipped into paint and left to drip-dry. The idea enhances my concept, as the thick paint I use leaves visible drips. A different set of rules emerges for each installation, and colour creates compositions within installations; the fishing net that supports the pegs is a blank canvas.

Is the final result predetermined or process-driven? We take a few days to install the pieces, continually stepping back and checking our progress. I call them 'site-specific installations', because I don't know exactly what will happen when we hang the net. Three things are vital to the installation as a whole: the shape of the space, the length of the net and the weight of the clothes pegs. I've started experimenting with different shapes. If I add a rope in the middle, I can split the 'belly' of the shape in two. Instead of accepting this belly as the final shape, we can grab certain points to create topographic landscapes. From one angle the Tender can look like a heart, for example, and from another something completely different.

Since your Tenders are formed by the weight of the pegs, do they sag over time and change shape? I have a trial Tender on my terrace, and initially I used a stool to attach the pegs. Now I can touch them with my head.

undulating surface — often a peg will fall. When that happens, I ask them to take it along, as a keepsake. I've also started laying T-shirts and canvases under the pegs while they drip-dry; the resultant paintings are a commemoration of the process.

There's also the occasional problem caused by a client who doesn't buy the finished work, leaving me with some 20,000 pegs. That's how the lamp came about, which I think is a great piece of design — and an object that can be compressed like an accordion to around 25 per cent of its original size. When you work with a single material, you get to know it inside out.

normal.com.ar

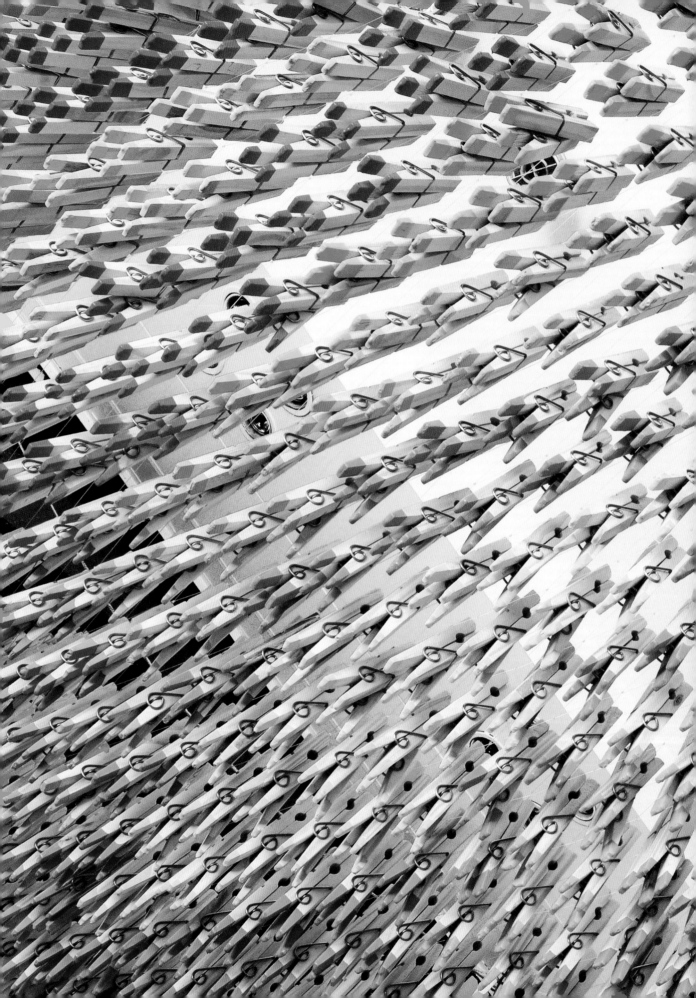

LI
GH
T

The contrast between light and dark is one
of the most basic concepts of human perception,
and artists employ it in various ways.
Clint Baclawski, Carlos Cruz-Diez and Liz West
use artificial light sources such as LEDs and
fluorescent lamps, while Dan Graham and
Jeppe Hein play with daylight using mirrored
glass. Germaine Kruip, on the other hand,
focusses on shadow. An unassuming ingredient
of daily life, light nevertheless intrigues
and captivates.

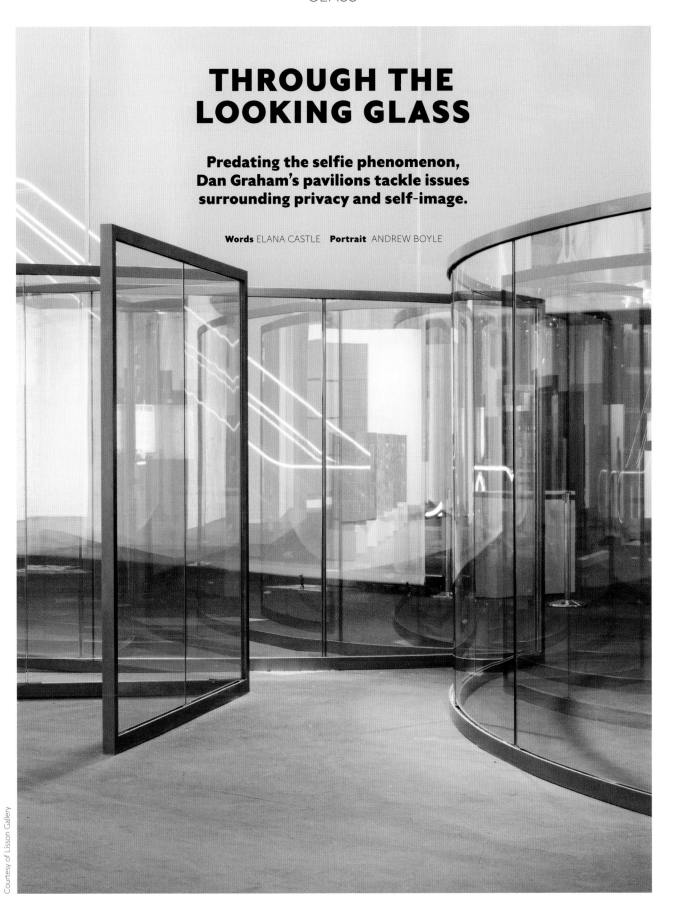

THROUGH THE LOOKING GLASS

Predating the selfie phenomenon, Dan Graham's pavilions tackle issues surrounding privacy and self-image.

Words ELANA CASTLE **Portrait** ANDREW BOYLE

Widely considered one of New York's most influential and versatile artists, Dan Graham is best known for his steel-and-glass pavilions. Often produced at human scale — and positioned somewhere between the genres of sculpture and architecture — his structures bear a sparseness reminiscent of the work of minimalist artists Sol LeWitt and Donald Judd, with whom Graham associated in the 1960s. Graham's art deconstructs and highlights the relationship between 'architectural' environments and those who inhabit them.

One of your first projects — *Homes for America* (1966-1967), a series of photographs illustrating suburban development in New Jersey — was accompanied by a commentary on the 'obsolescence of architecture and craftsmanship in America'. Did this investigation prompt your lifelong interest in architecture? DAN GRAHAM: My attraction to archi-

sion ... Yes. You know, I hated my junior high school — this idea of people staring at other people, who in turn stare at them. I read Jean-Paul Sartre's Being and Nothingness and became interested in the idea of gazing. Rather than serving as minimalist art sculptures, my pavilions derive their meaning from the people who look at their reflections and at others — and who are being looked at themselves.

You've also cited Renaissance, rococo and Chinese-garden pavilion forms. How does landscape inform your projects? I'm very landscape-oriented. I like the hedge outside the Barcelona Pavilion, for example. Hedges are important because they designate the edges of the city, whereas two-way mirror designates the business centre of the city. I bring these two things together. My installation for the roof garden of The Metropolitan Museum of Art [*Hedge Two-Way Mirror*

'Museums are good vehicles for reflecting the decade'

tecture came about because of the artists I was talking to at the time: people such as Sol LeWitt, who studied architecture and worked for I.M. Pei, as well as Donald Judd, whose 'Kansas City Report' was published in *Arts Magazine*. The essay was a commentary on urban planning — the idea of combining highway culture with a new classical city plan and minimalist forms. *Homes for America* was about the city plan and was my way of dealing with minimal art, which I disliked.

Your minimalist pavilions are often described as a commentary on the proliferation of the cold corporate skyscrapers of the 1970s and '80s. How so? One-way mirror was first used by corporates on big office buildings to cut down on air-conditioning costs. It worked only in Los Angeles, where there's a hot climate. But the material's use is actually an alibi for the corporates, because it reflects the surface of their massive buildings in the landscape. There are links to surveillance as well, because you can see outside from within without being seen. I was less interested in modernist architecture than in the modern office building — and in the idea of seeing the people inside physically working.

And this developed into a phenomenological study of consciousness and experience, and eventually into your use of pavilions as instruments of expres-

Walkabout (2014)] was the result of collaborating with landscape architect Günther Vogt. I noticed the straggly treetops visible from the roof garden and decided to base the form on the idea of a hedge — a baroque setting for people to explore in a fun way. We used Astroturf and two-way mirrors to create a provocative experience.

Your pavilions have appeared in various contexts. Where do you prefer to exhibit your work? I try to involve lawns and gardens in my work, and I prefer sites that can be seen from the city. I like to do installations near corporate office buildings, in settings where people have lunch and relax. Instead of being objective, my work becomes subjective.

In my opinion, my most successful pieces are larger exhibits at a human scale. *Waterloo Sunset* (2003), a collaboration with the Hayward Gallery in London, was loved by the locals.

Waterloo Sunset formed part of a scheme to improve the Hayward Gallery's foyer and facilities, but you also referred to it as a 'funhouse'. Why? Museums are good vehicles for reflecting the decade and the way they're used by the public at any given time. I like to work in the lobby, which is a romantic meeting place and has social structures like bookshops, restrooms and elevators. *Waterloo Sunset* incorporated a freestand-

ing glass-and-metal screen that had monitors displaying cartoons, artists' videos and information about the museum.

I also like to look at the changing role of the museum. I see it as a place in flux. In the '80s, for example, the French socialist government wanted to regionalize art. Bordering Paris, Parc de la Villette is on the edge of suburbia and the city. The intent was to combine entertainment and education in a park that could be seen from the highway. It's similar to *The Children's Pavilion* [an unrealized 1988-1989 project designed with Jeff Wall that proposed a cave inside an artificial hill], which was supposed to be like the world's fair.

Your portfolio also contains other art forms, like rock music and television. What are you exploring currently? I will be exhibiting in London at Lisson Gallery later this year. The show includes a stage set. I don't want to do only pavilions. I'd like to be working more in fashion. I was doing something for Christian Dior menswear: a staircase for the brand's showroom. I read a lot of rare architecture books. I often don't understand the architects' diagrams, but they inspire my work. I steal from architecture titles, and I heard that Herzog and de Meuron have books on my work, too. I also like to work within the many genres depicted in *Frame*.

lissongallery.com

Previous spread, right page
TWO V'S ENTRANCE-WAY, WHICH APPEARED AT THE 2016 EDITION OF ART BASEL, SERVED AS A PASSAGEWAY TO THE FAIR'S UNLIMITED SECTION; IT WAS A PORTAL THAT ALLOWED VISITORS TO ENCOUNTER THEMSELVES.

Following spread
SHOWING OFF *THE BODY* (2016) WAS EXHIBITED AS PART OF THE RUNWAY FOR CÉLINE'S S/S 2017 PRESENTATION AT TENNIS CLUB DE PARIS.

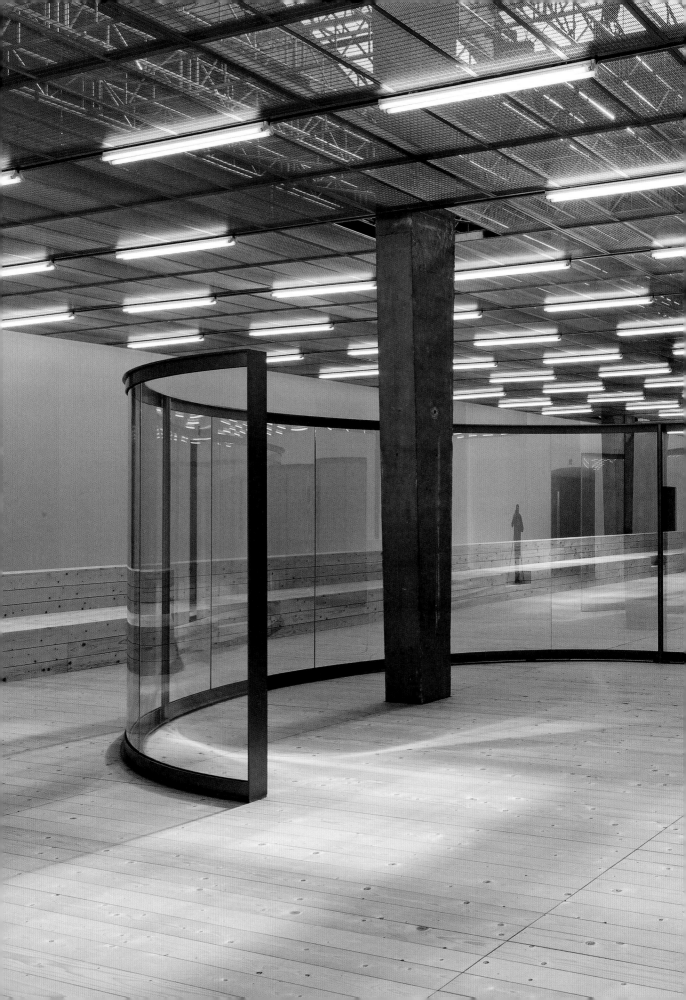

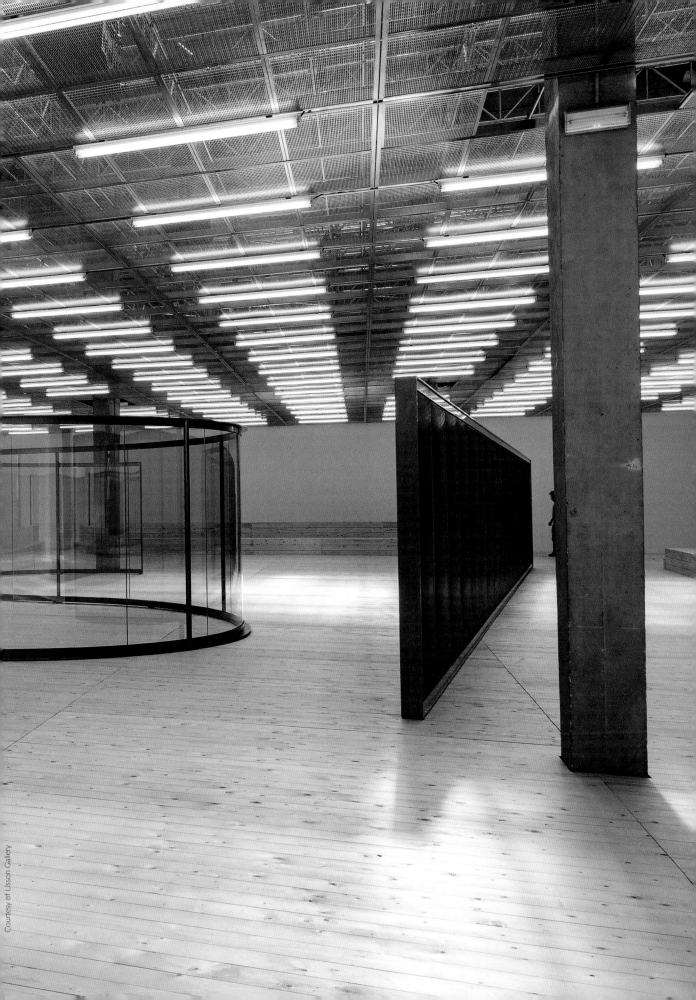

I SPY

Fixating on reflective materials, artist Jeppe Hein prompts his audience to observe — and to be observed.

Words JANE SZITA **Portrait** DANIEL HOFER

With titles like *Please Touch the Art* and a deceptively minimalist approach combined with sly humour, the installations of Jeppe Hein challenge the traditionally passive role of the observer. Reflective surfaces — including mirrored glass and foil, two-way mirrors and highly polished stainless steel — often play a central part in drawing the audience into his worlds and melting the boundaries between viewer, work and context. Born in Copenhagen, Hein studied art at the Royal Danish Academy of Arts and in Frankfurt. He currently lives in Berlin.

When did you start using mirrors in your work, and why? JEPPE HEIN: I created my first pieces with mirror surfaces, *Small Mirror Ball* and *Big Mirror Ball*, in 2002. I realized that a polished chrome surface is alluring and entices visitors to move closer to the object — to observe themselves and the surrounding space.

What appeals to you most about reflective materials? Mirrors make us contemplate our own presence by addressing our physical and mental experience of an environment and our position within it. Mirrors make us aware of the act of looking: we are watching ourselves watching. That's why my mirror installations always refer to the presence of the visitor, who in fact becomes essential to the work. My works ask the audience: why

You prefer public spaces to galleries. Why? One reason is the greater variety of people and behaviours in the audience. Another is because public spaces make it easier for them to lose their timidity and respect for art and to approach the piece. In museums, the relationship between viewer and art is already defined to a large degree.

What do you hope to achieve with your mirror pieces? Ideally, my works of art are intended to bring people together, providing them with an opportunity for mutual exchange. Whether you're a child or an art critic, you're encouraged to interact with the work, the environment and other people, which I hope strengthens your sense of community.

How would you like people to react to your works? Rather than passive perception or theoretical reflection, the visitor's direct physical experiences are important to me. Viewer participation is essential in my works. I want to invite people to take an active role. That's why it's always interesting to see people use them in unexpected ways. I don't want to prescribe the concept of use.

Which artists have influenced you? Dan Graham, Robert Morris, Robert Smithson, Larry Bell, Olafur Eli-

'Mirrors make us contemplate our own presence'

are you here? What are you doing here? How do you observe, and how are you observed?

Tell us about your installation Path of Silence in Norway. It's defined by an extensive mirror labyrinth that encloses three 'spaces of silence'. There's a contemplative space with Norwegian stones, where tall mirror steles prompt you to gaze up at the sky; a natural space, where a tree surrounded by a wooden bench within the sculpture links inside with outside; and an active space, where walls of water appear and disappear. Walking through these zones is like walking through the Norwegian landscape. Through three dimensions of silence — and moments of contemplation, concentration, seclusion and dialogue between oneself, others and nature — visitors can experience the site as a source of inner stillness.

asson and Asger Jorn, because of how they work with communication and experience. Their works are always physically present and perceptible. People don't just *look* at them; they also *feel* them.

jeppehein.net

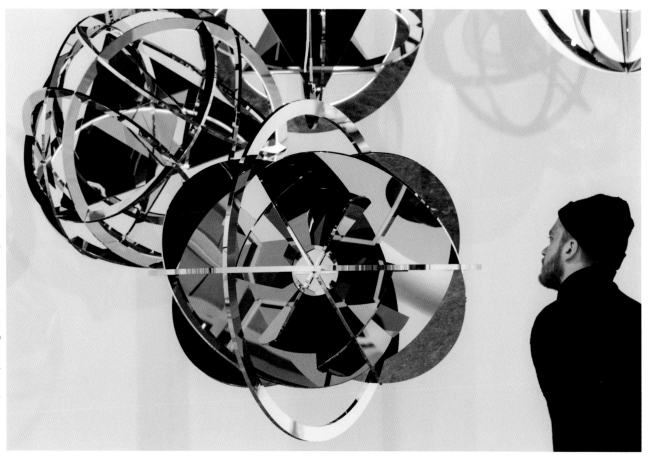

Above

SEVEN OBJECTS MADE WITH HIGHLY POLISHED
STAINLESS STEEL, *CHAKRA ENLIGHTENMENT*
(2015) IS HEIN'S INTERPRETATION OF THE BODY'S
SEVEN MAJOR ENERGY CENTRES. THE ARTIST
BELIEVES THE WORKS COME TO LIFE THROUGH
'THE FEELINGS AND ENERGIES PEOPLE CONNECT
AND ATTACH TO THEM'.

Following spread

EXHIBITED AT BROOKLYN BRIDGE PARK IN 2015,
MIRROR LABYRINTH NY IS AN UNDULATING
MAZE OF MIRRORED LAMELLAE THAT REFERS
TO THE MANHATTAN SKYLINE OPPOSITE.

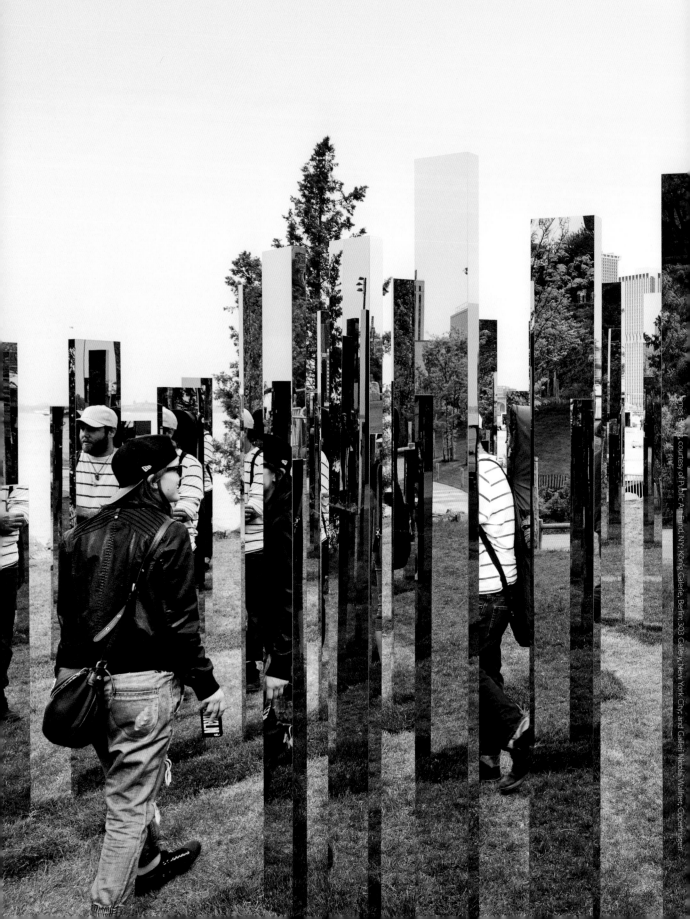

Jeppe Hein, courtesy of Public Art Fund, NY; König Galerie, Berlin; 303 Gallery, New York City; and Galleri Nicolai Wallner, Copenhagen

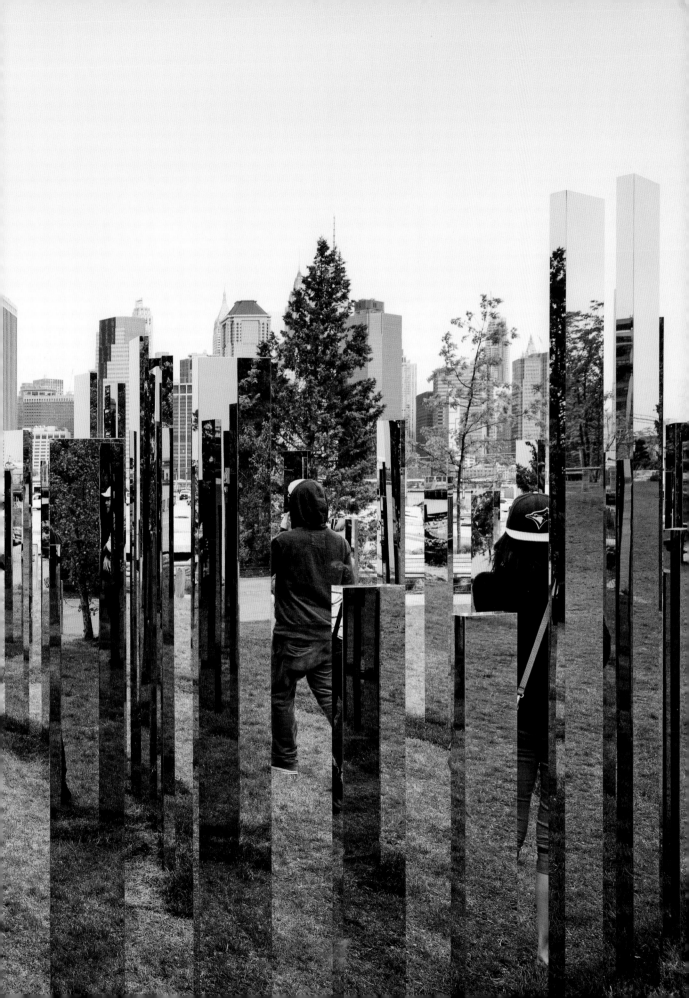

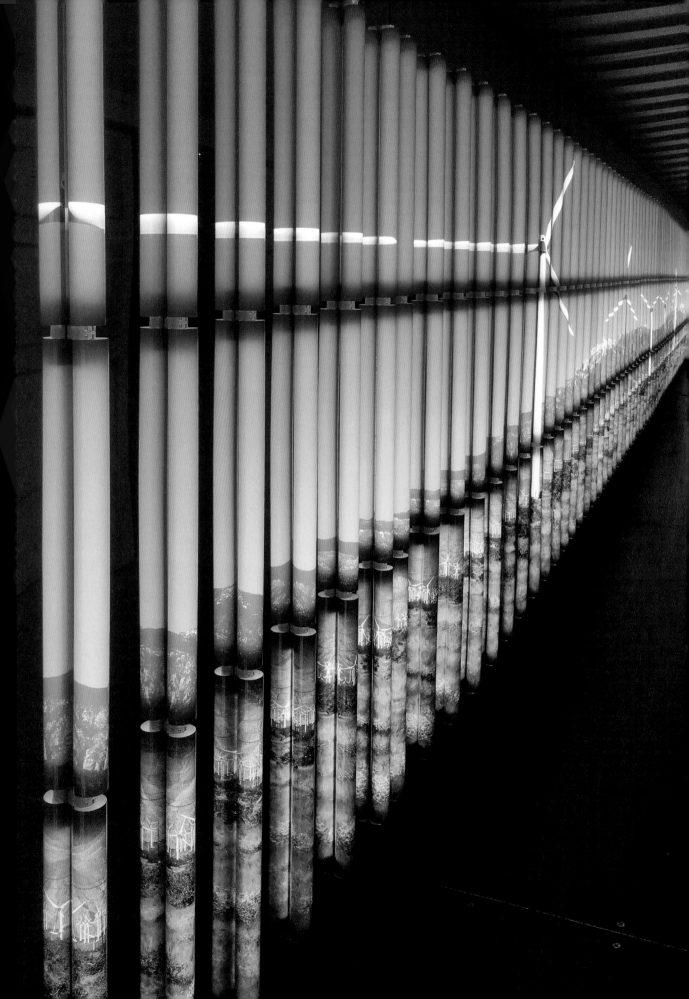

SIGN LIGHTER

**Clint Baclawski transforms photographic
images into 3D light installations,
morphing the commercial billboard into
an object of contemplation.**

Words JANE SZITA **Portrait** TONY LUONG

After some early adventures in advertising, Clint Baclawski embarked on a career in art. To his new field he brought a love of the backlit billboard image, adapting the advertising mainstay to create his distinctive installations. Taking large-format photos — images purged of ad-world glamour and glitz — he slices them into strips. Wrapped around LED bulbs contained in plastic tubes, then mounted in sequence on mirror Plexiglas, they become three-dimensional and dynamic, glowing landscapes that change as the viewer moves around them. His latest installation, *Zephyr*, features a brilliant panorama of wind turbines that seem to stretch into infinity. A native of Williamsport, Pennsylvania, Baclawski studied at Rochester Institute of Technology and Massachusetts College of Art and Design. He now lives and works in Boston.

From advertising photographer to artist — how did that happen? CLINT BACLAWSKI: Actually, becoming an advertising photographer was never my ambition. I was studying technical photography at Rochester Institute of Technology, and I opted for advertising photography, as it offered the best technical experience in large-format film, strobe lighting, still-life methods and

ing large-scale light boxes to display my photos, and I learned to wire them myself. One day I was working on a box when one of my prints fell onto a tube light and sort of draped over it, and that's how I got the idea for my tube installations.

How do you put your tube installations together? I start out with a photo I've taken. I get the image printed on inkjet backlit film and figure out how to slice it up. Then I wrap each image segment around an LED bulb and place it in a plastic tube — of a standard design, cut to size. Finally, I mount the tubes onto mirror Plexiglas. I collaborate a lot with others during this process — on the fabrication or electronics, for example. I can't do it all alone, even though I have a finger in all the processes.

What inspires the images in your pieces? I don't chase after specific images. I prefer to notice things in the moment, whether I'm driving home from work or travelling abroad. I like to visit national parks, photographing an abandoned camper for *Death Valley*, a church in an Indian village in the Grand Canyon for *Pink Church*, and so forth. I guess I'm looking for a different view. I gravitate towards images of nature, or images of

'I'm happy that I can embrace technology while still preserving craft'

so on. During my senior year, we visited New York City to meet with some of the top ad agencies. That trip already convinced me that advertising wasn't my scene, but after graduating I moved out to Oregon where, in between capturing action shots for several snowboard camps, I had the chance to do some advertising work. I did a shoot for a sunglasses company and was paid in sunglasses, which kind of confirmed that advertising wasn't for me.

What was the most important thing you took from the ad world? That it's all about getting the one shot. Once you get it, don't waste any more time shooting. In fact, I typically capture only one image when I take photos. I either nail it, or I don't.

Plus the billboard aesthetic, of course. That started at RIT, where we did a critique of each other's work every week by looking at prints on light tables. I always found them completely mesmerizing. Later, as a grad student at Massachusetts College of Art and Design, I began mak-

places that people inhabit but are free of advertising. If I have a 'dream image', it's one that requires very little touch-up work.

You shoot on an analogue camera. Why not digital? I love the graininess you get with film — that's what makes it so beautiful. And on a purely practical level, film gives me the freedom to enlarge my images beyond the dimensions a normal digital camera would allow. I like the fact that my work begins as an analogue process during image capture and then morphs into a digital output. I'm happy that I can embrace technology, and all its possibilities, while still preserving craft. I've shot with the same camera and the same lens for the last ten years. It's a Horseman 4×5 field camera with a standard 150-mm lens. I love the quality of film negatives, but I could see myself giving it up for a Hasselblad H5D.

Is it becoming harder to find places to develop film now? This is such a timely question, as the place I've used for the last 12 years just closed down. Although I don't

have another lab lined up, I hope to find one through my creative network.

Is the process costly? Yes. Producing my work, particularly as the scale has increased, definitely comes at a price. I often have to sell another piece of work to finance the next idea, but I've always been able to produce my vision and pay for it.

Which artists have influenced you? California's Light and Space movement is a big influence, especially Robert Irwin and James Turrell — I'm really fascinated by them. You can get lost in their work; you forget where you are. It's the installation aspect that I love. While I think my work nods to that of those artists, it takes a new and unexpected direction through the wrapping and slicing of images. Also, LEDs last longer, much longer than fluorescent bulbs. The kind of print I use is said to have a longevity of 100 years, whereas the average billboard is used for only two or three months.

How do people react to your work? It doesn't sound modest to say so, but people are generally pretty blown away. I love seeing people interact with my installations. The image comes together, then dissipates, and the eye reconstructs it in front of you. For this reason, video does my work more justice than photos.

What's the biggest challenge you face in your work? Balancing a teaching job, my art career, and being a par-ent. I've learned to be very disciplined with my time. I block out nights on my calendar for doing studio work and attending art openings.

How long does it take to make a piece? From conception to completion, anywhere from months to years. *Zephyr* took nearly four months from start to finish.

Is there a size limit for your installations? My biggest piece so far is 8 × 30 feet [approximately 2.4 × 9 m]. It occupied a narrow hallway. But I have a proposal out now for a larger piece of 10 × 40 feet [3 × 12 m] that would be permanent. The biggest tubes I use are 8 feet tall, but there's no reason you couldn't stack them on top of one other. The only limit is how small they can go, because the bulbs are never shorter than 6 inches [about 15 cm].

What would you like to work on next? There are a number of directions to develop. For example, in many pieces, like *Lush*, I use the bulbs horizontally or the image runs horizontally across a space. I'd like to create a piece where the image runs vertically up a wall, so you'd view it from the ground looking up. The tube still seems to offer infinite possibilities. It's a process of discovery.

clintbaclawski.com

Previous spread, left page
SHOWN WITHIN A SHIPPING CONTAINER IN CENTRAL BOSTON, *ZEPHYR* (2017) FEATURES A PANORAMA OF WIND TURBINES.

Following spread
BACLAWSKI CAPTURES THINGS HE NOTICES 'IN THE MOMENT'. AN ABANDONED CAMPER HE ENCOUNTERED WHILE VISITING A NATIONAL PARK BECAME THE SUBJECT OF *DEATH VALLEY* (2015).

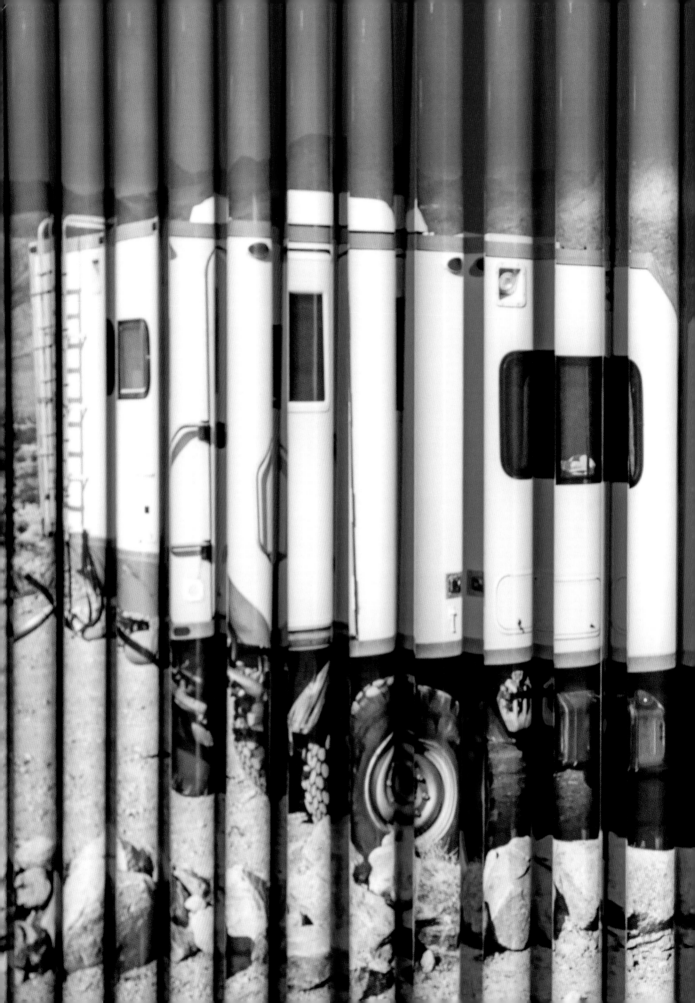

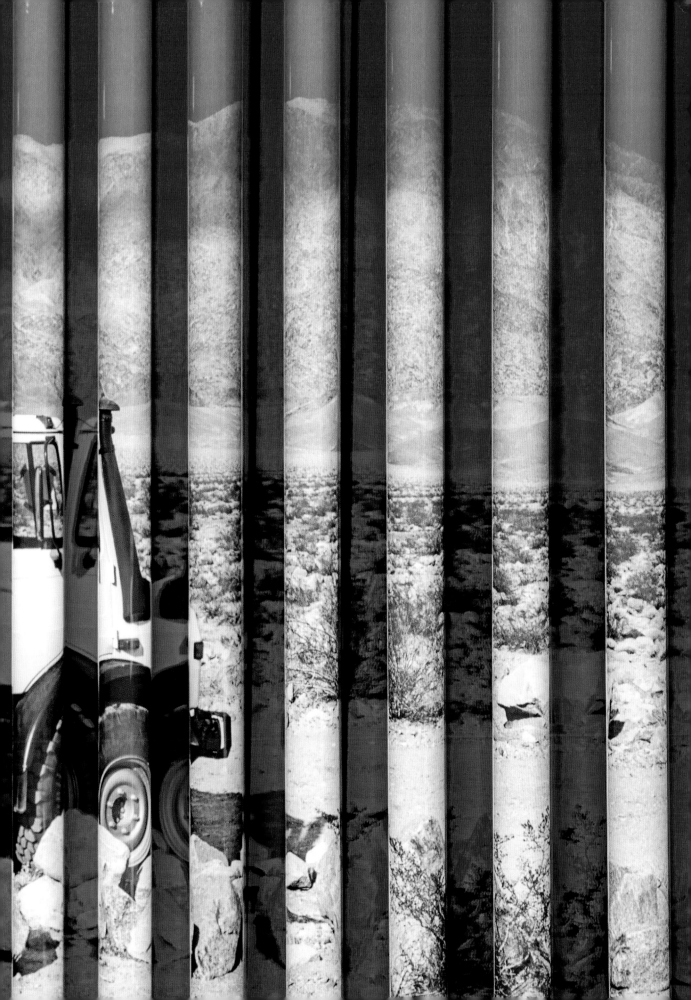

DO YOU SEE
WHAT I SEE?

**At the age of 94, Carlos Cruz-Diez is
still using the ephemeral nature of light
to transform colour into an event.**

Words ANNA SANSOM **Portrait** VALENTIN FOUGERAY

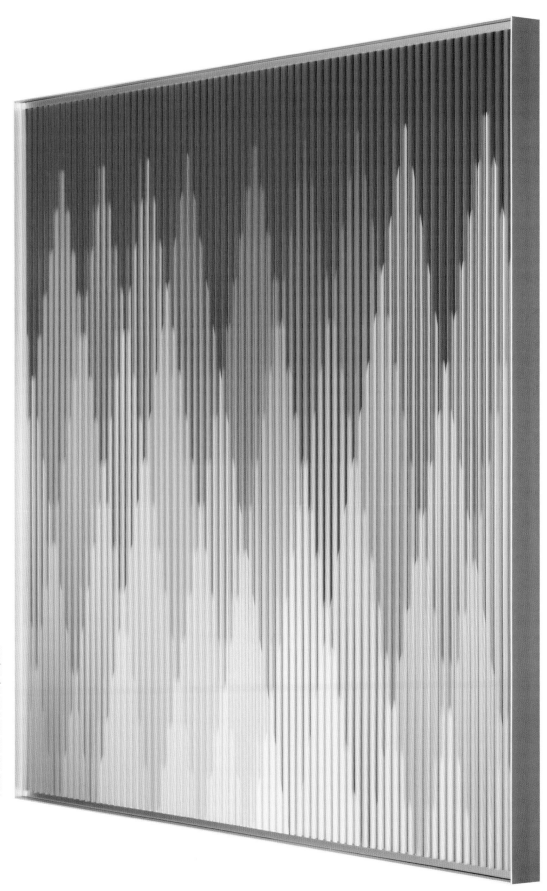

Carlos Cruz-Diez is often associated with the kinetic-art movement, owing to the sense of motion in his installations and intriguing *Physichromies*. Yet this classification belies the 94-year-old artist's singular objective: to transform our experience of colour into a participative event that is dependent on changing light. Born in Venezuela and now living in Paris, he expresses this philosophy — which has underscored his work since the 1960s — through *Chromosaturation*, a series of spatial installations bathed in colour. The artist's children established the Cruz-Diez Art Foundation (hosted by the Museum of Fine Arts, Houston) and the city of Caracas in Venezuela named a museum after him: Museo de la Estampa y del Diseño Carlos Cruz-Diez.

Your *Chromosaturation* installations are about bringing art into the public space and exploring the phenomenon of colour through light. What inspired you? CARLOS CRUZ-DIEZ: The Bauhaus talked about the integration of art into everyday life — and especially in architecture — but nobody had gone through with it until architect Carlos Raúl Villanueva designed the Ciudad Universitaria in Caracas [the main campus of the Central University of Venezuela, built between 1940 and 1960]. This inspired me, because I believe that art is about social engagement — that artists work for people.

Everywhere, art was exhausted; everybody was doing the same painting, whether it be abstract, philosophical or lyrical. When I came to Paris in 1955 to see the Salon de Mai exhibition at the Musée d'Art Moderne, I thought it could have been a solo show because the paintings all looked alike.

I realized that I needed to find new ways to integrate elements into my work — ideas outside the domain of painting — and I focused on colour, because it was

The first time you presented a *Chromosaturation* was in Grenoble in 1968, followed closely by the Odéon crossroads in Paris. How has the public's response to your work changed? Because people didn't encounter any drawings or objects in Grenoble, only a coloured empty space, they thought there was nothing to see. Then the City of Paris invited me to exhibit a *Chromosaturation* wherever I wanted. I chose the Odéon crossroads because people from diverse social backgrounds circulated there. But visitors who took part in a survey said it was a bourgeois experience and an elitist manipulation of the environment.

I've made 134 *Chromosaturations* so far. Today, people understand that something is happening — a discourse that reveals a space materialized by colour — and they stay to discover the piece. They realize that it's a participative event rather than something more contemplative, like a painting.

How do you approach the site-specificity of a *Chromosaturation*? Every solution is different, because every location is unpredictable. First, I study the space to see what colouration it already possesses. The answer lies in creating a harmonious relationship between the integrated work of art and its context and in having it be coherent with the whole environment. All my works change in relation to the light and the time of day. I try to make the situation as legible as possible so that colour can be perceived in time and space.

How have technological developments changed your way of working? Initially, I tried using electric light bulbs. Later I switched to a type of lamp that offered more nuances. Today I use LEDs. I've always been attentive to everything that industry and technology can offer

'Visitors said it was a bourgeois experience and an elitist manipulation of the environment'

neglected by artists. It was considered anecdotal and decorative. I thought that working with colour could lead to meaningful experiences, like how an August sunset in Venezuela can turn everything orange for a few seconds. Colour is not something to be applied to a surface with a brush; it needs to be brought into the space. It took me many years of experience, research and failure to create works such as the *Chromosaturation* installations, which allow light to evolve like an event.

to allow me to express myself. The result, not the materials, is what catches my interest. When I started, everything was in my head. Only after weeks of work could I see whether the result was satisfying. Now, thanks to the computer, I can more or less see what the final result will be in advance.

What have you learned during your many decades of working with colour? Dealing with colour inevitably

leads to surprises because of the impact of light. Even if I can anticipate what will happen, I always discover new information. Take the *Physichromie* on the wall behind me, for instance. How you perceive its colours depends on your movements and the surrounding light — the way the light strikes the work alters everything. What you see from your position is different from what I perceive from mine. My challenge is to show you a reality that has no past or future — a piece that exists in a perpetual present. One of the fundamental conditions of art is to provoke astonishment. My works are about triggering something that's different from what you experience when viewing a traditional painting.

Which work makes you proudest? *Additive Color Environment* [1974] — in the main hall of Simón Bolívar International Airport in Maiquetía, Venezuela — has become a symbol of the Venezuelan diaspora. Every day thousands of people are photographed as they move along the colourful walkway or make selfies that include the architectural intervention. Young people dedicate letters and poems to the piece. It has become an extraordinary reference of identity. I observe with sorrow the young talents that leave the country and the photographs of their farewells — with my work as a backdrop — as witnessed by countless messages and photographs on social networks. I only hope that these images prompt a reunion in the near future, when they return to their beloved country.

What are your plans for the future? I have exhibitions coming up in Germany, Russia and France. As artist Marcel Duchamp said, 'What's most difficult for an artist is the first 75 years.' [Laughs.] During my career, I've contributed art to planes, boats — even a high-speed train. Now there's a much wider audience for my work than ever before.

cruz-diez.com

Previous spread, right page
PHYSICHROMIE 1983 (2015).

Following spread
PART OF *KINESTHESIA: LATIN AMERICAN KINETIC ART, 1954-1969*, A 2017 EXHIBITION AT PALM SPRINGS ART MUSEUM, *CHROMOSATURATION* (1965-2017) EXPLORES THE PHENOMENON OF COLOUR THROUGH LIGHT.

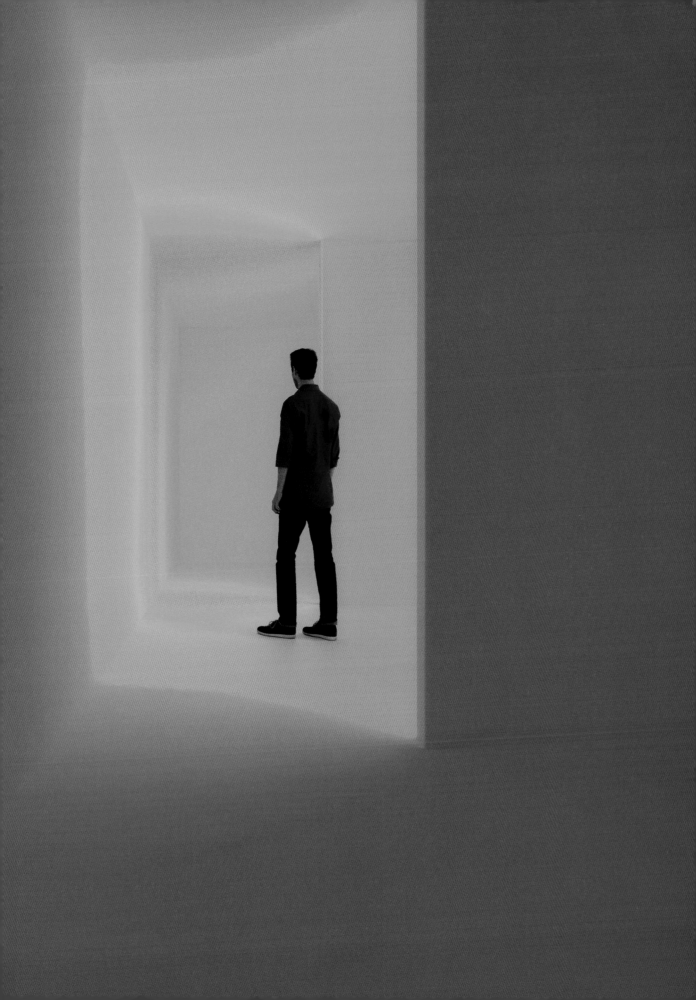

THE CHROMOPHILE

Ephemeral by nature, light is the material of choice for artist Liz West, who immerses her audience in intense colour.

Words JANE SZITA **Portraits** ANDREW MEREDITH

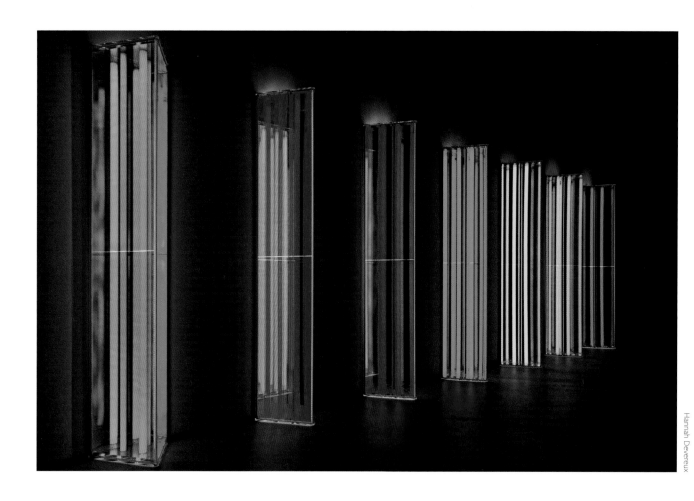

Hannah Devereux

Above

PART OF *COLOUR AND VISION: THROUGH THE EYES OF NATURE*, AN EXHIBITION AT THE NATURAL HISTORY MUSEUM IN LONDON, *OUR SPECTRAL VISION* (2016) IS A RAINBOW DISPLAY OF DICHROIC GLASS INSPIRED BY THE MUSEUM'S COLLECTION. IN THE WORDS OF THE ARTIST: 'IT CREATES COLOUR AS BUTTERFLY WINGS DO, BY REFLECTING LIGHT.'

Following spread

LIKE MOST OF LIZ WEST'S WORK, *OUR COLOUR REFLECTION* (2016) WAS A TEMPORARY SITE-SPECIFIC INSTALLATION THAT APPEARED ON THE FLOOR OF THE 20-21 VISUAL ARTS CENTRE, A FORMER CHURCH IN SCUNTHORPE, ENGLAND. HUNDREDS OF MIRRORS PROJECTED COLOURED CIRCLES OF LIGHT ONTO THE CEILING OF THE HISTORICAL INTERIOR.

Born in Manchester, Liz West grew up in Yorkshire and studied at the Glasgow School of Art, where she began working with coloured light in her final year. Ever since, she has been crafting luminous, immersive installations that explore our physical and psychological relationships with colour. Her pieces include *Our Spectral Vision* for the Natural History Museum in London, where, inspired by the collection, she filled the space with a rainbow display of dichroic glass: 'It creates colour as butterfly wings do, by reflecting light.'

How did you get started with light and colour? LIZ WEST: When I was working obsessively with dripping paint, I started to film it to capture the moment when it

What's the downside of your work? It's hard to photograph. It's ephemeral by nature, and viewing the works live elicits an emotional response from my audience. But I work with two photographers now who I absolutely trust. They manage to capture the work to a certain extent.

It is frustrating when a work has to be taken down, so I'm happy to have worked on several permanent projects.

Following your breakthrough with *Your Colour Perception* ... Yes, I proved I could work on that scale. I wanted to deal with space in a bold way, ignite an emotional response to colour. I used simple materials.

'I like the materiality of fluorescent, the rigidity'

was still wet, and I had this eureka moment — it was the light reflections I loved, not the pigment. So I ran with that.

What was your first project featuring light? An installation for my degree show — a mirrored room, with multiple yellow tube lights.

How many installations have you done since then? Between about 60 over the last ten years, averaging six a year. Each one can take up to nine months to develop.

How do you decide the direction for a given work? I think site-specific — what does this space need? It can be very simple. For *Solstice Ritual* at Penarth Pier Pavilion, I enhanced the effects of sunrise and sunset by covering the windows with yellow and pink films. At St John's Church in Scunthorpe, I used mirrors to magnify the effect of natural light filtered through the church's vast windows.

What's your preferred form of light? LED technology has come on leaps and bounds since I started working, but it offers too many options. I adore strip lights. I like the materiality of fluorescent, the rigidity. At the Natural History Museum I used LEDs because of the heat factor, but they look like fluorescent tubes. I like the linear effect.

Your palette is very pop, very bright. I have seasonal affective disorder, so warmer, vivid colours appeal to me.

I wrapped 1,600 bulbs in colour gels, cutting and taping each one to existing ceiling lighting before fitting a reflective grate over them. Instead of a directional colour light, the result was an immersive colour wash.

What was your most formative art-related experience? I remember Jim Lambie's vinyl-tape installation, *Zobop*, at *Days Like These*, a Tate Britain exhibition. It felt like a complete 360-degree whack of colour, which is what I try to achieve. Colour is very sensory — maybe even spiritual for some viewers.

What else inspires you? Artists like James Turrell, Daniel Buren, Dan Flavin — also Turner. And reading, things like Josef Albers' *Interaction of Colour*, David Batchelor's *Chromophobia* and Isaac Newton's thoughts on colour. Everyday life gives me ideas, too: shop signs, architecture and the possibilities of materials.

How do you want your works to affect people? As a decompression zone — allowing them to let go of their inhibitions. Colour opens people up. It affects everyone. It's a universal language, isn't it?

liz-west.com

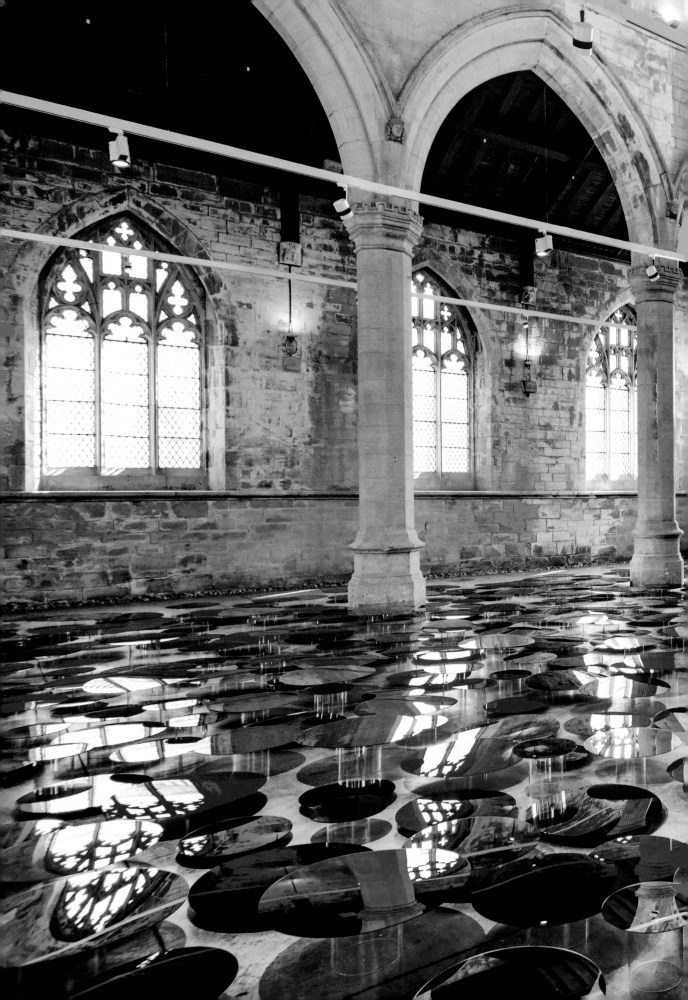

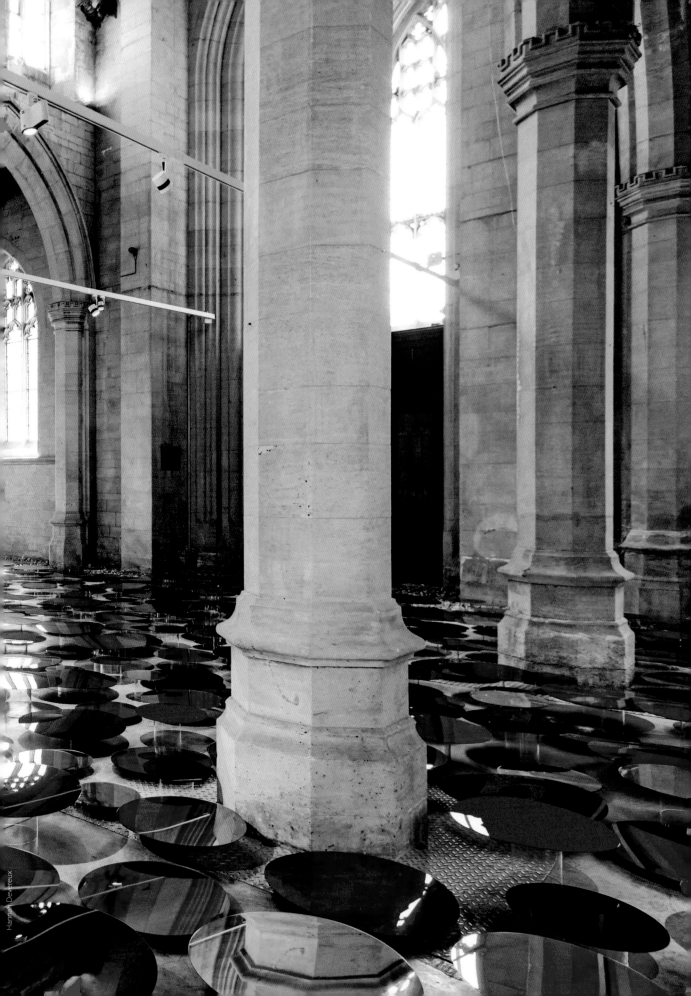

THE DARK SIDE

Relying heavily on the power of shadows, Germaine Kruip creates voids for her audience to fill.

Words JANE SZITA **Portrait** ANNE CLAIRE DE BREIJ

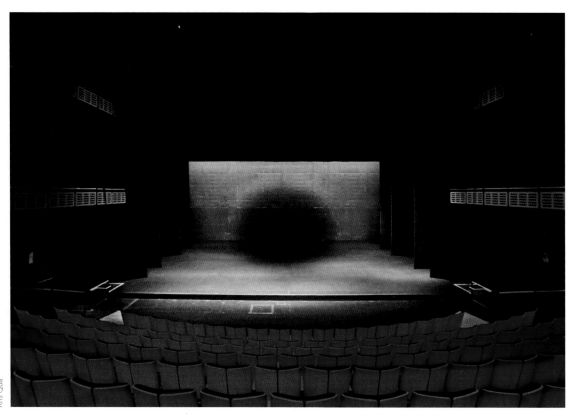

Kris Qua

Dutch artist Germaine Kruip began her career in the theatre after studying scenography. Later, a residency at the Rijksakademie in Amsterdam kick-started her work as a visual artist. Her pieces — from mechanized sculptures to collaborations with Raf Simons for Jil Sander stores — invite audience involvement through their unresolved ambiguity, an effect often achieved with shadows. Kruip lives and works in Amsterdam and Brussels.

How did you start working with light and shadows? GERMAINE KRUIP: *Counter Shadow* was the first piece I made that explored the subject. In the work, a sculpture casts a shadow that is fixed like a stage prop, in contrast

Your work calls for active observation. That's why the titles don't have a message — I am not telling people what to see. In *Simultaneous Contrast*, it's about a mental shadow, a kind of optical illusion. Two half circles move very fast, and you start to see a dark shadow spot. It's done with very detailed programming — very technical — but the whole point is to highlight the process that occurs in the gap between the eye and the brain.

How do people react to your pieces? They get involved. They sometimes ask: *Why is this art?* I don't consider that a negative remark at all. Art is about questioning things, not providing answers. Anyone is quali-

'A shadow is a void, and that's not entertaining or pleasing'

with a moving light. Like *Counter Composition*, a kinetic piece I made afterwards, the object is deconstructed into light and shadow. The shadow presents itself like the ghost of a work. It's like a meditation on appearing and disappearing, or a search for a moment between the two. A shadow is a void, and that's not entertaining or pleasing; for some, including me, it's vaguely threatening. Shadows always represent something else; they trigger the imagination.

Why did you make the switch from theatre to art? The question was: *Why do I have to imitate life in the theatre, when life is already so theatrical?* Instead of adding things, like you do as a scenographer, I wanted to subtract — to arrive at another view. My art is a kind of reverse process. At Art Basel, for instance, I made a reverse spotlight using a gobo [a lighting stencil]. I made a point of shadow, not light, on the floor — like an absent person. It's about creating an emptiness that the audience can fill with expectation.

In your 2016 exhibition at the Oude Kerk in Amsterdam, one work involved removing all the lights. *Oude Kerk Untitled* involved a kind of negative art direction. Taking all the lights away from the church allows the shadows to return, and they are constantly changing. When I begin any installation, I always start by removing everything, including the light sources.

Is there an element of confrontation in your work? Sometimes. For Frieze Art Fair I did a piece called *The Wavering Skies* in which a dark cloud moves over the entrance hall. Art fairs are constantly bright, like a casino. I wanted to add a different, slightly alarming, reality.

fied to look at art. I don't make a distinction between art critics and tourists. I believe in the public.

Theatre seems to be returning to your work. After 15 years as a visual artist, I do have one foot back in the theatre. In 2016 I showed *A Possibility of an Abstraction* at Kunstenfestivaldesarts in Brussels. People sat around an empty stage as a big black shadow — a void — appeared. They then saw a diamond floating and changing shape. They had to actively *look*; in fact, they ended up on the edge of their seats. I worked with a theatrical team and we had rehearsals, but there were no actors. It's about the collective gaze — the audience creates the work by looking.

germainekruip.com

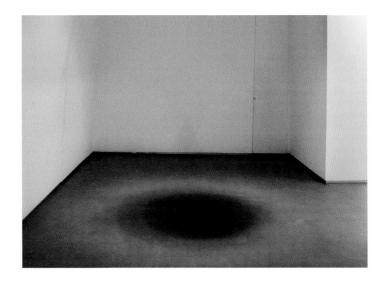

Above
PHANTOM (2013) IS SHADOW PIECE THAT
SUGGESTS AN NONEXISTENT OBJECT, ONLY
PRESENT THOUGH A CIRCULAR SHADOW.

COUNTER SHADOW (2008) IS SUSPENDED
FROM THE CEILING AND ACTIVATED BY A LIGHT
SHINING DIRECTLY ON TO IT.

Previous spread, right page
IN 2014 *A POSSIBILITY OF AN ABSTRACTION*
APPEARED AT THE EXPERIMENTAL MEDIA AND
PERFORMING ARTS CENTER IN TROY, NEW
YORK. DURING THE PERFORMANCE, WHICH
WILL BE PART OF KUNSTENFESTIVALDESARTS
IN BRUSSELS THIS MAY, A LARGE SHADOW
EMERGES FROM AN EMPTY STAGE.

Gert Jan Kocken

Above and opposite page
THE WAVERING SKIES SAW AN OMINOUS
SHIFTING CLOUD LOOM OVER
THE ENTRANCE PASSAGE OF LONDON'S
FRIEZE ART FAIR IN 2005.

NA
TU
RE

The volatility of nature is a great source for artistic endeavours. Whether it be Diana Scherer's whimsical plant roots, Hanayuishi Takaya's colourful vegetables, Clair Morgan's dead animals, or Berlinde De Bruyckere's slightly nauseating wax corpses, nature can be both supremely attractive and utterly repulsive. So why not use nature as inspiration for art that has the power to do the same?

NEW BLOOD

**Made from animal blood,
Jordan Eagles' vibrantly visceral works
have more to say about life than death.**

Words JANE SZITA **Photos** COURTESY OF JORDAN EAGLES

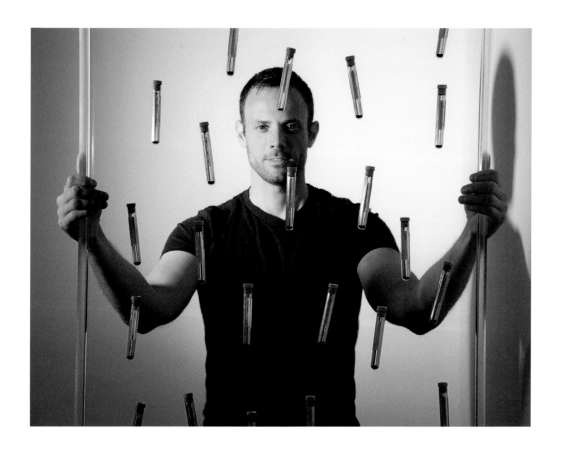

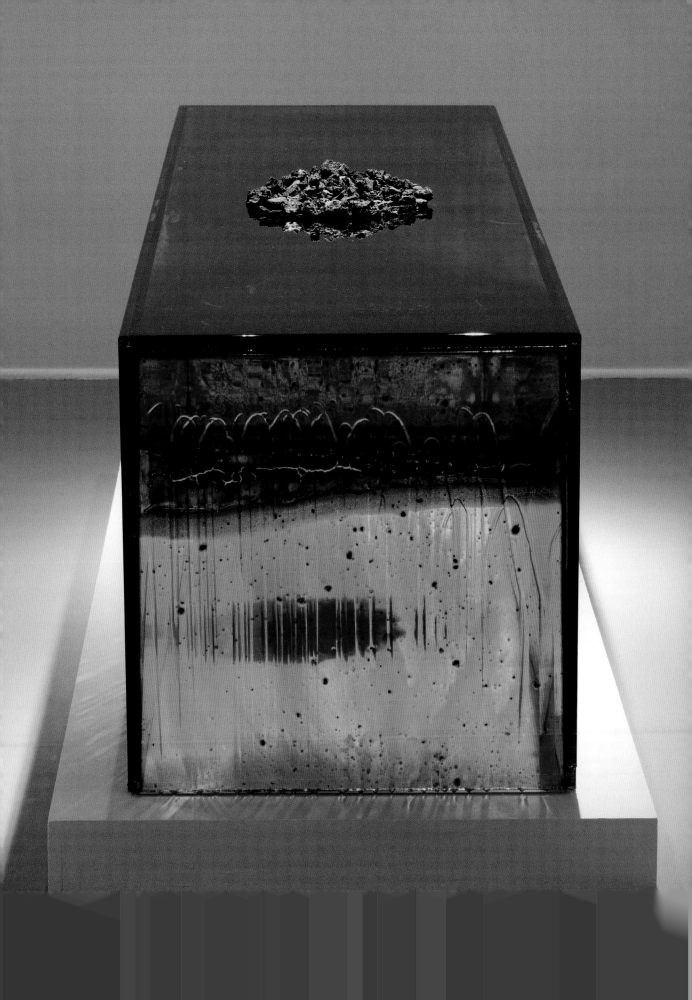

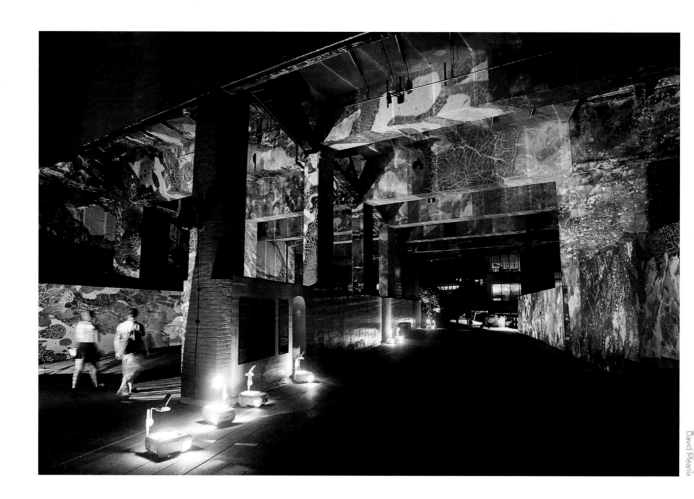

David Meanix

Above
BLOOD ILLUMINATION (2016)
AT THE HIGH LINE IN NEW YORK.

Former spread, right page
INSTALLATION IN THE BOSTON CENTER
FOR THE ARTS (2014).

In works that are a haemophobe's nightmare, New York-based artist Jordan Eagles has spent the last 20 years experimenting with the medium of blood, both animal and human, devising ways to preserve its extraordinary colour spectrum and textural richness. His self-invented technique uses resin and Plexiglas to encase the volatile organic material, preventing its decay. His works, which have been widely exhibited and feature in many permanent collections in the USA, vary from abstract panels to installations in which he bathes an entire room in projected 'blood light'.

Why did you start using blood? JORDAN EAGLES: I was in college and questioning the connection between body and spirit. I was looking through some childbirth illustrations in a medical encyclopaedia, and I was struck by how sterile and emotionless the images were. I began using these medical drawings as photo transfers, dripping red paint onto them, but the results were flat and lifeless. So instead of symbolizing blood with red

Can you keep evolving new techniques? Yes — in fact, just this week I was experimenting with blood and resin and varying the drying times in order to create new fractal patterns. I'll keep working with blood as long as I continue to be inspired by it.

Are you aware of challenging a taboo? I think blood is a special and sacred material. You can consider it taboo, because we humans have it running through our bodies. Each of us has a unique relationship with it. My works allow viewers to experience something they might not normally see, despite their innate connection with the material. On the other hand, artists have probably worked with blood ever since early cave paintings — think of Hermann Nitsch, Ana Mendieta, Damien Hirst, Marc Quinn, Ron Athey and Andres Serrano, to name just a few.

What do your blood works mean? My works are abstract and propose philosophical questions about

'The works come alive with the first drop'

paint, I decided to use real blood. This decision came to me with a great deal of exhilaration, and suddenly the works came alive with the first drop.

Your current works do seem exceptionally animated . . . At its core, my work is about regeneration, taking the life force of something no longer living and giving it new life. Blood is a fascinating material to work with because of its dynamic properties. It emits an intense and spiritual energy. The works seem to be lit from within.

Where does the blood come from? I buy cattle blood by the gallon from a slaughterhouse. In my studio I transfer it to smaller containers, freeze it and then defrost as needed. Some of it I dry, in order to use it in powdered form.

How do you stabilize such an organic material? Basically I use a UV-resistant resin to prevent the textures and colours fading over time. But I've evolved a number of other techniques. Recently I've been soaking gauze in blood, mixing blood with copper, and employing outdoor sun-drying techniques. I've also been using aged blood dust, which enables to me to generate dark colours and is another way to recycle the blood.

mortality, spirituality and creation. The works become relics of that which was once living, embodying transformation, regeneration and an allegory of death to life. The images themselves sometimes appear like the big bang, the beginning of time, prehistoric landscapes, molten lava, aerial views of land or lightning bolts.

What's the most ambitious blood work you've done? Perhaps BAR 1-9, a blood mural over 10 m wide and nearly 3 m tall.

Do people make vampire jokes about you? A lot. Sometimes my work is called 'vampire chic' or 'creepy' — it's fine with me, as long as people own their opinions.

Where else does your fascination with blood take you? My fascination with blood is primarily spiritual. For me, when I look out into the night sky or see images of outer space captured by telescopes, I realize how these celestial patterns are similar to the cellular makeup of blood, reminding me that we are all connected.

jordaneagles.com

BLOOD

Above
BRS 4.

Oppostie page
LFTSFK COMBINES BLOOD WITH COPPER AND
UV RESIN, PRESERVED ON PLEXIGLASS.

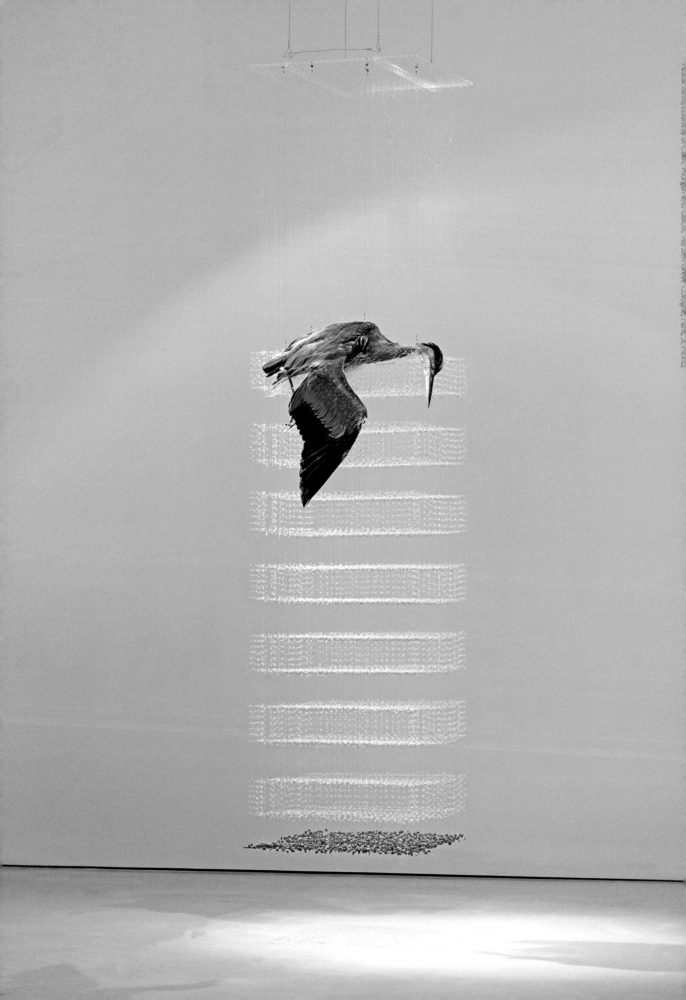

IN FOR THE KILL

Frozen in time, foxes, owls and other creatures inhabit geometric grids in Claire Morgan's haunting installations.

Words JANE SZITA **Portrait** ANDREW MEREDITH

Born in Belfast, Northern Ireland, Claire Morgan studied sculpture at Northumbria University in Newcastle. Using natural elements in her work — including dead animals — led her to study the craft of taxidermy. Today she creates large-scale installations in which animals and birds, seemingly in a state of suspended animation, navigate dense geometric grids of threads, dotted with seeds, insects and other materials.

Why did you start using taxidermy in your works?
CLAIRE MORGAN: About thirteen years ago I was working with changeable materials, like ice, rotting fruit and dead animals. As my work became more subtle, I wanted to have full control over how the animals are positioned and how they look, so I came to taxidermy as a means of achieving that.

How did you learn the technique? I taught myself for a year or two before attending annual conferences hosted by the UK Guild of Taxidermists, where there are

How do people react to your works? Usually positively. Sometimes people are not sure how they feel about the animals, especially viewers who are not 'art people', because they are hoping to look at something nice. But obviously that is not necessarily what I am aiming for. Quite the opposite, really. I'm always working around the fact that people have an instinctive response to beauty and that they're fascinated by very laborious and fragile things. I'm trying to use that to my advantage — to sort of catch people out, I suppose.

Where do the creatures in your works come from? They come from various places: roadkill, birds that have flown into windows, pets, small birds and rodents that were caught by cats. Occasionally they're animals classed as pests that have sadly been killed by pest control and will be otherwise incinerated.

Taxidermy has been called a 'hipster hobby'... A particular type of taxidermy has become trendy. It seems

'We're unwilling to reflect on our own mortality'

demonstrations and talks. I had a couple of days' tuition from Derek Frampton and Mike Gadd, who are both great taxidermists.

How did you arrive at the bird- or animal-and-grid format? What are you trying to communicate? I was asked a similar question recently and eventually came to the conclusion that it's about the way I see the world. It has to do with the connectedness of everything, the relationships between things — individuals and other humans, other animals, the environments we live in, life and death. Both positive and negative relationships. And how all these things are subtly woven together in our consciousness.

How do you go about making your installations?
I always start by making sketches, usually rough combinations of simple shapes, colours, materials, maybe animals or plants, words and phrases. I play with these until they start to fit together. Once I've reached a point where I find something I want to pursue, I make a sketch and then plan the work on layers of tracing paper. When everything is planned, I can start work on the taxidermy and on the suspended elements. The process of preparing all the threads is very long and drawn out.

to entail using lab mice or similar creatures, spending a few minutes on processes that should take much longer, roughly stuffing a poorly prepared skin with cotton wool, and attaching a hat or a walking stick. I hope it stops being fashionable. It cheapens the craft of taxidermy and the life of the unfortunate animal, too.

How do you think 21st-century people relate to nature? Nature is an integral part of the modern world. We will become extinct without land, rain, trees, clean air and water, insects and other animals. The danger lies in our unwillingness to see ourselves as part of the larger organism that is the earth. And also our unwillingness to reflect on our own mortality. That is a fundamental part of what drives me.

claire-morgan.co.uk

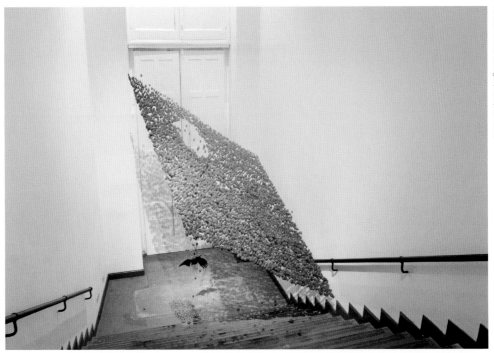

Ciszak Dalmas Tamango - La Casa Encendida, courtesy of Claire Morgan and Galerie Karsten Greve Cologne, Paris, St. Moritz

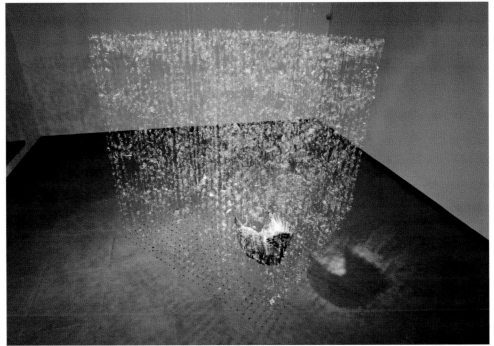

Claire Morgan, courtesy of Galerie Karsten Greve Cologne, Paris, St. Moritz

Above

FRUIT FLIES, BLUEBOTTLES AND STRAWBERRIES
FEATURE ALONGSIDE A STUFFED JACKDAW IN
DOWN TIME (2010).

UNDER ARREST (2012) JUXTAPOSES THE
ARTIFICIALITY OF CELLOPHANE SCRAPS WITH A
STUFFED MAGELLAN'S EAGLE OWL.

Previous spread, left page

A GREY HERON RESTS ATOP A 'STACK' OF
DANDELION SEEDS IN *PEDESTAL* (2011).

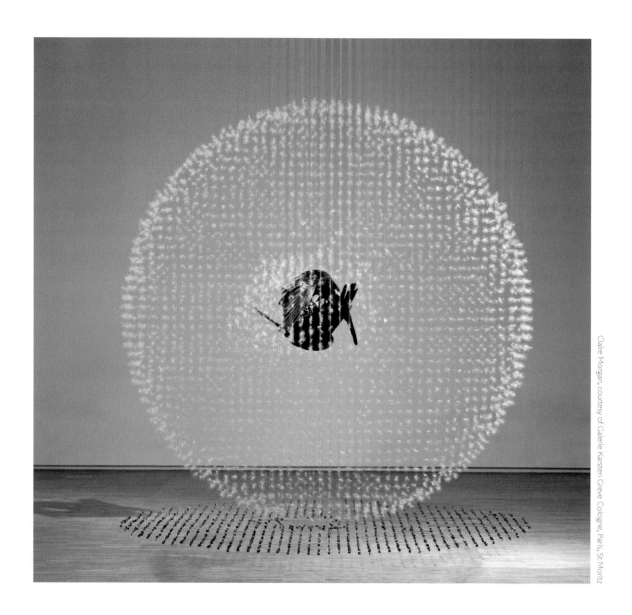

Above
ENTANGLED ROOKS ARE ENCAPSULATED BY
PLUME-LIKE THISTLE SEEDS IN *THROE* (2010).

Opposite page
GONE TO SEED (2011) PAIRS A STUFFED CARRION
CROW WITH FEATHERY THISTLEDOWN.

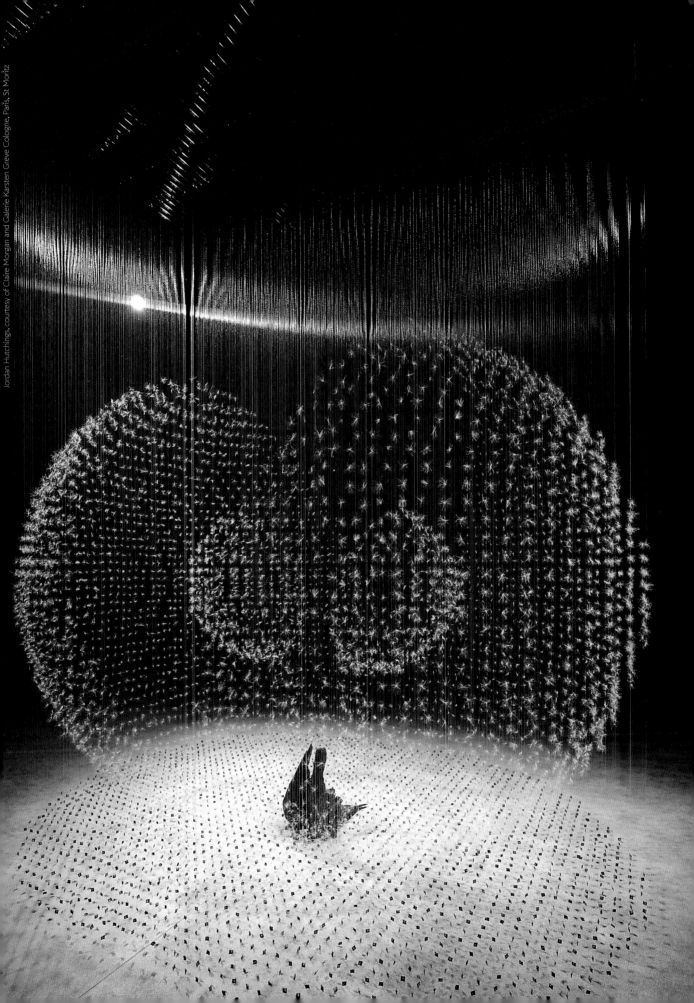

MORE THAN MEETS THE EYE

Klaus Kemp's complex symmetrical arrangements of tiny organisms are invisible to the naked eye.

Words JANE SZITA **Portrait** GARETH IWAN JONES

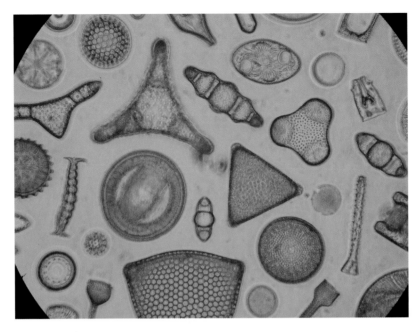

'I'm not an artist; I simply like orderly patterns'

For 60 years, Klaus Kemp has been perfecting the once-forgotten art of diatom arranging. Using a microscope slide as a canvas, he shapes complex geometric patterns using diatoms — intricately beautiful microorganisms that are invisible to the naked eye.

Born in Berlin, Kemp was just ten years old when he moved to the UK in 1948, in the wake of the Second World War. He encountered diatoms a few years later through his work for a scientific-supplies company and was instantly hooked. Gradually, he began to acquire clients who commissioned slides from him, and for the past 30 years Kemp has been a fulltime maker of diatom compositions. He lives in the English county of Somerset.

What can you tell us about diatoms? KLAUS KEMP: They are single-celled plants with a silica shell, like a glass box. The shell has an ornately sculpted surface; we're not sure why. Diatoms measure between 5 and 150 microns. You can barely see the biggest of them with the naked eye, but to view the smallest you need a powerful microscope. At the last count, there were over 600,000 diatom species, but there could easily be ten times as many — new ones are discovered all the time. Diatoms are found in all water sources and even in the atmosphere. They're responsible for two-thirds of all gaseous exchange on the planet, more than that occurring in the Amazon rainforest.

What sparked your interest in arranging them? Someone who was keen on microscopy showed me a slide with a diatom composition from the Victorian era, which was the heyday of the art form. I was stunned by its sheer beauty, and I desperately wanted to know how they had done it — so I began experimenting.

Victorian diatomists were competitors, so they never explained their techniques. I had to work mine out without advice. It took eight years to perfect and to develop a suitable glue to hold the diatoms in place. That glue is now *my* trade secret, but my wife is going to release the formula when I've passed away.

How do you go about making a composition? I position the cleaned diatoms on a glass slide with my adhesive. I create the pattern under the microscope, and once I'm happy with it, I set the glue with heat. Then I add a high refractive index mountant, which makes the diatoms appear more prominent. Finally, I protect the slide with a thin coverslip, which is held down by a shellac ring that acts as a kind of frame.

What inspires the intricate patterns in your work? They evolve from the material. I sit down with a selection of diatoms of various shapes. I place the first one, which determines how I position the next. Quite often I'm asked to make a specific form — a Christmas tree or an owl, for example — and people have also requested reproductions of Victorian diatom patterns, but I always make a slight change to avoid creating an exact copy.

Have you discovered a new species of diatom? At least ten. It's always exciting to find one you haven't seen before. I correspond with diatom experts worldwide. They often send me samples to work with, and sometimes I receive one I don't recognize.

Do you think of yourself as an artist? Not really, because my work is strictly geometric, not free in form. I simply like orderly patterns.

What's the largest pattern you've made? My current record is a pattern containing 1,050 diatoms.

Do you make other kinds of micro art? I work with butterfly scales and with radiolarians, which are the animal kingdom's equivalent of diatoms — not as abundant, but also beautiful. If I had a second life ahead of me, I'd devote it to radiolarians.

diatoms.co.uk

Opposite page
THERE ARE OVER 600,000 KNOWN DIATOM SPECIES.

KEMP HOLDS A DRAWER WITH DIATOMS.

Previous spread, left page
DIATOMS ARE SINGLE-CELLED PLANTS WITH ORNATE SILICA SHELLS.

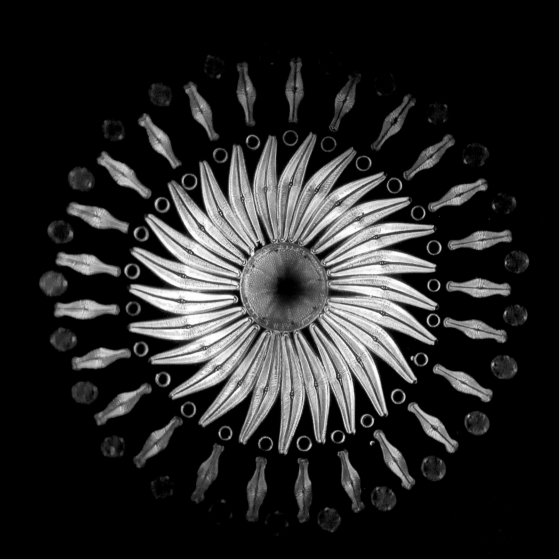

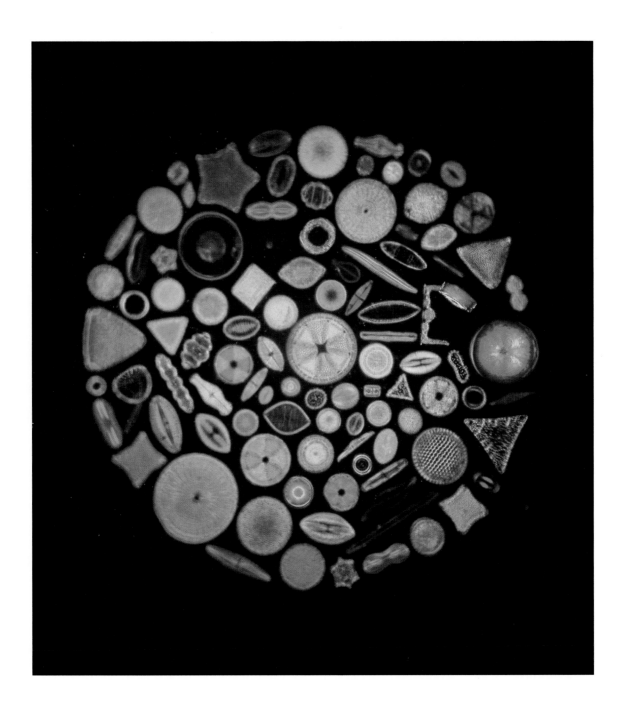

Above
EVEN THE LARGEST DIATOMS ARE BARELY BIG
ENOUGH TO BE SEEN WITH THE NAKED EYE.

Opposite page
THE 25-FORM STAR IS SMALL ENOUGH TO FALL
THROUGH A PINHOLE IN A PIECE OF PAPER.

QUILLS AND SPILLS

Like tidal waves or oil slicks, Kate MccGwire's installations of thousands of feathers invade and overwhelm their spaces with a vivid and elemental sense of disquiet.

Words JANE SZITA **Portrait** TESSA ANGUS

British artist Kate MccGwire began using feathers in her works when she lived next to an old shed that had been colonized by pigeons. Many sculptures and installations later, she's still entranced by the avian material.

Where does the fascination with feathers come from? KATE MCCGWIRE: There are so many reasons. I think one of the most important is their sense of otherness. When you find a feather on the ground, it always looks so utterly separate from the bird it came from. When you look at a quill, it's difficult to imagine that this fleshless stem was once attached to a bird. It's part of the mechanism that helps it to fly and keeps it warm, but seen in splendid isolation a feather becomes detached from these physiological concerns and becomes something 'alien' and a carrier of meaning in its own right.

How do you get so many? My feathers are sent to me by a variety of sources, and I think of them as being a by-product of an existing process, a form of recycling. The pigeons' feathers are the most straightforward. They are sent to me by a network of hundreds of racing-pigeon enthusiasts around the country. It has taken quite a few years to establish an ongoing relationship, whereby I write to them, showing what I plan to make. Then, when their birds moult, twice a year, they send me these beautiful feathers (which would otherwise be thrown away) through the post. I have kept every letter and envelope in which feathers have been sent to me, and I hope eventually to make them into an installation. Pheasant pluckers send game-bird feathers, and farmers and gamekeepers send those of crows and magpies. They are shot as pests, as they damage crops and kill fledgling birds.

You obviously like birds. I'm fascinated by them, although I don't really regard myself as a twitcher. I also know people who are completely terrified of birds, which I find really interesting.

How many feathers does a work contain? A lot. *Corvid*, for instance, is composed of approximately 18,000 crow and jackdaw feathers.

How long does it take to make an installation? Often it can take years, because collecting enough of any one type of feather can be a tortuous process. With *Corvid*, it took three years to collect enough feathers, and two to three months to make.

Can you explain the power of your pieces? I think it's unnerving to see an object that evokes a familiar thing, but then on an abnormal scale. An object that seems out of place can sometimes be really uncomfortable.

It's important to me that each work is viewed as a temporary installation, something that exists only for the period of the exhibition. It's a sort of performance piece, I suppose.

How do people usually react to your work? There's often an initial, overwhelming attraction to the work, which can be quickly turned on its head when people realize that the work is 'real' and they are actually looking at the feathers of many thousands of birds. I love watching that dawning realization.

katemccgwire.com

Opposite page
SLICK (2010) REFERS TO THE SLEEKNESS OF FEATHERS, BUT ALSO TO THE WAY IN WHICH THE INSTALLATION MIMICS AN OIL SPILL.

Previoius spread
KATE MCCGWIRE AT WORK ON *CORVID* (2011), WHICH COMPRISES 18,000 CROW AND JACKDAW FEATHERS. IT TOOK MCCGWIRE THREE YEARS TO COLLECT THEM.

Following spread , left page
ANOMALY (2017). MIXED MEDIA WITH MAGPIE FEATHERS IN BESPOKE CABINET.

Following spread , right page
SHIVER (2017). MIXED MEDIA WITH MAGPIE FEATHERS.

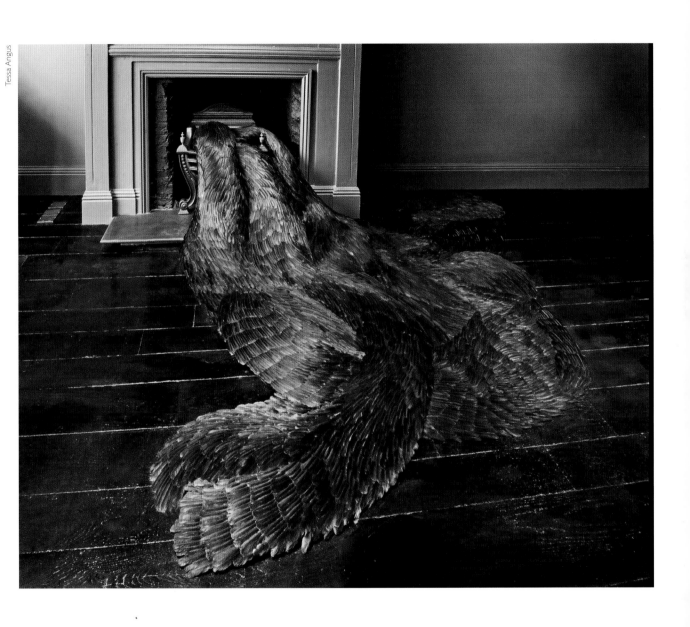

**'It's unnerving to see
an object that evokes a bird,
but on an abnormal scale'**

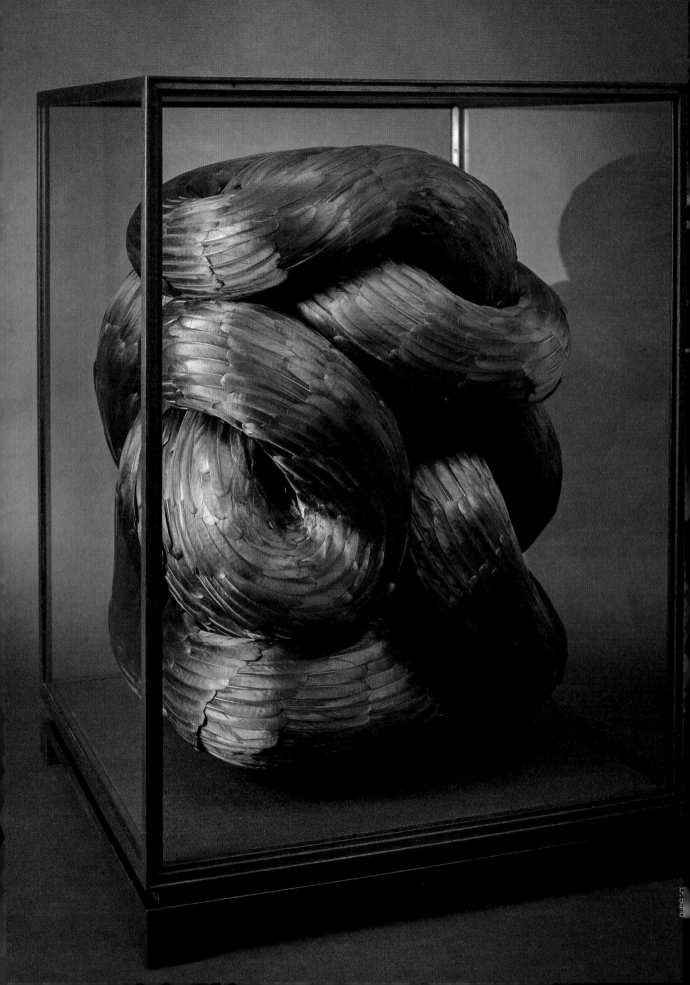

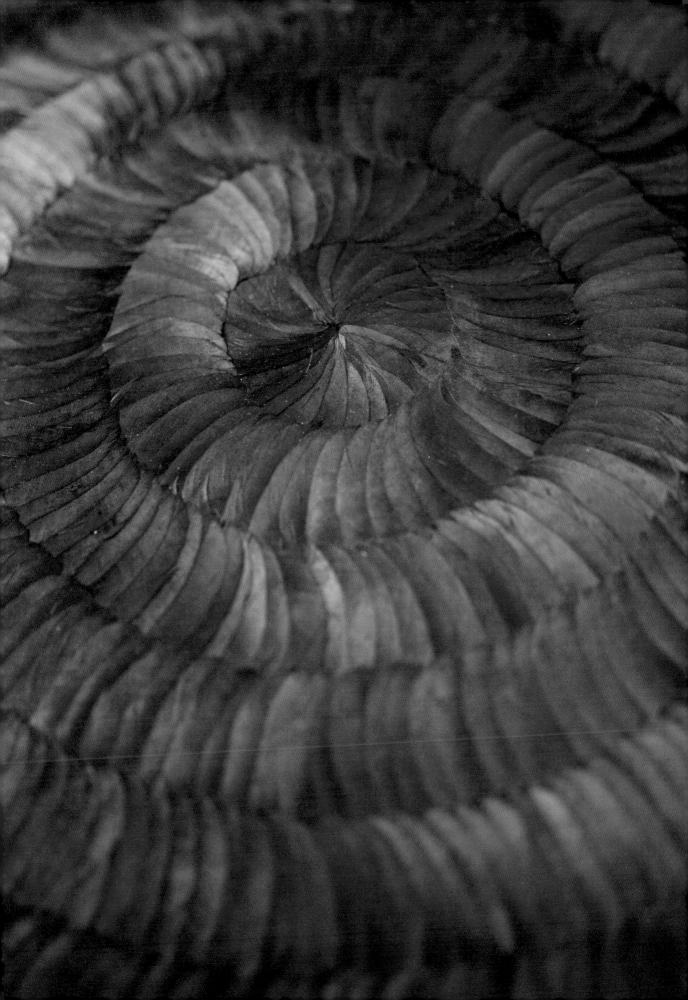

HAIR AND NOW

**In her intricate *Leaf* series,
Jenine Shereos uses hair to re-create
shapes found in nature.**

Words INÊS REVÉS **Photos** ROBERT DIAMANTE

Above
LEAF (BRUNETTE), 2011.

LEAVES, 2011.

Previous spread, right page
LEAF (BLONDE), 2011.

The main focus of work by Jenine Shereos is her exploration of fibre, textile and related processes. The Boston-based American artist, who received an MFA from California State University in Long Beach, uses human hair for her *Leaf* series: a replication of leaves that demands extreme patience and attention to detail. Her work has been exhibited in the USA, Canada and Europe.

When did you start the Leaf series? JENINE SHEREOS: I began working on the *Leaf* series almost ten years ago. While hiking in northern California, I came across a number of leaf skeletons that I collected and

work. I usually end up with a process that is very slow and meditative. For the *Leaf* series, it took quite a bit of experimentation and a number of unsuccessful iterations before I found a technique that satisfied me.

To create each leaf, I form the primary vein structures by grouping strands of hair and wrapping them together with another strand of hair against a water-soluble backing. I then sew in the details, threading a needle with an individual strand of hair that I tie with a knot, securing it to the needle. At each point where one strand of hair intersects with another, I stitch a tiny knot, so that when the backing is dissolved, the entire piece maintains

'Hair is such a humble material'

kept in my studio. I had been interested in branching and in organic forms for a long time, and I was drawn to the detailed and delicate nature of these leaves. The intricate line-work in the venation of the leaves reminded me so much of hair.

You worked with hair in your *Archive* project. What makes hair so fascinating? I often think of my work as 'dimensional drawing'. As a material, hair has the potential to produce such fine, delicate lines. I love the idea of working with detritus that is part of our everyday lives but goes unnoticed. I'm also fascinated by the personal quality of hair. I love that it's an extension of the self that goes out into the world and is encoded with our unique DNA. It functions as a sort of memory or trace. There is the reference to Victorian mourning jewellery as well — and, of course, the juxtaposition of attraction and repulsion. Hair on someone's head is seen as attractive, but when you find a single strand, it can be off-putting or repulsive.

What do these pieces represent? I like the idea of an object existing as two things simultaneously. The hair becomes the leaf, and the leaf becomes the hair. I'm drawing a parallel between the vascular tissue of plants and the vascular system of the human body. I'm also alluding to natural systems of growth and decay.

Where do you get the hair from? I collect my own, as well as hair from friends and family members. I have a whole drawer full of hair. I guess that's kind of creepy!

Tell us about the process. How do you handle such a fragile material? I love the process of having an idea and being faced with the challenge of making it

its shape. Even though hair is a fragile material, it holds together quite well when I use this technique.

How do people react to *Leaf*? Most people respond first to the intricate, detailed quality of the leaves and to the obsessiveness of the work.

Are you planning to use hair in other projects? I've been working on a related series, using the actual decomposing skeletons of leaves I've found on various walks. I replace the missing fragments by 'mending' the skeletons with hair, following a similar process. I really enjoy making these leaves. I'll probably continue to develop the work on some level throughout my life.

jenineshereos.com

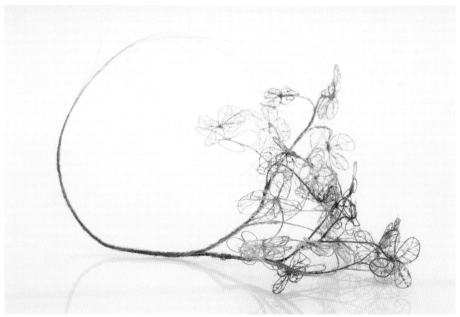

Above
LEAF, 2014.

HYDRANGEA, 2013.

Opposite page
LEAF (BLONDE), 2011, DETAIL.

NATURE'S APPRENTICE

In a series of works dating back over 40 years, artist Jacek Tylicki surrenders the creative reins to natural forces.

Words JANE SZITA **Portrait** KACPER OLOWSKI

Born in Sopot, Poland, during the communist era, Jacek Tylicki attended the Academy of Art in Gdansk. In 1972 he left Poland to study art history and philosophy at Sweden's Lund University. Here he hit upon the idea that led to his nature works, made by leaving blank sheets of paper or canvas in a natural setting for several days or weeks; the paper either disintegrates or develops an abstract imprint in earthy colours, as though composed by some invisible hand. Having started, he went on mak-

What do these works say about the artist's role? The artist's obligation is not to shape but to understand the riddles of reality. Nature is the greatest and most admirable creator.

How do you know when to retrieve the pieces? It's quite random. I simply have time or feel I have to go back. Sounds easy, but it's not. Often, when I find the spot from memory or by using my iPhone GPS, as I do

'I explore pure nature, without human interference

ing them. Tylicki spent a few years in Copenhagen before moving to New York in 1982 and eventually returning to Sopot. During the winter months, he travels to remote parts of the world, such as the Andaman Islands and Western India, where he continues his long-running nature series.

How did you get the idea for the nature works? JACEK TYLICKI: It came suddenly, one summer evening in 1973. Next morning I went out with some blank watercolour paper and spread it out in nature. A few days later I went back and collected the first pieces.

I think the idea has its roots in learning that Leonardo da Vinci urged his students and artists to search for inspiration in random forms. He contemplated the stains on old walls, the ashes of a fire, the shapes of clouds or patterns in mud. Da Vinci would throw a paint-filled sponge against the wall and study the random marks — demonstrating the energy and pattern that accompanies all processes in the universe, I think.

Can you explain what you do in more detail? Avoiding all control, I spread out sheets of white paper or canvas in the grass, on the riverbank or among stones. The materials must be of the highest quality, or they disintegrate quickly. The size can vary from 2 cm to 5 m. Then nature registers its presence, covering the surface of the paper or canvas with colours, forms and tracks.

Would you call yourself a natural-art pioneer? I began in the early years of land art, but the idea of adding objects to nature or using bulldozers to sculpt the landscape isn't my cup of tea. Richard Long used earth and mud in some of his work, but he was clearly creating his own forms. Yves Klein fastened a canvas covered in blue paint to the roof of his car, and it gathered dust while he was driving. But I explore pure nature, without human interference.

now, the paper will have fallen apart or be gone altogether. In that case, I'm too late in the race with the elements ...

How many have you done? Over 900. Unfortunately, many were destroyed when a hurricane hit my home in the Florida Keys back in 1999.

Are these images place-specific, or more universal? Universal, in that they are traces of the planet. But each particular place, from the volcanic landscape of Iceland to the jungles of Fuji, creates distinctly different pieces.

Where to next with the technique? I'm planning to work in all kinds of places around the world. The images are so diverse and captivating that I can't stop making them. The result is always a surprise, whether richly elaborate or minimalistic. Art happens everywhere, all the time. We just have to keep our minds open.

tylicki.com

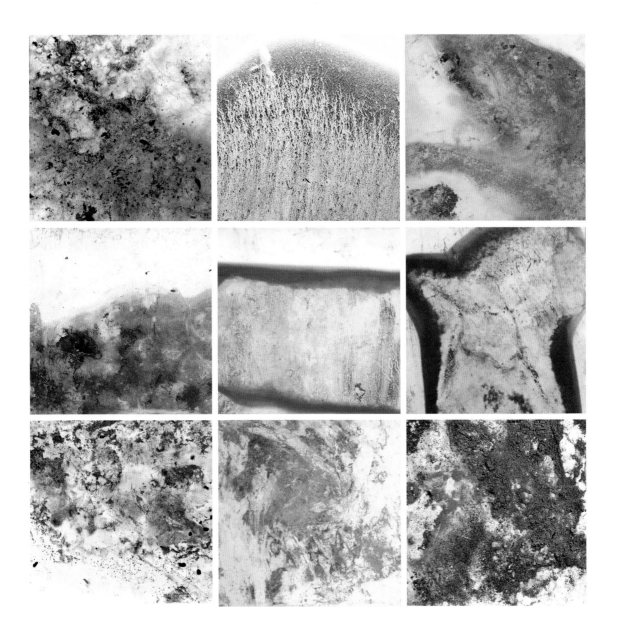

Above from left to right
NATURE NO. 1 (1973), *NATURE NO. 81* (1978),
NATURE NO. 213, NATURE NO. 343 (1979), *NATURE
NO. 364, NATURE NO. 365* (1979), *NATURE NO. 919,
NATURE NO. 933* (2014), *NATURE NO. 944* (2014).

Following spread
AFTER LETTING NATURE RUN ITS COURSE FOR A
PERIOD OF TIME, TYLICKI RETURNS TO FIND HIS
CANVASSES IMPRINTED WITH REMNANTS OF
THEIR SURROUNDINGS.

FORCER
OF NATURE

**Diana Scherer's intricate works
explore the potential of plant roots
as a new material.**

Words JANE SZITA **Portraits** MICHIEL SPIJKERS

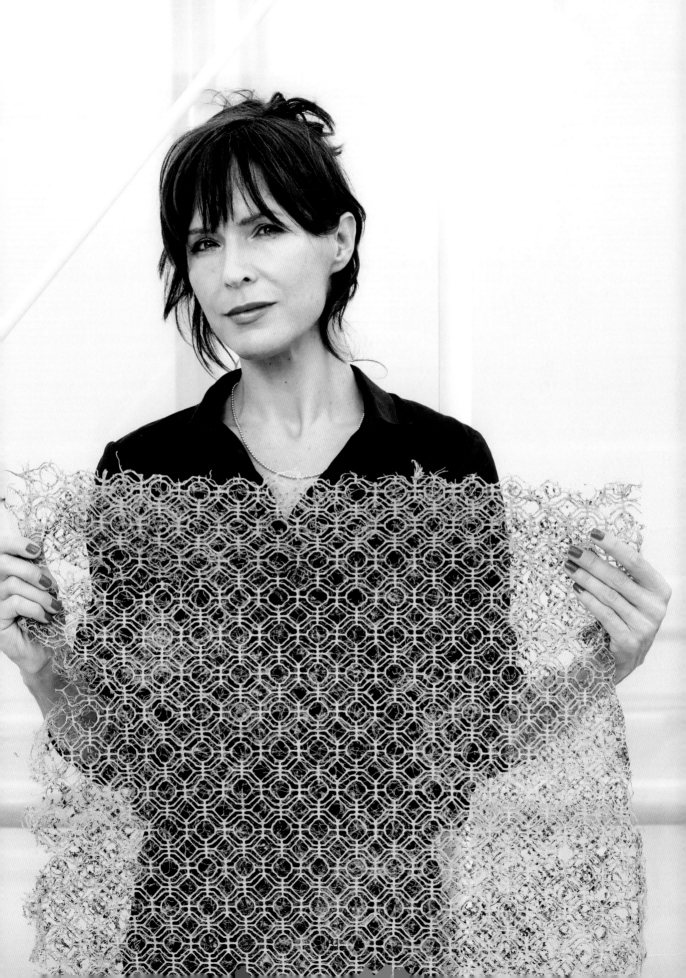

Born in Bavaria, Germany, Diana Scherer moved to London to pursue her dream of becoming a fashion designer, but life took a different turn when she met her Dutch partner and had a baby. The family relocated to Amsterdam, where Scherer studied art and photography at the Rietveld Academy. After graduating in 2002, she focused on art photography until a portrait series she made featuring plants and their roots prompted a change of direction. Intrigued by root systems, she began to develop techniques for manipulating them. Just two years later, as well as exhibiting the resulting textile-like pieces as works of art, she's investigating their potential as new materials.

A few years ago you were an art photographer. Today you're a plant-root artist and a materials researcher. How did you get here? DIANA SCHERER: I didn't choose it — it just happened. I became fascinated by plant roots, and to further my work I started collaborating with scientists. Then, with some of my first root pieces I won the New Materials Award at Dutch Design Week in 2016. Suddenly the design world was interested in my work and its potential for developing new materials that are organic and sustainable.

What was the original inspiration for the root pieces? It all started when I began to work with nature in 2009. I photographed flowers at first, and then I was inspired by a plant that — when I removed the pot — revealed only roots, no soil. I kept the photo of those

Can you describe the process you've evolved to create the root patterns? I use templates: moulds that I place below ground. I have several different kinds, which enable several different techniques. As an artist, I like to show the root work with soil and stones attached. As a designer, I like to show the pieces without soil. The templates are made from PLA plastic and can be reused. The patterns are derived from traditional ones based on nature's geometry — hexagons, for example. I sometimes work on the patterns with a designer. Once I have my patterned template, I bury it, sow the seeds, and wait.

How long does it take to grow a piece, and how do you harvest them? Growing time depends on the season — it's two weeks in July and August. In winter, it's a month in the greenhouse. Once the plants and roots have grown, I can finish the pieces. I remove the mould, invert the plants, photograph them and keep them alive by spraying them with water. They remain fresh for around a week. Then I dry them quickly so they don't rot, and I'm left with a textile-like piece. I like to present the three stages together in my exhibitions: the photos, the fresh living works and the dried pieces. The photos show aspects you can't see with the naked eye — tiny root hairs, for example.

You're quite coy about explaining your technique. Why is that? Partly because you have to be careful in the world of new materials — there are companies that are out to patent your process. But it's also because I

'Biologists are thrilled with the attention I'm bringing to plant roots'

roots in my studio for two years. Every time I saw it, I thought, *I really must do something with that.* Eventually, it led to a series in which I grew plants in differently shaped pots, then removed the pots to expose the roots and photograph them.

I was really happy with that series, but not sure how to continue. Then I hit upon the idea of creating patterns using the roots, only I wasn't sure how to achieve it. I believed in the idea, though, and soon started working with plant biologists at Radboud University in Nijmegen to improve my understanding of root systems. They liked working with an artist, but I don't think they really believed I could do it. Now they're thrilled with the attention I'm bringing to plant roots.

don't like to reveal *everything*. I'm afraid that the magic will disappear if I do. But perhaps I'm too secretive.

What kinds of plants do you use? After trying a lot of different types, I find that grasses are best — not common grasses but grains like oats, wheat and corn. They grow fast, and their roots are fairly thick.

How do you achieve the variations in texture we see in your works? The density of sowing is important. Sometimes I sow the seeds very thickly, which gives a lush, dense effect; other times I sow them thinly, and the effect is more like a drawing, or like lace. Different soils also produce different structures.

Is there a size limit for your root pieces? So far I've done them up to about 5 × 2 m. I think I could go on for kilometres, but you have to turn the work over in one piece, which is a challenge in larger formats.

I've noticed people reacting with great enthusiasm to these works. Does that surprise you? Yes. It's new for me. The roots are *my* fascination, and the things that fascinated me as an art photographer always failed to fascinate other people. I think the appeal is that roots are something you don't normally see. They are always there, yet hidden. I show the plants undressed, naked. I'm offering a new, different view of a fundamental thing. People can't believe it's possible. They find it very mysterious.

What explains your obsession with roots as a *material*? I'm interested in the manipulation of nature. It's absolutely not about being a nature lover. I'm amazed by the duality of gardeners, for example, who say they love plants but are really ruthless in the way they handle them. Bonsai cultivation is actually very cruel. I'm drawn to this mixture of love and cruelty. It's very basic, because we have always manipulated nature to survive. I really manipulate my pieces, and I leave no space at all for the roots to do what they want. The work is simple: just the naked plant plus manipulation. Another thing I recognize in my work is the human need to decorate the world.

What pieces are you currently working on? At the moment I'm working on a large carpet piece, the biggest I've done so far. I'm also growing an entire dress underground.

Sounds a bit spooky . . . It's a weird idea. Growing a dress underground and then exhuming it does suggest the idea of a grave. Also, it's a living thing that you ultimately have no control over.

When will we see the first usable new materials that emerge from your work? I think it will take an additional five years. I'm new to this field, so I'm attending conferences and events, as well as searching for more partners. I may work with TU Delft, for example. I want to make the material as strong as possible while keeping it lovely to look at. Applications could be everything from fabrics for the fashion industry to attractive insulation materials that can be kept visible. Plant roots capture carbon and could be a perfect eco-material. The goal is biofabrication: textiles that grow themselves below ground without using external energy. I find that a really romantic idea.

dianascherer.nl

Previous spread, left page
DIANA SCHERER'S WORK WAS PART OF
FASHIONED FROM NATURE, AN EXHIBITION
AT LONDON'S V&A IN 2018.

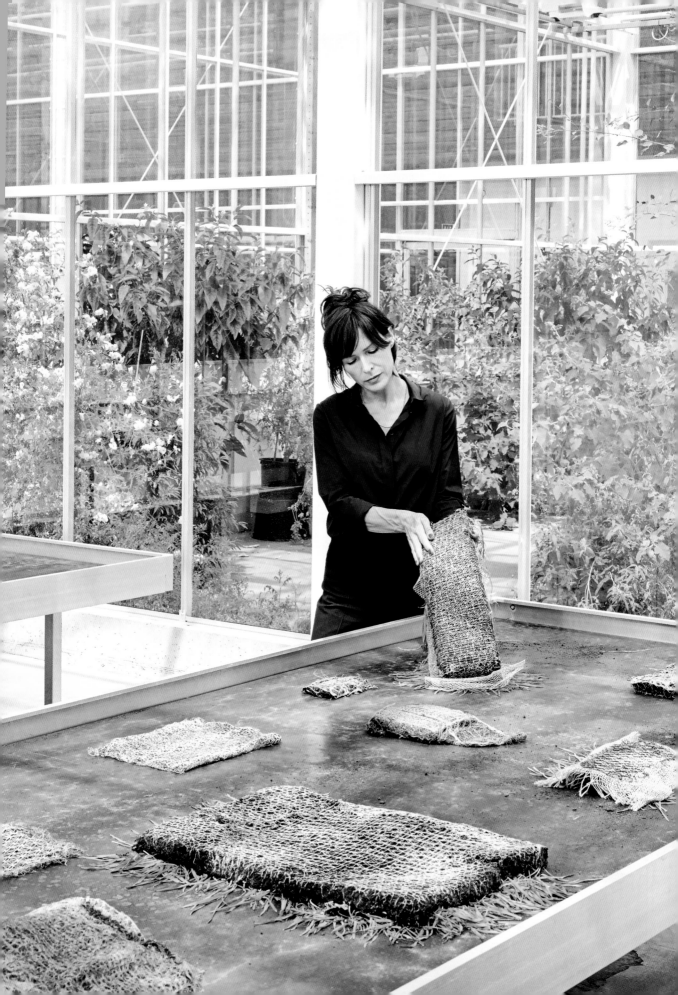

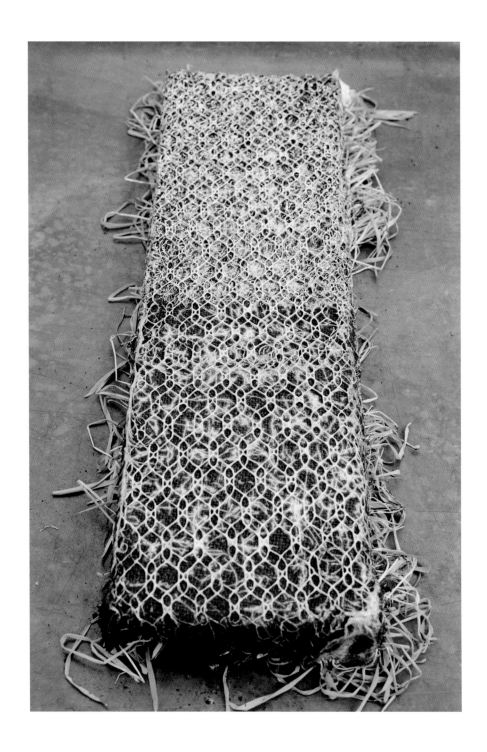

Above
SCHERER'S PATTERNS ARE DERIVED
FROM 'NATURE'S GEOMETRY –
HEXAGONS, FOR EXAMPLE'.

Opposite page
IN ADDITION TO HER STUDIO IN AMSTERDAM,
SCHERER HAS A WORKSPACE IN RADBOUD
UNIVERSITY NIJMEGEN'S GREENHOUSE
THAT ALLOWS HER TO PRODUCE PIECES
THROUGH THE WINTER.

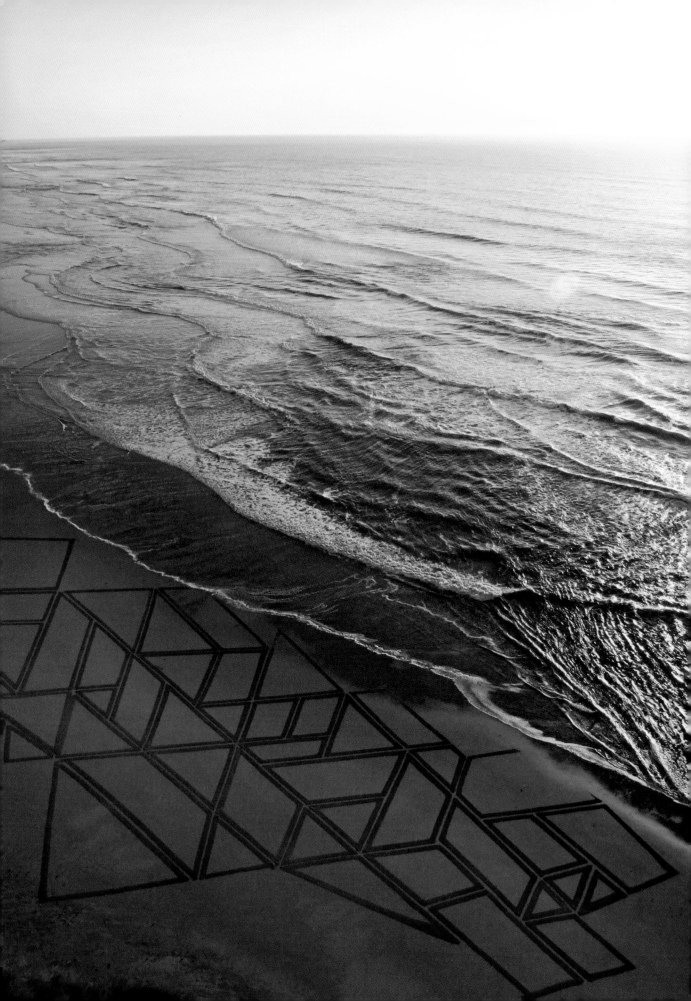

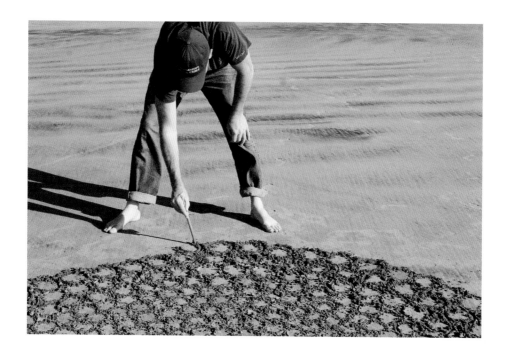

PRINCE OF TIDES

Jim Denevan elevates a universal summer occupation — drawing in the sand on the beach — to unforgettably epic heights.

Words JANE SZITA **Photos** COURTESY OF JIM DENEVAN

Using a rake or a piece of driftwood, California artist Jim Denevan shapes monumental works on the sandy beaches of the world, spending hours on huge and often complex geometric patterns destined to be washed away at the turn of the tide.

A surfer and a chef as well as a sand artist, Denevan has lived in Santa Cruz since he was a teenager, apart from spending a spell in Europe as a model. He began his sand drawings in the 1990s, when his mother — who raised him and his eight siblings alone, following the death of his father when he was only five years old — developed Alzheimer's disease. Sand art became a way for him to cope with her devastating decline. 'To get out every day and to lose a drawing that's a mile across every time — it's a great fight,' he says.

Despite their accuracy, his designs are the improvised work of the moment and are executed freehand, without plan or measurement. Photographs of his ephemeral works are in major collections, including that of New York's Museum of Modern Art. 'It's like drawing on a piece of paper,' he says, 'except my piece of paper happens to be several miles across.' A single drawing can involve the need for him to cover 40 km or more.

How did you get interested in sand as a material?
JIM DENEVAN: As I live close to the ocean, I am surrounded by sand. It's a profoundly common substance where I live. I thought to myself: Why not make a medium of it?

What conditions do you prefer?
I like low tides and places where large waves and storms have mixed the sand during the previous week. As the weather calms, the sand becomes uniform and more luminous.

Considering the quality of the sand for drawing is very important. I'm deeply involved in the qualities of sand, its colour and utility — is it good for drawing?

How has your technique evolved?
I started with just my finger, graduated to a short stick and then to a longer stick near my own height. After that, I began to use different rakes. Now I use both a long stick and rakes. For most of my drawings, I work alone. I generally work spontaneously, with no prior plan. My work is the result of a lot of practice. The circles aren't perfect, but they're close enough to look as though they are.

I've also done drawings on dry or frozen lakes, and those I make by walking and using vehicles.

What inspires your designs?
My inspiration is whatever comes to me that day. Generally, I try to solve an interesting visual problem. Something like — how to make a perfect circle. How to make a straight line. What is a ratio? What variations on curves can I make?

How many sand drawings have you made?
Thousands. Not all of them have been photographed, though.

What's the biggest sand work you've produced?
I once walked for hours while drawing a single straight line. That drawing would have been perhaps 22 km long. And I once made a circle that was 18 km in circumference.

How long do the works last?
The *complete* sand drawings exist for a very short time, generally only for a few minutes to a half hour.

How do people react to your work?
Sometimes playfully, sometimes with reverence and sometimes with simple curiosity — how did you do that? Others see it as a sort of meditation.

Are you ever tempted to make something more permanent?
I am, but perhaps something that requires constant attention in order to be considered 'done'. I am intrigued by the idea of maintenance, as in sports fields or roadways where potholes appear and must be filled.

Do your sand works relate to your other activities: surfing and organizing the Outstanding in the Field dinners?
My activities are interrelated in that they all involve following the weather and expressing myself as the phenomena allow.

jimdenevan.com

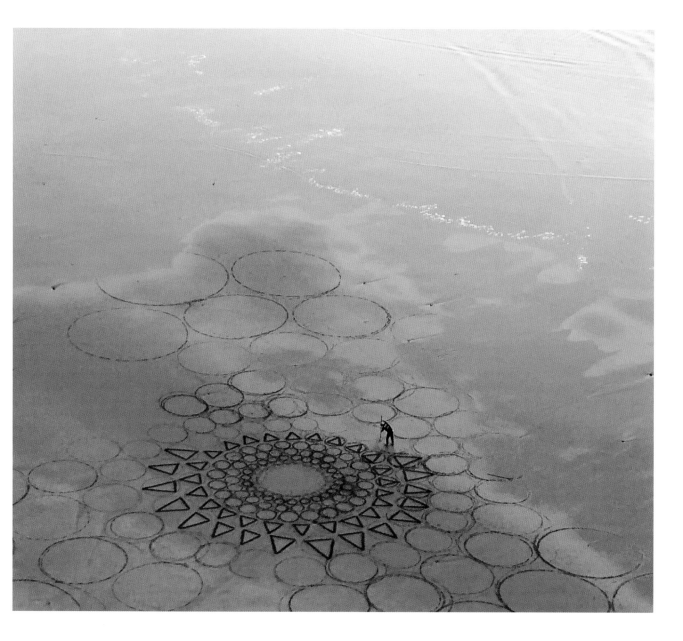

Above
DESPITE THEIR ACCURACY, HIS DESIGNS ARE
THE IMPROVISED WORK OF THE MOMENT AND
ARE EXECUTED FREEHAND, WITHOUT PLAN OR
MEASUREMENT.

Previous spread, left page
COMPLETE SAND DRAWINGS EXIST FOR A VERY
SHORT TIME, GENERALLY ONLY FOR A FEW
MINUTES TO A HALF HOUR.

Following spread, left page
DESPITE THEIR ACCURACY AND DIMENSIONS,
DENEVAN'S DESIGNS ARE THE IMPROVISED
WORK OF THE MOMENT AND ARE EXECUTED
FREEHAND, WITHOUT PLAN OR MEASUREMENT.

Following spread, right page
DENEVAN SPENDS HOURS ON COMPLEX
GEOMETRIC PATTERNS THAT WILL BE WASHED
AWAY AT THE TURN OF THE TIDE.

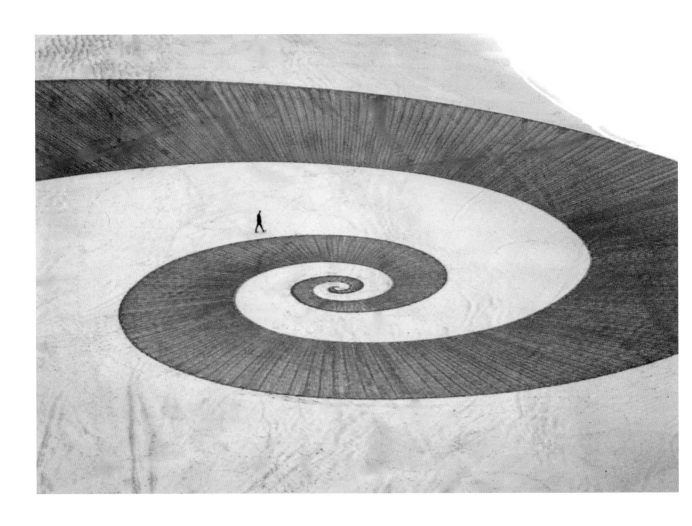

**'It's like drawing on a piece
of paper, except mine happens
to be several miles across'**

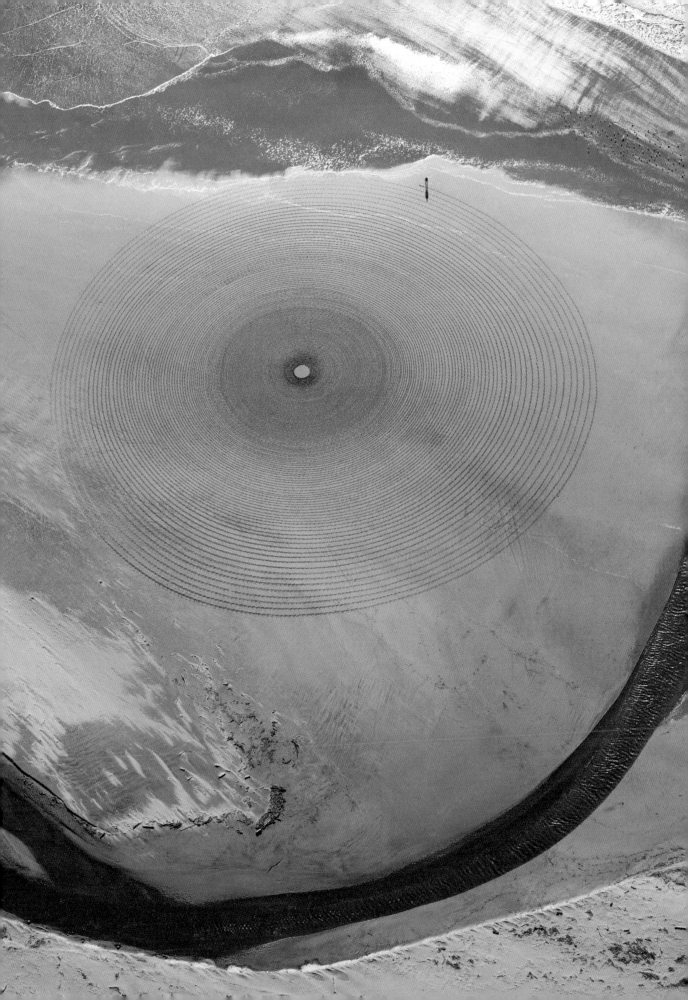

WHITE MAGICIAN

**By simply walking in the snow,
Simon Beck creates complex geometric
worlds of chilly crystalline beauty.**

Words JANE SZITA **Photos** SIMON BECK

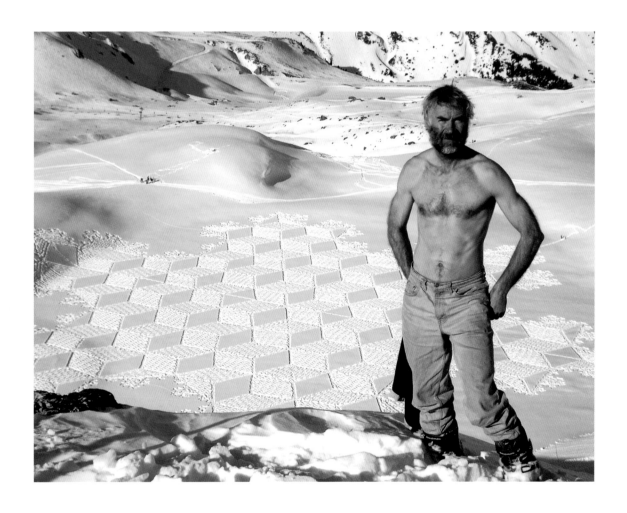

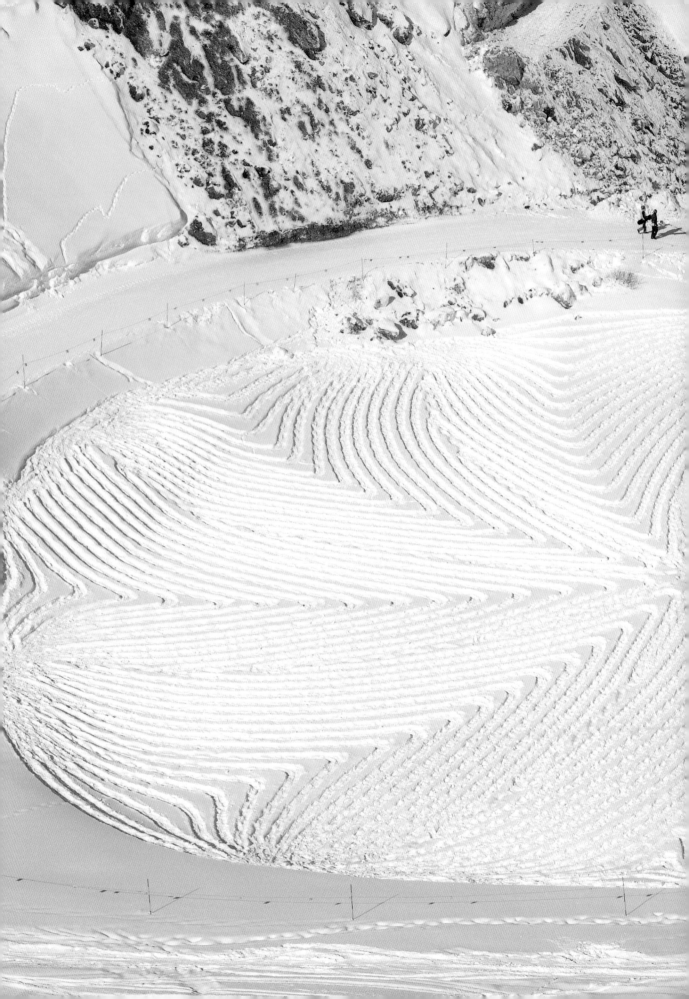

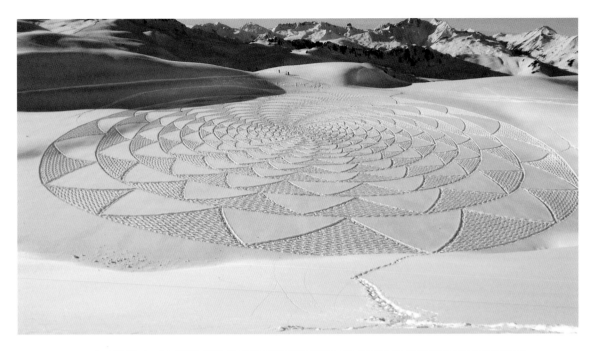

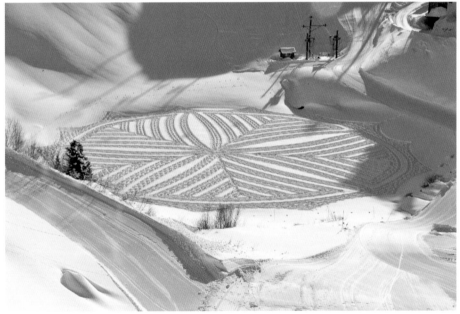

Above
AFTER MAKING A DRAWING, SIMON BECK
METICULOUSLY PACES OUT THE LINES OF HIS
DESIGNS IN THE SNOW BEFORE HE CREATES
THEM, LITERALLY STEP BY STEP.

Previous spread, right page
SIMON BECK, WHO LIVES IN THE FRENCH
ALPS, SETS OUT ON SNOWSHOES TO SHAPE
INTRICATE PATTERNS, OFTEN THE SIZE OF
SEVERAL FOOTBALL PITCHES.

Following spread
AFTER A DOZEN OR MORE HOURS OF
TRUDGING THROUGH THE SNOW, BECK
PHOTOGRAPHS THE COMPLETE DESIGN.

From his home in the French ski resort of Les Arcs, Simon Beck sets out on snowshoes to shape intricate patterns, often the size of several football pitches, literally step by step. Working from a drawing, British-born Beck, an Oxford University-educated engineer, orienteering mapmaker and keen skier, meticulously paces out the lines of the designs or measures them using a rope and compass. After a dozen or more hours of trudging through the snow, he photographs the complete design. Beck has attracted a growing following since creating his first 'snow drawing', as he calls them, in 2004.

How did you start making your snow art? SIMON BECK: It began as something to do after skiing. At first it was just a bit of fun, but gradually I started taking it more seriously. Then people started offering me money for the right to use my photos, and it really took off when I began posting the pictures on Facebook.

What kind of snow conditions do you need? The best would be new powder on a firm base, allowing me to make footprints about 25 cm deep. The worst thing that can happen is for the wind to blow. If the snow starts blowing around, then there's no point in doing anything beyond measuring and leaving marker sticks.

How did you evolve your technique? Well, the main skills are measuring and setting out, which I learned from orienteering-map production. Measuring requires focus and concentration — it's tough and boring. For simple drawings, measuring takes about an hour, but for more complex ones it can take several hours. Once the measuring is complete, I can relax and listen to some nice music. Then I start enjoying it.

What tools do you use to create these works? Snow shoes, marker sticks, a prismatic compass and a measuring rope.

How many designs have you completed? I have made about 100 snow drawings, although several have been repeated half a dozen times.

How do you make the geometric patterns so accurate? Usually, I use pace counting for distance measurement. Occasionally I use a measuring rope — actually a steel washing line — but this takes a lot longer. When I use a measuring rope, I have the additional problem of an unavoidable snow track into the middle of the pattern, so I often visually calculate a circle, even though it compromises the overall accuracy. Direciion is done using the same compass I use for orienteering-map production.

What's the best thing about working with snow? It's free.

What inspires your work? I regret to say that a lot of the drawings are based on what requires the least amount of measuring, and on what will look good even with a certain lack of accuracy. Measuring is a bit too much like work, but now that making snow drawings is *becoming* my work, I don't mind it so much. It is much easier to rationalize something you don't like when there's money on offer.

How long does it take to complete one of your snow works? It depends on the complexity. A good one covers an area of three football fields and takes 12 hours.

How long do they last? Until they are covered by fresh snow. Often the 'ghost' of an earlier drawing will be visible, overlapping a more recent drawing. Sometimes they reappear when the snow melts in the spring.

Are you ever tempted to make something in a more permanent medium? I'd like to make a drawing by walking in concrete before it sets.

What do you do in summer? Sometimes I feel I would like to be in the snow again and wonder whether I should make the effort to go to the southern hemisphere. Perhaps I'll do that next year.

Does your work have a message? I like to show people that there's a lot of beauty out there that is worth preserving. I may do some environmental-political works in the future.

Will you continue to work in snow? Yes, as nobody else seems to be doing this.

What's the hardest thing about being a snow artist? Getting a good photo when the work is complete. Winter days are short, and I need to have sunshine on the day after I make the drawing. About a third of the drawings have to be repeated because I fail to get a good photo. I ought to get myself properly organized with floodlights for the main sites, but in a way I feel that would be cheating …

snowart.gallery

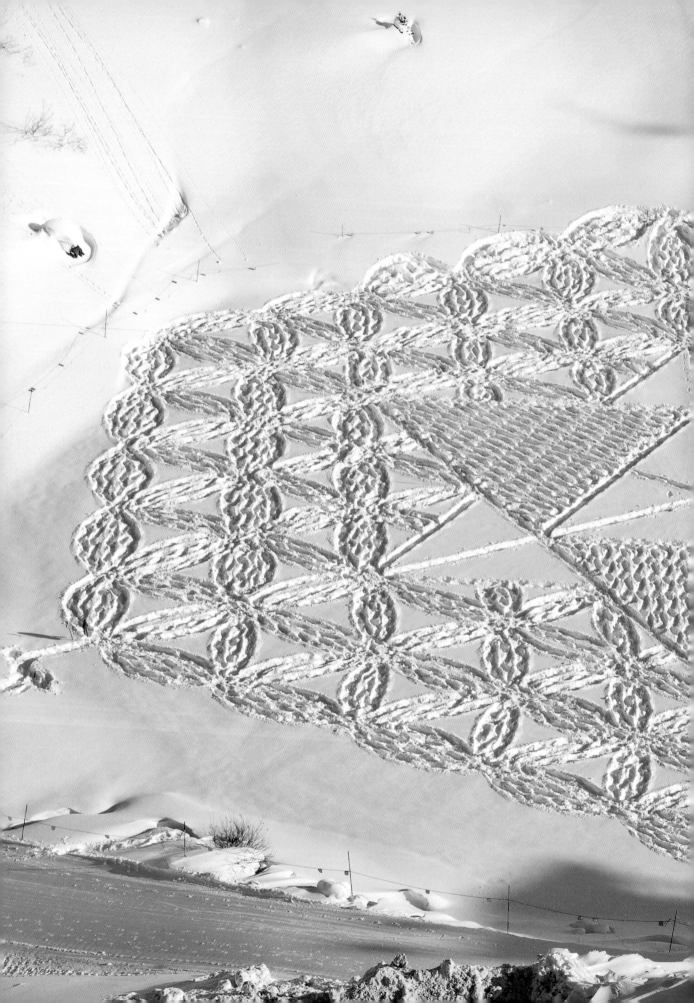

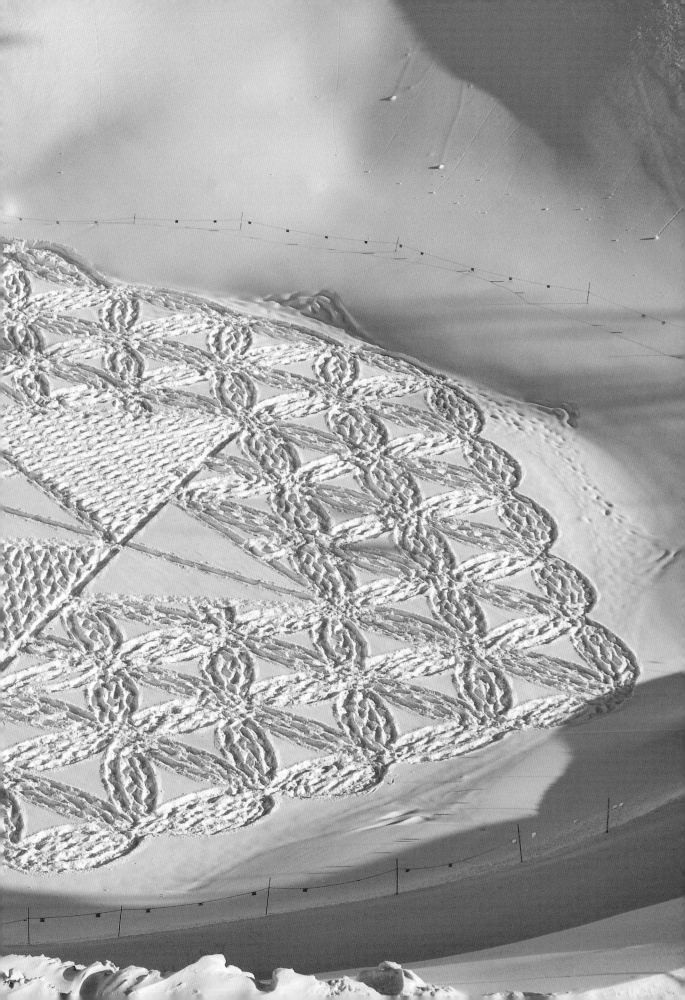

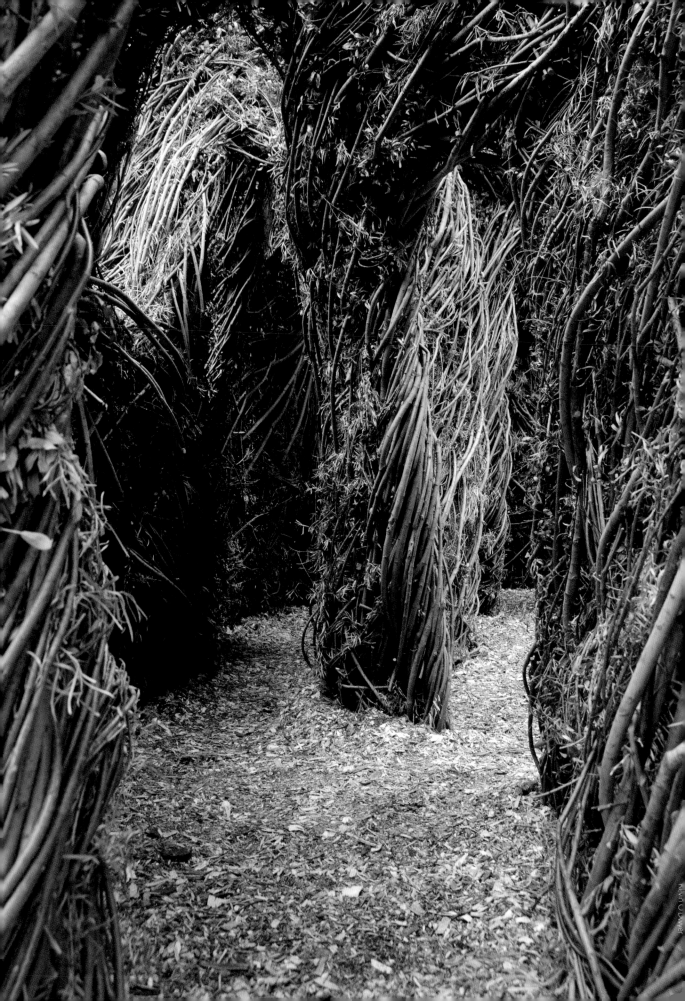

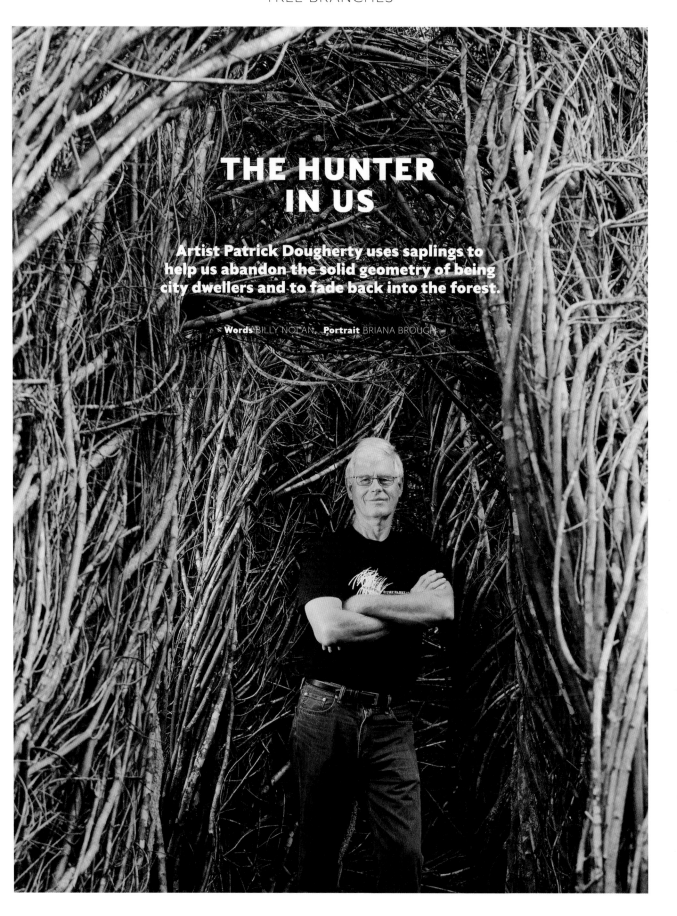

THE HUNTER IN US

Artist Patrick Dougherty uses saplings to help us abandon the solid geometry of being city dwellers and to fade back into the forest.

Words BILLY NOLAN. **Portrait** BRIANA BROUGH

Saplings? PATRICK DOUGHERTY: The key to a sculptor's choice of materials can often be found in childhood. Tree branches and saplings have rich associations with childhood play and with shelters built by animals.

So you had a rural upbringing. I grew up in the woodlands of North Carolina, where forests are a tangle of intersecting natural lines.

And you revive those forms that have been embedded in your memory since childhood? Even earlier. I think we carry this sort of know-how with us as a legacy from our hunting and gathering past. When I turned to sculpture in the early 1980s, I had to rediscover what birds already knew: sticks have an infuriating tendency to entangle with one another.

By building with sticks, you're imitating nature. I'm fond of saying that sticks were mankind's first building material, and even the modern person continues to have a deep affinity for how to use them.

Describe how you set about making a work. I start by finding a good stand of saplings nearby. The construction technique is a layering process. First I pull one stick through another and build a haphazard matrix to create the rough shape of the sculpture. Next comes the drawing phase, in which I picture a pile of sticks as a bundle of lines with which to sketch the surface texture.

And all those surface swirls and eddies? I've learned to amass the smaller ends of sticks in one direction to give the impression that the surface is moving. The final step is 'fix up', a cosmetic treatment in which I erase certain mistakes by covering them with very small twigs.

The perfect sapling is … Willow is a favourite, but I also use maple, sweet gum, elm and dogwood. Sometimes I use more exotic saplings like sassafras, crab apple or fruit woods. In Japan I experimented with reeds and bamboo, and I have also used strawberry guava in Hawaii.

What do passers-by say as you're working? I sense in the comments a profound connection between humans and the plant world that surrounds them. Time and again, I've heard a well-dressed man say to his wife, 'Listen honey, we could live here … No, I mean it. It would be perfect for us.'

stickwork.net

Previous spread, left page
TREE CIRCUS, BLACKFOOT PATHWAYS
SCULPTURE IN THE WILD, LINCOLN,
MT, USA (2017).

Oppostie page
SORTIE DE CAVE, JARDIN DES ARTS,
CHATEAUBOURG, BRITTANY (2008). NINE
BORDEAUX BOTTLES TOWERING ALMOST
7 M HIGH SIT AT THE EDGE OF A POND.

THE ROYALS, MCKEE BOTANCIAL GARDEN,
VERO BEACH, FL, USA (2017). THIS SCULPTURE IS
SITUATED IN THE ROYAL PALM GROVE,
THE SIGNATURE PLACE IN THE MCKEE
BOTANICAL GARDEN.

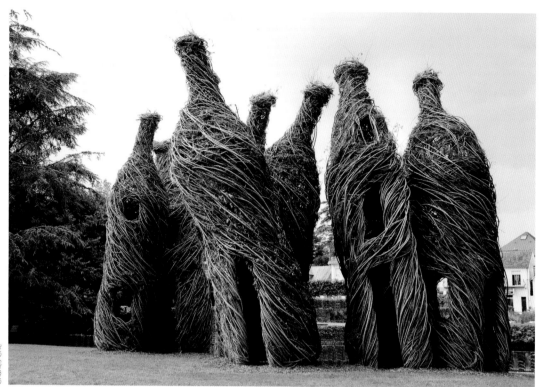

Charles Crié

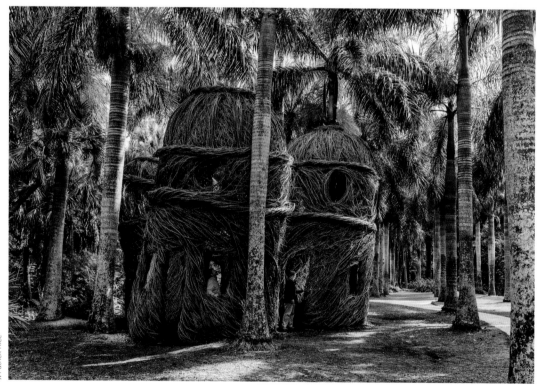

J. Patrick Rice

'The key to a sculptor's choice of materials can often be found in childhood'

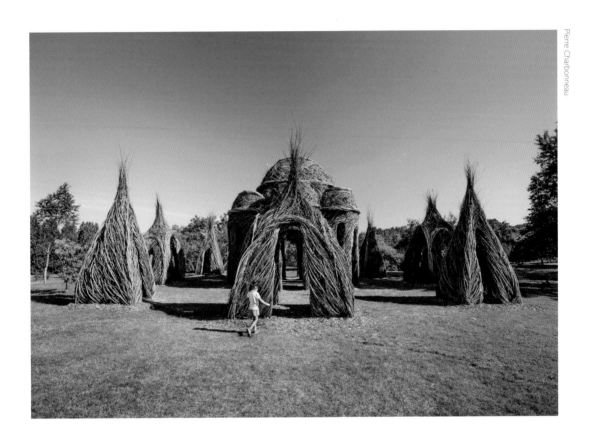

Pierre Charbonneau

Above and opposite page
FANCY'S BOWER, MONTREAL BOTANICAL
GARDEN, MONTREAL, QB, CANADA (2017).
INSPIRATION FOR THIS WORK CAME FROM
ANCIENT OBSERVATORIES. THE CENTRE TOWER
HAS A LARGE OCULUS IN THE CEILING TO
ENHANCE THE FEELING OF LOOKING SKYWARD.
THE OUTLYING PYRAMIDS REFERENCE
STONEHENGE AND OTHER SUCH MONUMENTS
TO ANCIENT ASTRONOMY.

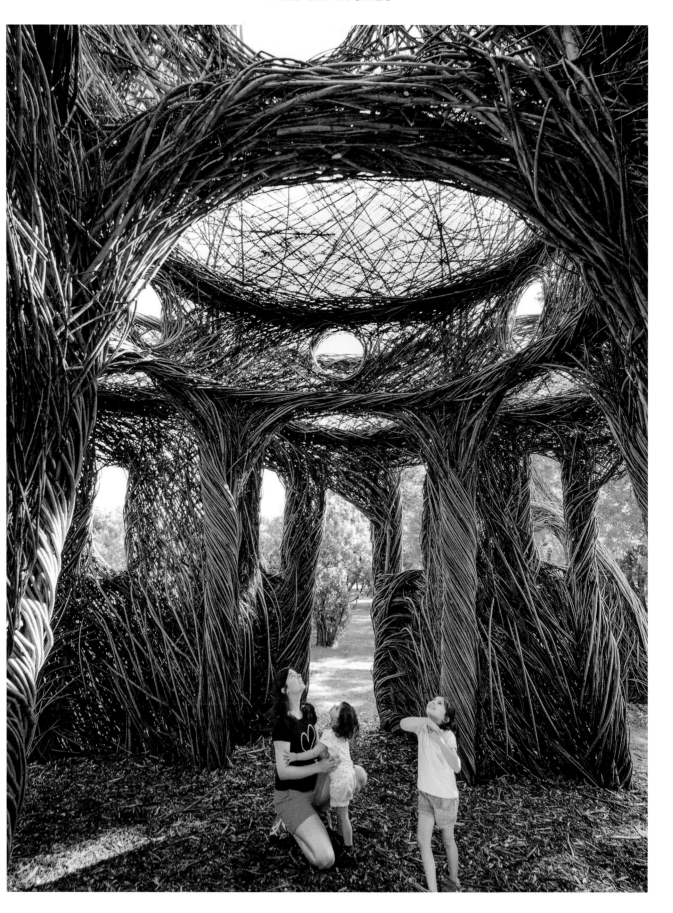

JUICY STORY

While working on their Raw Color project, Daniera ter Haar and Christoph Brach were captivated by the colour of natural juices.

Words FEMKE DE WILD **Photos** COURTESY OF RAW COLOR

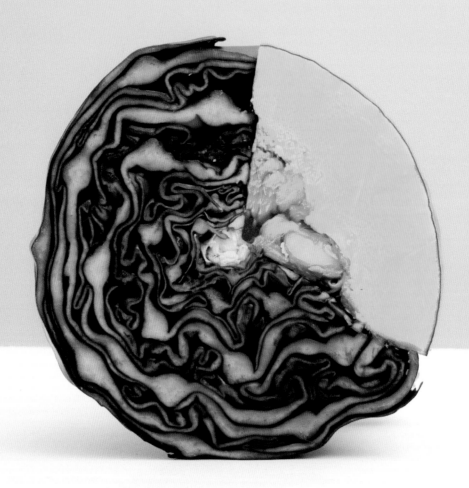

Stichting Plaatsmaken, Graphic Matters, Raw Color

Above

SOLIDS & STROKES (2017) IS AN EXPLORATION
OF SILKSCREEN PRINTING AND ITS
POSSIBILITIES TO CREATE DIVERSE COLOUR
COMBINATIONS. SUPERIMPOSED RECTANGLES
ARE SYSTEMATICALLY ARRANGED IN
VARIOUS COMPOSITIONS, APPLYING SIXTEEN
COLOURS IN 32 PRINT RUNS.

When did you start working with vegetables? DANIERA TER HAAR: In 2007 we were asked to participate in an exhibition – NAT Designing Nature – with a project that combined nature, culture, biology and design. Christoph and I wanted to create a transparent vegetable by removing all colour from a beetroot. That was impossible, of course. So we designed 100% Juice, an apparatus that squeezes juice from beetroot and empties the inky fluid into a sheet of paper, where it creates a two-dimensional image of the vegetable. The three-dimensional beet becomes a flat picture. We tried it with carrots as well, but the colour faded very quickly.

After you finished that project, why did you keep working with vegetables? It wasn't so much the vegetables that fascinated us, but the natural inks we could make out of them. Natural colours stay alive. Light tints disappear rapidly, but dark shades continue to change, even after being used for printing. It's intriguing, but it's also difficult. A Dutch organization, Platform 21, gave us

rently, we can't guarantee that the print you buy will remain unchanged. Normal fixatives spoil the colours of both ink and image. Another problem is the limited 'shelf life' of the juice, which makes the process very labour-intensive. Everything's got to happen in one day; after that, we have to start all over again. Right before Inside Design in Amsterdam, for instance, we realized that the juice we'd planned to use was too thin for screen printing. We worked all night to get exactly the right binding agent and barely managed to finish the screen prints on time. Talk about an adrenalin rush!

What do you want to achieve? It would be fantastic to finally develop a usable organic ink, even though we don't want to be ink suppliers. From our perspective, this project is all about letting people see how we think as designers. We'll continue to approach the work as an investigation – one that includes a search for the origins of colours. While we were making colour charts, we discovered not only that the colours keep changing but also

'Colour is usually avoided, because it makes such a powerful statement'

the opportunity to do in-depth research on the possibilities of converting vegetables into natural inks. We had two days a week to experiment in any way we wanted. We squeezed the fluid out of all kinds of vegetables and made various blends as well.

What was the purpose of the project? We had no predetermined goal. Raw Color is truly a research project. With every step we take, we run into a new problem. Solving those problems leads to fresh discoveries and, in turn, new projects. It's become an ongoing study.

What kinds of discoveries? We thought it was a shame, for instance, to throw away all the leftovers. One idea was to dry vegetable pulp in ovens. And what happened? The drying process provided us with very strong pigments. Another time, while we were compiling colour charts, we discovered that the colours produced by red cabbage, beetroot and pumpkin were nearly the same as cyan, magenta and yellow, the three basic colours used in printing. When we used our inks in a standard ink-jet printer, we got great results, but the print heads clogged very quickly. We'd like to develop a printer that works well with vegetable juice.

Any other problems? We're looking for a way to make sure the colours stay alive without fading away. Cur-

that the juice from red cabbages isn't always the same colour. Sometimes it's a beautiful blue, and at other times it's purple. That's probably due to the level of acidity in the ground where the cabbages are grown. It's the influence of such factors that really rouses our curiosity.

Is the 'natural' aspect of the project important to you? A project doesn't necessarily have to be natural to interest us. My graduation project featured fabrics, and materials fascinate me. My partner, Christoph, has a background in graphics, and this project definitely has a graphic character. Here we're working only with paper, not with textile. Our backgrounds and our life together – we're partners both professionally and privately – has led, little by little, to a shared passion for colour.

Why do you think colour fascinates you so much? Colour is usually avoided, because it makes such a powerful statement. That's why people opt for white, which is safer. We see colour as an enhancer. We often make series of colours, and we like colours that clash a bit. In our eyes, colour is a material – it's become the leitmotif in our work.

rawcolor.nl

Above
MIXING JUICE FROM DIFFERENT TYPES OF
VEGETABLES PROVIDES A BROAD VARIATION
IN COLOUR.

Opposite page
TER HAAR AND BRACH MADE PHOTOGRAPHIC
VISUALIZATIONS OF COLOUR COMBINATIONS
CREATED WITH THE JUICE OF VARIOUS
VEGETABLES.

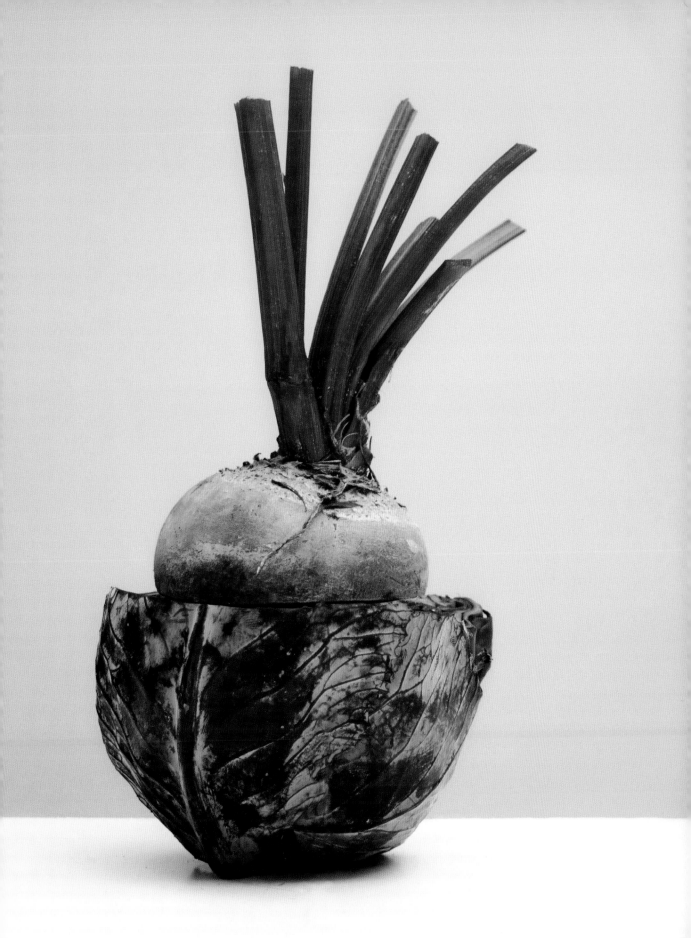

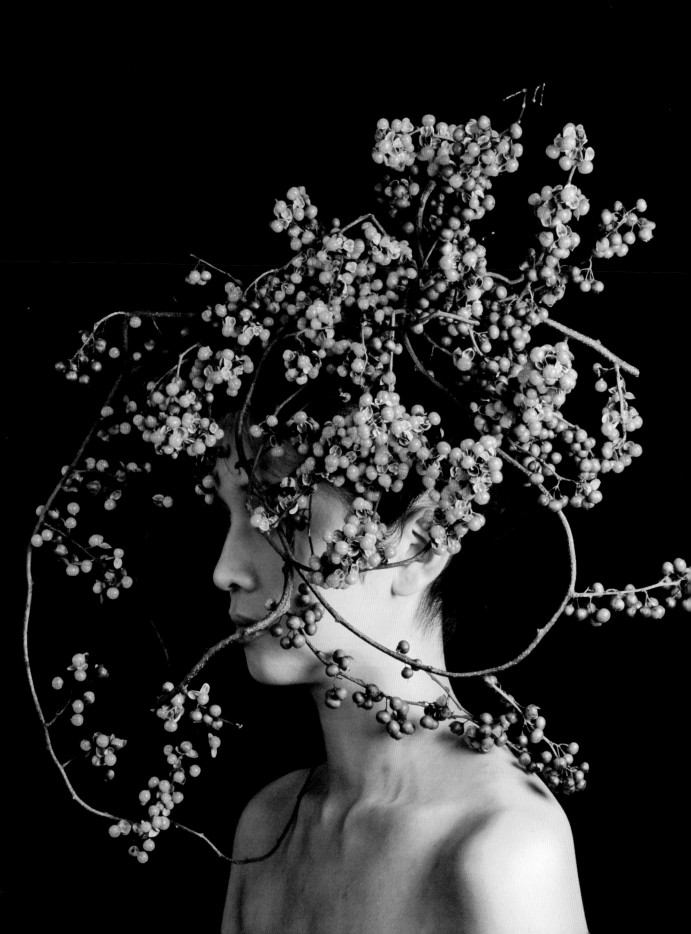

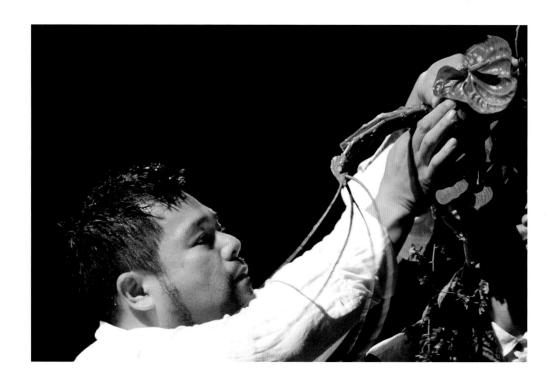

VEG HEAD

Like a horticultural Philip Treacy, Japanese designer Hanayuishi Takaya makes — and photographs — extravagant headpieces made of vegetables, fruit and flowers.

Words JANE SZITA **Photos** HANAYUISHI TAKAYA

Born in 1975, Japanese artist Takaya started out as a chef before photography led him to *hanayui*, the art of using vegetation to dress hair. After attaching plants and flowers to the head, he sculpts the foliage into shape using scissors. As well as crafting striking, Arcimboldo-like compositions for his own photos, Takaya makes creations that are in demand for fashion shows, weddings, live performances and media campaigns. He lives and works in Kyoto.

When did you start on this series of works? HANAYUISHI TAKAYA: In 2004, when I decided to change my life around and start a new career as an artist. I was a French chef before that. From when I was nine years old, I'd dreamed of having my own restaurant. I began working as a *pâtissier* when I was 15, became a fully fledged French chef at 19 and made my dream come true at 24, when I opened my own bistro. When I was 30, I decided I wanted to change.

What gave you the idea of putting these arrangements on people? I like to take photographs. One day when I was thinking about what subjects I'd like to shoot, I had a vision of a woman with flowers growing out of her head. As a result of that vision, I got a model to pose while I arranged flowers on her head, and I really felt something – a sense of creation and design springing from my hands. It was then I realized that what I really wanted to do was unite nature and humanity.

Who are your influences? I think I'm influenced by the surroundings I grew up in, by the beautiful architecture of Kyoto and the history of Japan.

Do you object to being called a florist? I describe myself as an artist, but of course people do sometimes ask whether I'm a make-up artist or a florist. I tell them I'm a *hanayuishi*, a new creative profession that combines floristry, make-up and art.

What is it that fascinates you about vegetation as a material? I can't compete with the beauty of nature. Flowers, fruits and vegetables are all wonderful examples of design in themselves. So I guess I'm challenging myself to achieve better designs based on natural beauty, which keeps my motivation high.

How long do the arrangements take to do, and how long do they last? I can improvise the design in ten or 15 minutes. How long they last depends on the temperature, wind and humidity, as well as the model's body temperature. In summer they may hold for three or four hours – in winter about eight hours.

Isn't it hard seeing your living coiffures wither so quickly? The beauty of plants illuminates our life, and then it's gone. I devote myself to the moment in which my works can shine. Taking photographs of my pieces helps me to preserve something of what I've made.

How do you see your work in the future? I'm excited about the future. Who knows, I might become a hat designer. And I'd love to work with fashion designers all over the world. I've done a show in Tokyo using only male models. But I'd love to take my work beyond Japan.

takaya.boo.jp

Previous spread, left page
PERISHABLE PERFECTION: TAKAYA'S PIECES LAST ONLY THREE HOURS IN THE SUMMER AND EIGHT IN THE WINTER.

Opposite page
TAKAYA USES RAW VEGETABLES TO CREATE HEADDRESSES THAT ARE REMINISCENT OF THE SURREAL WORK OF 16TH-CENTURY ITALIAN ARTIST ARCIMBOLDO.

Following spread
EACH COMPOSITION IS TAILORED TO THE FEATURES OF THE MODEL.

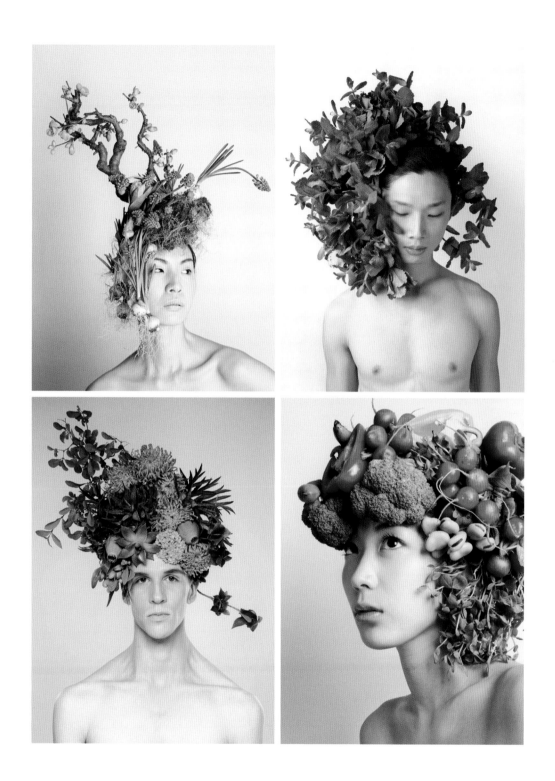

**'I unite nature
and humanity'**

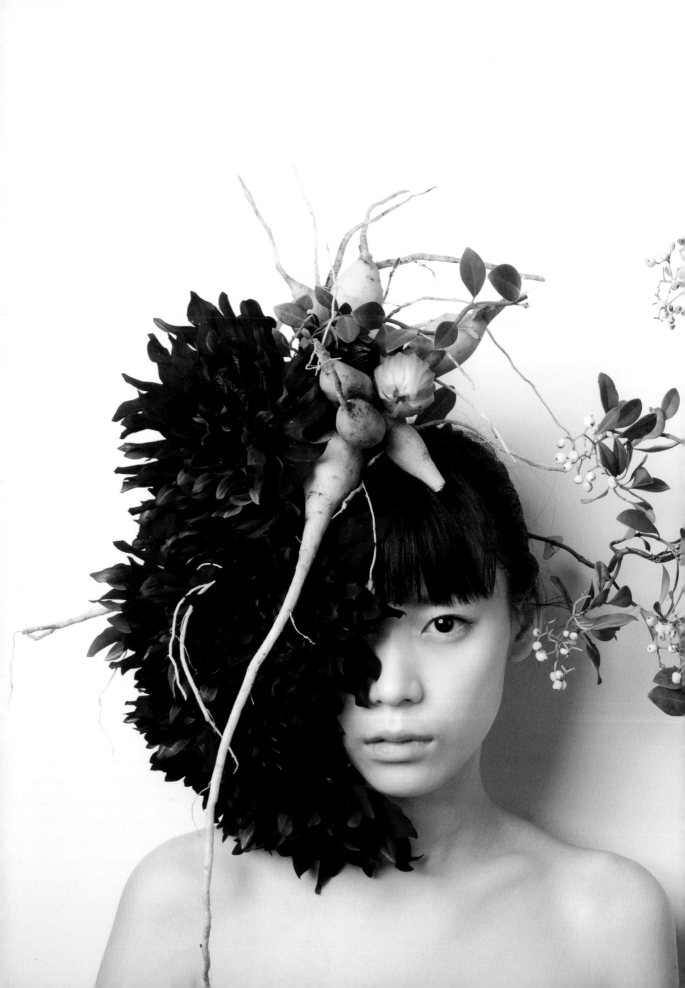

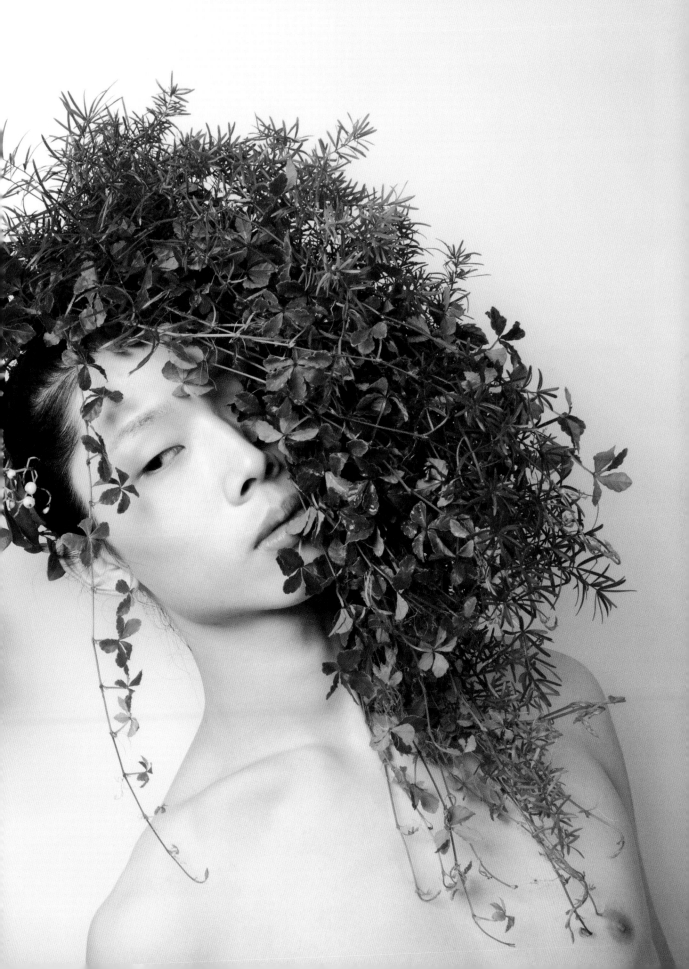

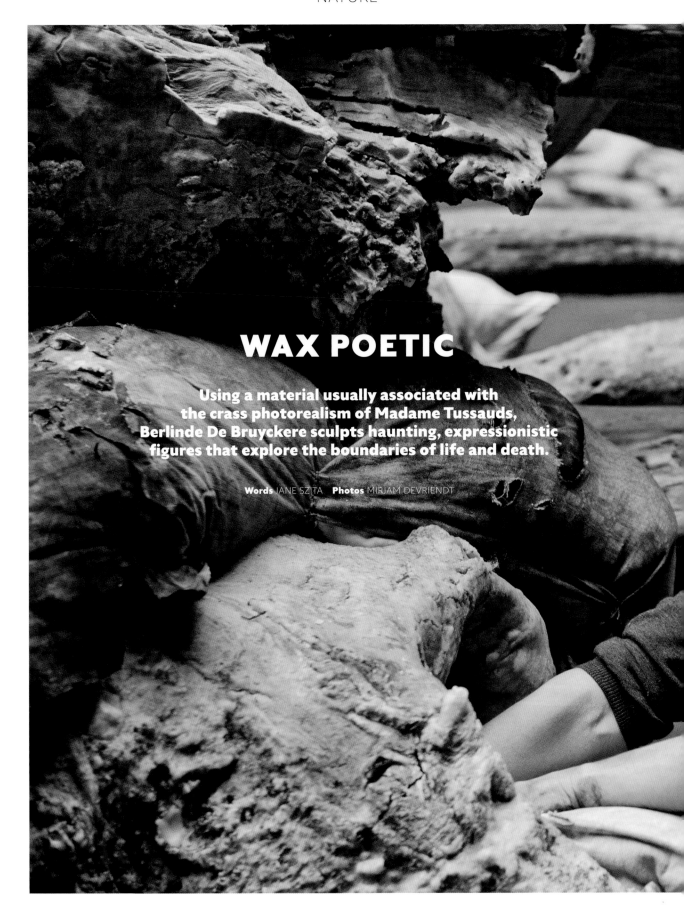

WAX POETIC

**Using a material usually associated with
the crass photorealism of Madame Tussauds,
Berlinde De Bruyckere sculpts haunting, expressionistic
figures that explore the boundaries of life and death.**

Words JANE SZITA **Photos** MIRJAM DEVRIENDT

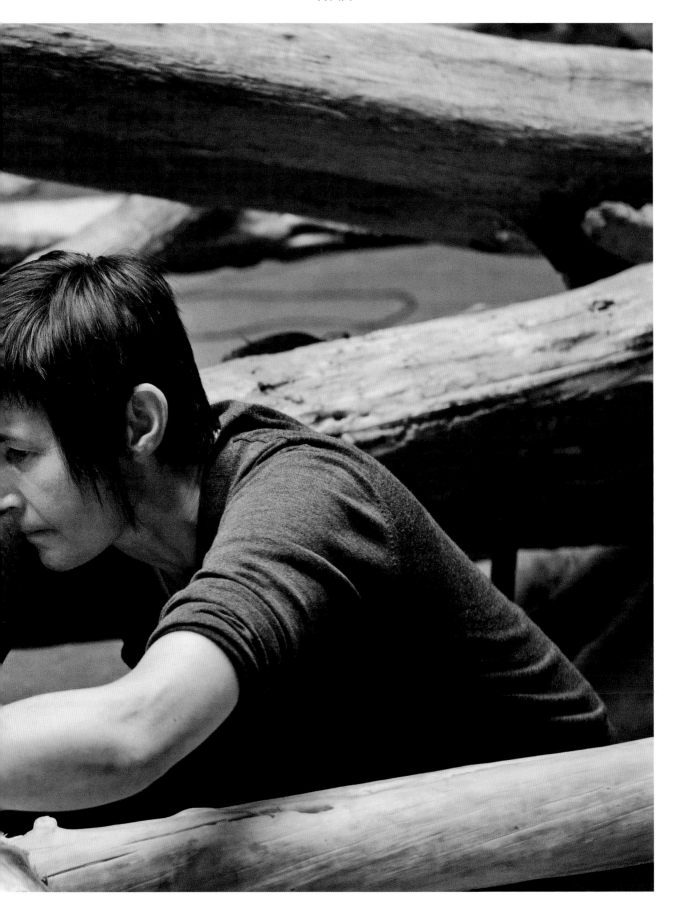

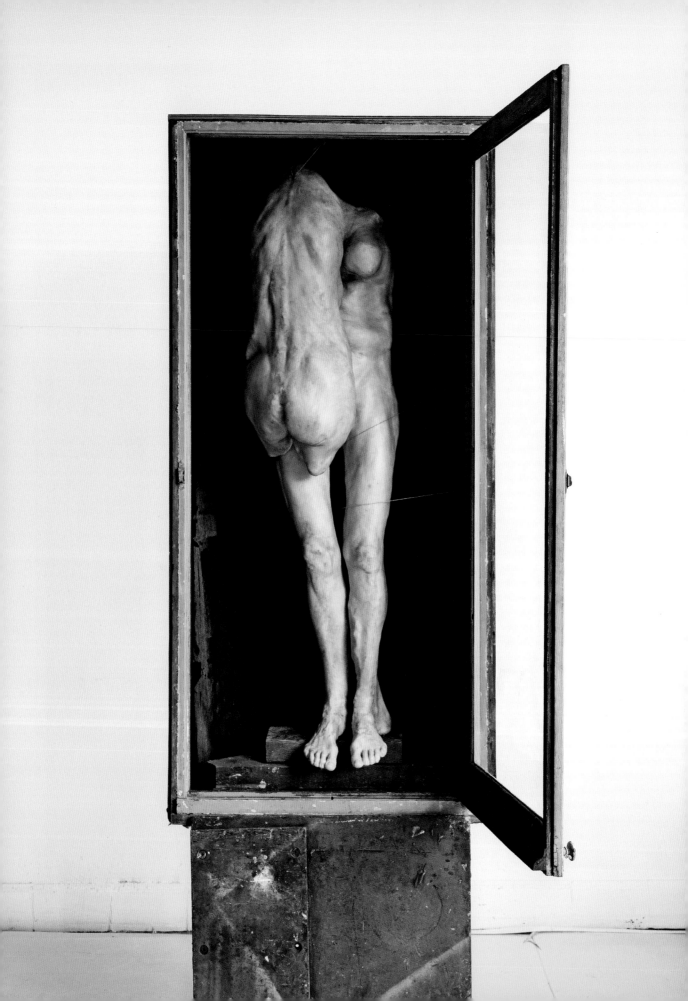

Cripplewood, which was on show at the 2013 Venice Biennale, is the largest work by Belgian artist Berlinde De Bruyckere. A straggling jumble of branches attached to a huge trunk, flesh-coloured and partly bandaged to underline its resemblance to a human figure, *Cripplewood* was cast in wax, a medium that she has elevated to an epic level.

Although De Bruyckere has been working since the 1980s, her efforts attracted international attention only in 2000, when she created a war-themed commission for the In Flanders Fields Museum in Ypres. The resulting installation of five life-size, contorted wax casts of horses marked out the border domain between life and death, the animal and the human, that has characterized her art ever since. De Bruyckere explains the forgiving nature of her material, her outside-in technique and the darkness of the world it inhabits.

What was the initial inspiration for *Cripplewood*? BERLINDE DE BRUYCKERE: It started when, travelling to France, I came across an uprooted tree lying in a field. I was struck by its loneliness, and by the fact that it was already a sculpture in itself. A trunk with branches, which looked like a big torso with human limbs, made me think of an uprooted person. Later I cast the tree, together with some smaller branches collected from dead trees that I found in the woods near my studio. The finished piece was cast in 29 sections. It measures 16 m long, 5 m wide and, at its highest point, 2.5 m. We had to assemble it on location in Venice.

Why did you begin using wax? In the 1990s I started making my 'blanket women' – human figures with all but the legs and feet swathed in blankets. Wanting the legs to look as lifelike as possible, I asked Madame Tussauds about their wax process, but they didn't want to share their secrets, so I just had to experiment. For my early attempts I used plaster moulds, which were not ideal, because you lose a lot of detail. Silicone is better.

So there was a lot to learn along the way? Yes, since I didn't train to be a sculptor. Because I wanted to create an illusion of skin or flesh, I gradually developed a technique whereby I paint layers of hot wax onto the inside of my silicone moulds. So you're starting from the outside and working in. I use between 12 and 25 layers of wax in different colours to achieve the skin effect. The hot wax melts into the previous layers, so it's like painting with watercolours. We add layers of epoxy to stabilize the wax and metal elements to support it. We connect the sections by welding them together during final assembly.

What's the hardest part of the process? That you don't see the piece until you take it out of the mould, so it's really beyond your control. Also, the process is very intuitive; we melt the wax in pans on a stove, and I have to judge the temperature and the effect that it will have on all the other layers. Once you take the piece out of the mould, you have just 20 minutes to deform or reshape it before it hardens. Back in the early days, we had a lot of problems with pieces that cracked owing to cold temperatures or the wrong kind of transport.

What kind of wax do you use? We make our own blends from different products, so it's not something you can buy. We use different mixes and different pigments for different effects.

What do you most appreciate about the medium? I can work very fast with wax. It's very responsive, very flexible and easy to change. It's almost as though the material is listening to me.

Your work has many art-historical overtones. How did you first get interested in the old masters? When I was five, I was sent to a Catholic boarding school outside Ghent, and I spent as much time as I could in the library, looking at art books. I'm still very much drawn by the way artists like Lucas Cranach and Caravaggio painted skin.

Another aspect of your childhood – your father was a butcher. Yes, and as a result, I'm not afraid of big dead animals. Making casts of horse cadavers has never been a problem for me. What I'm doing is totally different to what my father did, though. He cut up carcasses for people to eat, but it's as though I'm giving dead creatures a new life.

What will you be doing next? My next project is St Sebastian, which was inspired by my time in Venice. So I'll start with a photoshoot of a model, then make drawings, then work with the model again on the moulds, then do the wax. It's a long process.

Your work is rather dark. Does it reflect how you feel about life? The world *is* a dark place. There often doesn't seem to be much hope when you look at events in Syria and other alarming places. In my work, I have to answer some existential questions for myself, and my hope is that the answers help others to find a language for despair, fear and loss.

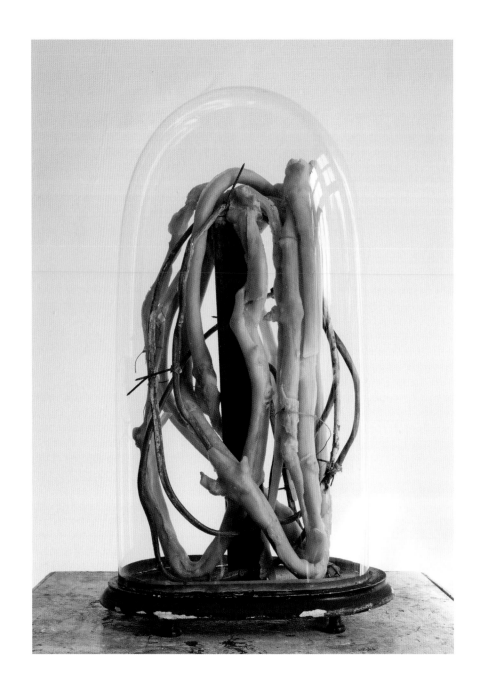

Above
DOORNENKROON II (2008).

Opposite page
CRIPPLEWOOD, A DISTURBING WAX SCULPTURE
BY BERLINDE DE BRUYCKERE, GREETS VISITORS
TO THE BELGIAN PAVILION AT THE VENICE
BIENNALE 2013. A TANGLE OF BRANCHES
IS MADE CORPOREAL WITH FLESHY TONES
AND BANDAGES.

Previous spread, left page
PIÉTA (2007) HIGHLIGHTS THE ART-HISTORICAL
OVERTONES IN DE BRUYCKERE'S WORK.

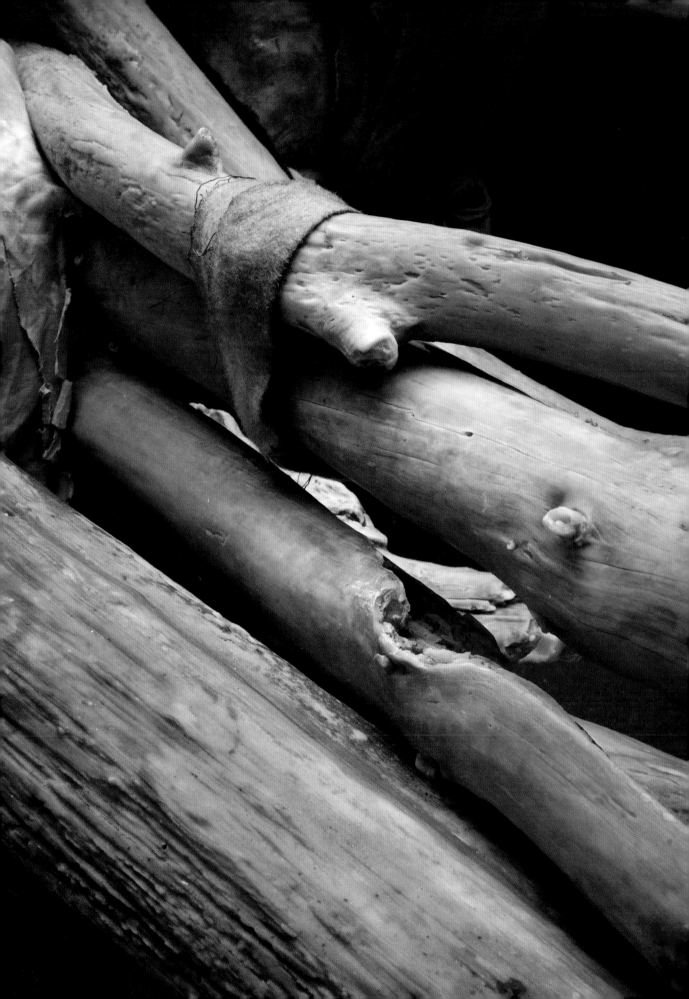

OB
JE
CT

Sculpture has a venerable history and remains an important art form. Gwon Osang's life-size dolls covered with photographs, Davide Quagliola's CNC-milled polystyrene statues and Paiko's glass objects are all contemporary pieces that resonate with art-historical tradition. They combine a conceptually strong approach with a meticulous execution.

WINGS OF DESIRE

Michail Pirgelis recycles old aircraft to create mesmerizing meditations on flight itself.

Words JANE SZITA **Photos** COURTESY OF MICHAIL PIRGELIS

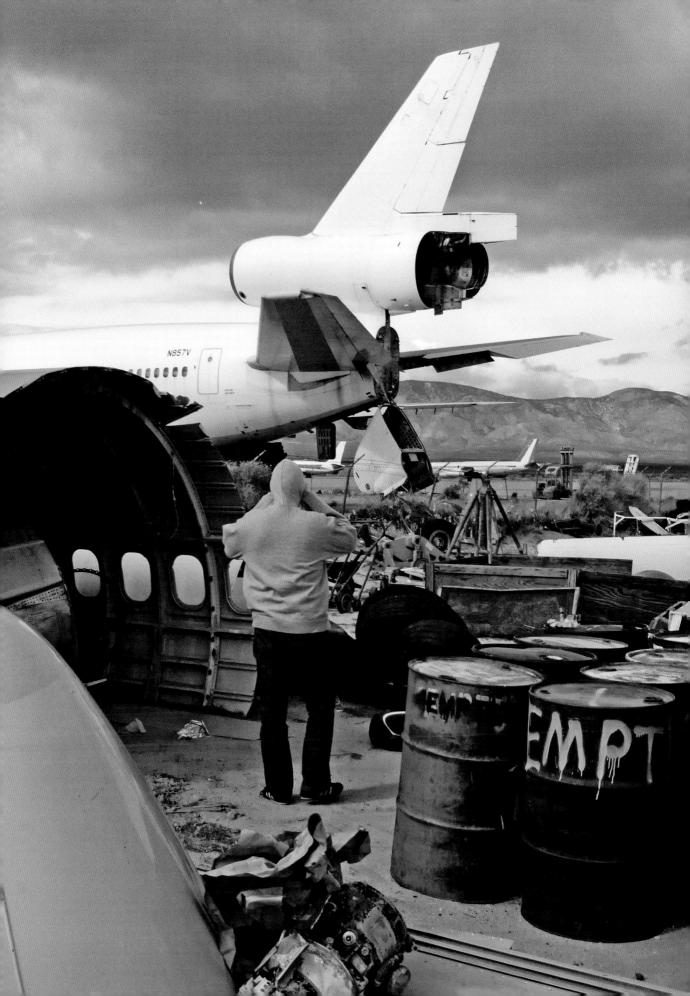

**'Some people interpret my art
as a kind of catastrophe scenario'**

Born in Germany, and raised in Xanthi, Greece, artist Michail Pirgelis now divides his time between a studio in Cologne and the 'plane graveyards' of the Mojave Desert and Arizona, where he finds the raw materials for his work. His sculptural pieces and installations breathe new life into old, unwanted planes, often transforming them into sleek, polished icons — as if Pirgelis is trying to capture the quintessence of the airborne speed they once embodied. *Frame* caught up with him as he touched down in the desert on yet another plane hunt.

Can you explain your obsession with planes? MICHAIL PIRGELIS: They fascinate me as a human achievement. On the one hand, there's this archaic desire to fly that secretly underlies planes; on the other, they embody this high level of technological attainment. Flying is a phenomenon that is not at all easy for a layperson to understand — it isn't obvious how such a heavy craft can take off and then safely land again. I think one of our greatest dreams and challenges has always been to fly.

You obviously like flying. I don't like it — I *love* it.

Where do you source your aircraft parts? I'm always searching for discarded wide-bodied aircraft. Over the past few years I've been travelling to the Mojave Desert and Arizona, where I've discovered plane graveyards. Sometimes I'm able to cut the outer shell wall of a plane or take parts of the cabin away to use. Other times, I'm borrowing elements of an aircraft for an installation, which I later have to return either to the airline or the recycler. Many of my works no longer exist, because they were made out of loan pieces.

Can you describe the process of making one of your pieces? It's hard to describe, because it's always different. Some works use the aircraft segment as a 'found' piece or ready-made, while others have ground, highly polished surfaces. I often reuse the smaller objects I've made for space-oriented installations. In this way, I modify my work over and over again.

Is there more mileage — pardon the pun — in aircraft sculpture? Yes, absolutely. I want to do more. An old aircraft constitutes a material with a history. Aircraft parts belong to the dream of flying and therefore have a special aura.

How do people react to your work? They see different things in it. Some people interpret it as a kind of catastrophe scenario, whereas others see the poetry of it.

Any plans to design an actual plane? I'm really more interested in the old and the existing — but if I get the chance, why not?

Oppostie page, left
FOREVER ALONE (2016).

Oppostie page, right
PERSIAN BOY (2015).

Previous spread, left page
SAM SITTING (2016).

Above
ROLLFELD (2007).

Oppostie page
AERIAL (2006).

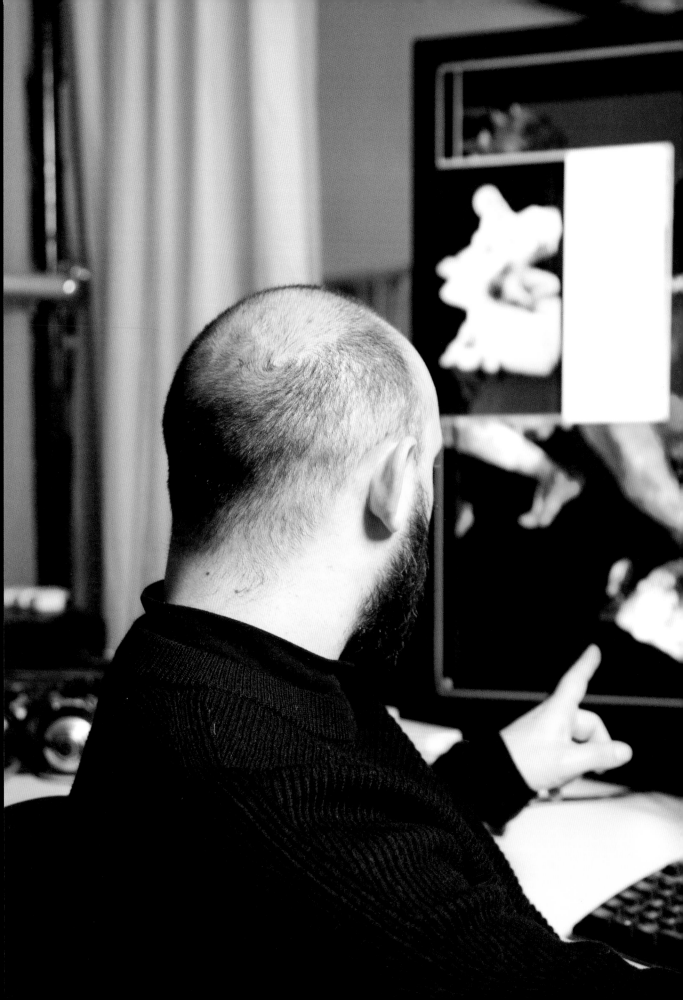

GHOSTS IN THE MACHINE

Drill-wielding robots create Quayola's classical sculptures for the digital age.

Words JANE SZITA **Portraits** WASSINKLUNDGREN

Artist Quayola – alias Davide Quagliola – credits his enduring obsession with classical art to having been born and raised in Rome. After studying digital media in London, he began making films that blend digital animations and old masters to generate otherworldly geometries. In his series *Captives* Quayola's work migrates from the screen to the physical world: rows of 2-m-tall sculptures inhabit a hybrid environment of movement and sound. 'I intended to make another film,' he says, 'but I was seduced by the idea of producing real objects on a classical scale.'

It's hard to know exactly what your materials are. *Captives* is executed in high-density foam, but the figures can be constructed only with the use of software and robots. DAVIDE QUAGLIOLA: There are various layers to my work, all essentially collaborative. I work with a team of programmers and sound engineers and, in the case of the statues, a fabricator. I'm like a film director making a documentary. I define the boundaries in the beginning, but I never know exactly where I'm going, although I do know just enough about the technology to direct people.

So you didn't personally operate the robots? No, they wouldn't let me play with them. At first I thought using a big robotic arm with a drill would be easy, but that was naive. The process is nothing like 3D printing. We used two robots for the project, one on a customized long truck. I had to do lots of research on how to carve blocks digitally, a task that meant we had to develop custom software. Initially, I wanted to use marble, but that was too difficult. Instead, we chose a dense EPS foam, a material generally used for prototypes.

Where did you find the robots? We collaborated with a Danish fabricator. The technology originated in the car industry, and I really like the contrast between the classicism of the subject matter and the use of industrial robots. The exhibition turned out to be what I call a 'sculpture factory' – a cross between an atelier and a car production line. The performance aspect was really important.

What was your inspiration for *Captives*? Michelangelo's series of unfinished sculptures, *Prigioni*, which I often went to see as a child in Rome. We don't really know why he left them unfinished, but I like to think it was deliberate. What fascinates me about them is how our attention shifts from the figurative subject to the articulation of marble.

How would you describe your statues? Imaginary archaeological discoveries.

Can you explain your fascination with classical art? I think classicism is part of our DNA: it informs our ideas of beauty and perfection. Classical art is the art of perfection; it's almost as if it's not made by humans. My own work is an attempt to view it in a new way, with a certain detachment, to challenge the idea of perfection.

What else is your work about? I would say my subject is matter as a theme – not only as a material. In *Captives* I explore the thin line between the polished, archetypal form and the raw nature of the material. It's a strange collision between two different worlds. Perhaps I should also mention that *2001: A Space Odyssey* is another major influence in my work.

quayola.com

Oppostie page
THE ROBOTS USED TO CARVE THE SCULPTURES CAME FROM A CAR PRODUCTION LINE.

Following spread
AS IN MICHELANGELO'S *PRIGIONI*, THE SCULPTED FIGURES ARE LEFT UNFINISHED, DOCUMENTING THEIR HISTORY AND TRANSFORMATION.

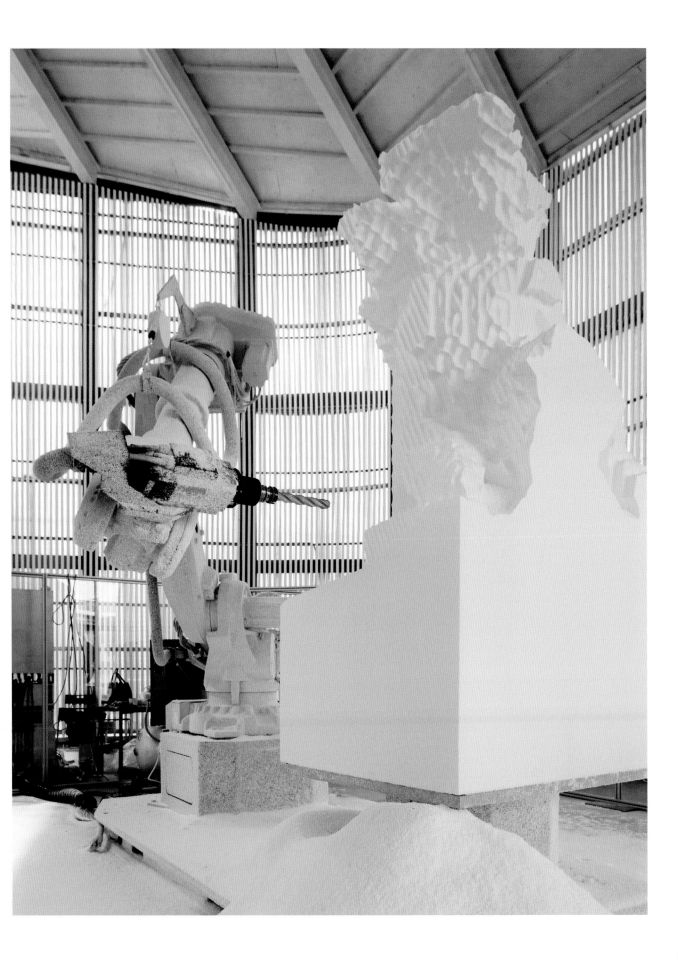

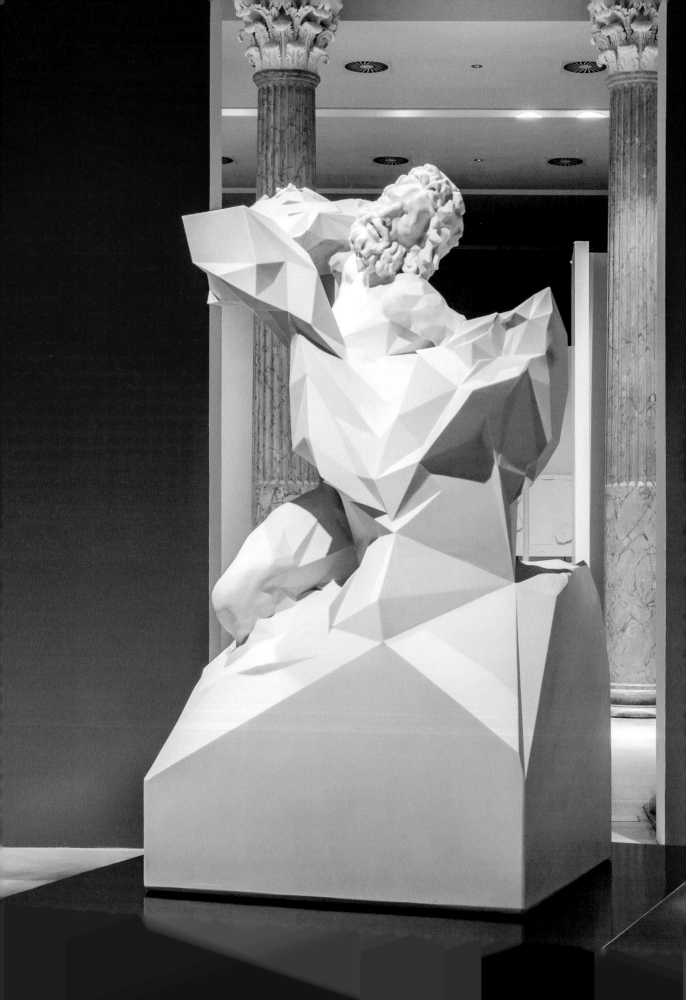

**'My statues are imaginary
archaeological discoveries'**

HEART OF GLASS

Andy Paiko's dazzling glass pieces are intricate working machines based on antiquated technologies.

Words AMARA HOLSTEIN **Photos** COURTESY ANDY PAIKO

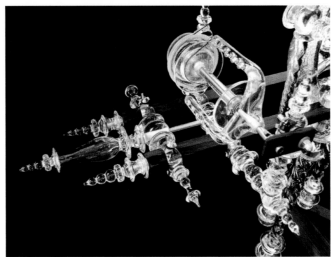

Above
IMPLEMENT (2013).

SPINNING WHEEL, DETAIL (2007).

Previous spread, left page
ANIMA MUNDI FOUNTAIN IN ETCHED GLASS.

The work of glass artist Andy Paiko has been variously described as space Goth, futuristic, Victorian and punk, and it always pushes the traditional boundaries of the medium. Paiko spent his late teens and early 20s blowing glass as an apprentice in various small coastal Californian studios, taking art classes at California Polytechnic and surfing azure waves. Now living in Portland, Oregon, he's split from the Venetian tradition of working in a team to hone his craft alone. Creating kinetic glass sculptures — a balance that's accurate within five grams, a working spinning wheel, an hourglass that keeps time — he refers to his technique as 'Galapagos style', in that it's always evolving in unexpected ways. *Transference* [2009], for instance, a collaborative art installation with composer Ethan Rose at Portland's former Museum of Contemporary Craft, consisted of 60 spinning glass bowls that were intermittently touched with felted hammers to play a piece of music. Inspired by the glass armonica popular in the late 1700s, this installation aptly summed up Paiko's approach: innovative, unconventional and always looking to the future with an eye to the past.

Why work with glass? ANDY PAIKO: Glass is one of the hardest things to do, and that interests me a lot. Apart from the sheer physics of it, there's a sense of immediacy and delicacy in your hand, in the way you have to deal with it. You can't muscle it around.

Immediacy? It's not like a painting or a piece of clay or a sculpture, where you can stop and walk away. You only get 15 to 60 minutes to work on something in the hot shop. You have to make snap decisions. Get it right, and

tionality of the material. When people see the spinning wheel for the first time and it moves, they're surprised. When you can actually use a piece, it adds a whole new dimension to the work.

How do you choose objects to make? I have to be able to see how it works, or at least be able to figure it out. You can't figure out how a computer or cell phone works. That's one reason for choosing antiquated technologies: they're simpler and more elemental.

What goes into making something like the spinning wheel? First, I do research. I watched someone spin wool and looked at books. Then I broke it down into all its parts and focused on what I thought would be the hardest part to make — the hub and frame of the driving wheel — and started in on those. I welded up three moulds to cast into, and gathered and appropriated parts from a hardware store. It took two to three months of work, though, before I had enough parts to test it. When I roughed in the frame with some scrap wood, then put my parts together and let it go, I swear to you that I cried a little.

While most glass art is a single piece, your work is comprised of multiple pieces put together. The way I work is more three-dimensional collage. I make a bunch of different parts — 180 parts in the case of the spinning wheel. I can go for weeks in the hot shop making parts. Then I put them all together in the studio, using my grinder and drills to create ways to make joints, and cold fuse the pieces together. Working that way, the process

'When I put my parts together and let it go, I swear to you that I cried a little'

you get a nice finished piece. Get it wrong, and everything falls to the ground and breaks.

Much of your work is functional and plays on the notion of the fragility of glass. How did you arrive at this approach? Glass is a strong material; it's got all kinds of incredible properties. A lot of glass-blowers make vases, plates, cups, bowls. But one of my professors at school said, why make this stuff? Does the world need another glass vase or bowl?

The first object I made that got me thinking in this direction was a glass hammer, and then a whole workbench full of tools. Some of them worked and some of them didn't, but it let me toy with the idea of the func-

becomes much more deliberate. You have time to fit things together in a certain way, and add and add — it's a layering process. That has allowed me to build more and more complex objects. If you just think of blowing glass as one piece, you're severely limited. But when you make a lot of glass parts, that's when you start to understand that you can make anything. And that's exciting.

andypaikoglass.com

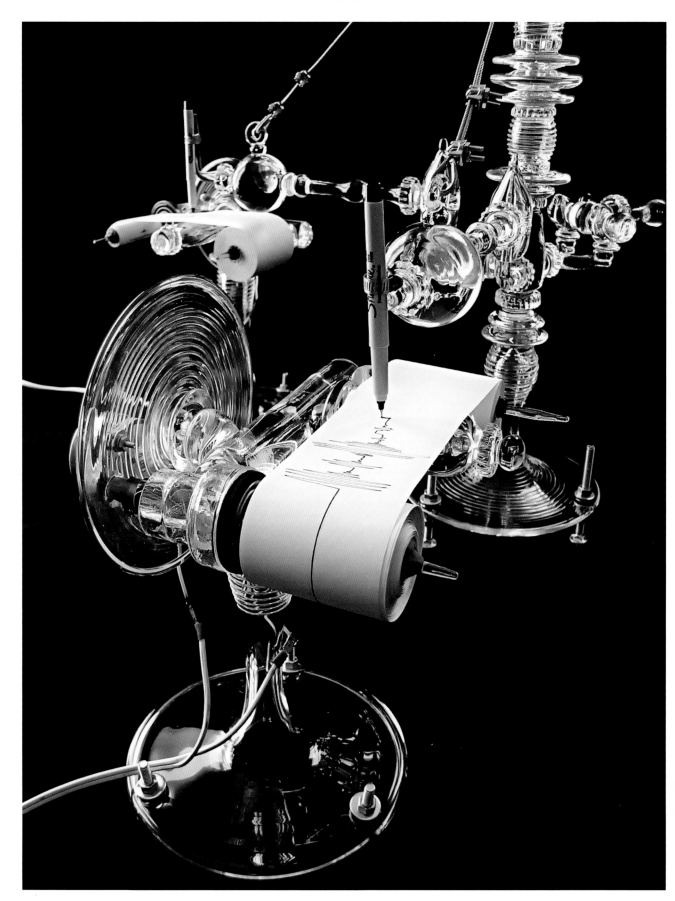

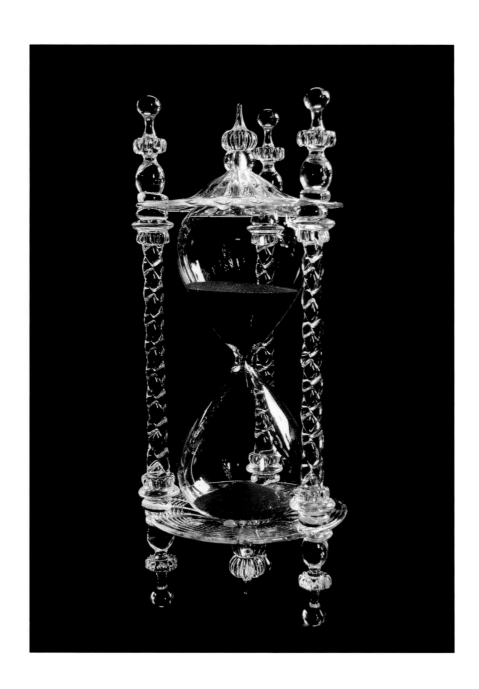

Above
HOURGLASS.

Oppostie page
SEISMOGRAPH (2006).

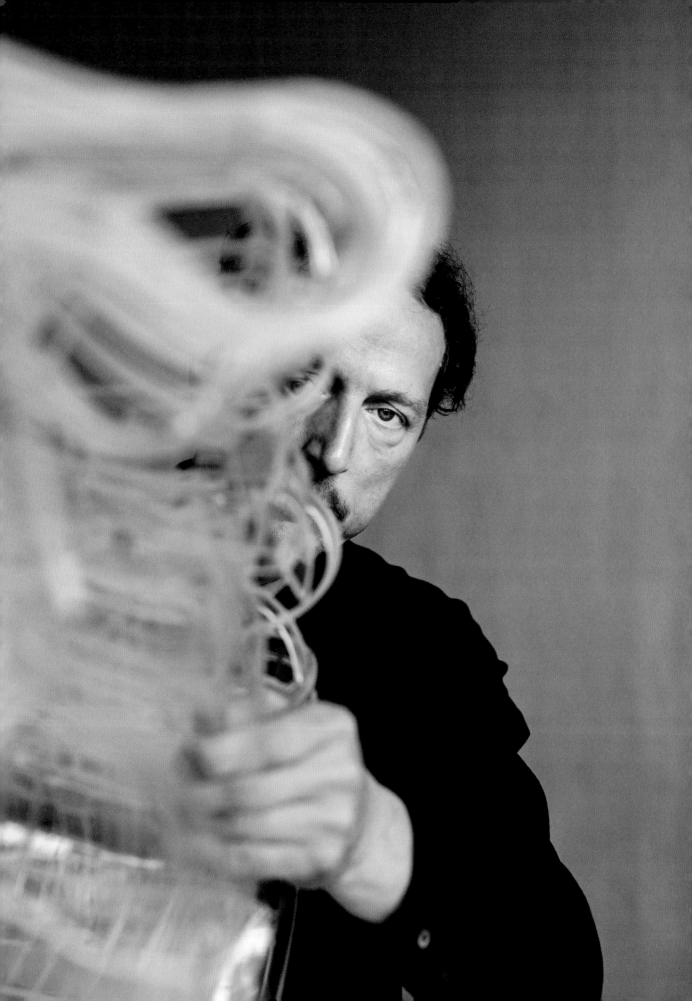

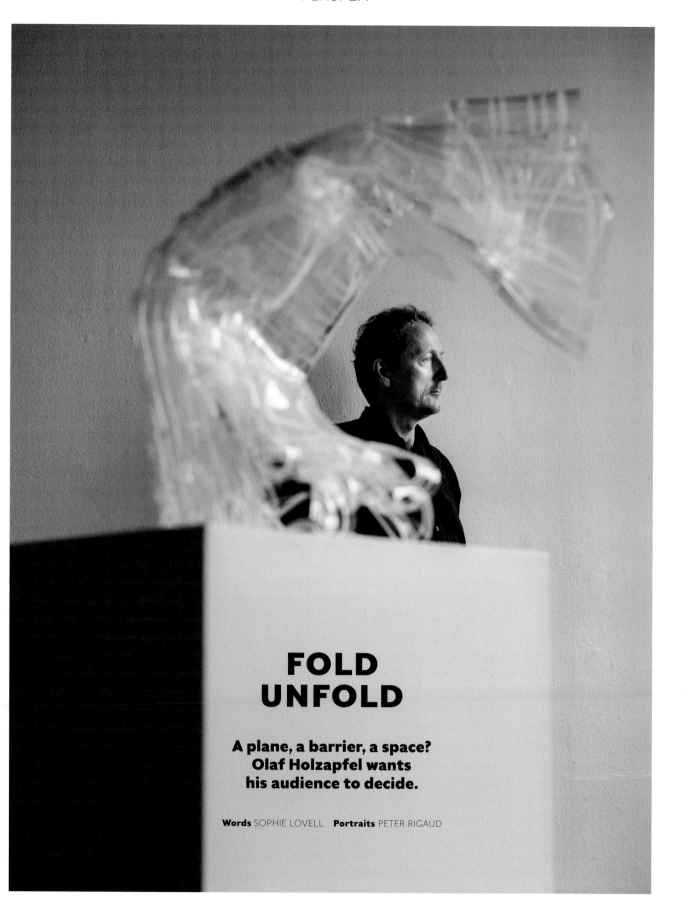

FOLD
UNFOLD

**A plane, a barrier, a space?
Olaf Holzapfel wants
his audience to decide.**

Words SOPHIE LOVELL **Portraits** PETER RIGAUD

German artist Olaf Holzapfel uses a range of materials, media and scales to explore themes relating to the self and decision-making. His Perspex pieces — along with works by a number of other creatives — were included in *Sur/face: Mirrors*. The group show at Museum Angewandte Kunst (MAK) in Frankfurt was true to its title, but Holzapfel's work is about far more than shallow reflections.

As an artist who grew up in the GDR before the reunification, do you feel as if people still tag you with that particular label? OLAF HOLZAPFEL: Yes, it's a strange thing. No-one would ever say that Georg Baselitz or Joseph Beuys — who grew up during the Nazi era — are former Nazi artists. But my bios, especially in Germany, always point out that 'he grew up in the GDR'. For a while I thought it was typical chauvinism. They keep you out; you're not part of their system and thus not a competitor. But it's more than that. I think there's still an inner conflict in German society.

But your background is perhaps interesting in the context of working with themes that involve borders and thresholds. Is there a relationship there? I was a refugee in 1989. I jumped over the border in Hun-

Your Perspex works seem to draw viewers into the very individual threshold of self and surroundings. I began the acrylic pieces after a long stay in India, where I studied at the National Institute of Design with Singanapali Balaram. Much building activity in India is unplanned growth in and around villages. When areas get denser, the farmers don't leave; they just park their livestock on the streets and people deal with it. They have a different attitude to 'inside' and 'outside'. Being 'in between' can mean that if you're not part of something, you don't exist.

I understand 'in between' to mean neither here nor there. Is it possible to be both here *and* there? They have different, multilayered interpretations. The Western model is about bringing the inside and the outside into a dialectical system to create a balance. But an Indian person might say that when the inside is in harmony, the outside is in chaos anyway.

Can you elaborate? Indians are okay with chaos. It's a part of life, as is polytheism, a belief I associate with the virtual world and the internet. The idea of decentralization was popular at the end of the 1990s, with talk of the global village and so on. Now everything is extremely

'When we are pushed out of shape, we become something like a bubble, or a fold'

gary — it *was* a biographical moment. I grew up in a state that was very safe and, in a way, very stable. There was one clear enemy: the government. But ordinary people were very disconnected in their opposition; it was like a silent protest. A big break came in '89, but soon afterwards — in around 1991 — the new media revolution began. That was important for me and my work, and I think it was important in general. The starting point for perestroika was when Gorbachev realized there were fewer computers in the whole of Russia than there were PCs in California.

You initially studied architecture, didn't you? I studied thermodynamics for a year. I wanted to be a physicist, but then I felt the need for a change and a closer relationship with materials, so I studied architecture. When I realized that what I do is more theoretical and more independent of use, I switched again. It was a long process, with obvious biographical reasons. In a limited society like the GDR, the function of an artist is limited as well. I needed time to develop my capabilities.

centralized, and there's absolute control. The idea back then was that everyone could participate, could do their own thing and create many centres. I saw similarities with India's 'multilayers', which still exist to a certain extent but always cause stress in Western-thinking people, whereas coping well with chaos has more to do with your internal attitude — with what you radiate from the inside out.

How does it relate to your Perspex sculptures? A central part of sculpture is the artist's portrayal of tension. The object you make is charged with a tension that comes from within. I don't mean an abstract surface tension, but a tension of the whole form that goes from inside to outside. My thinking was: when we are pushed out of shape, we become something like a bubble, or a fold. We can let our spaces unfold in different ways. That explains my approach to these forms. Other obvious aspects are that they have been made by hand and that they are affected by gravity.

Let's go back to the impression that your work involves borders and thresholds on a variety of scales. If a two-dimensional object is a plane or a barrier and a three-dimensional object is a spatial form, the result is a kind of interaction. Do you agree? I see it in a more fluid sense. I want to set the object in motion. Two- and three-dimensionality are just conventions, a fact we've forgotten. There is a legendary argument in art — and probably in architecture as well — about whether a painting is an object, a relief or a surface. It's important to decide for yourself what it is, and the same applies to barriers.

You're saying it comes back to personal perception, whether you see a flat plane or a space? It's more about understanding that works of art are unfinished — that the viewer is part of them: the one who can and must decide. Such decisions occur throughout my work.

The theme of the group show in Frankfurt is mirrors. Is your work more about self-reflection or a reflection of the surrounding space? Both. It's about in-between-ness. We could philosophize now about bubbles. I could talk about how we are always both inside and outside. But what interests me even more is that within this regarding, this reflection, is a sort of corridor. The thing I observe between possible decisions becomes my corridor. To be in and to define the interspace I'm describing is a quality, not an error. To use architecture as a metaphor: we are going to build a house now, but if you don't participate, it will decay. You being inside makes you part of the house and the house part of you, but it also creates an interspace between you and your house. The connection is there, but you don't yet know what you might have to do and what the results will be. The situation is dynamic. So much architecture today behaves as if it is final, but is still gets torn down after 30 years. We know it's not built for eternity, but we no longer participate in the dynamic element; we have the authorities or another external party to do it for us.

Participation — when making a building or a sculpture — is central to my work, perhaps the most important part of it. Participation allows *you* to determine, and it means that it's not necessary to make things that are final or complete.

Reflections are not just about exploring the self but about self-validation as well. I think the whole thing about tattoos, selfies and the like has to do with the increasing distance between us and the physical world. People are compelled to do something with or to their bodies in order to ascertain that they actually have a body. The whole fitness thing is a kind of self-affirmation.

Most people do less and less physical work yet consciously do more and more for their bodies. It's not really about health, but about showing and sensing the self. I'm more interested in a different kind of physical reflection.

olafholzapfel.de

Following spread
IHRE FEHLERHAFTIGKEIT VERLEIHT DEN MASCHINEN EIN NATÜRLICHES MOMENT (GERMAN FOR 'THEIR FAULTINESS LENDS THE MACHINES A NATURAL ELEMENT') WAS DEVELOPED IN 2012, BEFORE THE IRIDESCENT-MATERIAL TREND WENT MAINSTREAM.

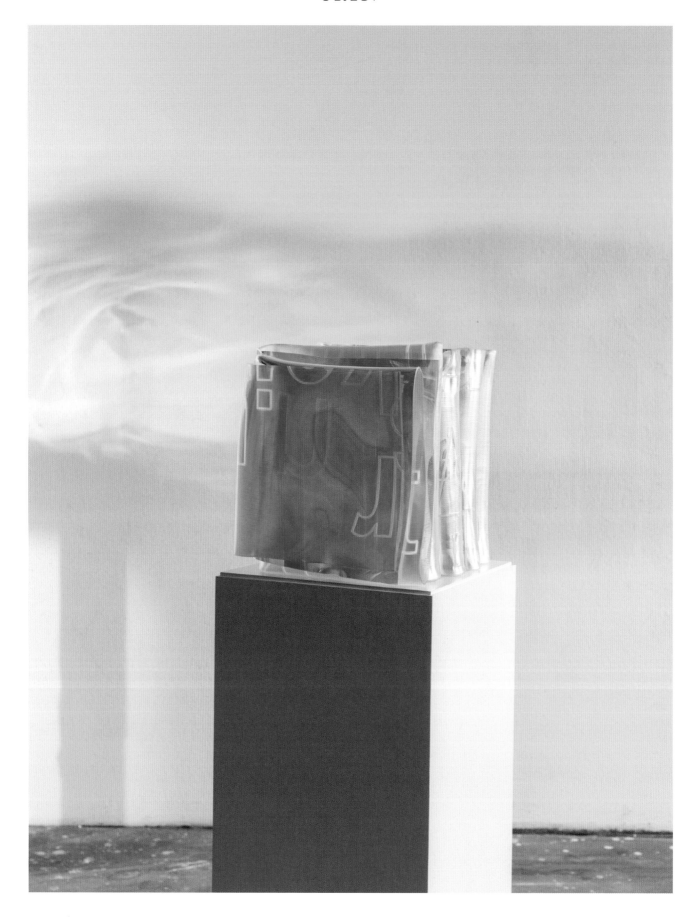

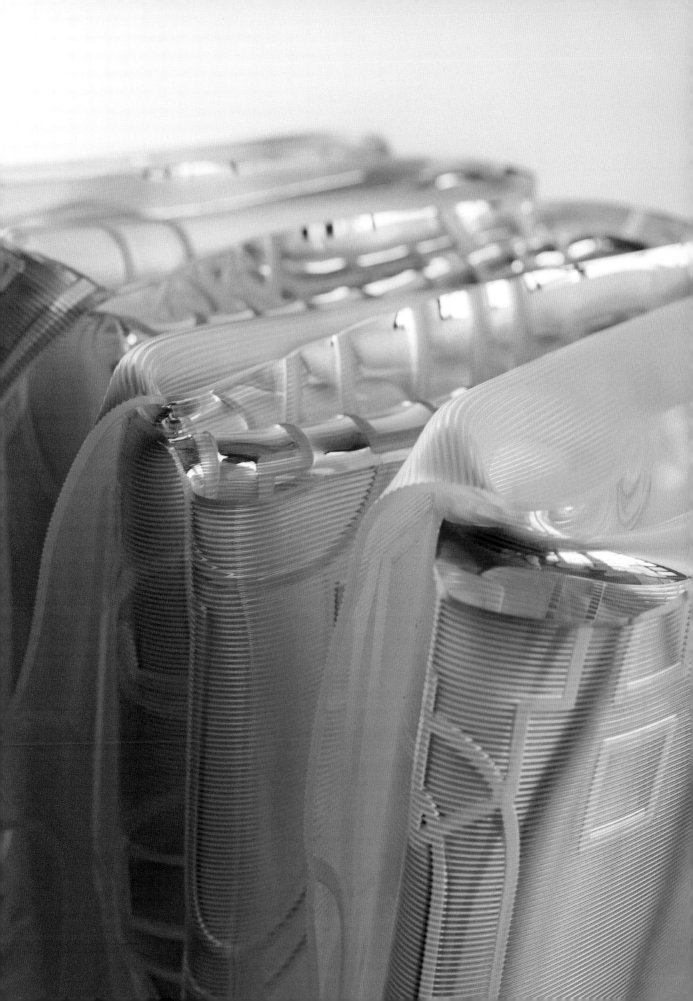

LARGE AS LIFE

**Korean sculptor Gwon Osang creates his
unnerving life-size portrait figures from
nothing more than a series of photos
and some polystyrene.**

Words JANE SZITA **Photos** GWON OSANG / ARARIO GALLERY

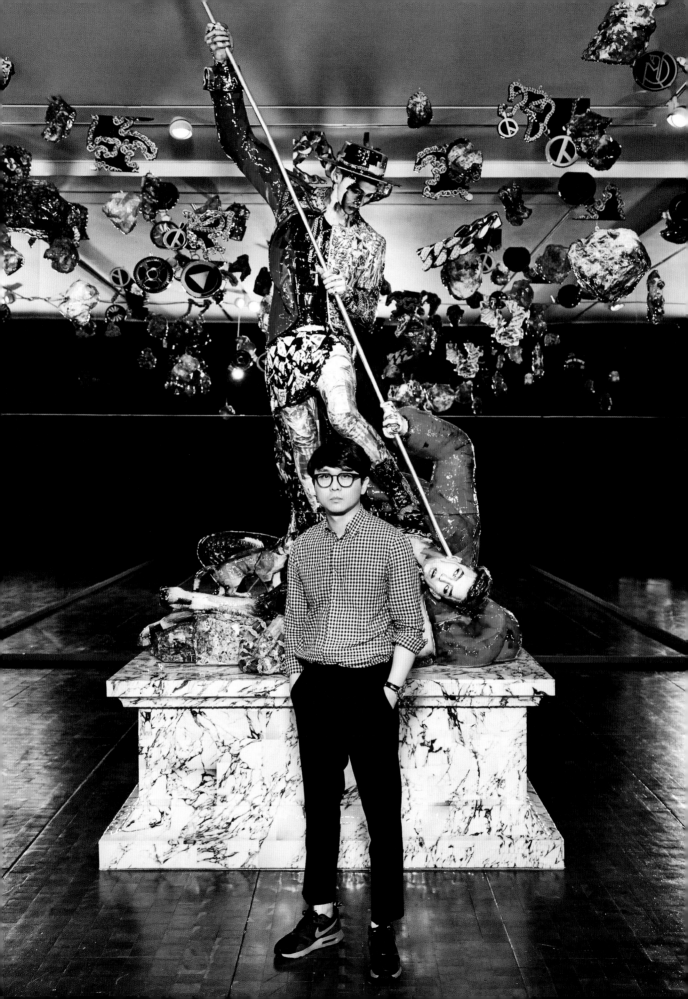

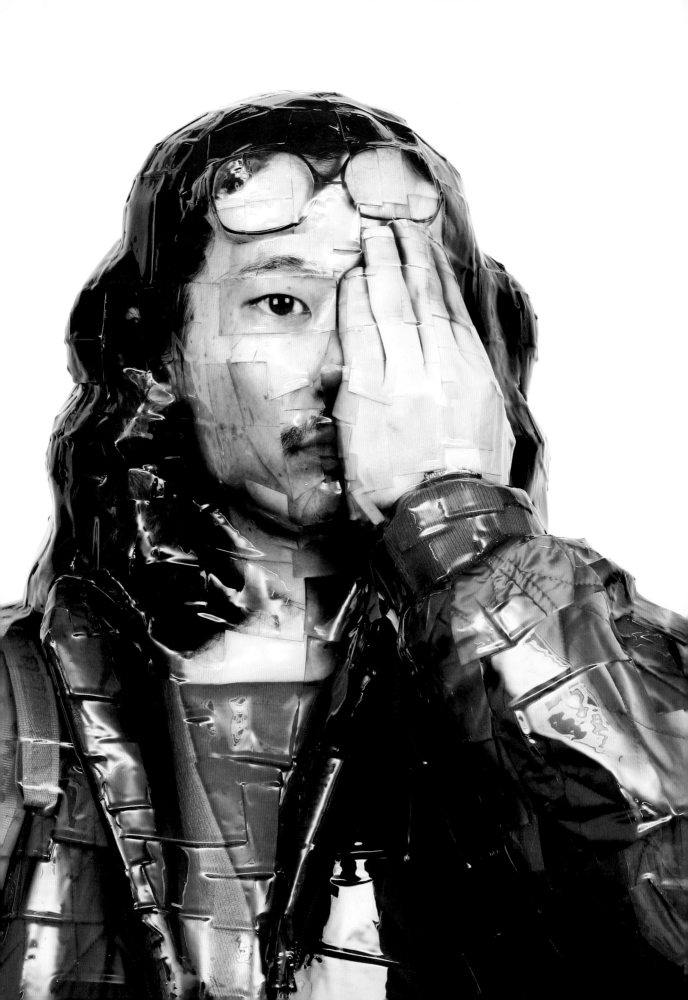

Photographic sculpture or sculptural photography — whatever you call it, Seoul-based Gwon Osang most likely invented it. A sculptor by training, he begins a project by taking several hundred photographs of his model from every angle. He pastes the resulting skin onto a carved body shape and calls the results *Deodorant Types* (the name originally referred to a certain unsuccessful advertising campaign in Korea), because the postures of his figures are often taken from ads. Advertising images also appear explicitly in his work as 'found' sculptures, which he photographs for his *Flat* series.

What made you start doing this kind of work?
GWON OSANG: With *Deodorant Types*, I initially wanted to create a sculpture that was light and easy for

images I cut out of magazines, but in the case of my earlier work, *Watches*, for which I collected images over a couple of years, I did all the cutting and pasting myself, and it took two to three months. I once cut out all jewellery images in every issue of a certain magazine over a five-year period, but that project took only six weeks with the help of a few assistants.

Your work is often compared to that of other artists. Some people compare my photo sculptures to David Hockney's work, which is a great honour. Hockney also expresses Picasso's influence, as Picasso appears in his paintings and drawings from time to time.

However, in the case of David Meanix or Oliver Herring, whose work is rather like mine, I understand that

'Advertising images represent modernity, with a bit of fantasy thrown in for good measure'

me to move without help. As the photographs themselves are just pieces of paper, of course, I thought it would be perfect to quilt them together and to create a sculpture made out of this super-light material. At first, there was nothing underneath the photos — to begin with, the sculptures weighed only a few grams.

Describe your working process. When making a figure sculpture, I choose a model, take photographs, carve a base model out of polystyrene foam, and paste cutouts on the model. The surface of the sculpture then goes through UV protection coating and a final plastic coating.

In the case of my *Flat* series, I cut out images from magazines, paste steel wires to their backs, arrange them on the floor and photograph, print and frame the assembled piece. Printing and framing takes place in a factory in Germany.

Both works take a long time to produce. Each figure created for *Deodorant Types* takes about two months. Pieces for the *Flat* series depend on how many

their initial pieces date from 2002 and 2004, respectively. These works were created after the debut of my first photo sculptures in the 1990s, so it would be better for you to ask them about the relationship between their work and mine!

What is your work saying about contemporary reality? You know, if all emotions could be expressed in words, there would be fewer reasons to make art. I think that most works of art embody a mixture of the artist's instincts and philosophy. The focus of my sculptures is to show the world we live in today.

Sometimes, commercial advertising images are shown directly, such as in my *Flat* series. Sometimes, as in *Deodorant Types*, I try to find the common ground between commercial advertising poses and traditional sculptural poses. This is because advertising images represent the face of modernity, with a bit of fantasy thrown in for good measure.

osang.net

Opposite page
EYE CAPTURE (DETAIL) (2008).

Previous spread, left page
BACKSLIDER (2007-08).

Following spread
FUSE (2007-08).

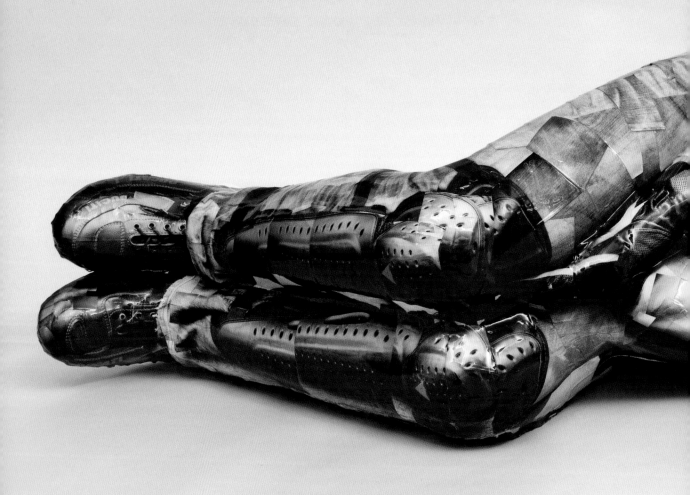

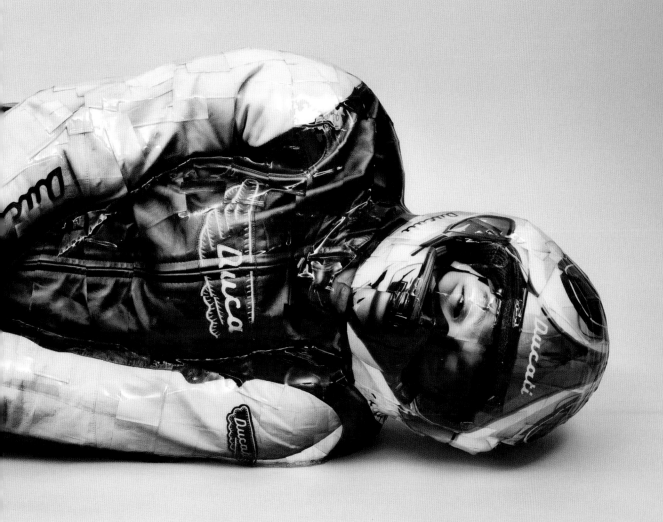

MONOLITH MAKER

**Amy Brener shapes otherworldly forms by
trapping found objects in layers of resin.**

Words JANE SZITA **Portrait** ANDREW BOYLE

Born in Canada, Amy Brener studied art at the University of British Columbia before completing her master's degree at Hunter College in New York City in 2010. Since then, she has made a name for herself as a sculptor of intriguing freestanding monoliths, created by capturing objects she's collected in layers of poured resin. Brener lives and works in New York City.

How did you arrive at the idea of using resin in this way? AMY BRENER: The initial spark was the desire to create an object that could seem bigger than its physical size and could occupy space in a more complex way. In graduate school, I made a large sculpture out of glass tabletops, and I was interested in the way that it seemed to transcend its materiality when properly lit. This led me towards translucent materials. I also became intrigued by the idea of building a sculpture from scratch. Casting is the ultimate making-from-scratch practice, since you are taking liquid and transforming it into a solid mass.

Tell us about your technique. I build a framework out of plywood and two-by-fours and pour pigmented resin into it in many layers. Each layer is slightly different, as is evident in the striation of colours running along the side of the finished sculpture. Once the pouring is done, I remove the sculpture from its mould — a rather violent procedure — and chisel its surface until it pleases me.

How do you choose the found objects that you incorporate into your sculptures? My studio contains an arsenal of objects and materials: bounty from the street, the beach, thrift stores, dollar stores and eBay. I'm constantly collecting; it's a bit of a problem. The process of selecting objects and arranging them in the sculptures is a matter of composition and of studying how forms interact.

How would you like your current sculptures to be regarded in the future? I like the idea of art works as

'I like the idea of art works as cultural artefacts'

Apart from glass, resin is pretty much the only translucent casting material, so it became the obvious choice.

What else is appealing about resin as a material? Since my earliest attempts at sculpture, I've felt compelled to combine highly synthetic materials with earthy, organic ones. Resin can resemble geological forms yet remain recognizable as plastic. It is also acts as a miracle glue, and can encapsulate almost any object. Like natural resin, synthetic resin acts as a protective membrane that can potentially preserve things for the future.

What inspires the forms that the sculptures take? Before the resin works, I had been making sculptures that loosely resembled vehicles or machines. I wanted to imply utility, without defining it. My earliest resin sculpture is titled *Switchboard* (2011) and looks like a surfboard leaning against the wall. On the underside is a composition of knobs and buttons — the elaborate control panels featured in science-fiction movies fascinate me.

My subsequent sculptures are more abstract in silhouette. I search for forms that seem vaguely familiar yet can't be identified as specific things. I like to contrast rough, broken edges with intricately cut-out ones. Hints of technology and function remain as patterns of keys, buttons and other textures.

cultural artefacts. If my sculptures stick around, I hope they will embody something specific to this time that can't quite be put into words.

Your father, Roland Brener, was also a sculptor. Was it easy following in his footsteps? I knew I was suited to the creative arts, but I was first drawn to poetry and music. After making my way through a few different departments in college, I eventually wound up in visual arts. As I was working on my first sculpture assignment, something clicked. This was only a year or so before my father died, but I'm thankful that we managed to have some great conversations about making art.

Do you think you can keep developing this technique? It's healthy for artists to go through phases of exploration and development. I'm in an explorative period right now, and the sculptures I'm making are quite different from my previous work. I'm excited to see how they will progress.

amybrener.com

Above
UNTITLED (DISK), A WORK FROM 2013,
INCORPORATES A FRESNEL LENS.

Previous spread, left page
ELEMENT (2013).

Following spread, left page
BRENER HINTS AT TECHNOLOGY AND
FUNCTION THROUGH KEY- AND BUTTON-
SHAPED PATTERNS. THE JUXTAPOSITION OF
HIGH-TECH MATERIALS AND ORGANIC OBJECTS
— AS SEEN IN HER INCORPORATION OF MUSSEL
SHELLS IN *HANGAR* (2014) — MAKES FOR
A SURREAL SIGHT.

Following spread, right page
JOTTER (2013).

CLOSET CANNIBAL

**Michael Samuels makes abstract
sculptures from deconstructed vintage
modernist furniture that other people
would prefer to preserve intact.**

Words JANE SZITA **Portrait** TIM SMYTH

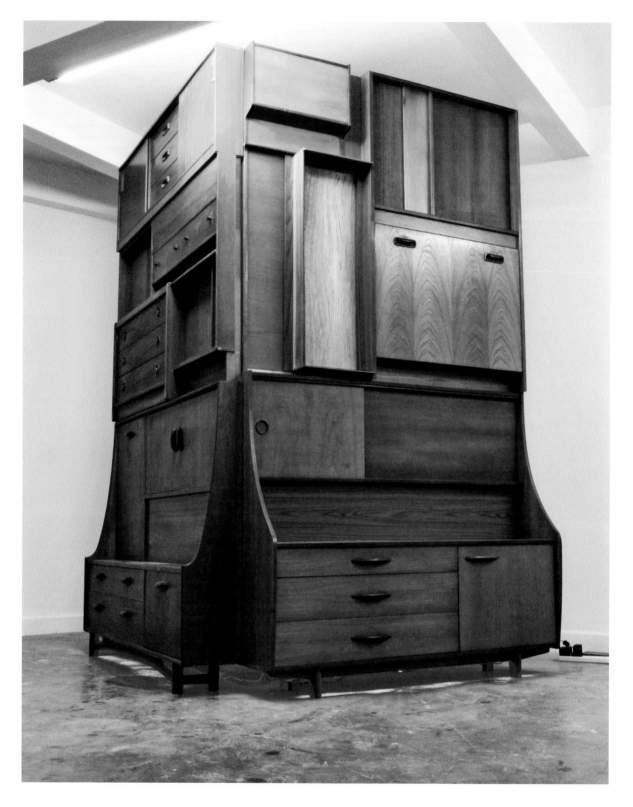

Above
CONFESSIONAL 1, G-PLAN, FOR COMME DES
GARÇONS (2010'S) IN GINZA, TOKYO.

Previous spread, right page
MODULATOR DEMODULATOR, G-PLAN,
ERCOL, 1960'S SPEAKERS (2014).

London-based Michael Samuels, who has an MA in sculpture from the Royal College of Art, uses furniture that was once the future — early mass-produced modernist pieces for the home, such as those made by G Plan — to build architectural constructions that render the functional nonfunctional and seem to reflect on past and present conceptions of domesticity. His works appear in the Commes des Garçons Dover Street Market stores in London and Ginza, and have featured in group and individual exhibitions.

So why the obsession with modernist furniture? MICHAEL SAMUELS: I started using pieces of furniture initially as alternatives for plinths, but then I began to approach them as a medium in their own right. First of all it was 1960s domestic Formica furniture and now it's G Plan. The Formica was all about the palette of colours.

You switched to G Plan because . . . After working with Formica furniture, I was looking for something less colourful and a bit more sophisticated. G Plan appeals because of the tonal palette, but also because of the history and the possibility of exposing the veneer and mass production of each piece. It was the first readily available modernist furniture in the UK, and it became a staple of British households. I like its simplicity and how it is very evocative of a certain period in British domesticity.

Where do you get the pieces from? I used to run around to second-hand shops, but now I just spend an unhealthy amount of time on eBay.

Who or what inspires your approach? No one really, unless subconsciously. I try to steer clear of looking for influences or of being influenced, in order to maintain some originality and a unique visual language. It's easy to see too much these days, so I try to limit what I see.

What techniques do you use to construct your sculptures? Fundamentally, it's about the aesthetics and whichever way I can achieve something without dwelling on the idea of permanence. Often the quickest and most direct way to build a structure is with the use of clamps. I find the more time I take the less successful the work becomes, so haste is the key.

Can you continue taking the work in new directions? Absolutely. I haven't even scratched the surface. I'm waiting for the opportunity to have a gigantic space in which to push it further.

You've got a long-running relationship with Commes des Garçons. How did that begin? I got a polite email asking me to design a space for the London shop. They had seen my work online. In terms of commissions it's very easy, as there are few restrictions. Basically, it's do what you like and we'll help you.

How long do you think you can continue working with this material? The moment I get bored in the studio is when I know I have to move on.

How do people tend to respond to your works? In all manner of ways. I enjoy watching people engage with them, but I guess it's evenly split between people who like them and people who think: Oh no, what a waste of good furniture. I'm always interested in how people contextualize my work. Often what I see is completely different to what someone else sees.

What are your pieces saying? I'd like to think that they continue an investigation into abstraction and the pictorial plane. Using everyday materials makes them more familiar, but essentially it's about abstraction.

The inherently domestic quality of the material seems key to your work. I've always wanted to use something very domestic. I think it helps the audience relate to the work easier, as a lot of people will have had some experience with the material. Traditional sculptural materials do not appeal to me, as they usually come with their own baggage, and for me being domestic makes it less masculine. Office furniture would not have the domestic appeal I am after.

On his blog, graphic designer Richard Hogg showed off a great router shelf you made. Are you planning to do any more functional furniture? Richard is in the studio next door to me. It was a simple solution to a problem and a bit of fun. As much as I like rendering functional objects nonfunctional, I have no qualms about making some works slightly functional, hence the work with Comme des Garçons. I like the challenge; I've always liked design and architecture, so this just furthers my practice and makes it a bit less limited.

Would you object to anyone using your art pieces as furniture? No. Once they own it, they can do what they like with it. I'm not precious.

michaelsamuels.co.uk

Above
SPENT, CAST CONCRETE SAUSAGE,
1960'S STOOL, HEAT SHRINK (2017).

Opposite page
SPITZWEG 2, ERCOL, SCANDINAVIAN
GLASS VASE, CONCRETE (2015).

SPACE

'Space is my favourite piece of furniture', actress Joanna Lumley once joked about being house poor. As it happens, it's also an important ingredient for the visual arts. Yusuke Kamata's optically intriguing installations, Rebecca Ward's dream-like evocations of distant memories, and Levi van Veluw's eerie reconstructions of his childhood bedroom all establish links between mind and space, working both at the visceral and the intellectual level.

BLACK BOXES

In installations composed only of 3D frames, Japanese artist Yusuke Kamata perverts our perception of perspective.

Words KANAE HASEGAWA **Portrait** HAJIME KATO

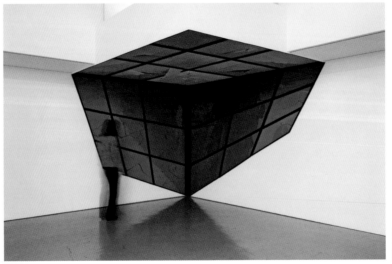

Ken Kato

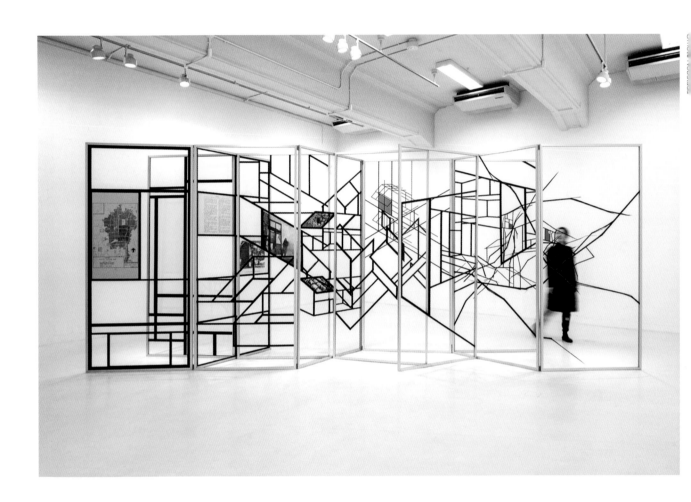

Above
CONSTRUCTION ATLAS AT
THE KYOTO ART CENTER (2014).

Previous spread, left page
CUBE (REVERSE), SHISEIDO GALLERY,
TOKYO (2012).

Following spread
A HUNDRED DEFINITIONS (2010).

Japanese artist Yusuke Kamata uses the simple device of the frame to construct intriguing installations that puzzle our notions of perspective. Having trained to be a painter, Yokohama-based Kamata confesses that he does tend to think of himself as one. Whereas a painter normally uses picture frames to 'contain' art, though, he uses frames to 'free' art.

How did you arrive at the idea of making installations with picture frames? YUSUKE KAMATA: At university, I practised painting and studied its history. While searching for something new in painting, I realized that everything had already been done. So I shifted my focus and tried to understand its nature – what makes a thing a painting? That led me to frames, which can be seen as defining elements of paintings. I then attempted to make a 'painting' without actually painting but by making a frame that looked as though it had been foreshortened in a painting.

Why the strange angles? I was intrigued by the fact that in galleries and museums people view paintings only from the front. They hardly ever look at them from

Your installations are actually three-dimensional, as is each frame you use, even though we normally think of a frame as a flat object. Yes. I wanted to eliminate the frontality of painting – to convey that the things we see have various perspectives and to prove that there is actually no 'front'. In one of my works from 2009, I tried to show 100 different perspectives. I made 100 cubic structures out of connecting frames. I made them using parallel, oblique, isometric and trimetric projections, and so on. These are all accurate perspectival approaches used for drawing 3D objects in 2D, but they appear to be distorted. My work is about a 100-dimensional space and not about the 2D world of painting.

Although the frames are accurately drawn according to the perspectives you mention, everything seems to be askew. This is due to the thickness of the sides of each frame. In the real world, perspective makes a line that's closer to you thicker than one that's farther away. But I intentionally made some of a frame's sides thinner in the front and thicker at the back to confuse the perspective. When you walk around inside these structures, however, you see no front or back anyway.

'I want to destroy the frontality of painting'

any other angle. Do paintings need to be seen frontally? How would they look if seen from other angles? Questions like these led me to distort the picture frame, which resulted in the destruction of the perspective that is a golden rule in classical painting.

Who or what inspired you? A particular source is *The Ambassadors*, a 16th-century painting by Hans Holbein the Younger that hangs in the National Gallery in London. Two ambassadors are portrayed in all their worldly pomp and dignity. But on the floor is an odd object, unrecognizable when you stand right in front of the painting. You have to view the picture at an angle to see the object resolve into a *vanitas* motif – a skull. I think it's an incredible painting, and it gave me a new understanding of perspective.

And Cubism? Cubism has also influenced my work. The Cubist painter struggled to show the various profiles of his subject from many different angles in just one painting. It's like walking around a sculpture, but then in two dimensions.

Different perspectives are all cluttered within one space, which is what happens in reality when lots of people look at the same thing at the same time. There isn't one vanishing point like you see in a painting. There are as many vanishing points as there are people.

yusukekamata.com

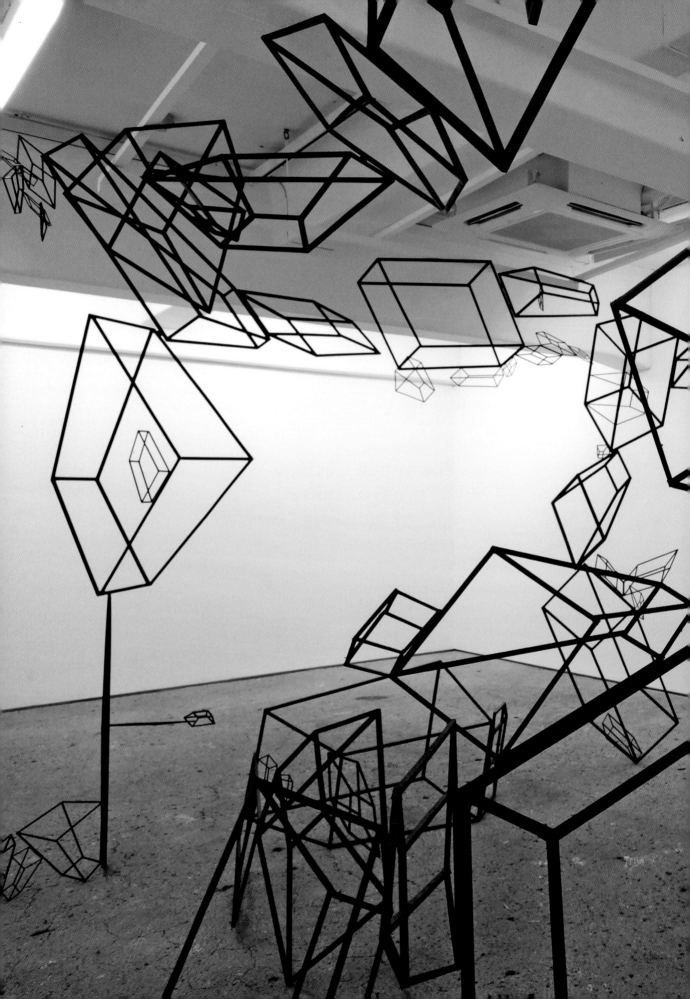

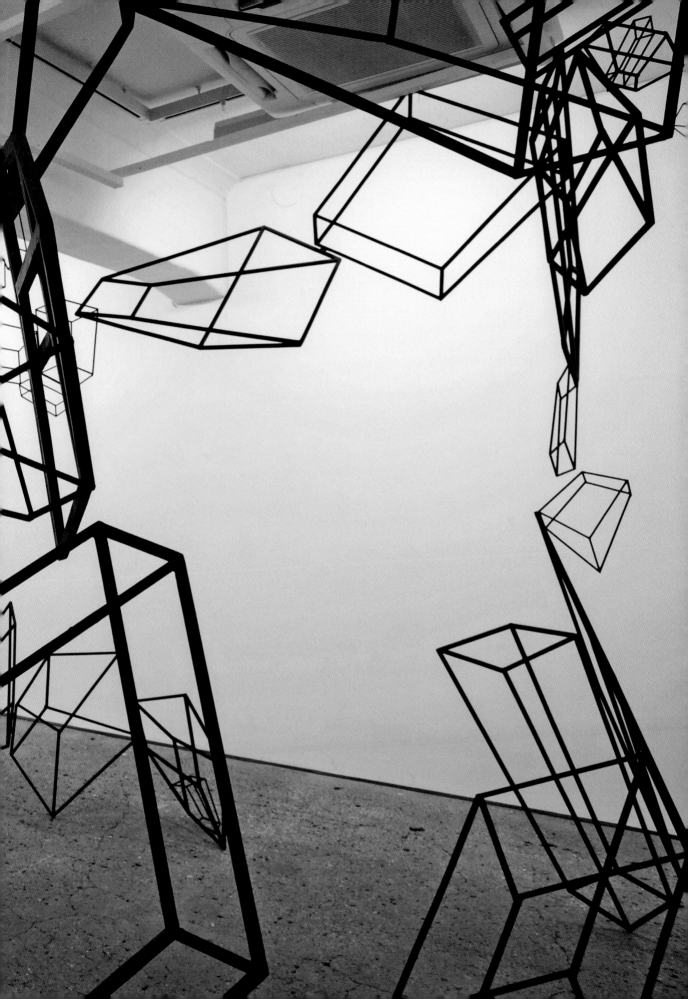

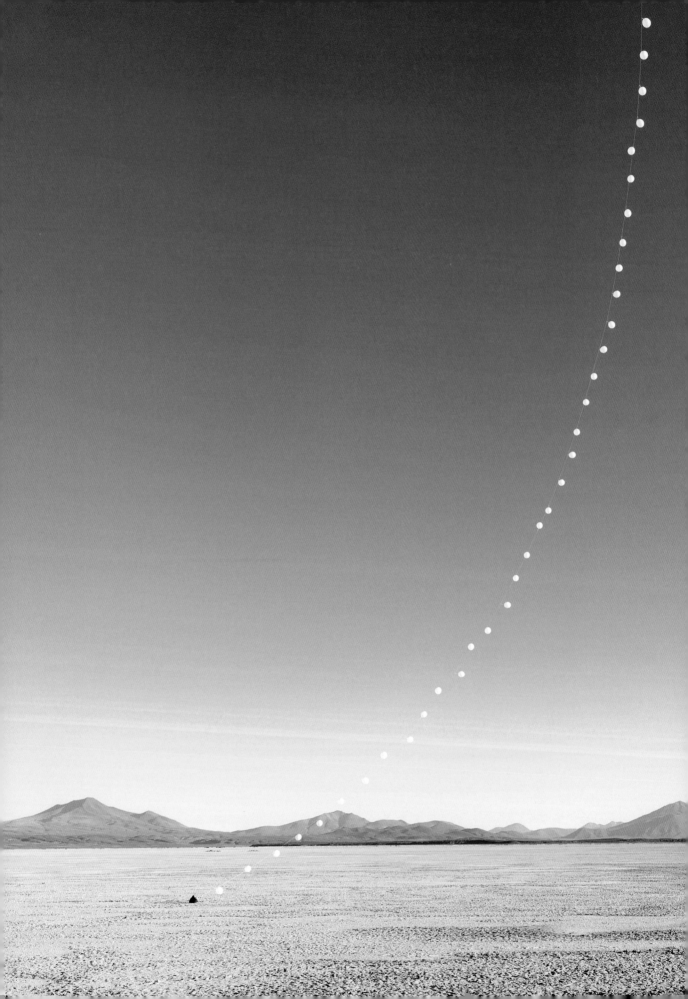

BUBBLE BLOWER

Using the most innocently childlike of props, Charles Pétillon subverts our habitual ways of seeing.

Words JANE SZITA **Photos** COURTESY DANYSZ GALLERY

The self-taught French artist and photographer Charles Pétillon began his career as an assistant to Jean Larivière (well-known for his work with Louis Vuitton and other luxury brands) gravitating to still life photography. He started working as an independent advertising photographer in 2002, and currently combines meticulous work for brands (including Acqua di Parma, Cartier and Christian Dior) with his own Invasions series, depicting installations using white balloons, which he began in 2009. Erupting like champagne bubbles from burned-out cars, dumpsters, basketball courts and derelict houses, or hovering over beaches and woodlands, Pétillon's surreal balloon images force us to take a second look at all kinds of mundane spaces – public, private, built and natural. He describes Invasions as 'a project about humans and their environment and, in consequence, the memories of these places'. He lives in Paris and Lille.

How did you start working with balloons? CHARLES PÉTILLON: It all began in the form of a research project oriented towards my still life artwork. It turned out that over the course of my experiments, I began to realize that balloons, used in assemblages, could become a kind of raw material. A bit like paint for a painter. Very quickly,

latex balloons. For the time being they are brought to waste collection, but we're currently working on a balloon recycling method.

What did you learn from working with photographer Jean Larivière, and why did you gravitate to still life photography? I learned to use my eyes to see, and not just to look. The appeal of the still life for me is that there is not much that helps the photographer. It's just you and the object. All you need is a good idea and beautiful light.

How many balloon installations have you done so far? About 40, including some I've never made prints for.

What's the biggest you've made? That would be *Heartbeat*, in the grand 19th-century Covent Garden Market Hall in London. It was composed of 100,000 balloons and measured 54 m by 12 m.

Can you describe how you go about creating one of your *Invasions* series? Finding a location is the most time-consuming, and exciting, phase of the process – it can require several months of research to find the right

'Balloons create a contrast between their own delicacy with the roughness of the places where I put them'

I saw that I could use this raw material to address different social and philosophical topics. The balloons allow me to materialize ideas or concepts in a poetic way.

What advantages do they have as a material? Using balloons is interesting because they immediately create a contrast between their own delicacy and fragility as a medium with the rawness and roughness of the places where I put the installations. The balloon is a universal object. It's simple, accessible and we all recognize the dimensions and proportions immediately – useful since my finished works are photographic prints. The colour white was essential from the start because it is neutral and evokes rest and a kind of tranquillity. The whiteness reinforces the contrast and the absurdity in the combination of materials and location.

What kind of balloons do you use, and what happens to them after use? They are one hundred percent

place. Inflating and assembling the balloons in clusters can take also quite a while – up to a week in the case of larger installations, with help from assistants or volunteers. I use sophisticated pumps for that. Wires support the balloon clusters in their place, along with lighting, if we are using it. Taking the photos is the fastest part of the process.

How have your works developed over time? *Igloo* (2011) marks an important progression. It was the first time I used artificial light in my installations, and the first time I treated the installation in a much more autonomous way, so that it almost dispenses with space.

You call the balloons 'a metaphor'. Can you explain? The way I see it, the balloons allow me to create metaphors by giving a new function to spaces or objects. This modifies the perception of it. You don't see things anymore, instead you observe them.

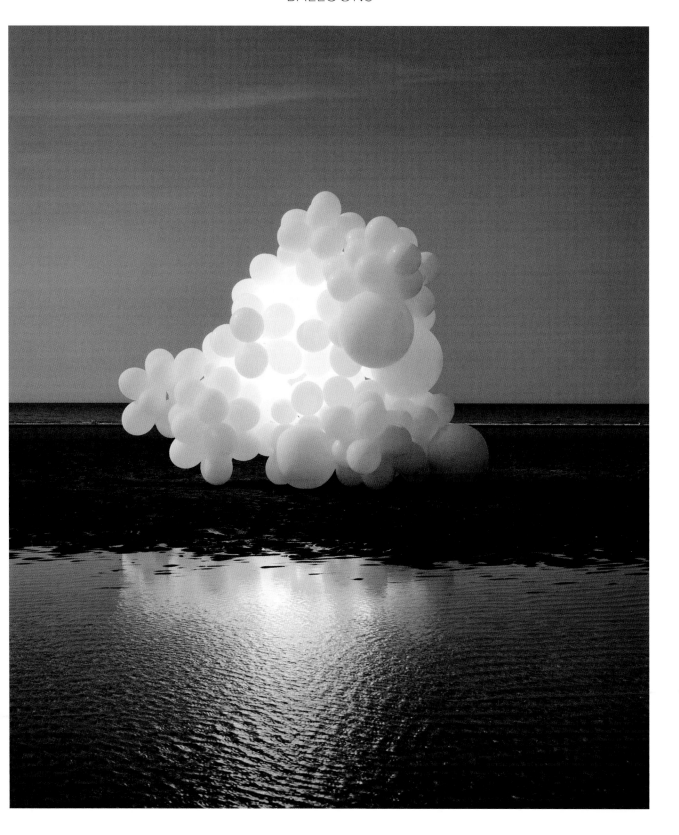

Above
IGLOO 2 (2013).

Previous spread, left page
RIBAMBELLE 2 (2013).

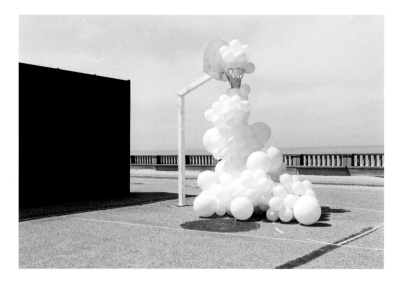

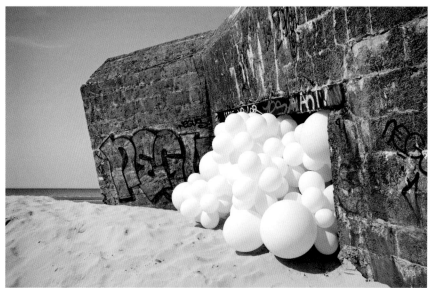

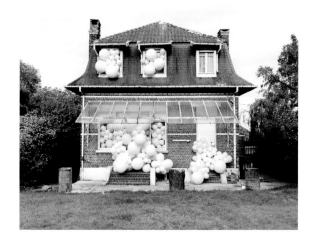

**'Most of the time, my work
makes people smile'**

What conditions do your installations have to take into account, and how long do they last? It all depends on whether the installation is indoors or outdoors. Outside, the wind and the heat are the two biggest challenges. These are latex balloons that degrade over time and heat accelerates this process. That's why an outdoor installation can last for three days maximum.

How do you go about looking for a location? That's too complicated to describe — suffice it to say that I stop my research when I think I've found the space that forms a kind of balance between the perception and the representation that we have of it. The choice of locations for my installations is fundamental, because the place and the subject are one. The space in which I install my balloons defines the work. The installation itself maintains a kind of dialogue or a balance of power with the place.

What meaning do your works convey? Each of my installations explores an explicit topic. For example, *Souvenirs de Famille* is a metaphor for our memories: are they really necessary? In *Copy Paste*, a work for Shanghai, I consider whether we aren't all pursuing the same things, regardless of culture and background. And in *33 Kilometres*, I explore the plight of migrants trapped in Calais while they try to make the sea crossing to the United Kingdom. That said, I'm just asking questions. It's up to the public to provide the answers. If I had the answers, I'd be a politician!

Which brands have you worked with, and how do your *Invasions* compare with your work for brands? My clients include Acqua di Parma, Cartier, Christian Dior, Giorgio Armani, Jérôme Dreyfuss, Louis Vuitton, Prada, Shiseido, Trussardi Parfums, and Van Cleef and Arpels. My commercial, commissioned work is very structured. It's designed to meet the codes of magazines, fashion or advertising. This is a very specific language. I think my photographs with balloons aren't very far apart from my commercial images. It's true that I install my balloons so as to create a form that's often organic and rather chaotic. But I often use frontal framing, imposing the subject on the viewer so you cannot escape it. This is a fairly general technique in advertising. The only real difference is that in choosing the subject for my balloon installations, I'm free.

Which artists inspire you? I find myself very responsive to land art, design and street art. So my influences range from Georges Rousse, Banksy, JR, and Ronan and Erwan Bouroullec, to Richard Long, Michael Heizer, Robert Smithson and James Turrell.

Ultimately, is it about the photograph or the installation? The installations and the photographs are two completely different things that evoke completely different emotions. In the end though, the photography is the only trace left by the installations.

How does your work affect people? Most of the time, it makes them smile — I think because balloons speak a universal language that everyone can understand.

What will your next installation be? I'm working on projects in France and China. But I don't like to talk about my next piece, because it can change right up until the last moment.

charlespétillon.com

Opposite page
PLAYSTATION 2 (2013).

SUPERPOSITIONS (2013).

SOUVENIRS DE FAMILLE (2011).

Marc Shoul

BUILDING BUSTER

**Marjan Teeuwen's installations transform
condemned buildings as she explores
the strange beauty of destructive forces.**

Words JANE SZITA **Photos** COURTESY OF MARJAN TEEUWEN AND NOUVELLES IMAGES GALLERY

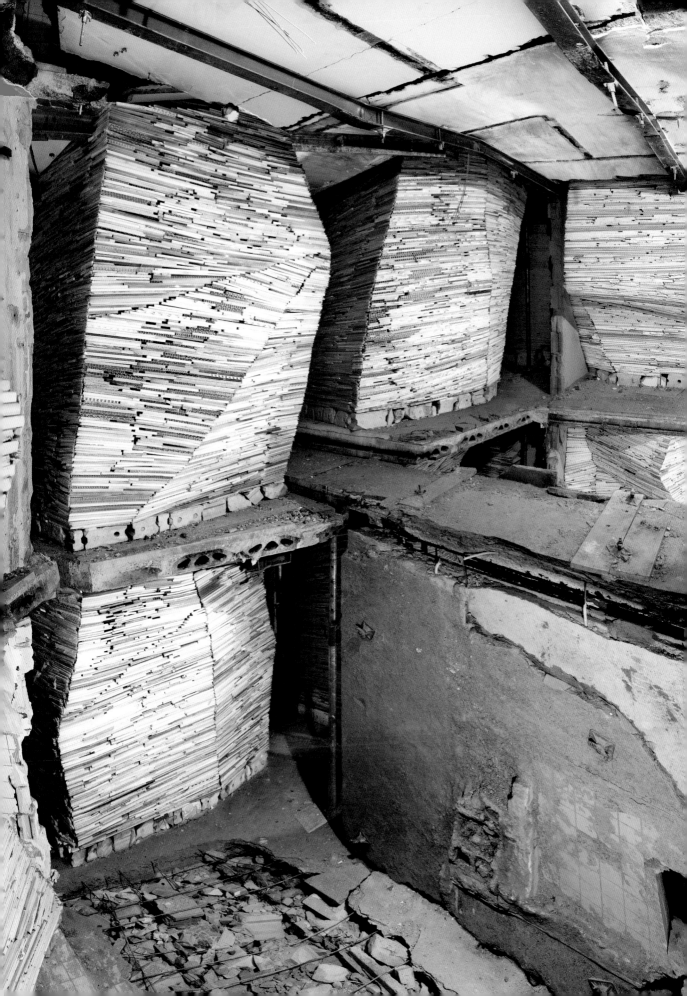

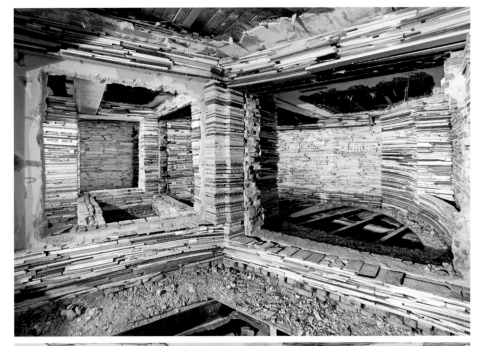

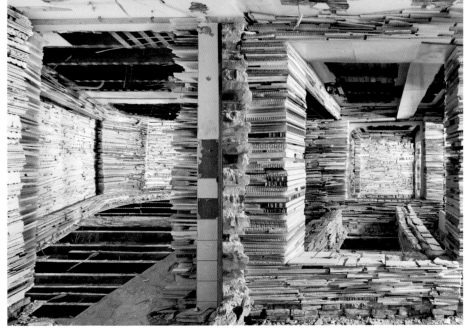

Above
VERWOEST HUIS BLOEMHOF WAS COMPLETED
IN ROTTERDAM, THE NETHERLANDS, IN 2013.

Previous spread, right page
FOR *VERWOEST HUIS OP NOORD* (2014),
TEEUWEN TURNED 210 PARTIALLY RAZED
APARTMENTS INSIDE OUT, COLLECTING DEBRIS
TO USE AS BUILDING MATERIALS.

Following spread
GEOMETRIC SHAPES PIERCE THE WALLS
IN SOME OF TEEUWEN'S INSTALLATIONS,
AS EXEMPLIFIED BY *VERWOEST HUIS PIET
MONDRIAANSTRAAT* (2010-2011).

After graduating from art academies in the Dutch cities of Tilburg and Breda (Fontys and St Joost, respectively), Marjan Teeuwen painted for 12 years before changing direction. 'I'm not a painter,' she says. 'I'm a builder.' A series of one-room installations (2000 to 2005) followed, and in 2008 (surely not coincidentally at the outbreak of the financial crisis) she embarked on a sequence called *Verwoest Huizen* (English title: *Destroyed Houses*). With these, she reworks derelict buildings into temporary ruined monuments, removing floors, walls and ceilings and filling them with the stacked detritus of the lives formerly lived there. Her treatment of 14 council flats in Amsterdam-North (2014), which she painstakingly dismantled, seemed to commemorate the demise of the Dutch welfare state. The series culminated in *Destroyed Houses* in Leiden (2015) and Gaza (2016-2017). Teeuwen lives in Den Bosch.

How would you describe your art work? MARJAN TEEUWEN: As architectural sculpture. The buildings I work on become sculptures; I carefully model them into an artistic form.

What process do you use to transform buildings into sculptures? Mine are intensive works in which all the floors, walls and ceilings of a structure are affected — I systematically destroy them. Then I construct an artistic image using materials from the homes themselves, which I supplement with materials from outside. I use these materials to form stacks, which I arrange to proliferate like a kind of virus throughout the house. On the outside, nothing can be seen of my work. Inside, the once modest homes are transformed into large, monumental spaces. It's all about the forces of construction and destruction, of decay and growth.

Who else works on these projects? Apart from myself, a small team that includes a contractor.

How long do they take to complete? Several months. The 14 flats in Amsterdam-North took us between four and five months. We worked very hard, with enormous speed. In total, about 300 doors and lots of other demolition material had to be lugged inside, all taken from the 210 homes on the site. Control is an important factor during the construction period. We often had about six people in the building. That means a lot of chaos and noise.

How do your works reflect your views on life? The social context — natural disasters, war and political conflict — is increasingly inescapable for me. In my work, I bring events on the global scale back down to the human dimension.

How do people react to your work? Interestingly, many visitors who comment refer to the fact that they are being overwhelmed by forces greater than themselves. We are all mortal; we all carry that vulnerability with us. Our nothingness, as experienced while seeing the beauty-in-demolition of the building, is a characteristic of the sublime.

How have personal circumstances influenced your work? As a small child in a far from harmonious family, I became disabled due to polio. I was hospitalized over and over again. I had to break free. So the artistic process coincides with who I am. Wanting to overcome obstacles has become part of my life and my personality. As a disabled person, I belong to a minority group. This makes me alert to the forces of power and powerlessness, construction and destruction, inclusion and exclusion, flowering and decline.

And you were born shortly after World War II ... I was a reconstruction child. Destructive forces dominate the news and usually receive all the attention, whereas constructive powers are often taken for granted, but in my view the two are mutually linked. I agree with Dostoevsky's conclusion in *Notes from the Underground*, which goes something like this: Man is equally inclined to build up the world and to destroy it; this polarity is in his genes.

Why did you abandon painting for architectural installations? In painting, I could not express myself. I have a strong psychological urge to handle things that appear just a little too big. I probably made the choice to go to the max at a very young age, and in 2002 I started making three-dimensional works — more monumental than I would ever have imagined prior to that time. In the process I had to deal with a great deal of resistance, chaos, mess, noise, debris and waste. Thinking big implies that you can fall far as well. Maybe that's artistic maturity.

marjanteeuwen.nl

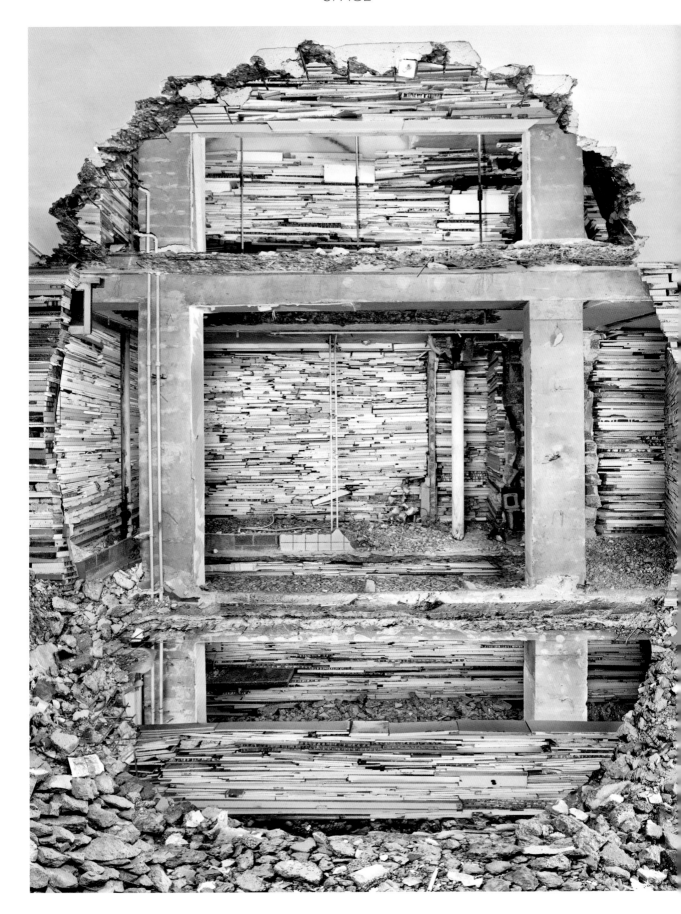

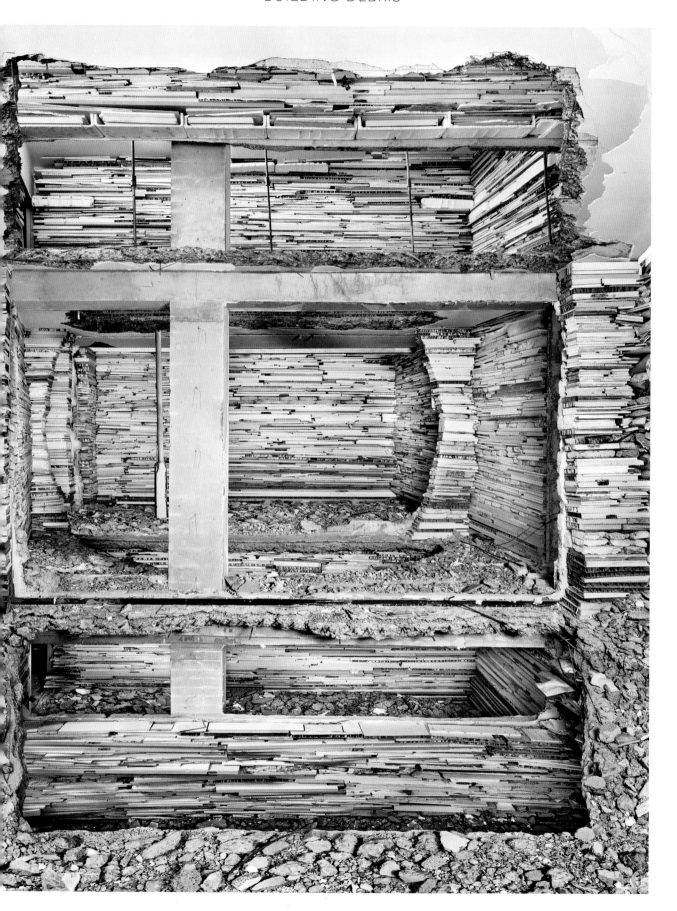

WEB MASTER

Using glue and little else, Yasuaki Onishi weaves installations of gossamer beauty on a giant scale.

Words JANE SZITA **Photos** COURTESY OF YASUAKI ONISHI

Chloe Bartram

The hot glue gun is a familiar quick fix for many of us, but in Yasuaki Onishi's hands it becomes the means of creating immersive environments as delicate and structurally impressive as a spider's web. Osaka-born Onishi, who studied sculpture at the University of Tsukuba and Kyoto City University of Arts, uses black glue in combination with plastic sheeting to shape vast, mysterious mountain landscapes that appear to float in midair. More recently, his work has also started to feature tree branches or wires, which he drapes with thousands of rain-like threads of glue and then covers with a crystalline material. The end result suggests both frozen forest and Gothic architecture.

How did you discover the creative possibilities of glue? YASUAKI ONISHI: It was when I had a residency in Korea, in a very large studio where I also slept. One night, as I was going to bed, I noticed that the hot glue had stretched very far from the working area to the corner where I slept, and I was intrigued. I was already working with plastic bags, so it was natural to combine the glue with the plastic I was using. The first works I made were quite small, created by draping plastic sheeting over a chair and then dripping the glue onto the sheet until the glue could support the plastic layer unaided.

What techniques do you use? For my plastic-sheet works, I cover furniture or other objects like stacked boxes with the plastic. When I have a shape I like, I stretch fishing wire between the walls just below the ceiling and drip glue from the wire. The glue I use is black, which makes a strong contrast with the plastic under the lighting. Finally, I remove the objects, leaving the suspended plastic sheet. With my more recent works, I use tree branches or wires to create the base structure, from which I drip the glue, finally spraying it with a urea solution that forms crystals.

How long does it take to make a work? The largest ones take around three weeks, working eight hours a day together with an assistant.

What appeals to you about glue as a material? It's not a high-cost material. It's actually very ordinary, and using glue I can create huge landscapes that fill a whole gallery space. The glue melts and drips; it takes a lot of time to fill the space, yet the glue itself dries in only five minutes. I like the organic quality of the lines that dripping glue creates. People can watch the process and relate to it — yet the finished work looks completely different from the process.

Who or what has influenced your work? When I was studying, I was particularly impressed by British sculpture, especially the work of Rachel Whiteread, which inspired my interest in negative space — the space around and between.

What territory are you exploring with your glue works? They are casting the invisible — I'm interested in non-visible things, like air, time and gravity. I see my work as creating a sort of void or empty sculpture, something that is the reverse of volume. A sculpture is normally a mass, a volume. In my case, it's more like delineating a border that lets you see both inside and outside, both positive and negative images. My plastic-sheet works, for example, are often like inverted mountains. My installations are based on information that I obtain from the space, and they are shaped by invisible forces — by gravity and time. Form, colour, movement — they all become transformed into simple elements: points, lines and light effects. For me, empty space has a double meaning: something has gone, leaving the possibility for something new to enter.

Can you explain the development in your work — the transition from plastic-sheet installations to new ones with crystalline finishes? I wanted to change how I went about filling empty space, so my newer works are experiments in creating sculptural volumes using tree branches or wires. Every time I start a project, the space inspires my work. With Vertical Emptiness, the space is a former sake brewery. I made what I call an 'organic parabola' by connecting wires to the wooden ceiling.

Your landscapes look very vulnerable. Is this a comment on our fragile environment? I think it suggests the reverse side of our world — something of which we cannot be conscious in daily life.

How do people react to your work? With curiosity — they want to know how I made it. As to the meaning it has for them, they have to use their own imagination.

onys.net

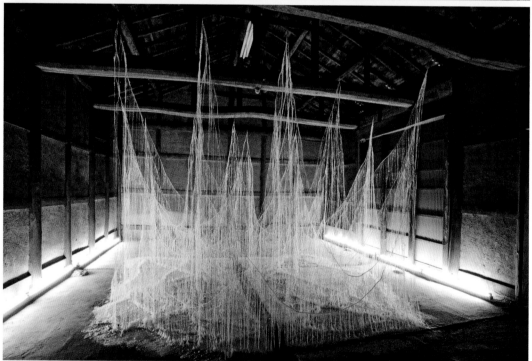

Above and previous spread, left page
VERTICAL EMPTINESS (ORGANIC PARABOLA)
(2013), IN THE FORMER ASAHI SAKE WAREHOUSE,
YAMATOKORIYAMA JAPAN.

Following spread
REVERSE OF VOLUME NMN (2017), IN THE
ON THE ART OF BUILDING A TEAHOUSE
EXHIBITION AT THE NEUES MUSEUM,
NUREMBERG, GERMANY.

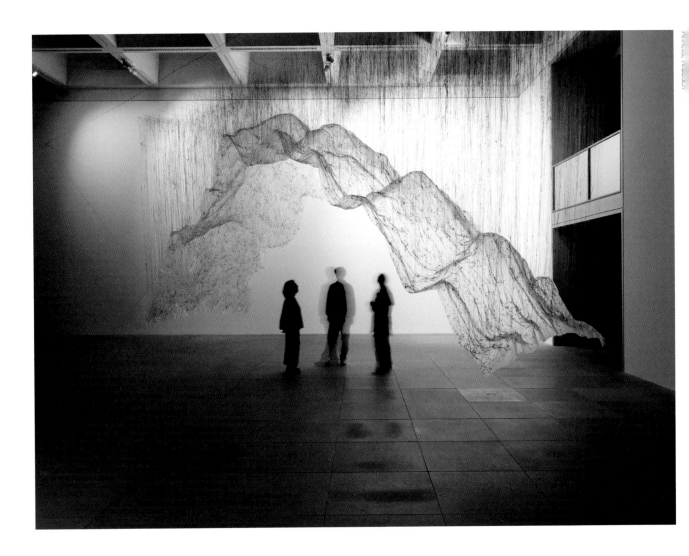

**'The glue melts and drips;
it takes a lot of time to fill the space'**

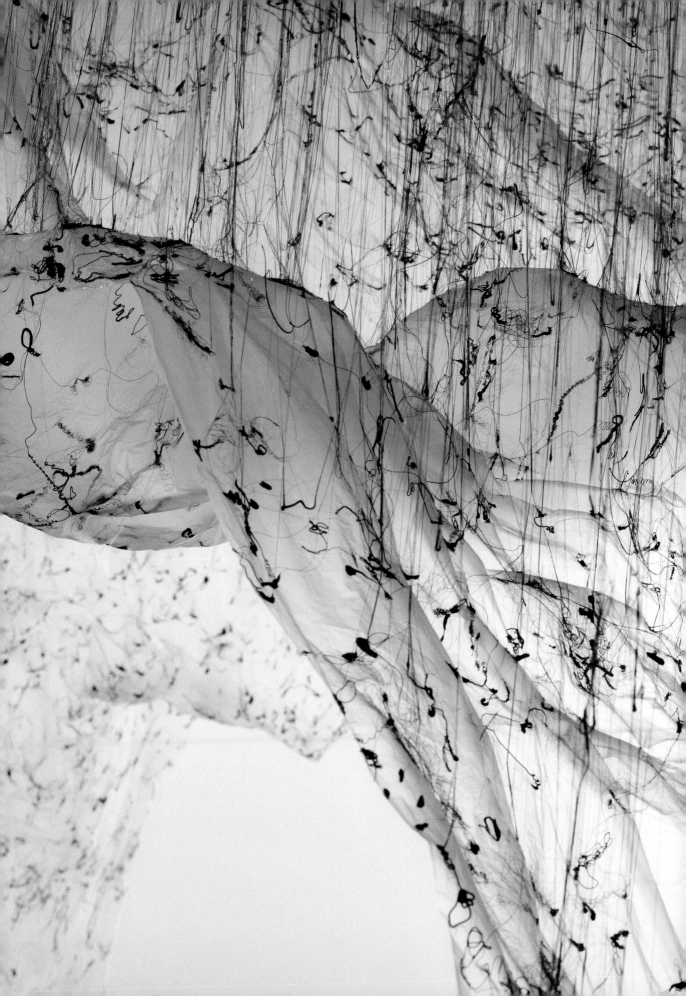

MIND OVER MATTER

**Translating biofeedback into visual and sonic
spectacle is artist Lisa Park, whose body of
work is defined by an intangible material.**

Words JANE SZITA **Portrait** ANDREW BOYLE

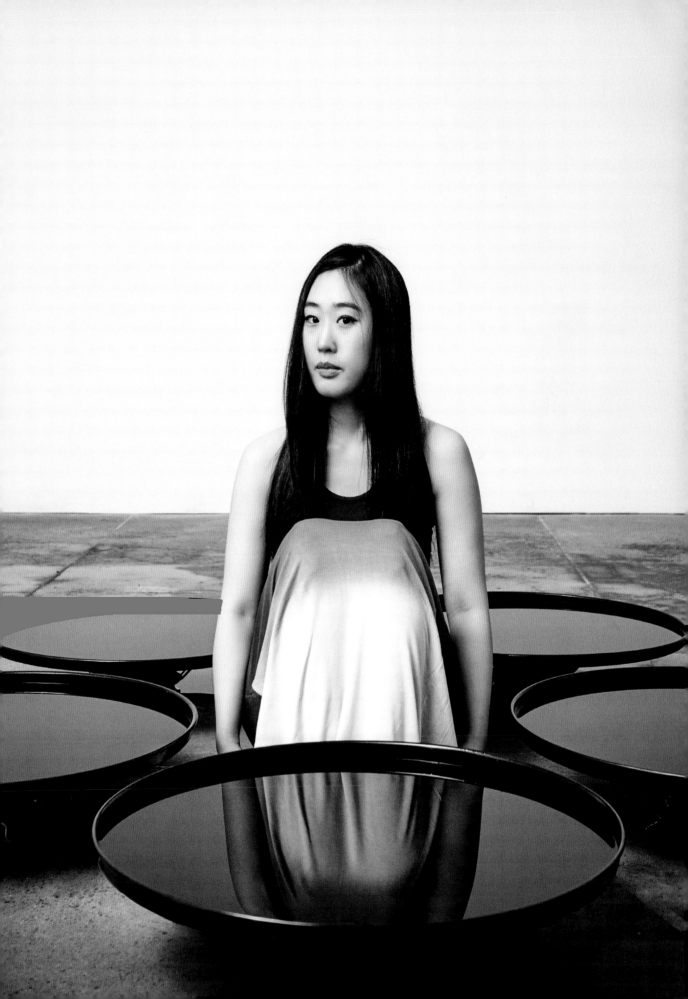

Above
CONFRONTING HER FEAR OF BUTTERFLIES IN
A WORK CALLED *OBSESSION IS SAD PASSION*,
PARK SEALED HER HEAD INSIDE A PLASTIC ORB
CONTAINING THE WINGED CREATURES,
WHILE A SENSOR MONITORED HER HEARTBEAT.

Previous spread
LISA PARK POSES WITH ELEMENTS FROM
EUNOIA II, WHOSE RIPPLING POOLS OF
WATER RESPOND TO THE ARTIST'S
INNER EMOTIONAL STATE.

Inspired by a compulsion to 'control my consciousness', Lisa Park's performance pieces employ commercial biofeedback tools, such as heart-rate monitors and brainwave headsets. She converts the data into visual and sonic form, producing poetic representations of her inner emotional state, such as the rippling pools of water in *Eunoia I* and *II*: 'Water is a mirror of the self,' she says. Raised in South Korea, Park studied fine art in California followed by interactive media at NYU in New York, where she lives and works today.

In Eunoia *I* and *II*, you move water with your mind. How do you work this magic? LISA PARK: In each of the two performances, I use a different commercial

How do people react to your work? When I'm performing, I feel as though the audience and I have an unspoken dialogue. I feel their presence, and they influence me. It's like a feedback loop. Outside the performances, people do question whether brainwave headsets are accurate enough to portray emotions. After all, I'm working with a developing technology that gives an impression, not a precise picture.

What impact have these works had on your life? They have helped me to develop a meditation practice. Also, I sometimes wear the headset in social situations; I'm fascinated by how I respond to my environment in everyday life.

'My goal is to master my own mind'

brainwave headset with its own software program. It comes with concentration and meditation values, plus the five common brainwave frequencies — alpha, beta, gamma, delta and theta. I basically translate these input values into sound, using the programming language Max, and the sound is then sent to speakers. The speakers are placed under bowls of water, and the sound ripples the water.

Why use your emotional state as your material in this way? I've always thought of myself as an emotional person, and I wanted more control over my emotions. That's my goal: to master my own mind. I started using biofeedback in an attempt to calm myself for each performance. My first work of this type, *Obsession Is Sad Passion*, was inspired by my fear of butterflies. My head was in a plastic orb into which butterflies were released, while a sensor monitored my heartbeat. Its fluctuations were translated into variations in the speed, pitch and tone of a prerecorded reading of Patrick Süskind's 'Depth Wish'. After the performance, I felt I had confronted my own vulnerability. I was no longer afraid of my own fear.

How difficult is it to manipulate your feelings during a performance? The irony is that I created *Eunoia* in order to calm myself, but people want to see some variation in order to believe it works. I really have to choreograph myself during the performance. The headset analyses certain emotions better than others — it responds well to frustration, for example. I conjure certain memories, reliving various frustrating emotional scenarios.

Might your emotion-based works have real-world applications? I would like my work to be used as therapy or to help people meditate. Brain sensors have been shown to help with ADHD and other disorders. I'd like my work to build on that.

What are you working on next? I'm starting a new project about sleep. I want to create a representation of my dream state, using data from my brainwaves to control media in some way. I've also begun to collect my tears — which I see as water that contains feelings — to make a kind of tear diary. I note the date and why I cried. Later I'll examine them under a microscope.

thelisapark.com

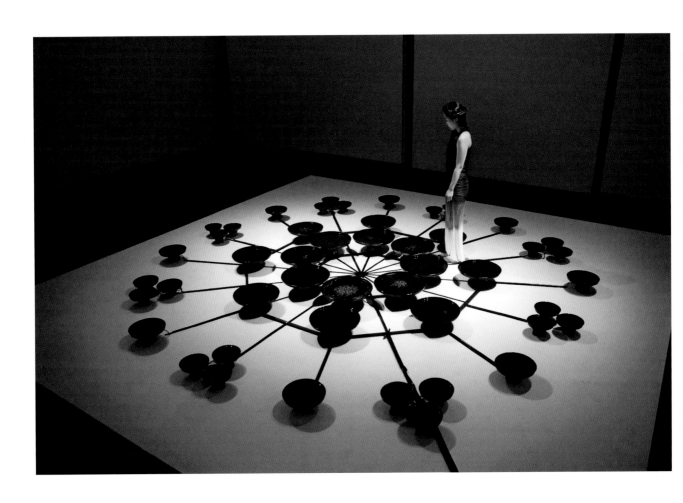

Above and opposite page
COMMERCIALLY AVAILABLE HEADSETS
MONITOR PARK'S BRAINWAVE FREQUENCIES
IN *EUNOIA I* AND *II*. THE DATA RECEIVED IS
TRANSLATED INTO SOUND AND SENT
TO SPEAKERS, WHICH VIBRATE BENEATH
BOWLS OF WATER.

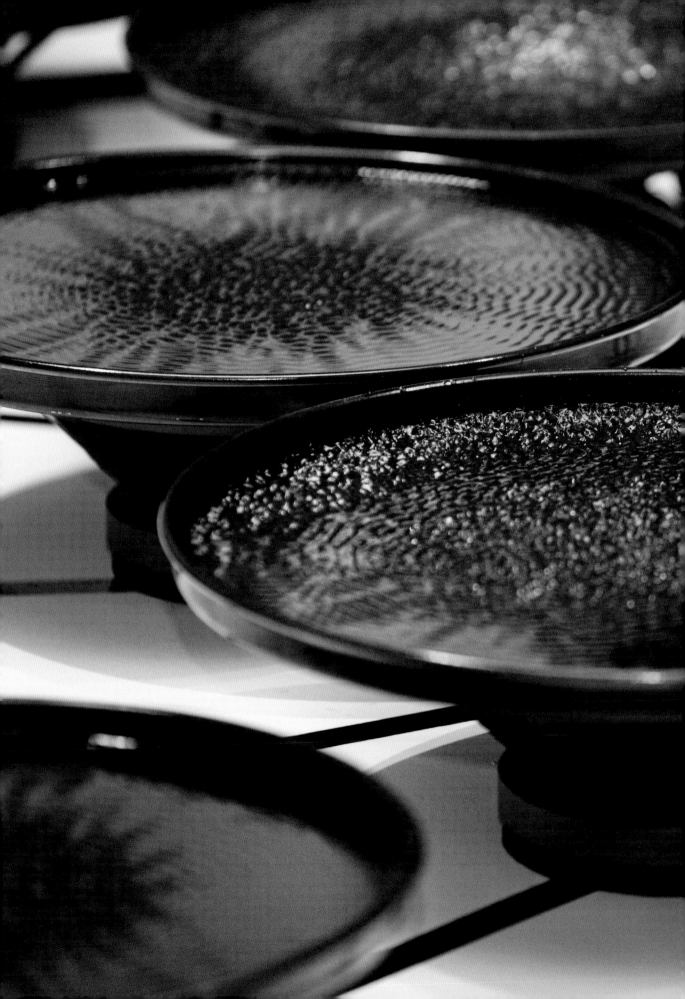

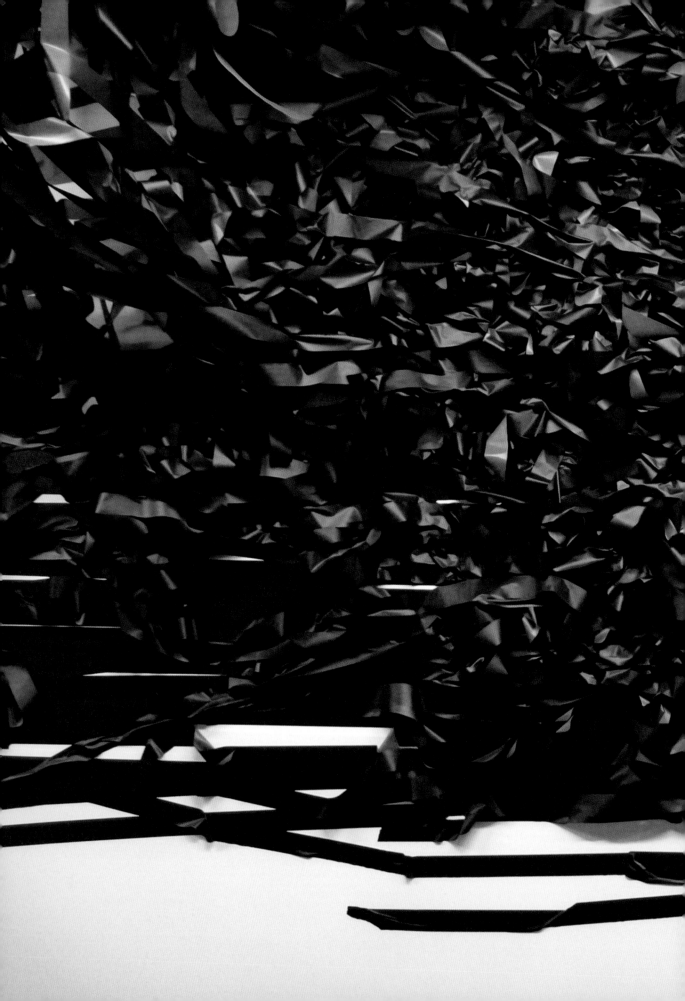

LINE DANCER

In Monika Grzymala's crisply choreographed installations, adhesive tape becomes an explosively expressive medium.

Words JANE SZITA **Photos** COURTESY OF MONIKA GRYZMALA

If drawing, as Paul Klee famously said, is 'taking a line for a walk', Monika Grzymala's installations are more like taking a line on a high-energy gymnastic marathon. For over a decade, Gryzmala has travelled the world armed only with the numerous rolls of adhesive tape she uses to create works whose expressive power and energy belie their banal origins.

Born in Poland, Grzymala has lived most of her life in Germany and is currently based in Berlin. She initially trained as a stonemason before studying fine art at the universities of Karlsruhe, Kassel and Hamburg. While concentrating on drawing, she quickly found that her line works escaped the page, migrating first onto gallery walls and then into space with the help of sticky tape. She had discovered her true interest: 'The moment when a drawing becomes a sculpture.' With her tape pieces, she says, 'I am not filling space; I am more transforming it according to a personal point of view of how human interaction with the space might be visualized.'

How did you start making your works with tape? MONIKA GRZYMALA: It all started with drawings on paper, which later became wall drawings. I wanted to take the lines of my two-dimensional drawings and allow them to enter the third dimension and become an object or a sculpture. So using tape was more or less a logical consequence of my work.

What's the best thing about tape as a material? It's very practical. It is essentially a line on a roll, which is easy to handle and to transport. With adhesive tape, I can make a line three-dimensional. I can draw in space, draw like a sculptor.

How many tape works have you made so far? I've never counted, but there are dozens on my website, all of which I've created over the past 18 years.

How do you go about making them? Every new project starts with a drawing on paper, preferably done with ink or watercolour as a kind of calligraphy. To describe the method and the outcome of my works, I use a German term I coined myself, *Raumzeichnung*. It means 'spatial or three-dimensional drawing', and it's a logical continuation of my drawing practice as a sculptor. I never correct my work, so the outcome is a linear 1:1 translation of the process.

What tools do you use? My hands and my body are the most important ones — in connection with my mind, of course, and how it perceives a place. Making art is a local event in general. On the practical level, I use ladders and lift platforms if necessary.

Do you work with an assistant? Generally not, as every work is about the authentic dynamic in the process and how I deal with it in a site-specific piece.

How long does it take to make a work? Usually about seven to ten days.

How long do the works last? They are all temporary, organic interventions in space and thus ephemeral. I keep most of the de-installed works in my studio for a while, to remind me of the process or to be reactivated in another show. Sometimes, though, I decide to create a completely new piece.

What kind of tape do you use? All sorts — I pick them up all over the world. When starting a new project, I begin by choosing the optimal texture, materiality and colour, like a painter who decides to use oil on canvas or another medium.

How much tape does it take to make a work? Usually between 3 and 10 kilometres.

What inspires your designs? Movement, the proportions of the human body, and my perception of and reaction to the surrounding space. There is also a strong connection to music or sound, as well as to performance or dance.

Do you find it ironic that many people know your 3D interpretations of 2D lines only through 2D images? It's interesting that people who look at photographs made to document my tape works react mainly to the graphic aspects on a visual level. Photos represent the return to a two-dimensional manifestation of a three-dimensional object.

When visiting the exhibition and experiencing the tape work not only with the eyes but also with the body, people can perceive the piece on a physical level, translated through the proportions of my body and through ideas pertaining to the surrounding space.

What is the biggest challenge of working with this material? Only one — the physical aspects of installing the piece. As an installation artist, I find it natural to express ideas by making every gesture visible, and adhesive tape offers the best option for that expression.

t-r-a-n-s-i-t.net

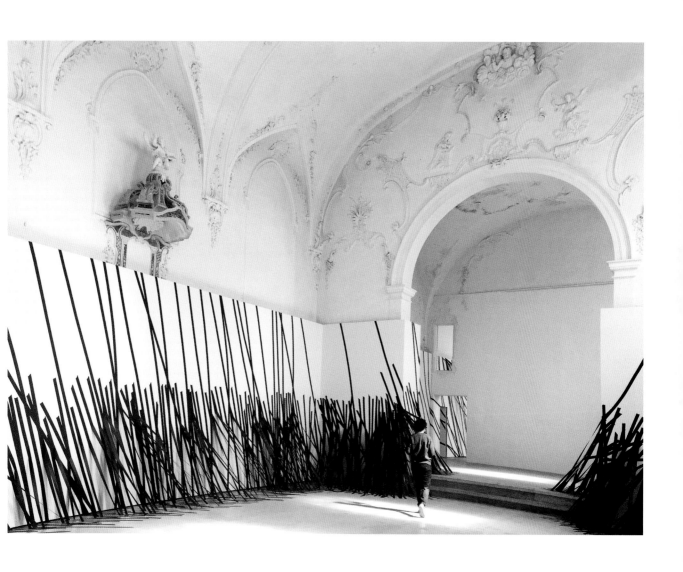

Above
RAUMZEICHNUNG (SOLITAER), 2017. 5 KM BLACK
PAPER TAPE. SOLO EXHIBITION IN HAUS DER
KUNST ST. JOSEF, SOLOTHURN, SWITZERLAND.

Previous spread, left page
TWO CORNERS, 2013. 5 KM BLACK PAPER TAPE.
SOLO EXHIBITION AT THE ARSENAL MONTREAL,
CANADA.

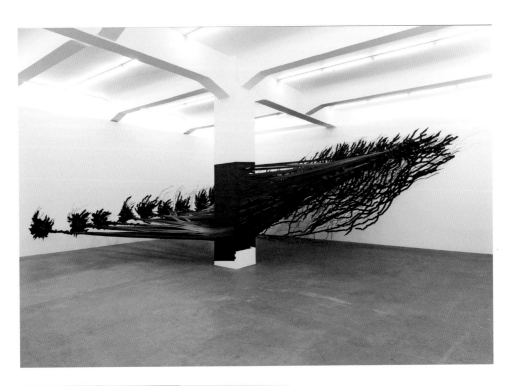

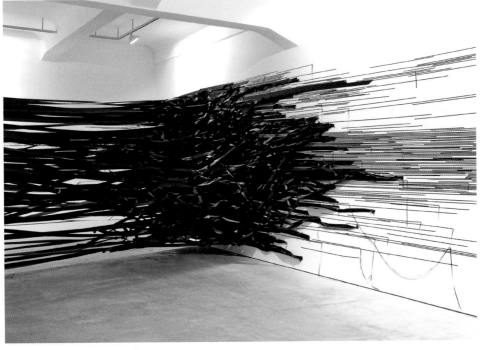

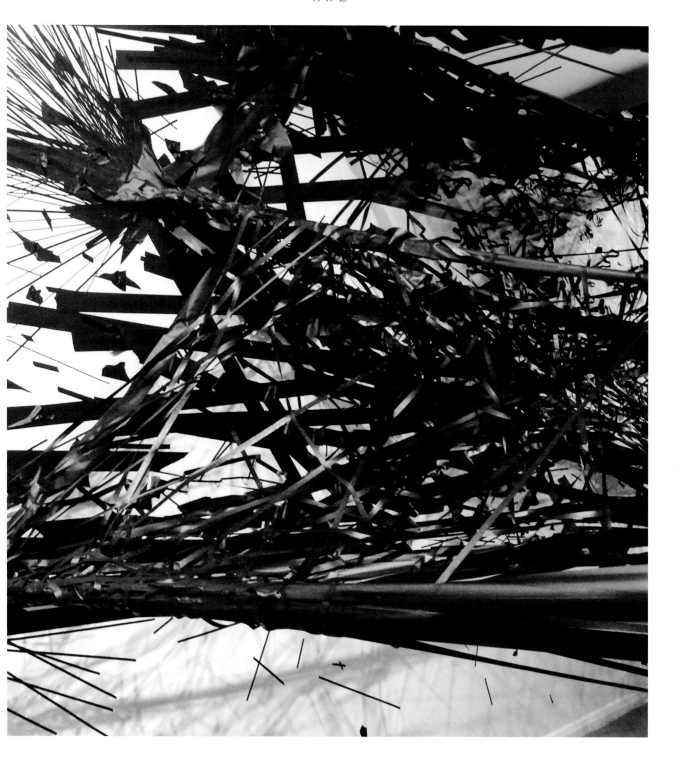

Above
RAUMZEICHNUNG (XYZ), 2011. 3,3 KM BLACK
PAPER TAPE. SOLO EXHIBITION AT THE
SUMARRIA LUNN GALLERY IN LONDON, UK.

Opposite page
RAUMZEICHNUNG (BASS), 2012. 5 KM BLACK
PAPER TAPE. SOLO EXHIBITION AT GALERIE
CRONE IN BERLIN, GERMANY.

RAUMZEICHNUNG (LOGARITHM), 2013.

STICKY BUSINESS

**Artist Rebecca Ward uses humble vinyl
and electrical tape to create her colourful,
geometric explorations of space.**

Words JANE SZITA **Portrait** FRANCESCA HOLSEN

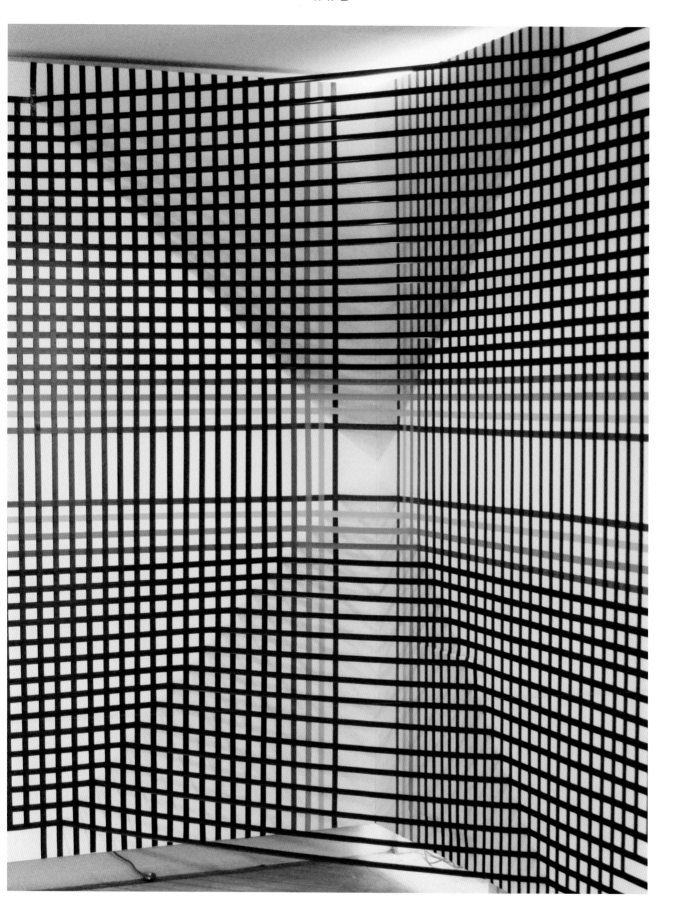

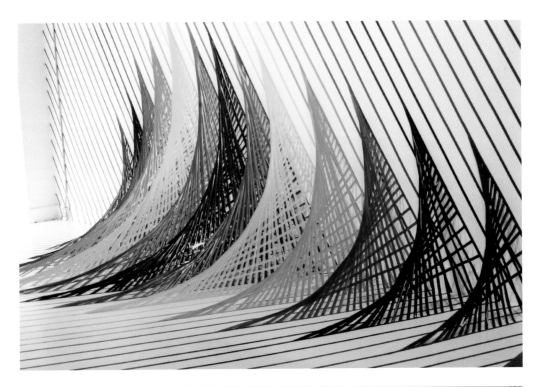

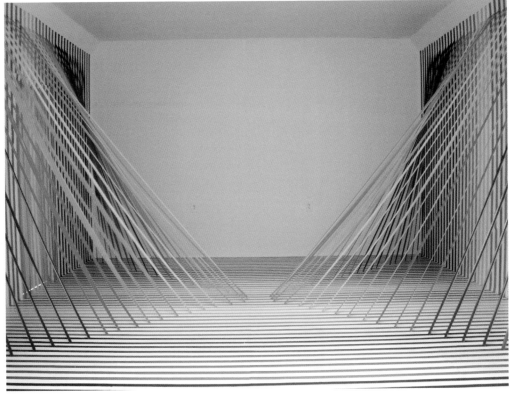

**'My favourite is
electrical tape — it's dreamy'**

So — how did it all begin? REBECCA WARD: Since I was little, I've always been attracted to tape. I used flagging tape, masking tape and electrical tape to decorate my room when I was in school. It was tacky, but I was obsessed with lines and stripes and bright colours. There's also something incredibly alluring about the texture of the material: so shiny, smooth, and overwhelmingly plastic.

What type of tape do you use? Duct tape mainly — it's a good width and comes in lots of colours, and the end results are good. My favourite though is electrical tape. It's dreamy. If it sticks to itself, it's easy to pull apart …

Where do you find all the different colours you use? Thanks to the internet, it's easy — I just order them online.

How do you go about creating a tape installation? First, I measure every tiny detail. Every nook and cranny is important and could affect how the end piece looks. One of my favourite parts of the process is looking at how lines flow together and run into each other. I also like exploring the different measurements of a site and finding patterns in those numbers. Sometimes I can balance the number patterns and measurements with the colours I'm using. If a space measures 144 inches [366 cm] wide, that's a beautiful number — 12 squared — so I might try to use 12 colours and to use each one an even number of times. It's all about a playfulness with numbers and colours.

How do you stop the tape sticking to itself and getting air bubbles? It can be difficult. Sometimes pieces stick to each other, and I have to start over. But that's just part of the process.

How do people react to your work? Positively and viscerally. People want to touch it. Adults generally like the ones that took the most time to make. Kids like the ones that create an encapsulating environment.

Have you fully explored all the possibilities of tape? Definitely not! Perhaps once I was ready to leave it behind, but now I feel as though I've barely scratched the surface. I'm a bit obsessed with tape at this point.

rebeccaward.net

Oppostie page
SEVENTEEN IS SHARP (2009).

TAPE 3 (2006).

Previous spread, right page
STELLA WAS RIGHT (2010).

Following spread
THICKLY SLICED (2011).

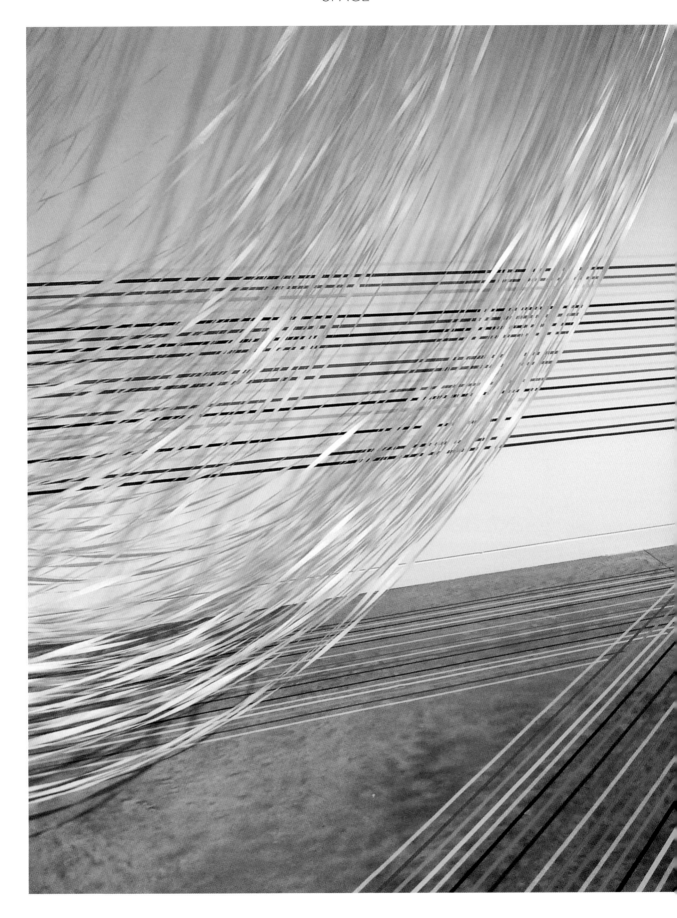

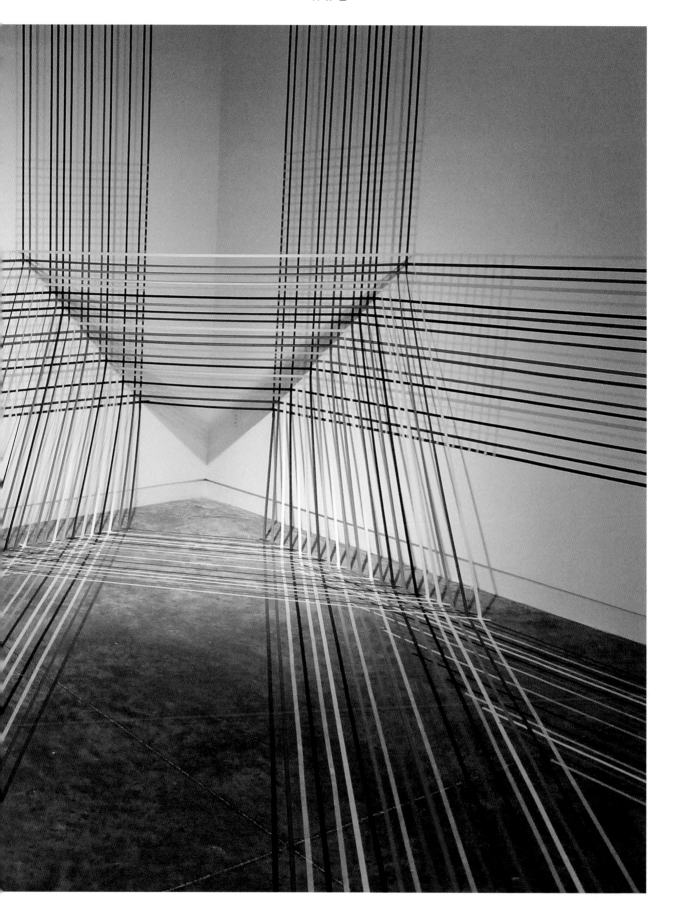

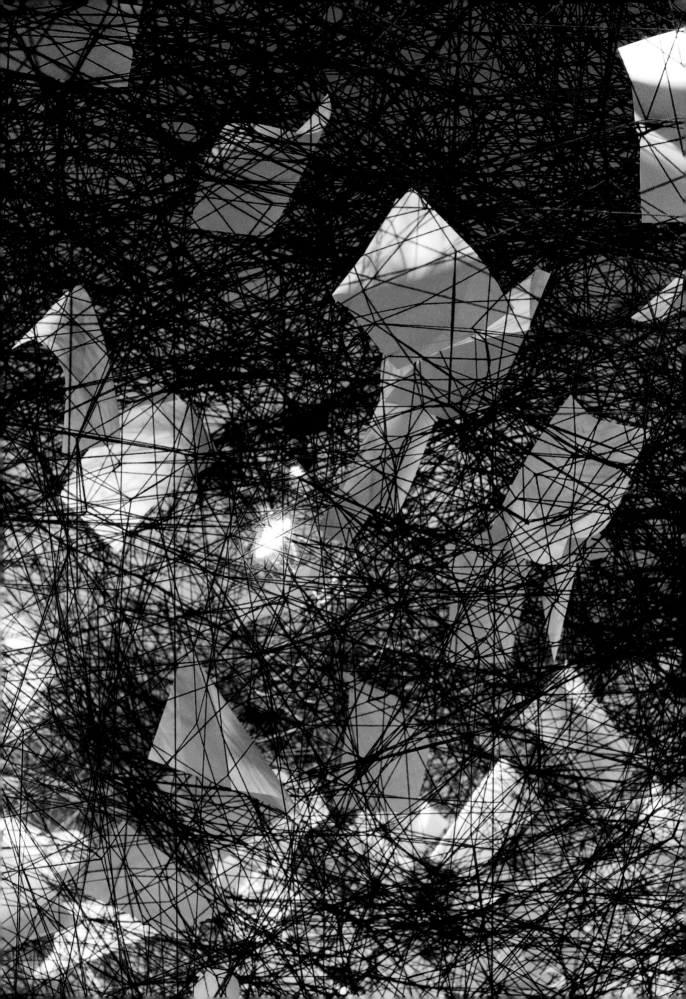

RED (AND BLACK) THREAD

Favouring just two colours of yarn, Chiharu Shiota weaves infinite stories in her site-specific installations.

Words ANNA SANSOM **Portrait** DANIEL HOFER

Born in Japan, Chiharu Shiota studied painting in Tokyo before being educated under Marina Abramović at the Braunschweig University of Art in Germany and completing her schooling at the University of the Arts in Berlin, the city in which she now resides. A desire to draw in the air led her to use yarn — usually black and red — in her work. She makes large-scale, site-specific installations that involve threads woven from floor to ceiling, enmeshing everyday objects such as beds, dresses,

Daniel Templon in Brussels? The bed is important to me. Many people are born and die in a bed, making the bed the beginning and the end of life — and a place filled with stories. I wanted to make an installation with beds, but in a new style. When I sleep, I sometimes feel that I can't wake up any more. And when I do wake up, even though my brain is working, I'm still dreaming. It's this kind of world that I wanted to create, within a space that would show dreaming, reality and movement. At the gal-

'Red is what's inside me, and black is what's outside'

musical instruments and keys. After representing Japan at the Venice Biennale in 2015, Shiota presented a solo show, *Sleeping Is Like Death*, at Galerie Daniel Templon in Brussels earlier this year. During a performance at the opening, three young women appeared to be asleep in hospital beds.

How did you become interested in using yarn in your work? CHIHARU SHIOTA: When I was a student, I was in the painting department and I wanted to draw — but in three dimensions, not two. So I started making lines with string in the air — in space — when I was about 20.

You use black or red string in your installations. What do these colours signify for you? Black is the universe. It's like the night sky — deep and dark. Red is something inside, like the body or blood. Red is what's inside me, and black is what's outside. The two come together in my work.

How would you describe the process of making an installation? I have 70 per cent of what I do in my head before I start weaving, but the final result always turns out to be different from what I'd envisioned. I rely on my imagination and try not to make drawings first, because when I draw something, I feel that the work is already finished. I like to bring materials to the site and start making something there. Things made in the studio beforehand are less dynamic, and often they don't fit into the space. My work is more about drawing in the space by weaving than about responding to architecture. My eyes are still those of a painter.

You first made an installation with beds in 2000. What inspired you to revisit the idea in a more open, dynamic style for your exhibition at Galerie

lery in Brussels, people could walk into and through the installation, whereas the piece I made in 2000 kept them outside, where they could only walk around it.

How does this installation differ from *The Key in the Hand* at the Venice Biennale? There it was about weaving from the ceiling downwards. The threads carried the weight of the keys, a combined load of one tonne. In Brussels I was able to extend the woven threads across the dimensions of the space. The work was freer, like a wave, and had much more feeling, so that dreams could envelop the sleepers.

How do you choose which objects to use? I pick ordinary things that human beings use every day, like a key or a suitcase. I travel a lot, so I often use a suitcase. Seeing either of these objects conjures up memories and stories, which inspire me to start weaving.

How do people respond to your work? I would say that people generally feel they *belong* to my art pieces, as they often talk about how engaging my installations can be. My goal is to express human emotions through my objects, and people tend to find my work touching.

You also participated at the Biennale of Sydney in 2016. What did you show there? *Conscious Sleep* was on Cockatoo Island [near Sydney Harbour]. The site was formerly a prison, so the work was about convicts sleeping. The prison's inmates didn't have beds; they slept on the floor. I used 20 beds, propped up diagonally against the walls. It's a metaphor for my thoughts about more than 100 prisoners sleeping together in a small room.

chiharu-shiota.com

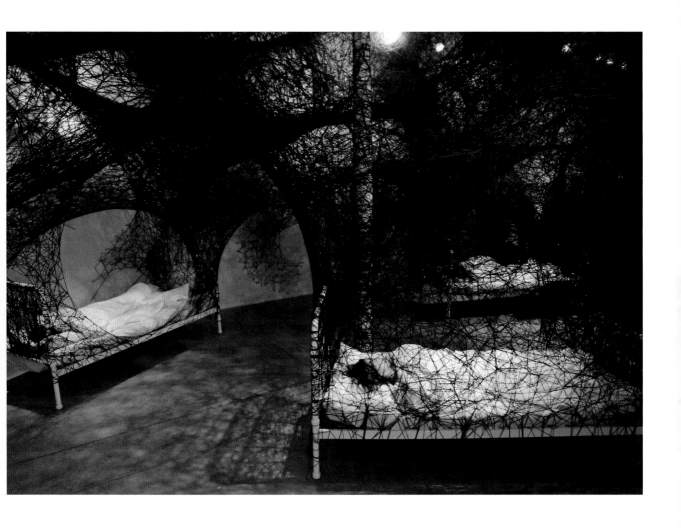

Above
SLEEPING IS LIKE DEATH INVOLVED
A PERFORMANCE IN WHICH FIGURES
RESTED IN THREAD-ENCAPSULATED BEDS.

Previous spread, left page
A LONG DAY, SHIOTA'S SOLO SHOW AT K21 IN
DÜSSELDORF IN 2016, FEATURED AN OLD DESK,
AN OLD CHAIR AND SHEETS OF PAPER TRAPPED
LIKE INSECTS IN A BILLOWING WEB OF BLACK
THREADS.

Following spread
SLEEPING IS LIKE DEATH (2016), AN EXHIBITION
AT GALERIE DANIEL TEMPLON IN BRUSSELS,
INCORPORATED BEDS, AN IMPORTANT THEME
IN SHIOTA'S ART. FOR HER, BEDS SIGNIFY THE
'BEGINNING AND THE END OF LIFE'.

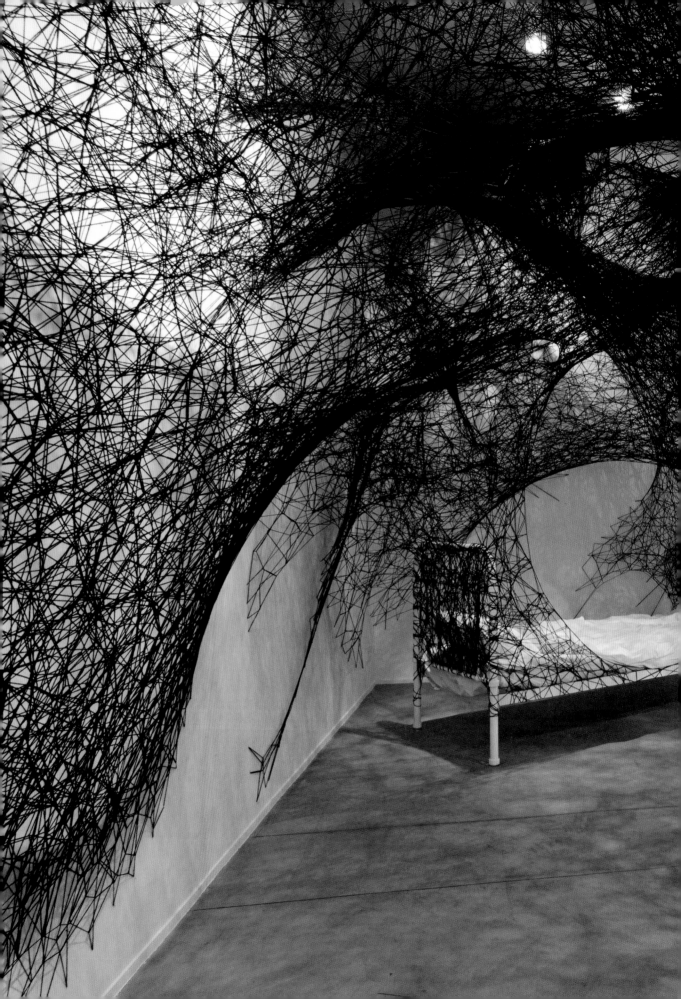

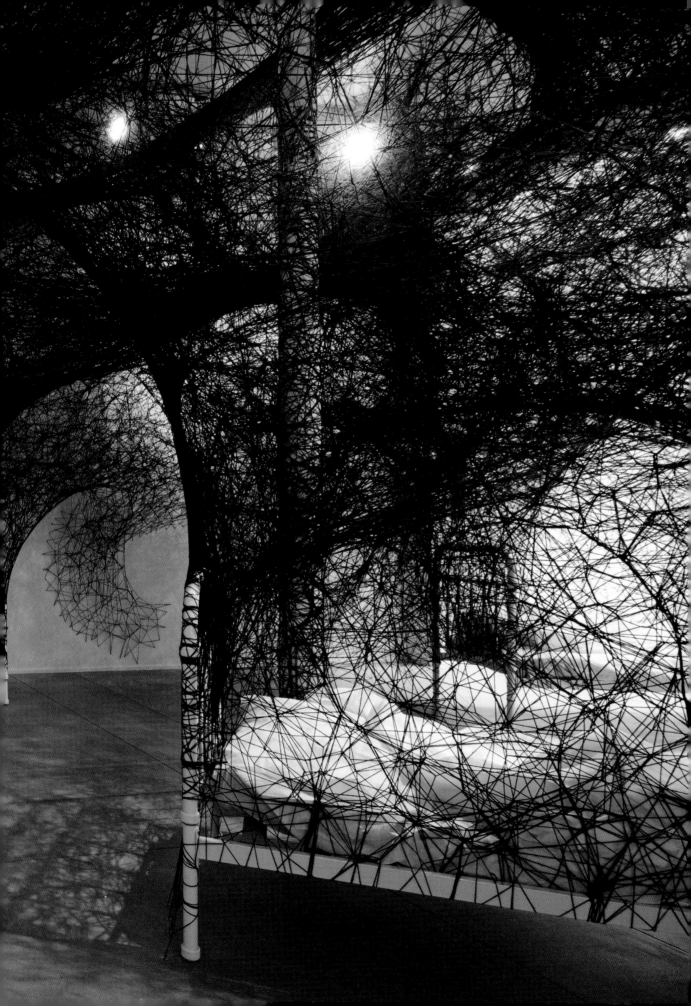

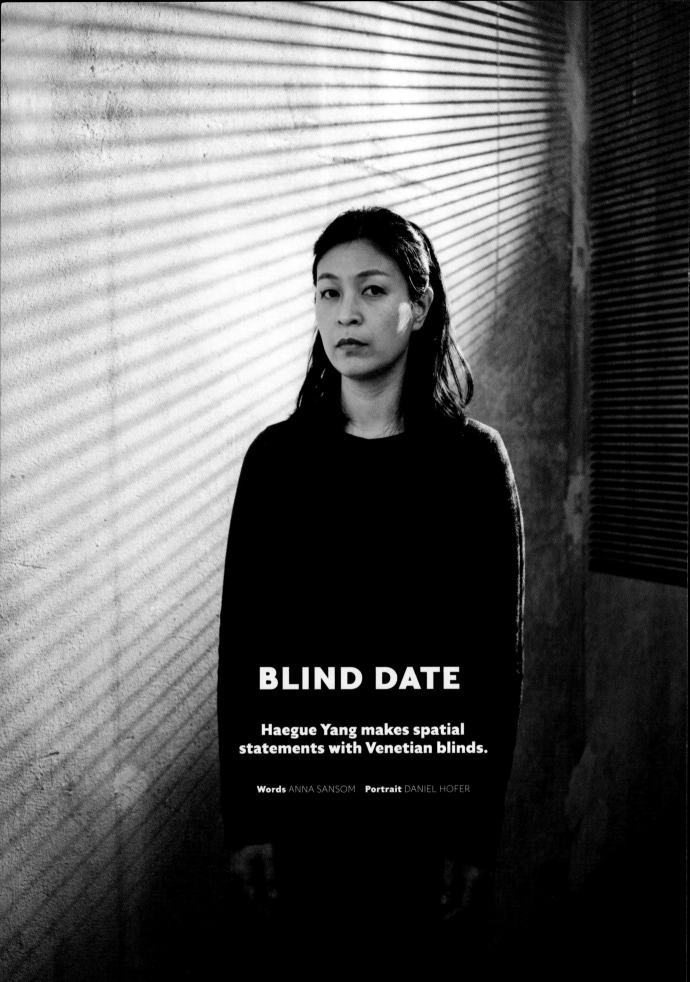

BLIND DATE

Haegue Yang makes spatial statements with Venetian blinds.

Words ANNA SANSOM **Portrait** DANIEL HOFER

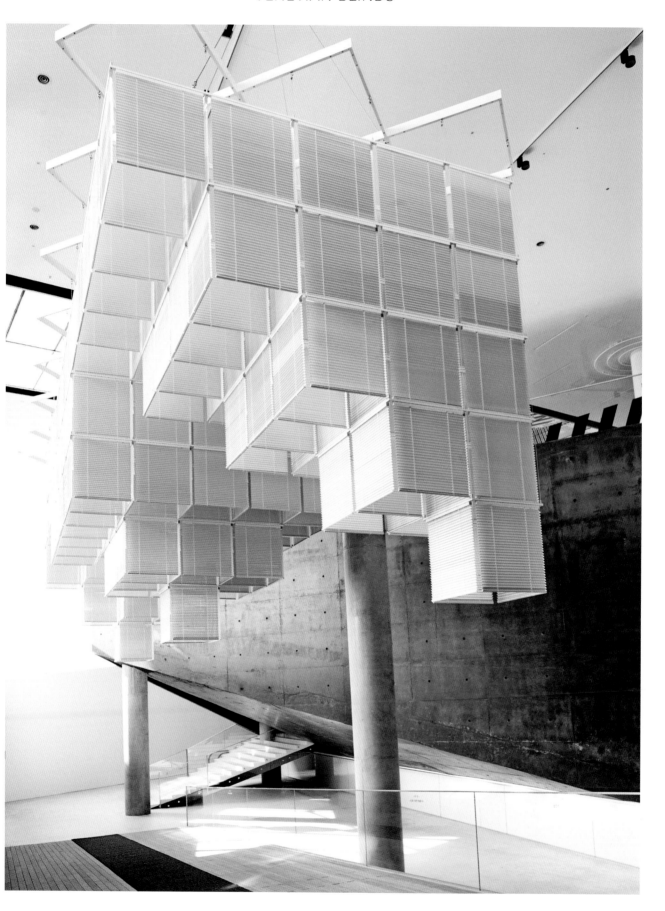

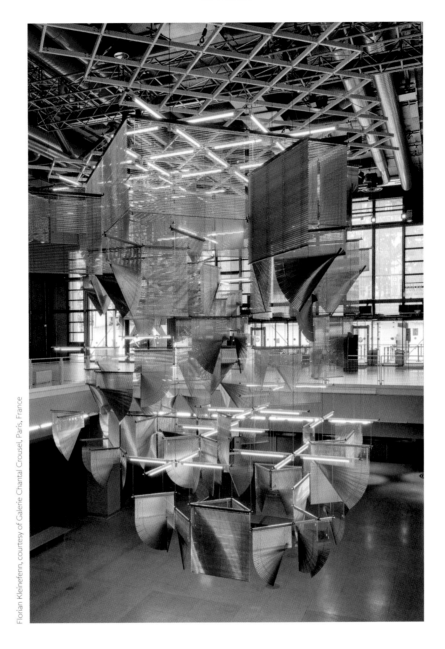

Florian Kleinefenn, courtesy of Galerie Chantal Crousel, Paris, France

Above
AN INSTALLATION IN THE CENTRE POMPIDOU
IN PARIS, *LINGERING NOUS* (2016) ENTERS INTO
A DIALOGUE WITH THE LINEAR ARCHITECTURE
OF THE MUSEUM COMPLEX.

Previous spread, right page
*SOL LEWITT UPSIDE DOWN – STRUCTURE WITH
THREE TOWERS, EXPANDED 23 TIMES* (2015)
EXEMPLIFIES HAEGUE YANG'S FASCINATION
WITH THE WORK OF SOL LEWITT, WHOSE
STRUCTURE WITH THREE TOWERS (1986)
SHE EXPANDED AND REVERTED USING
LAYERS OF BLINDS.

Following spread
'*MOUNTAINS OF ENCOUNTER* (2008) MARKED
THE FIRST SHIFT FROM NARRATION TO
ABSTRACTION,' SAYS HAEGUE YANG OF
HER INSTALLATION.

Dividing her time between Seoul and Berlin, Haegue Yang makes conceptual work using everyday materials, which she employs in abstract and subtly narrative ways. The results range from compositions featuring envelope security patterns to sculptures built around products like clothing racks. The 45-year-old artist has made sculptures and installations out of Venetian blinds since 2006.

You first used Venetian blinds in *Series of Vulnerable Arrangements – Version Utrecht*, your multisensory installation from 2006. How did your interest in blinds develop? HAEGUE YANG: That installation was a mute sensorial field, composed of devices such as lights and scent emitters that were juxtaposed with a 'voice' from video essays in the same space, which was demarcated by Venetian blinds. The obliqueness of the blinds achieved an ambivalence of being comfortingly separated yet sufficiently connected. This discovery informed my next piece, *Series of Vulnerable Arrangements – Blind Room*, also from 2006. Guided by the blinds, one wandered into a field of light/shadow, wind, heat, humidity and smells, the mind strolling in associative memories. Although the contemplation of senses occurred individually, visitors were bound to one another through a shared experience of fragmentation and separation.

How has using Venetian blinds helped you to think about space and architectural volume? My 2008 installation, *Mountains of Encounter*, marked the first shift from narration to abstraction. The spiral layout of vibrant red Venetian blinds sloping at different angles portrayed the mountainous landscape of Yan'an, China, where Korean underground revolutionary Kim San had an unlikely encounter with American journalist Helen Foster Snow in the 1930s, leading to her biography about him. The hypnotizing choreography of four moving lights sharply cut the blinds' surface, while white circles and two strong floodlights in the spiral's centre dimmed and brightened. As lights and blinds intensely confronted each other, heroic and universal qualities of this encounter penetrated across history.

Your installations seem to be inspired by figures from literature, their politics and passions. How do Venetian blinds enable you to develop an abstract narrative? One example is *Lethal Love* from 2008, which lingered on the intense companionship and tragic end in the story of Petra Kelly, founding member of the German Green Party, and Gert Bastian, former German general and peace-movement hero. [In 1992, Bastian apparently shot Kelly dead in her sleep before killing himself.] The installation activated an experimental template to explore their narrative, using materials suggestive of what happened, such as gunmetal-coloured Venetian blinds, smells of wildflowers and gunpowder, and an extreme reflection of blinding light. The viewer, however, remained more or less blind to the concrete narrative, which is my goal in achieving abstraction. For me, abstraction gives value to narratives that appear within and around us without constituting its own limits.

How important is it that visitors understand the meaning behind the piece? It's not very important – more of an option than an obligation for the viewer. Although I don't want to give up learning about historical figures, the work and the audience should be free from my eagerness to dive into those stories. I'd rather invite the audience to enter a visual and spatial field that has a somewhat abstruse articulation than one that produces an obvious meaning.

Other pieces reference 20th-century art, such as Sol LeWitt's geometric white structures. What triggered this aspect of your work? I felt liberated by Sol LeWitt's approach to works such as his modular structures and by his statement: 'Conceptual artists are mystics rather than rationalists. They leap to conclusions that logic cannot reach.' The primary translation mechanism of my piece from 2015, *Sol LeWitt Upside Down – Structure with Three Towers, Expanded 23 Times*, is an expansion and inversion of LeWitt's 1986 *Structure with Three Towers*. The work becomes progressively opaque as the layers of blinds accumulate, while the shallow areas maintain their transparency.

How does playing with transparency and opacity relate to Korea's modern history? Experiencing modern Korean history, with its long and brutal military dictatorship – a dominance of state-led economic development and the sacrifice of freedom of speech and democratic values – made me conscious of the authoritarian abuse of power. I wish not only to remember but to render official history in a subjective way, so that it doesn't become knowledge to be learned.

You often choose what have been called 'indescribable, uncategorizable colours', such as the iridescent green and pink in *Lingering Nous*, exhibited at the Centre Pompidou in 2016. What are your criteria for choosing colours? Each colour in *Lingering Nous* relates to a specific angle defined by my own octagonal connector system and echoes the primary colour scheme of the Centre Pompidou's building services, such as ventilation and electricity.

What are you currently working on? A solo exhibition at the Geffen Contemporary in Los Angeles, part of the city's Museum of Contemporary Art. Scheduled to open in June 2019, the show will encompass works from 1994 to the present, including major installations featuring Venetian blinds.

heikejung.de

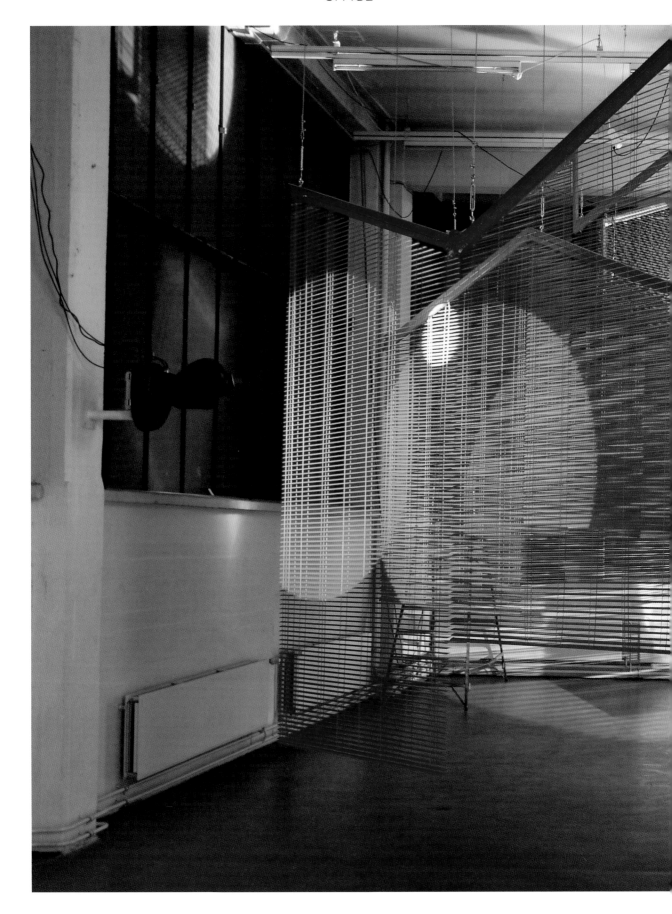

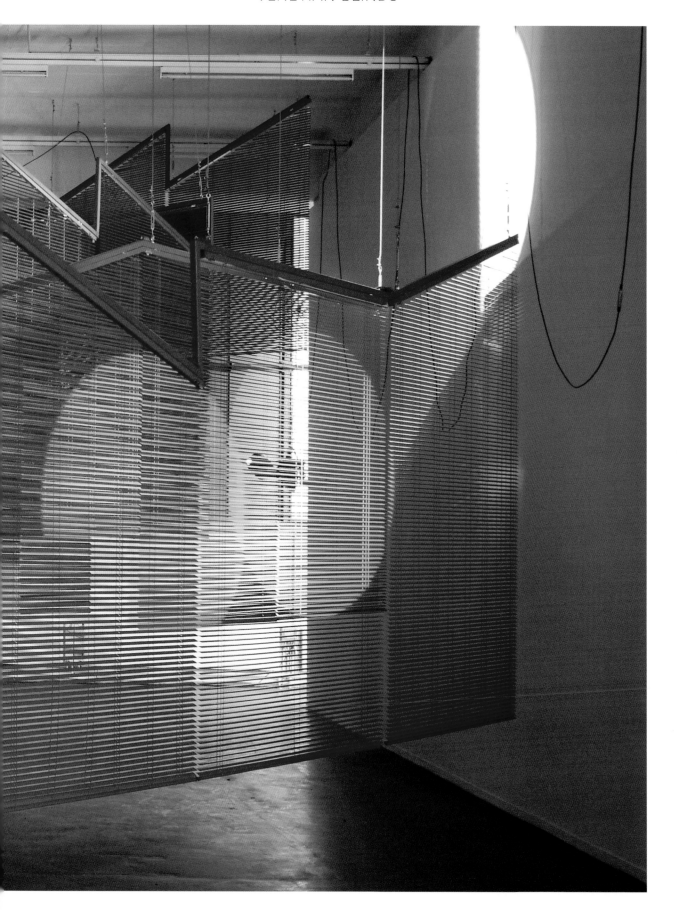

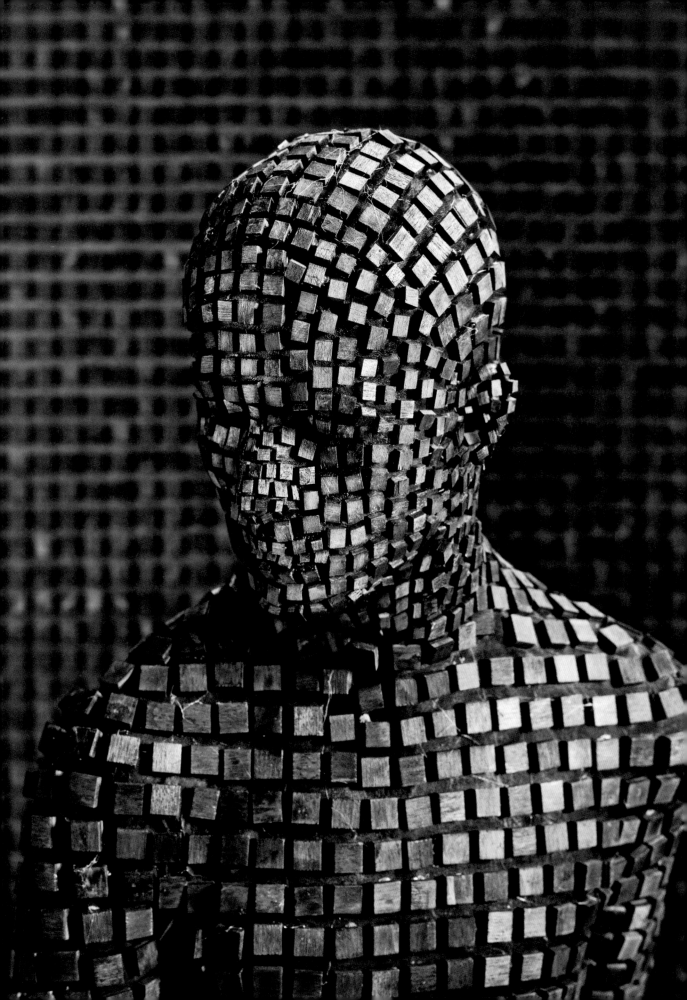

Catharina Gerritsen

SQUARE ROOTS

**Self-portraitist Levi van Veluw
revisits his childhood — using only
wooden blocks, balls and slats.**

Words JANE SZITA **Photos** COURTESY OF RON MANDOS GALLERY

Born in the Dutch town of Hoevelaken in 1985, Levi van Veluw studied at the ArtEZ Institute of Fine Art in Arnhem before taking up an internship with photographer Erwin Olaf. Photography is an important theme in Van Veluw's work, and he also sculpts in various media, but his subject is always the same: himself. For *Origin of the Beginning* — a rather sombre series of installations for the Ron Mandos Gallery in Rotterdam — Van Veluw set off in a new direction, using small pieces of wood (squares, balls and slats) to re-create the bedroom of his childhood.

What inspired the mosaic-like rooms in Origin of the Beginning? LEVI VAN VELUW: They are about my childhood, a time when I didn't have very much structure in my life. I was searching for control, which resulted in an obsession with structure, pattern and repetition.

I was thinking about my self portraits and trying to find out where my fixation on materials and structures came from. So I decided to go back to my youth and re-create the personal environment where the obsession started. When I was a child, I used to spend a lot of time in my bedroom all by myself, and I was always experimenting with materials. I took three elements from those memories and built three rooms around them.

Dare I ask — how many wooden blocks did you use in the room based on squares? I used 14,000 of them, and each one measures 16 cm^2. I made them all myself. The room measures 4 × 2.5 × 2.5 m, just like the other two. They are all life-sized. If you add up the squares, balls and slats, it comes to 30,000 different pieces, each of which I placed by hand.

Must have taken ages. I started in November 2010 and finished in May the year after. Along with the accompanying photos and videos, it was way too much work in such a short time.

Why use such a repetitive material and technique? The square symbolizes a kind of symmetry and precision. But I glued all the blocks by hand, one by one, without using any measuring instruments, so although it looks organized, actually everything is skewed. I wanted the work to show the struggle needed to lend structure to the chaos of blocks. It's about me searching for control.

Then in the room with all the wooden balls, you see a pattern on the left side that blends into chaos. This was a returning nightmare I had at that time, trying to keep the rolling balls in one line, but eventually ending up in chaos. In this work, you see me losing control.

Your works are solely self portraits. Why? For me, it works to keep the concept close to myself. I don't have any ambitions to create political or social work.

Yet in your work you are hardly ever recognizable. That's because it's not really about me. I just use myself as a subject. If you could see me, the blocks would become a suit, and that's not what I want. The setting has to look believable and real.

Are you planning more works in this medium? Yes, but maybe more as an experience — as something you can walk through.

levivanveluw.nl

'It's about searching for control'

Above
THE CHAPEL (2017).

Opposite page
THE ALTAR INSIDE *THE CHAPEL* (2017).

SUR
FA
CE

The oldest and most primitive art works known to mankind are cave paintings. Lines drawn on a surface transcend their two-dimensional nature and become abstract concepts. That's visible in Bart Lodewijk's graphic drawings in chalk, Mark Khaisman's artistry with tape and Simon Schubert's mesmerising folded paper scenes. They show how much can be achieved with modest means. Drawing — using whatever medium — is the art of the imagination.

THE INTRUDER

Loaded with both chalk and charm, artist Bart Lodewijks made his way into the homes and lives of people in Moscou-Bernadette, a neighbourhood in Ghent.

Words FEMKE DE WILD **Photos** HUIG BARTELS

How did the Moscou-Bernadette project get started? BART LODEWIJKS: In 2005, for a retrospective on Roma Publications at S.M.A.K., the municipal museum of Ghent, I drew lines on interior walls. But I wanted to work outside. A museum is a terminal—a place where all the focus is on art. I'd rather live among the people. S.M.A.K originated as a museum without a permanent home—the freedom of working in the city is in sync with that concept. What's more, it's a museum that enters into long-term relationships with artists working on projects with undetermined beginnings and endings. Moscou-Bernadette is part of a longer trajectory.

How does it work? I start by making drawings on low walls. Then I ask to draw on the façade of a house. The next step is to have the lines on one house continue onto the neighbouring house. The work is about the site and about the people who live there, but also about the houses without drawings, which seem to question the project. Gradually, I get acquainted with the occupants and ask to be invited inside.

Why do you use chalk? Without chalk, I'd never have got this far. Nobody would let me in with a can of paint, and working in public space means dealing with bureaucracy, and permits. Chalk keeps the process dynamic and the pace high. Chalk is also a point of departure: at school, the teacher uses chalk to explain the world, and artists use chalk to make preliminary sketches for murals. Drawing is a journey on which I meet people. I use a piece of chalk to create a network. And I'm also talking about a network of lines. With lines, you can do anything: they confine, frame, connect.

How do you apply the lines? For years I derived lines from spaces that I'd measured and relocated, as it were. Now I do it intuitively; I seldom use a preliminary sketch.

I have a spirit level, but I don't use it as a spirit level. When I need a ladder, I borrow it from neighbourhood residents. Sometimes I use tape to indicate lines, but when I'm feeling good, I don't need it. Drawing takes continuous concentration; it's a slow activity, comparable to a long bike ride.

Is your work primarily about the process? When I'm concentrating, I feel as though I'm doing something worthwhile. It's as if I'm following the drawing and, by doing that, creating a sense of certainty. Sometimes, when I'm drawing inside, I work through the evening and all night long—the experience is like being in a kind of trance. It's also about temptation. By going into people's homes and drawing on the wallpaper, I'm crossing a boundary. It's like I'm drawing on their skin.

But chalk wears away. Is transience part of your work? I don't mind when the chalk disappears, because I'm not out to change a space. The locations where I work are interesting because they're evolving and because they're honest. My drawings are a positive intervention. They're like immigrants, never merging with the place but adapting to it all the same; they disappear and leave only a memory behind. People think it's a pity that they vanish, but if they were permanent, the drawings would give viewers a completely different feeling. What's more, my work is captured in photographs and published in books, so it doesn't go away entirely.

bartlodewijks.nl

Oppostie page
AFTER LODEWIJKS GETS ACQUAINTED WITH PEOPLE AND IS INVITED INTO THEIR HOMES, HE DRAWS ON INTERIOR WALLS WHILE GETTING AN UP-CLOSE-AND-PERSONAL LOOK AT LIFE.

THE OCCUPANT OF THE RAILWAY HOUSE LIES ON THE SOFA AS LODEWIJKS DRAWS NEARBY.

Previous spread, right page
OFTEN A DRAWING THAT BEGINS ON THE FAÇADE OF ONE HOUSE CONTINUES ONTO NEIGHBOURING HOUSES.

Following spread
THE DRAWING ON A RAILWAY HOUSE IN MOSCOU-BERNADETTE, A NEIGHBOURHOOD IN GHENT, WAS PART OF *TRACK*, A CITYWIDE EXHIBITION ORGANIZED BY S.M.A.K., THE MUNICIPAL MUSEUM OF GHENT, IN 2012.

**'Drawing is a journey
on which I meet people'**

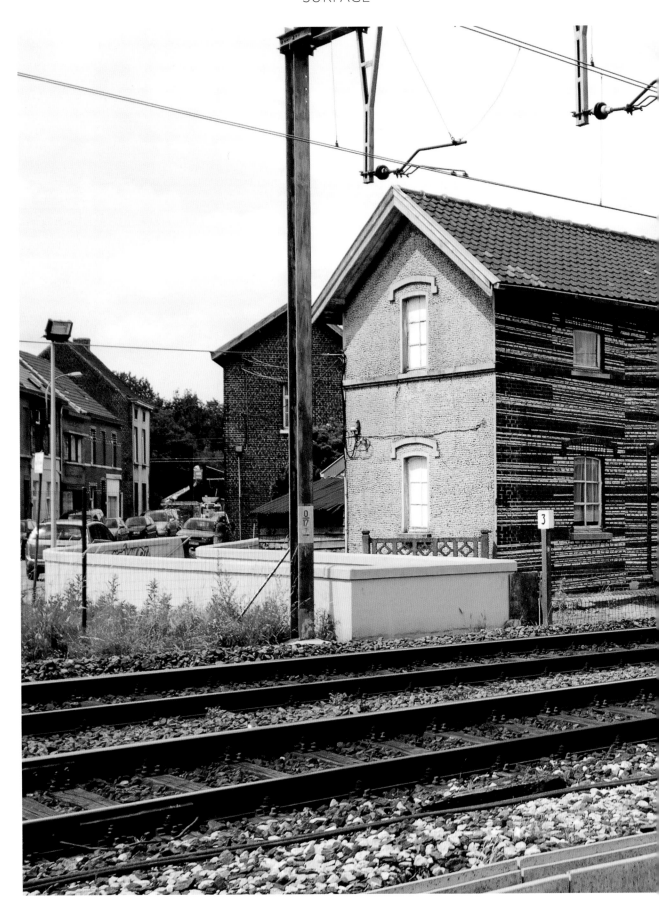

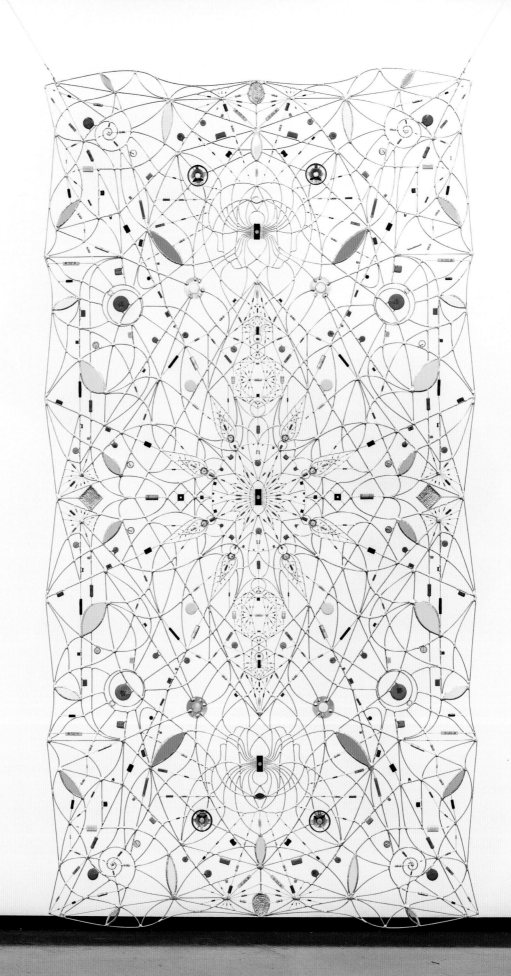

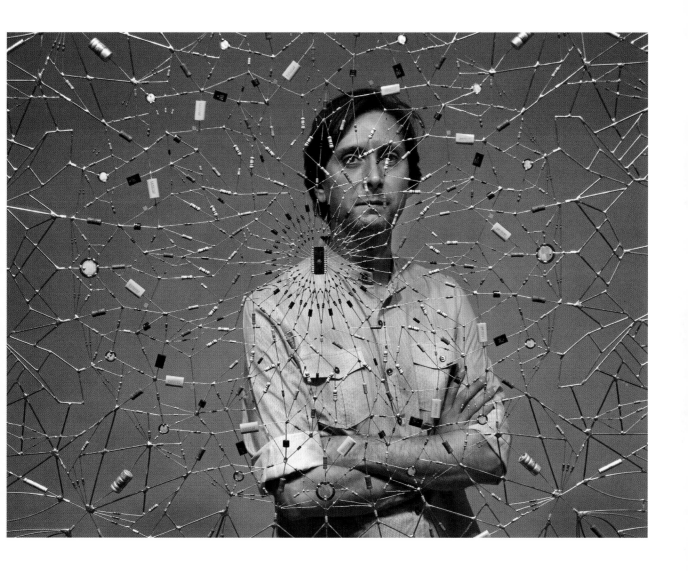

DIGITAL DHARMA

Leonardo Ulian's mandalas, made from electronic components, are an unlikely merger of traditional spirituality and modern technology.

Words JANE SZITA **Photos** COURTESY OF LEONARDO ULIAN

Young artist Leonardo Ulian lists his interests as 'making things, dismantling things, systems (of any kind), electronic gizmos, noise, nature, science and graphics'. As well as a bachelor's degree in fine art, he has earned diplomas in microelectronics and multimedia. His mixed background is apparent in the mandalas (traditional meditational aids) he creates from electronic components. 'I am interested in how systems can be applied in the process of making art, how something can survive within a conventional scheme,' says Ulian. Born in Ruda, Italy, he currently lives in London.

Why would you make mandalas in the 21st century? LEONARDO ULIAN: I liked the idea of combining different worlds, and mandalas represent a spirituality that certainly seems far removed from technology. For me, making mandalas from electronic components underlines the fact that technology has become a fundamental part of daily life — in fact, almost something we worship. I'm also fascinated by the pure exercise of geometry used

could do what they do within electronic devices. After studying fine art, I started to rethink my old passions and interests. This is why now, in my eyes, the electronic components have lost their usual functionality in order to become ephemeral objects, able to affect the eyes and minds of the viewer, but then in a different way.

How many technological mandalas have you made so far? Over one hundred. I'm still working on them.

What are you saying with these works? I think about my mandalas as ephemeral gizmos — ephemeral because in a way technology is impermanent. It's constantly changing and becoming obsolete, like the sand mandalas that can be brushed away after a day.

What's the best thing about this material? I like the fact that one day I won't be able to find the electronic components to make my mandalas. Because the electronics industry is working to miniaturize the compo-

'I think about my mandalas as ephemeral gizmos'

for the construction of traditional mandalas: an ordered representation intended to explain something that probably has nothing to do with geometry, which is the meaning of everything we perceive around us as living beings. I guess my artistic and spiritual research led me to mandalas. I'm not a spiritual person, or at least not in the traditional manner, and I don't have a specific belief. But I do like the idea of a world composed of infinite connections between people, objects or places, like the connections I make in my technological mandalas. I also believe that what happens in one of the connected parts can affect all the others.

What do you use to make your pieces? I use a wide range of electronic components and metal wire, such as copper or steel.

Where do you get the parts? Sometimes I recycle electronic components from old radios, televisions or other electronic equipment, but most of the time I buy what I need online.

What first led you to use this material? Electronic components have fascinated me since I was really young. There's something about them that has always captured my imagination. I asked myself how these little things

nents, the day will come when I won't be able to find the colourful components I now use for my artefacts. This means I will have to transform my art practice, and I find this fact quite stimulating. Where will the future take me?

Will you continue to make them? I'll definitely continue to make technological mandalas. The idea is just beginning. It's evolving and leading me to new creations.

Does your work reflect your feelings about technology? As an artist, I see a society that worships electronic technology, and that's what I want to represent in my mandalas. This is not a criticism of what I observe, but more a reflection on a fact.

leonardoulian.it

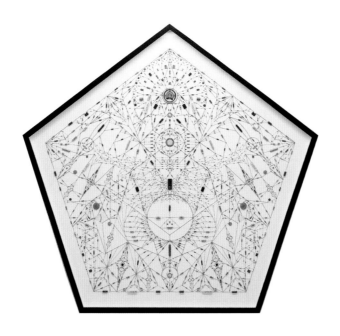

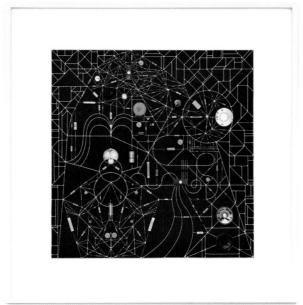

Above
TECHNOLOGICAL MANDALA 25 – 3,6,7 (2014).

*TECHNOLOGICAL MANDALA 116 – TRANSIT
WITHIN THE BLACK SQUARE* (2017).

Previous spread, left page
*TECHNOLOGICAL MANDALA 118 – REVOLUTION,
INVOLUTION* (2017).

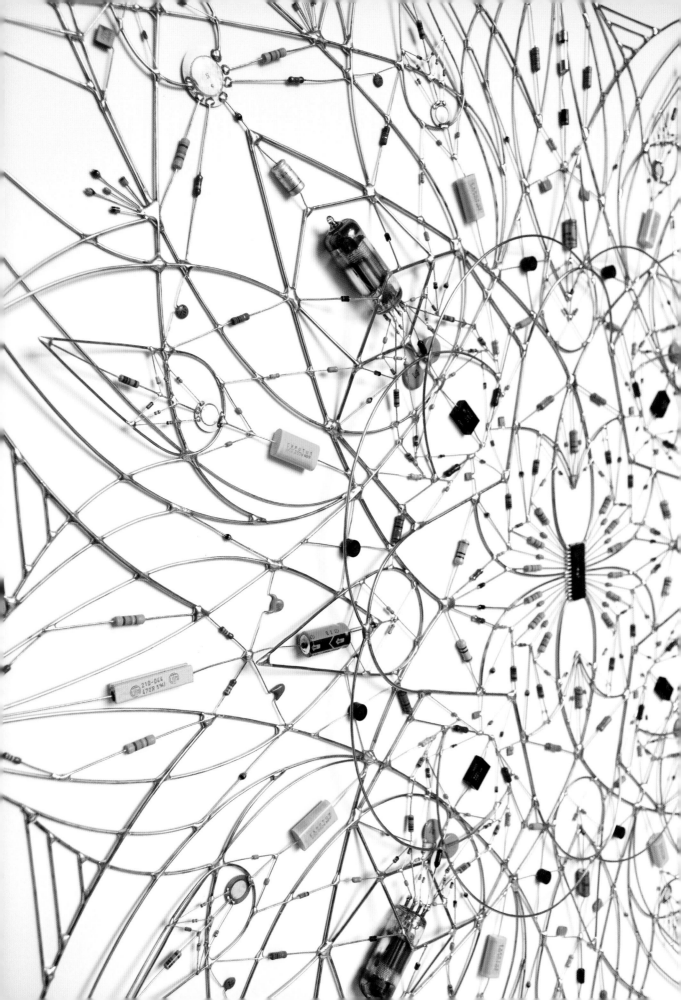

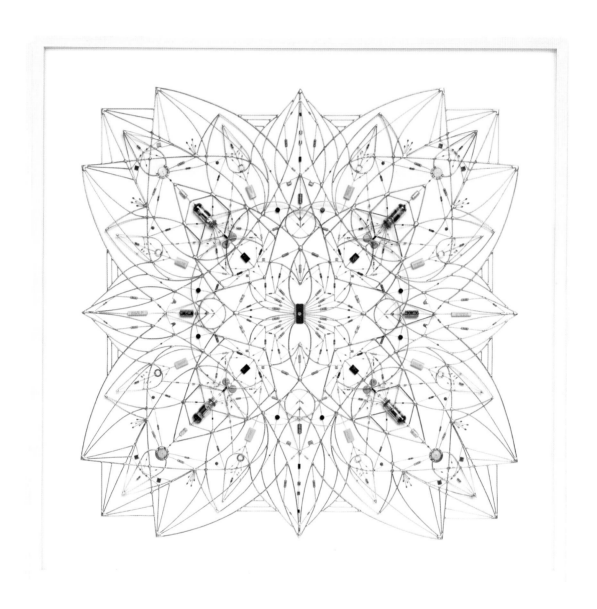

Above and opposite page
*TECHNOLOGICAL MANDALA 92 –
MODEL OF EVERYTHING* (2016).

Lilith Hawemann

WHITE MAGIC

**Simon Schubert creates the
illusion of a serene 3D world —
using only folded paper.**

Words JANE SZITA **Photos** COURTESY KUDLEK-VAN
DER GRINTEN GALLERY, UPSTAIRS BERLIN GALLERY

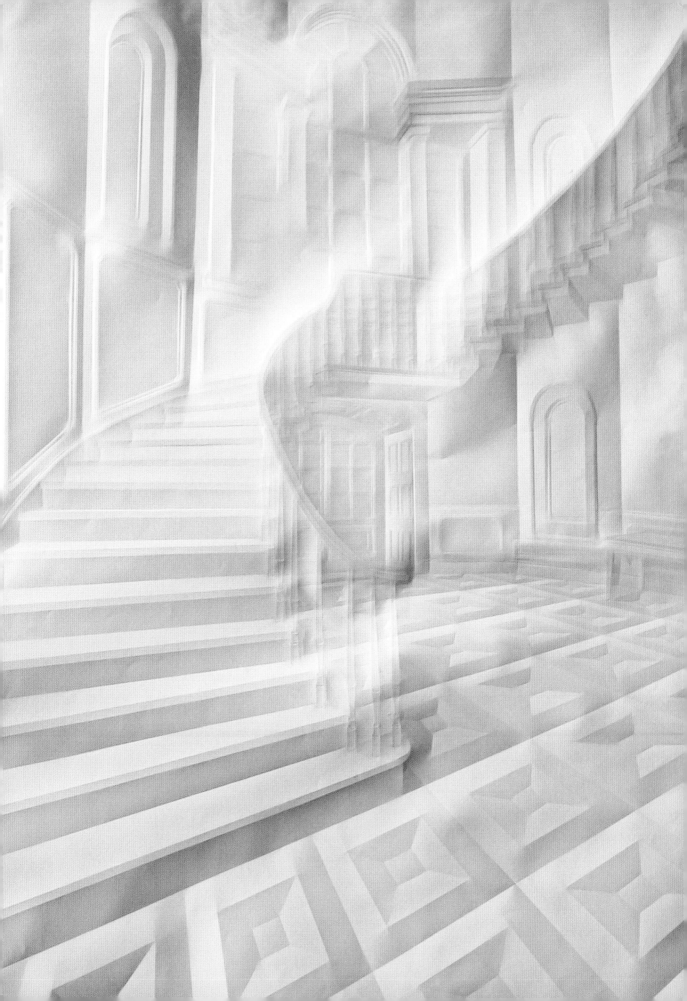

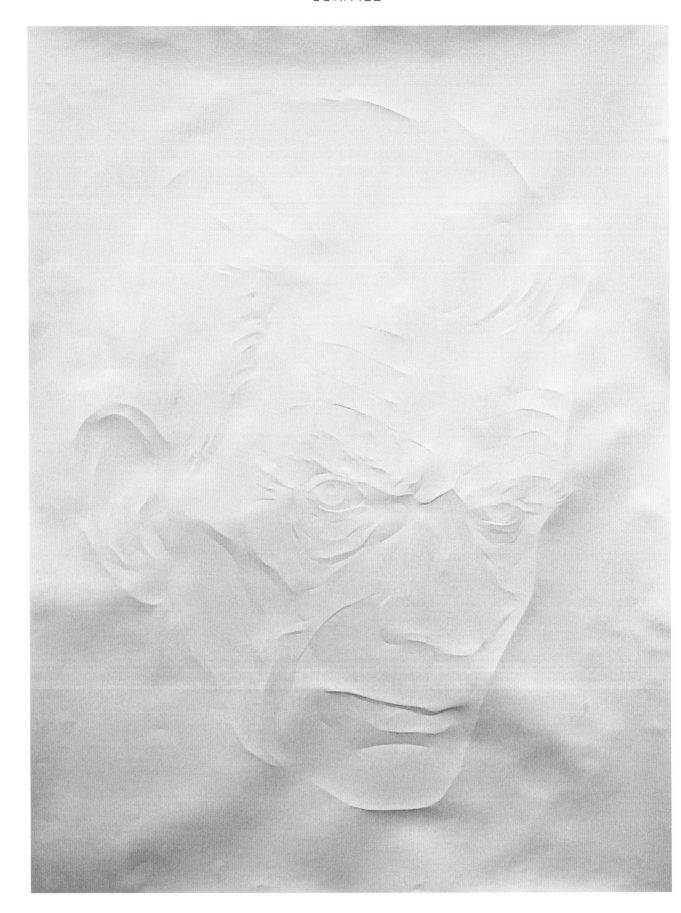

How did you start working with paper? SIMON SCHUBERT: I was trying to find a way of portraying Samuel Beckett. The paper folds resembled the wrinkles in his face. I also wanted to find an equivalent for his idea of 'fading into white'.

But now you're fascinated with interiors. I think it's an interesting idea that 3-D space can be understood as a flat surface, folded. I try to build complex spatial pictures, where different levels of space interlock.

Do you only use white? Sometimes black. But the play of light and shadow can best be seen on white.

What scale do you work on? Mostly, my pictures are sized between 75 cm x 50 cm and 180 cm x 125 cm. But the installation In Apnoesie is a room made of paper, which was built in the 75-m² gallery room of the gallery Upstairs Berlin. The walls and ceiling use 170 single pieces of paper, folded to resemble 18th-century panelling complete with framed pictures. I wanted to transport visitors to another world.

What inspires you? The writings of Samuel Beckett and Edgar Allen Poe, the philosophy of Leibniz and Gilles Deleuze and Douglas Hofstadter's theory — plus the films of David Lynch and Stanley Kubrick.

Why paper? It's pure. It has hundreds of years of art history behind it, and it's the writer's raw material, too. Plus it isn't expensive, and you can take it anywhere.

simonschubert.de

Oppostie page
PORTRAIT SAMUEL BECKETT, 2008.

Previous spread, right page
UNTITLED (STAIRCASE), 2008.

Following spread, left page
UNTITLED (DOORS), 2008.

Following spread, right page
UNTITLED (LONG HALLWAY), 2009.

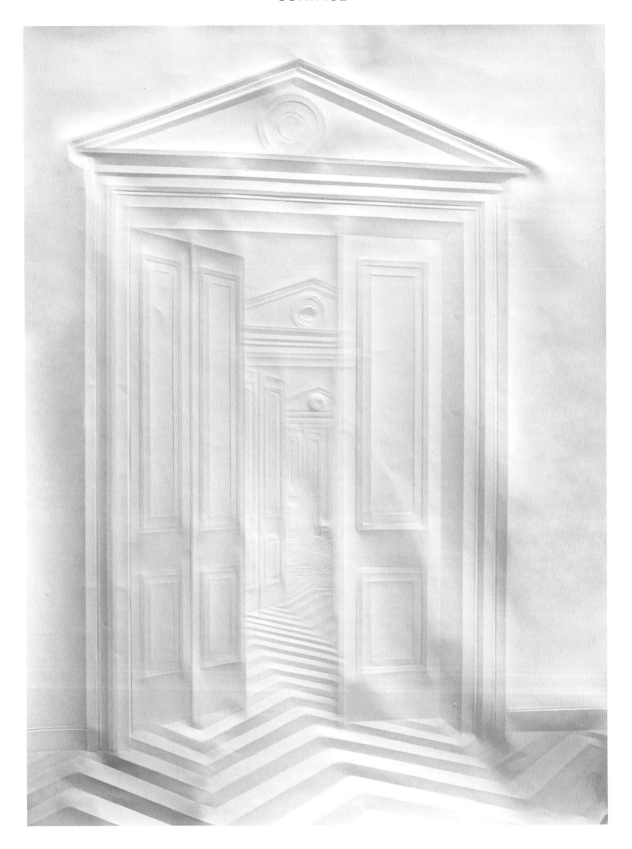

**'Paper is pure
and inexpensive'**

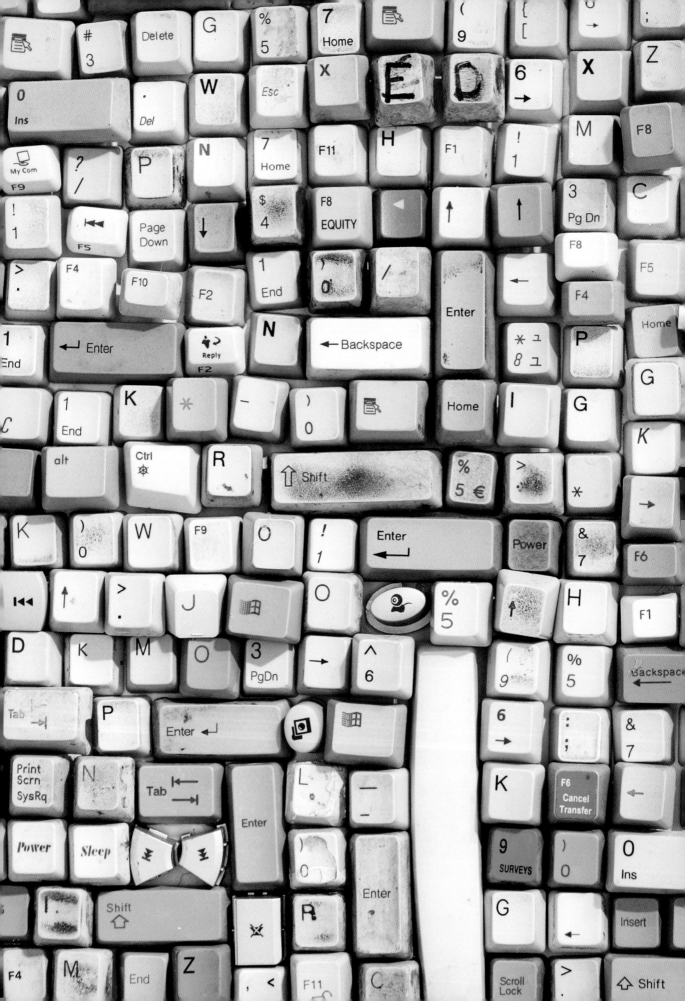

TRUE TO TYPE

Using thousands of recycled keys, Sarah Frost creates wall-sized landscapes of texture, colour and pattern.

Words JANE SZITA **Portrait** MATT KILE

Born in Detroit, raised in Rochester, NY, and trained in painting and sculpture, St Louis-based artist Sarah Frost displays an enthusiasm for found objects that has led to a compelling series of works using mind-boggling numbers of recycled keyboard keys. Over the last two years, her large-scale installations have featured in museum and gallery shows, and one has found a permanent home in the lobby of New York's James Hotel. Frost has also experimented with smaller, framed compositions.

Why did you decide to use old keys as a raw material? SARAH FROST: The keyboards are part of a broader exploration. I'm interested in cast-off objects that show their history and evidence of use. I want to know what these objects say about their users as individuals and as

the earth tones of the marble drove my design.
At Laumeier Sculpture Park and Museum, the installation covered the walls of a large space that was full of oddities — different baseboards on different walls, a basement door, a vent, a fire alarm, a light switch and an enormous old gold thermostat. The colour and tonal shifts of the walls related to how the viewer passed through the space, as well as to the characteristics of these oddities. I attach the keys to boards, and it looks as if the keys are glued to the walls themselves.

Do you plan to keep making installations like these, or does the technique have a shelf life? The pieces are driven by the particular space they are in, so if the opportunity to work in an exciting space comes along,

'I'm interested in cast-off objects that show their history and evidence of use'

part of a culture. The keys grew out of an earlier exploration of obsolete communications technology, including materials such as computer mice, SCSI cables and telephone cords. The keyboards are appealing because they are ubiquitous — the keys in these pieces are taken from a cross section of computer users: individuals, manufacturing plants, Fortune 500 companies, stockbrokers, small businesses, government offices, a grocery-store chain, and so on. Each key has a unique history and bears the residue of its user — each has been personalized by a wear pattern, handwriting, grease marks and even nail polish. While this individuality is apparent upon close inspection, on this large scale it is lost in the overall mass at a distance. The tension between individuals and whole systems is a theme in much of my work.

Where do you find so many abandoned keyboards? I collect them from various electronic recyclers, as well as from garage sales and individuals.

Were you inspired by mosaics? No. The material itself and the scale I was aiming for dictated the form of the installations.

How do you go about making a key wall? I collect the boards, pull the keys off and then research the site. Each piece is site-specific, so the design is driven by the characteristics of the space it is in and by how the viewer approaches and moves through that space. For the James Hotel, the piece is along a stairwell and adjacent to a marble wall. The upward movement of the stairs and

I can see doing more. Yes, there will come a day when I will no longer work with keyboards. But I think that exploring cast-off objects and forms will continue to engage me for a long time.

sarahfrost.info

Above
QWERTY EAST (2010).

Previous spread, left page
DETAIL OF *QWERTY*.

Above
QWERTY NORTH (2010).

QWERTY WEST (2010).

Opposite page
QWERTY AND *WHITE WALL*.

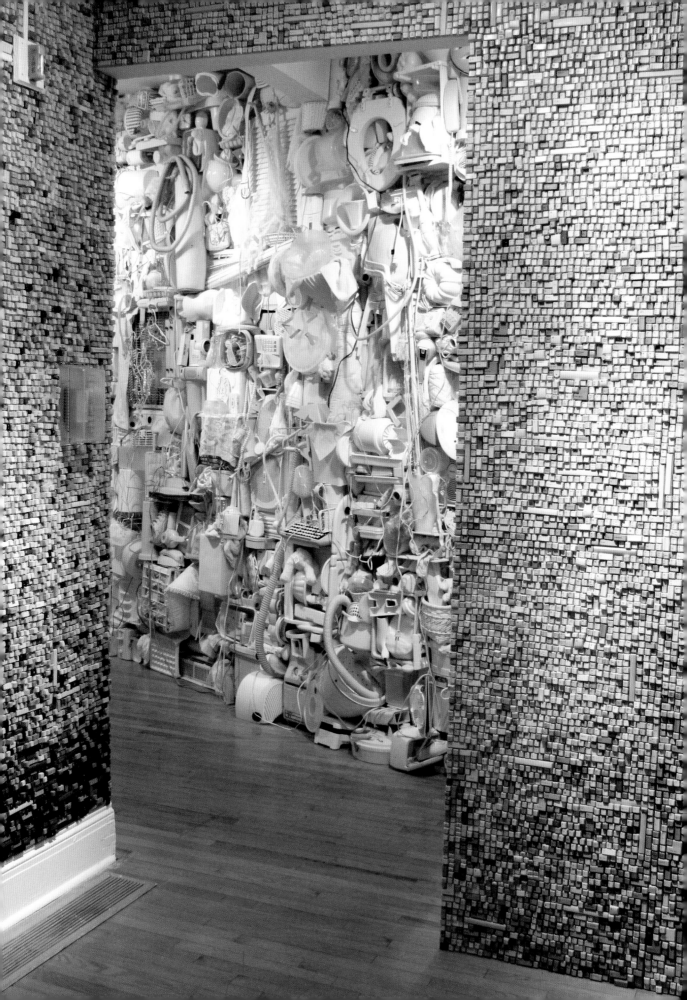

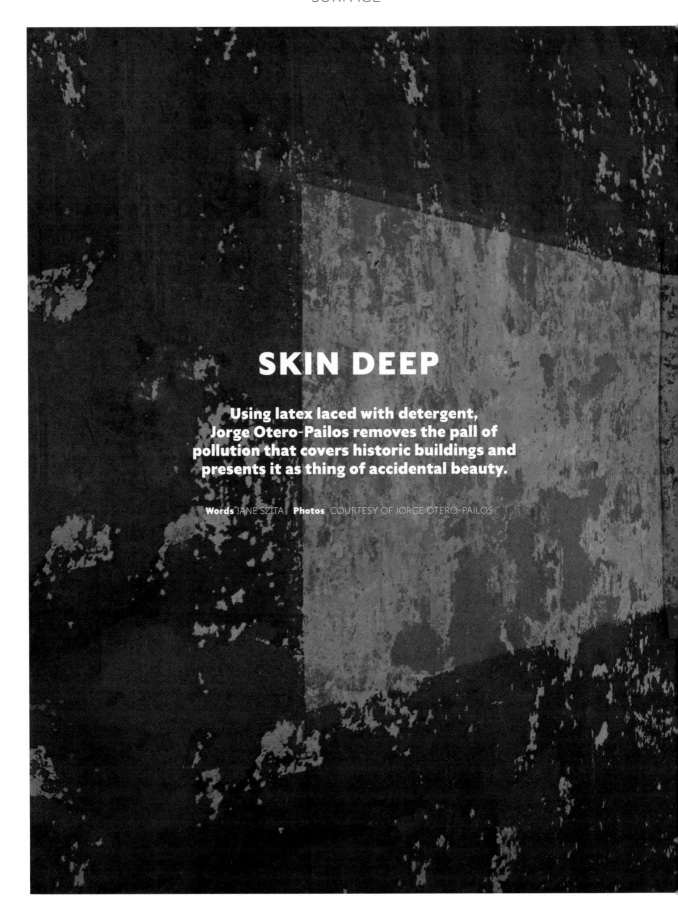

SKIN DEEP

**Using latex laced with detergent,
Jorge Otero-Pailos removes the pall of
pollution that covers historic buildings and
presents it as thing of accidental beauty.**

Words JANE SZITA **Photos** COURTESY OF JORGE OTERO-PAILOS

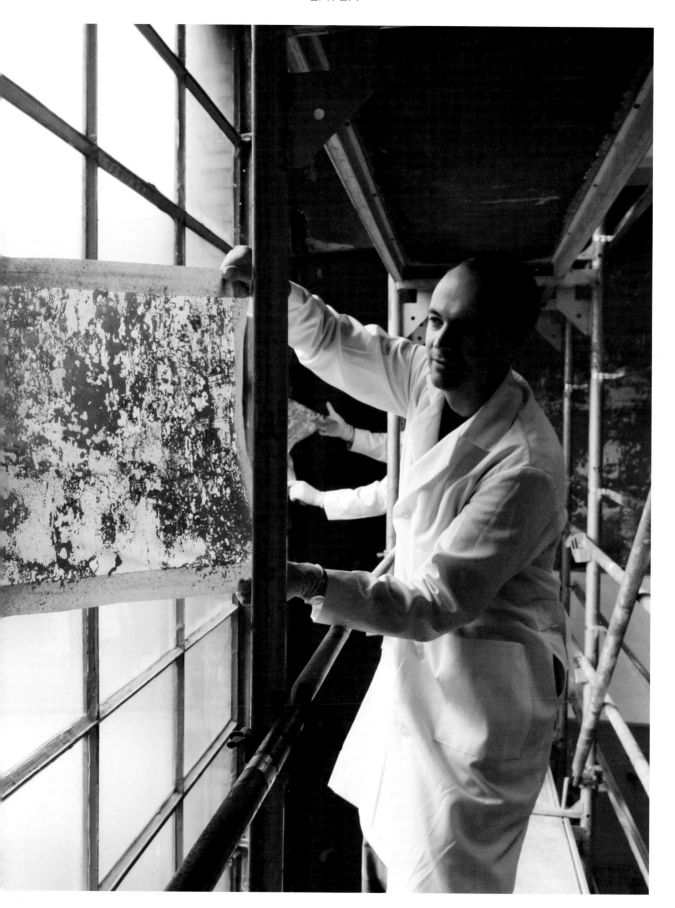

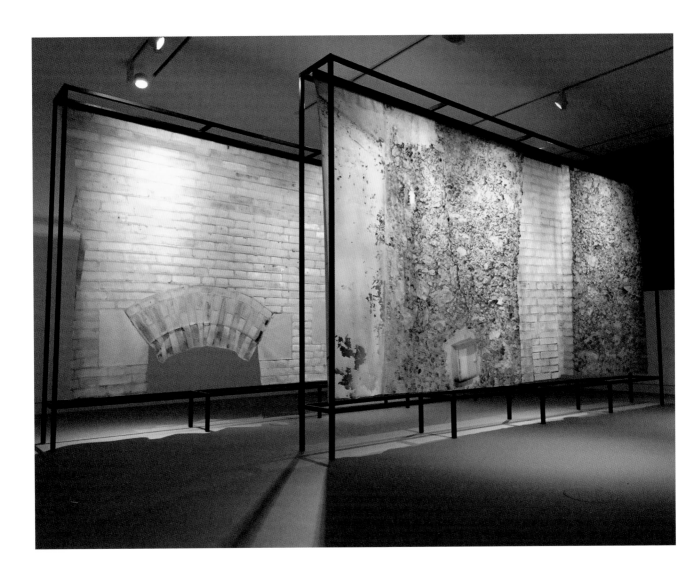

**'We owe our civilization
to pollution, yet pollution
threatens to destroy us'**

Born in Madrid, Jorge Otero-Pailos left home at 13 to study in the USA. Today, he's an architect, artist and theorist with a special interest in forms of preservation. His intriguing, large-scale wall hangings are made from pollution, 'harvested' from historic buildings by coating them in latex, which is later peeled off, taking centuries of dirt with it.

How did you arrive at this unusual art form? JORGE OTERO-PAILOS: I was trying to come up with a way for people to see pollution as a material. There are artists who work with it, but as a pigment. I wanted to allow it to tell its own story. It's a paradox that we owe our civilization to pollution, yet pollution threatens to destroy us. Restoration simply erases it from the visual realm. Most architectural preservation perpetuates the idea that pollution has no place in our culture, so I wanted to find a meaningful place for it.

It's a long-running project you're engaged in, isn't it? Yes. It's called *The Ethics of Dust* and it began in the Italian Alps, at the Alumix aluminium factory in Bolzano. Then I took it to Venice, to the Doge's Palace. The next piece was in London.

With *The Ethics of Dust*, you've used a phrase of John Ruskin's. Ruskin was the founder of modern conservation; he talked about the surfaces of buildings and he lived at a time when pollution accelerated. I'm kind of retracing his footsteps. He wrote about the Doge's Palace, of course, and I made a piece there. Then he went to the Alps, where I've also worked, and soon I'll be in London, Ruskin's backyard.

How do you make these pieces? I use a latex that you can add detergent to — this helps to lightly lift off the pollution. I paint it on, wait for it to dry, and peel it off. This is tricky — the latex sheets are very big, and can rip; you need a few people to do it. Then the sheets are hung and illuminated. What's interesting about the finished objects is that you can view them from two sides — the front side shows the pollution; the back side is a view from within that layer, next to the stone itself. That's something you normally can't see.

How do people respond to them? As if they are looking at something precious and lovely, with great depth. Sometimes they think they're looking at gold leaf. Generally, they're surprised at the beauty of the objects.

Does your work have implications for conservation? Conservation thinks of itself as mechanical, but my work casts light on its creative dimension — something we don't often appreciate. After all, when we look at a historical monument, we're seeing the results of conservation. The past is a mediated experience, and conservation is the mediator.

oteropailos.com

Opposite page
THE ETHICS OF DUST: MAISON DE FAMILLE LOUIS VUITTON (2015). PANELS 7 AND 2 OF THE HEPTAPTYCH. LOUIS VUITTON COLLECTION.

Previous spread
JORGE OTERO-PAILOS PEELS LATEX — AND POLLUTION — FROM THE WALL OF THE ALUMIX FACTORY IN BOLZANO.

Following spread
THE ETHICS OF DUST: OLD US MINT, SAN FRANCISCO (2016). COLLECTION OF THE SFMOMA.

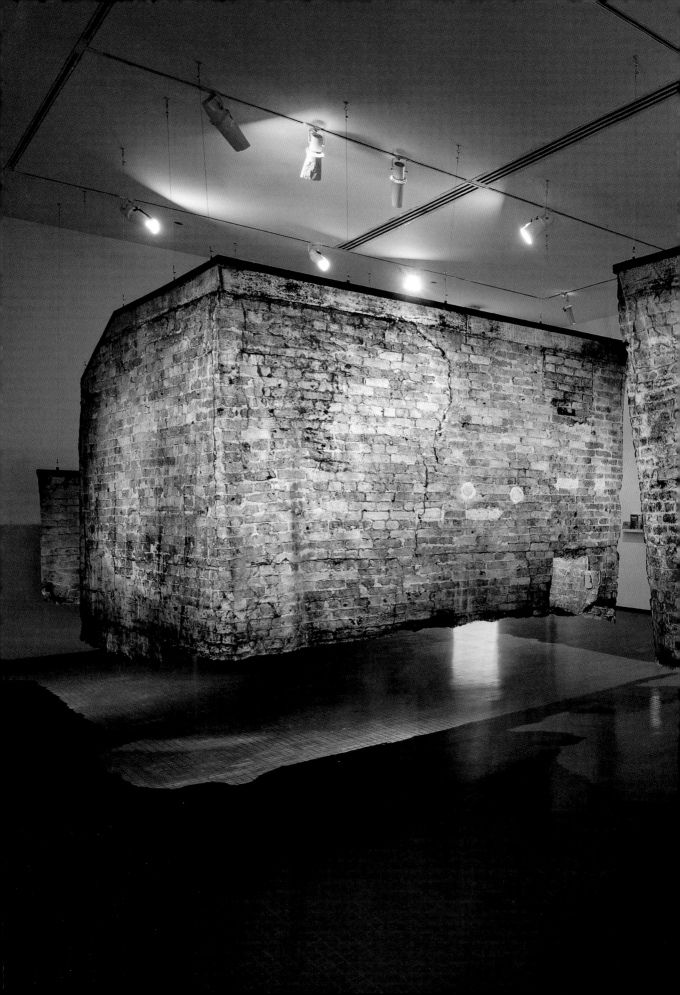

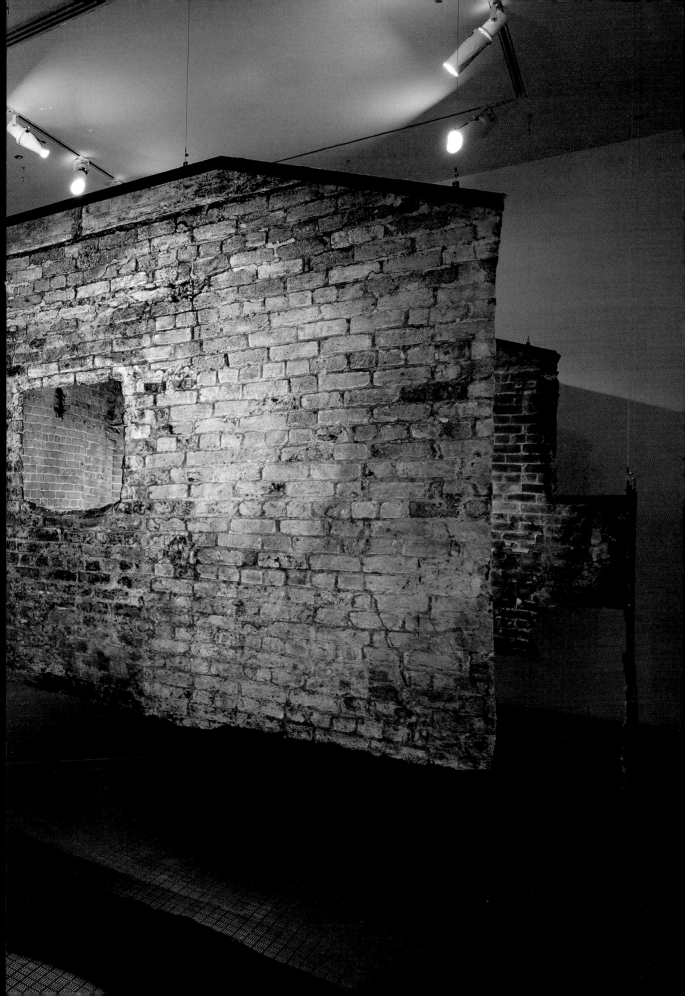

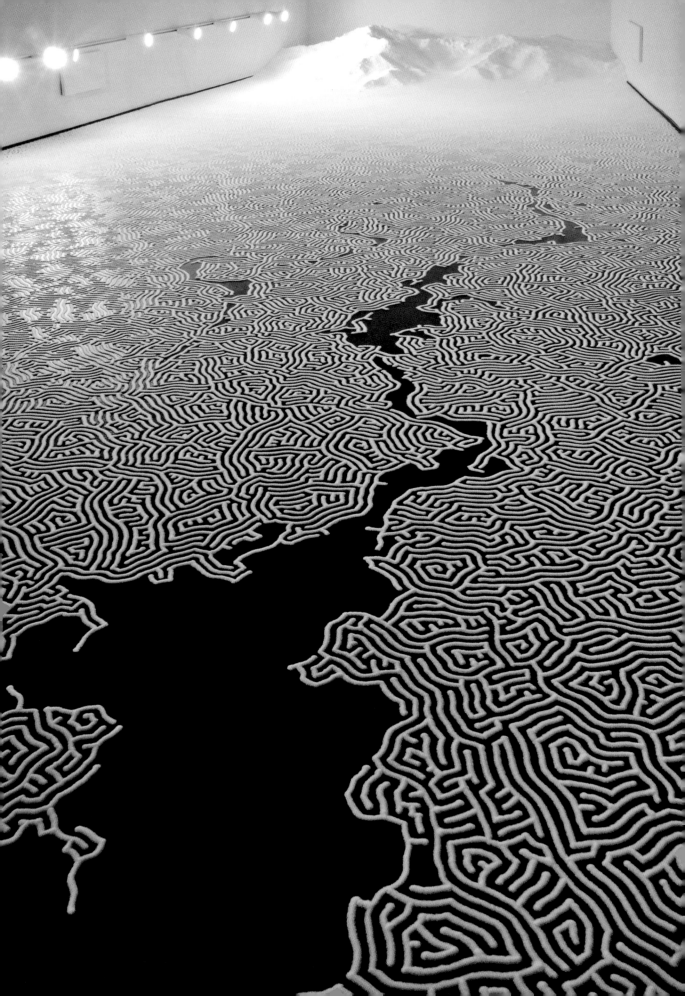

LIFE SAVOUR

**Motoi Yamamoto digs deep
into the cosmic significance
of an everyday substance.**

Words JANE SZITA **Photos** MOTOI YAMAMOTO

Once a precious resource, now a cheap and banal commodity, salt still retains a symbolic vital aura in Japan, where it is often used in rituals – a fact that goes some way to explain the work of artist Motoi Yamamoto, who adopted it as his only material following a family death in the 1990s. Since then, he has fired and sculpted salt blocks into monolithic volumes and poured out the grains like paint to shape the vast yet delicate landscapes he calls 'labyrinths'. These enigmatic mazes are his attempts to probe the mysteries of life and death: when the exhibition ends, each work is dismantled and carried to the sea in a final act of audience participation. Born in Onomichi, Hiroshima, Motoi Yamamoto studied painting at the art college in Kanazawa, where he still lives.

It was a tragedy that led you to use this material. MOTOI YAMAMOTO: When my sister died of a brain tumour, aged only 24, my work became about accepting this reality. I started to focus on funerary customs in Japan, which often include the use of salt for purification. From there it was a short step to concentrating on the material itself, and in 1996 I produced my first work in salt: an installation of blocks which I'd fired myself.

What qualities drew you to salt? Its subtle transparency and its symbolism. Salt seems to possess a close relationship to human life beyond time and space. Gradually, I came to the conclusion that the salt in my work might once have been a part of some creature and supported its life. Now I believe that salt enfolds the 'memory of lives'. I've had a special feeling about my work since I started using it as a material.

What kind of salt do you use? Refined sea salt. It dries and keeps the size of its grain.

A simple material – but your designs are very complex. How do you create them? First I draw an illustration, a small sketch. I go to visit the space, taking the sketch with me, and then I reconsider it. I draw my work directly onto the floor with salt, which I pour like paint. It took about 20 drawings to determine the design of *Return to the Sea*, which I made for the Halsey Institute of Contemporary Art in Charleston. I drew the sketches by hand and scanned them into the computer, then overlaid the images on top of a diagram of the floor space at Halsey. The process of drawing – and comparing drawing and space – helps ingrain the pattern into my mind. Useful, as I work freehand.

What's the biggest salt work you've made? The biggest labyrinth work was for Nizayama Forest Art Museum in 2005. I used about eight tonnes of salt, and it took ten days to make. At the other end of the scale, my smallest labyrinth work was on a tabletop.

No matter how big they are, once the exhibition is over, the work is dismantled. Is that a difficult moment? It's such an important part of my work, the dismantling and returning the salt to the sea. I get the audience to participate in this, and it actually gives me great pleasure to see people sweeping up the salt and throwing it into the ocean. When I see their joy in doing that, it makes me very happy.

Can you explain what your salt works mean to you? The thought that I won't see somebody again, even though I want to, led me to want to see something that cannot be recorded by writing or photographs, something at the nucleus of my memory. Perhaps salt contains the memory of life itself? I make my work with the feeling that maybe, at the end of the maze, I'll be able to meet somebody whom I can't meet under any other circumstances.

Are the salt pieces going to be your life's work? Probably. What other material would express my concept?

motoi.biz

'Salt seems to possess a close relationship to human life beyond time and space'

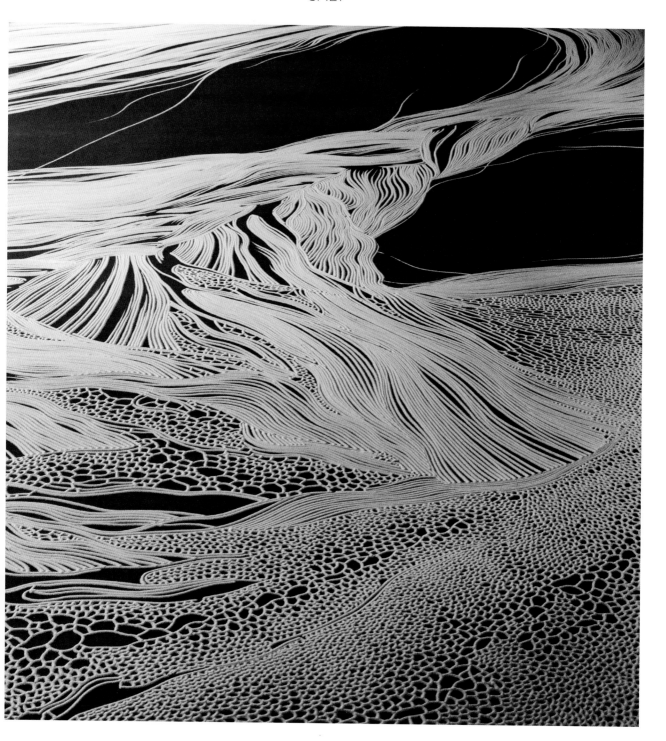

Above
THE DRAGONS OF LAPIS LAZULI, A CORRIDOR
OF ART THROUGH THE MOUNTAIN AND SEAS,
MOMO-SHIMA ISLAND, HIROSHIMA, JAPAN (2017).

Previous spread, left page
LABYRINTH, BELLEVUE ARTS MUSEUM,
BELLEVUE, WA, USA (2012).

Following spread
LABYRINTH, ROPPONGI ART NIGHT 2016,
ROPPONGI, TOKYO, JAPAN (2016).

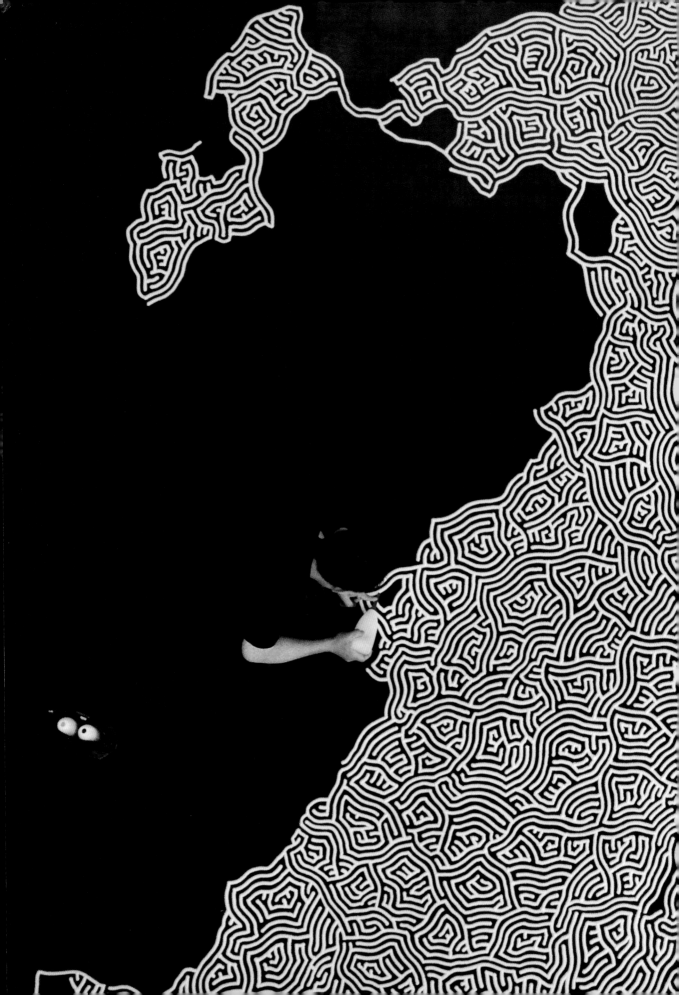

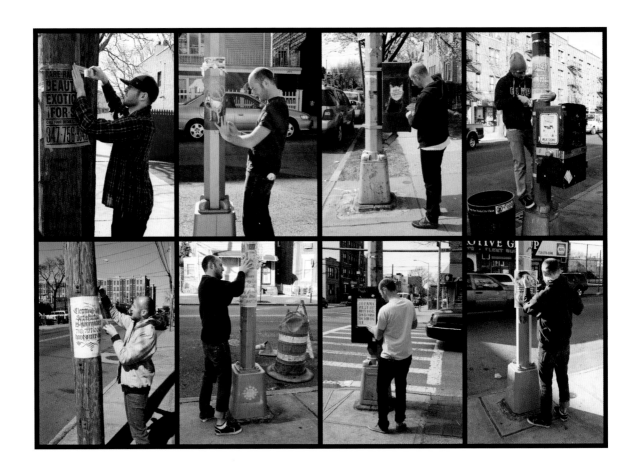

LOST AND FOUND

Home-made street posters are the raw material of Cardon Webb's project, Cardon Copy, an exercise in transformation.

Words JANE SZITA **Photos** COURTESY OF CARDON WEBB

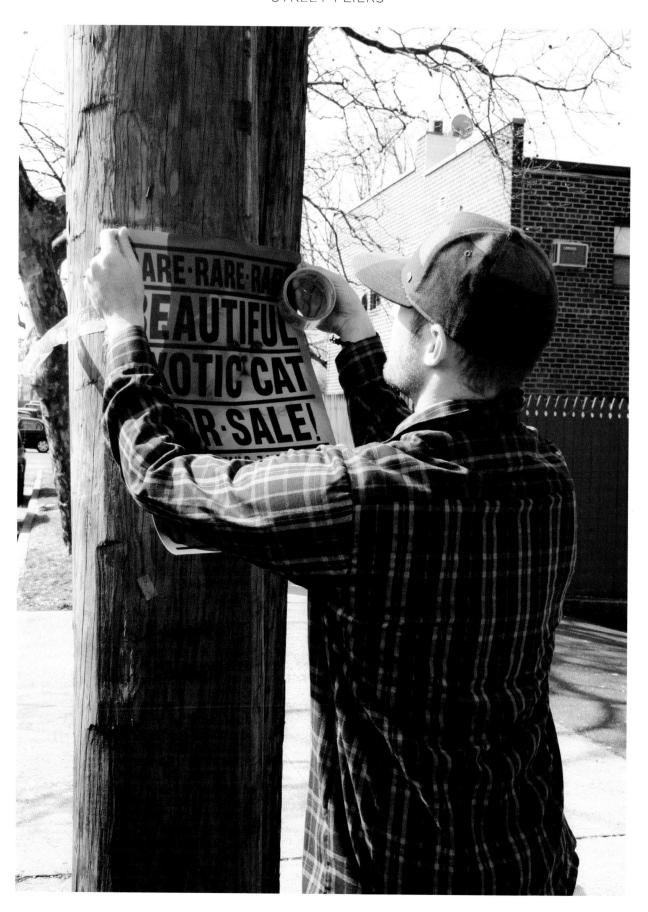

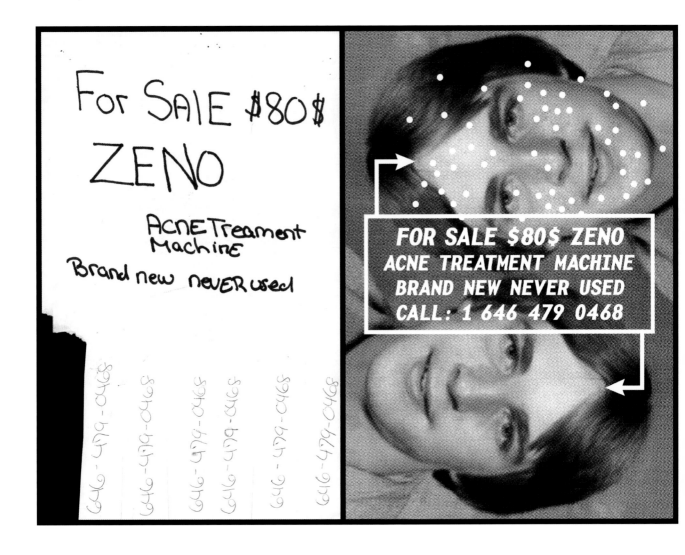

Above and following spread
BEFORE AND AFTER: WEBB'S TRANSFORMATION
OF STREET FLIERS.

Previous spread, left page
CARDON WEBB'S WORK IS MOST PROMINENT
IN QUEENS, BUT ALSO CROPS UP IN OTHER
AREAS OF NEW YORK CITY.

Cardon Webb was born in Albuquerque, New Mexico, and raised in Boise, Idaho. He now lives in New York City, where as a graphic designer and artist he tries to capture the 'ever-evolving environments, patterns, colours and people' of the metropolis in his work. He has collaborated with the likes of David Salle, Maya Hayuk and Andrew Schoultz, and his work featured in a solo exhibition in the city's Type Directors Club (TDC). For his Cardon Copy project, he hijacks home-made street fliers and tear-offs, subjects them to professional design and transforms them.

Why did you start redesigning posters? CARDON WEBB: It began as an experiment. I wanted to demonstrate the power of visual communication. It also gives me a medium for creation and self-expression, allowing me to combine my art, design and typographic ideas. By considering, then altering, such things as colour, composition, image and type, I can transform a common street flier with a message as simple as 'I lost my cat' into something more interesting. The message changes, although the text is the same, word for word. Is the new visual language helping or harming the message? Will products sell better? Will ads get a bigger response? Are people more inclined to notice the message, yet not necessarily trust it? What demographic will answer an ad for a rental apartment when the poster is handwritten in marker rather than printed and well designed? The medium and the design of a message can affect the success or failure of its communication and purpose. I'm hoping to start this type of conversation.

Do you think something in your background explains why you've gravitated to this kind of street design? I grew up skateboarding, playing in bands and writing on walls. I like to think these influences are subtly apparent in my work, given that they are a large part of who I am today. A style was something I never really had to work to achieve. I developed one naturally, early on, without realizing it — until people started pointing it out. I draw a lot of influence from contemporary and low-brow art, as well as from nostalgic and throwback design from the mid-20th century.

Is there a certain geographical area in which you harvest posters? I live in Queens, New York, so by default the majority of the fliers I redesign originate in Queens — about 75 per cent, I'd say. The rest are from either Manhattan or Brooklyn

Many of them have a sense of pathos — lost cats, for example. Is this part of the appeal? I think so. These fliers are naturally very human and even intimate, from one person to another, communicating a specific need. It's important to note that I am not dismissing these simple posters by redesigning them. In fact, I appreciate the originals, aesthetically and conceptually. Because of this, I only redesign fliers that appear in multiples. This way, both the original and the redesign — or Cardon Copy — coexist in the community and can be compared and contrasted. I like to think that what I'm doing helps people to discover what is often overlooked.

Your work has generated a lot of media interest. I see a number of reasons for that. The posters are familiar, something all of us have seen, ignored, related to or commented on in the past. They evoke feelings of pity or compassion. I think a successful piece of art should elicit a polar reaction from its audience. That's where the interesting conversation takes place. I have been called a 'genius' and an 'egotist' on the same day. Some people say I shouldn't do what I do. Some pick apart the design. Others can laugh at it. Cardon Copy is meant to be slightly facetious. There is something comic about seeing familiar street fliers presented in such an elaborate way.

How long have you been doing this? I started Cardon Copy almost a decade ago. In the beginning, the project wasn't as well defined as it is now. Originally, I was working with any handwritten type of signage — things like price tags from fruit stands, bodega lotto posters — even a homeless man's cardboard sign. Something about the street fliers made them the most satisfying. Tampering with the messages by injecting a little design sense gives such a surprising result. I enjoy each one in a different way. I went a couple of months without doing one and found myself really missing it: the creative process, seeing the final outcome, and going out to re-post the finished design.

How does Cardon Copy relate to your day job? I'm a book designer, and I'm loving it. Similar to the Cardon Copies, my book covers consist of a limited amount of copy and imagery. I spend my days looking for new and interesting ways to marry these two elements.

cardonwebb.com

**'Design changes the
message, although the text
is the same, word for word'**

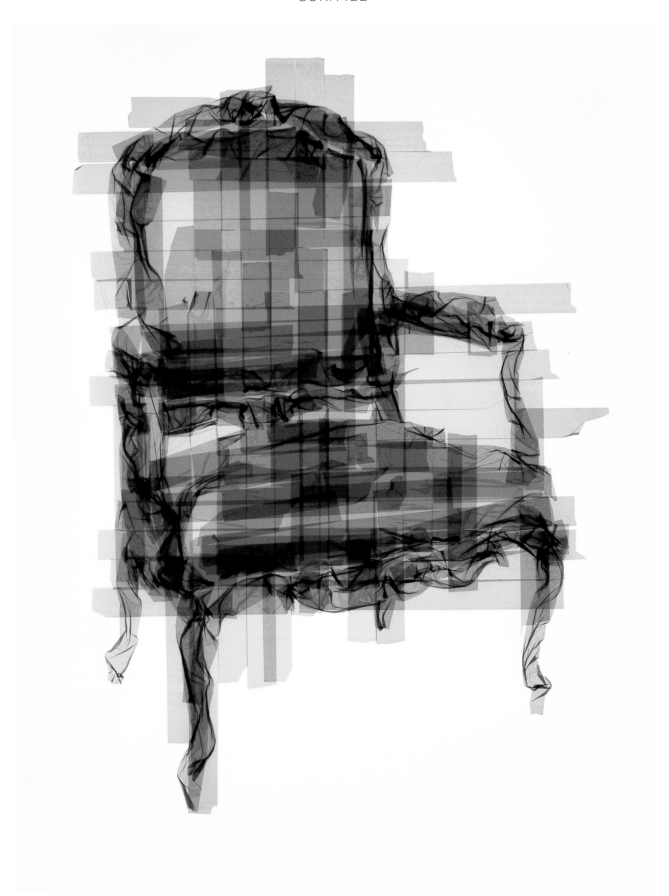

THE KHAISMAN TAPES

Using the most basic of materials, Mark Khaisman creates opulent images with a mesmerizing layered surface.

Words JANE SZITA **Photos** GEORGE P. RAUSCH

You've gone from being an architect to painting with tape. What's the relationship between the two? MARK KHAISMAN: It's strange. It's a love-hate relationship. On one hand, my images are constructed and calculated. On the other, my medium is all about deconstruction, anti-construction. My images imply a fragile, temporary presence, unlike the grandeur that architecture aspires to. Breaking the image into pixels, into layers, and converting matter into a visual illusion — this 'anti-matter' approach to the image is central to my work. Most of my images exist only under certain conditions, such as the presence of light, and may disappear at any moment.

Why the choice of the Louis VX armchairs as a subject? My installations are open conversations between my tape images and the interior space. Rendering over-scaled Louis XV-epoch chairs in tape, in an old factory brightened by clean 'art walls', is my way of playing with scale, of transforming the factory into a doll's house, and of giving flat chairs an architectural appearance.

How do you create such a painterly effect? I use layer upon layer of translucent packing tape applied to clear Plexiglas, often placing the work in front of a light box to give the image shadow and depth. I see my tape art as a form of painting. The 5-cm tape acts as a wide brush and the light behind the panels as an alchemist's luminous blending medium.

Your work seems to extract a kind of symbolic significance from tape. There's a strong counterpoint between the texture and associations of tape with the opulent images I use, like the Louis XV chairs, an opulence ironically belied by the humble medium, like a ball gown made from burlap fabric. The obvious messiness of the tape seems to mesh with the precise image I want, and contrasts effectively with clean or opulent surfaces.

How do people react to your work? People react to my work because it talks to them on many levels, starting from the very basic level of tactility — almost everyone has held this tape in their hands and is familiar with the sensation of striking a line with it. Many may almost feel it and hear the sound of adhesive being pulled off the roll.

What are you working on now? Currently, I'm showing a new series, which expands on the themes of film-noir imagery and on how this cinema still sticks with us.

And your ambition for this technique? I am waiting for the time when people start reacting to my work for the subtler intentions behind my use of tape. I've been working with my invented medium long enough to know it's not just a simple trick, and I enjoy exploring the finer points.

Do you think you have explored all its possibilities yet? My conversation with tape is still ongoing, and I'm still fascinated by it. Actually, I think I might be stuck with it.

khaismanstudio.com

Oppostie page
TAPE NOIR 129 (2017).

Previous spread, left page
$40,700 IN 1991 (2007).

Following spread
TAPE NOIR 110 RUNNING MAN (2016).

**'My images imply
a fragile, temporary
presence'**

CREDITS

One Artist, One Material
Fifty-five makers on their medium

Publisher
FRAME PUBLISHERS

Authors
ELENA CASTLE, KANAE HASEGAWA, AMARA HOLSTEIN, TRACEY INGRAM, SOPHIE LOVELL, BILLY NOLAN, JONATHAN OPENSHAW, INÊS REVÉS, ANNA SANSOM, LOUISE SCHOUWENBERG, JANE SZITA, FEMKE DE WILD

Copy editing
INOTHERWORDS (D'LAINE CAMP, DONNA DE VRIES-HERMANSADER)

Production
DAVID KEUNING

Graphic design
ZOE BAR-PEREG (FRAME PUBLISHERS)

Prepress
EDWARD DE NIJS

Special thanks to
THE EDITORS OF FRAME (ROBERT THIEMANN, TRACEY INGRAM, FLOOR KUITERT, ANOUK HAEGENS)

Trade distribution USA and Canada
CONSORTIUM BOOK SALES & DISTRIBUTION, LLC.
34 THIRTEENTH AVENUE NE, SUITE 101
MINNEAPOLIS, MN 55413-1007
UNITED STATES
T +1 612 746 2600
T +1 800 283 3572 (ORDERS)
F +1 612 746 2606

Trade distribution Benelux
FRAME PUBLISHERS
LUCHTVAARTSTRAAT 4
1059 CA AMSTERDAM
THE NETHERLANDS
DISTRIBUTION@FRAMEWEB.COM
FRAMEWEB.COM

Trade distribution rest of world
THAMES & HUDSON LTD
181A HIGH HOLBORN
LONDON WC1V 7QX
UNITED KINGDOM
T +44 20 7845 5000
F +44 20 7845 5050

ISBN 978-94-92311-27-6
© 2018 Frame Publishers, Amsterdam, 2018

PRINTED ON ACID-FREE PAPER PRODUCED FROM CHLORINE-FREE PULP. TCF-CERTIFIED.
PRINTED IN POLAND

987654321